NO LONGER PROPERTY OF
SEATTLE PUBLIC LIBRARY

SPACE
CRAZE

SPACE CRAZE

AMERICA'S ENDURING FASCINATION WITH REAL AND IMAGINED SPACEFLIGHT

MARGARET A. WEITEKAMP

SMITHSONIAN BOOKS
WASHINGTON, DC

© 2022 by Smithsonian Institution

All rights reserved. No part of this publication may be reproduced or transmitted in any form or by any means, electronic or mechanical, including photocopying, recording, or information storage or retrieval system, without permission in writing from the publishers.

Published by Smithsonian Books

Director: Carolyn Gleason
Senior Editor: Jaime Schwender
Assistant Editor: Julie Huggins

Edited by Gregory McNamee
Designed by Gary Tooth

This book may be purchased for educational, business, or sales promotional use. For information, please write: Special Markets Department, Smithsonian Books, P. O. Box 37012, MRC 513, Washington, DC 20013

Library of Congress Cataloging-in-Publication Data
Names: Weitekamp, Margaret A., 1971- author.
Title: Space craze : America's enduring fascination with real and imagined spaceflight / Margaret A. Weitekamp.
Description: Washington, DC : Smithsonian Books, [2022] | Includes bibliographical references and index.
Identifiers: LCCN 2022019584 (print) | LCCN 2022019585 (ebook) | ISBN 9781588347251 (hardcover) | ISBN 9781588347299 (ebk)
Subjects: LCSH: Astronautics--History--Popular works. | Manned space flight--Public opinion--United States. | Popular culture--United States. | Voyages, Imaginary.
Classification: LCC TL793 .W43 2022 (print) | LCC TL793 (ebook) | DDC 629.4--dc23/eng/20220711
LC record available at https://lccn.loc.gov/2022019584
LC ebook record available at https://lccn.loc.gov/2022019585

Printed in the United States of America

26 25 24 23 22 1 2 3 4 5

For permission to reproduce illustrations appearing in this book, please correspond directly with the owners of the works. Smithsonian Books does not retain reproduction rights for these images individually or maintain a file of addresses for sources.

For John and Ann Gannon

Contents

- 1 **Introduction**
- 8 **Chapter 1**
 Buck Rogers, Ray Guns, and the Space Frontier
- 36 **Chapter 2**
 Space Forts, Television, and the Cold War Mindset
- 74 **Chapter 3**
 John Glenn, the Apollo Program, and Fluctuating Spaceflight Enthusiasm
- 115 **Chapter 4**
 Star Trek, *Star Wars*, and Burgeoning Fandoms
- 157 **Chapter 5**
 Generation X, the Space Shuttle, and Promoting Education
- 187 **Chapter 6**
 Space Stations, Spaceflight Enthusiasm, and Online Fandom
- 227 **Chapter 7**
 Streaming Services, Battling Billionaires, and Accelerated Change
- 263 **Acknowledgments**
- 267 **Notes**
- 289 **Index**

Introduction

As I stood on the taped floor mark smiling into the blinding glare of television lights, the doors opened behind me, and people began streaming into the new Boeing Milestones of Flight Hall. Our exhibit team had done its job. After almost three years of intense work, the central exhibit space of the Smithsonian's National Air and Space Museum had been reconceived. Its grand opening on July 1, 2016, coincided with the fortieth anniversary of the Museum's National Mall building. As I spoke to the viewing audience online, introducing myself as one of the Museum's curators and giving a verbal tour of the newly renovated space, crowds of people flooded into an all-night open house. The Hall—and indeed, the entire Museum building—remained crowded until the wee hours of the morning. Almost 54,000 people visited the Museum that night alone. When I left at 3:20 a.m., a line of visitors still waiting to enter snaked out the door.

The National Air and Space Museum has consistently been one of the most visited museums in the world. Before the restrictions of COVID-19 upended travel and public gatherings worldwide, the statistics for the Museum's visitation ranked it just behind the National Museum of China in Beijing and the Louvre in Paris—and in a long-term friendly competition with the Smithsonian's own National Museum of Natural History across the Mall. Before 2020, the Museum's downtown building alone has received around 7 million visits a year for some time, plus more than 1.5 million visits to its second site, the Steven F. Udvar-Hazy Center near Dulles Airport.

A large part of the National Air and Space Museum's appeal remains its central subject: flight. From the public excitement that greeted the first barnstorming

exhibitions and early air races, Americans have had a love affair with flight. So, too, with spaceflight, whether in imaginative visions or real-life missions.

Long before the first Soviet and American spaceflights, however, American science fiction heroes were rocketing off to new locations, leading motley bands of adventurers to explore new frontiers, and encountering new aliens. Conceptions of spaceflight often reflected their national contexts. For instance, the Soviet space program fit well with the distinctively Russian intellectual movement called cosmism, which posited that through technology, humanity would transcend death and earthly depravations by moving away from the planet. Recent studies of "astroculture" have explored how European spaceflight visions developed in ways that reflected their particular cultural context. Likewise, traditional Confucian culture shaped Korean science fiction. Whether in North Korean science fiction adventures taking place on other worlds or South Korean science fiction set in alternative Koreas, the characters rarely engage other races or aliens as equals. The basic form of American science fiction was just as historically grounded and culturally based.

Beginning in the late 1920s, the dream of spaceflight that coalesced in the United States reflected contemporary concerns, especially gender roles and racial stereotypes. The American science fiction motif, which I am calling the Buck Rogers archetype—rocket-propelled vehicles boosting astronauts into space adventures at the point of a gun—emerged alongside the earliest successful liquid-fueled rockets. It grew through several decades of science fiction depictions of human space adventures. The phenomenon is not uniquely American, but it took a recognizably American form. It is no accident that many such stories in the United States, beginning with *Buck Rogers* and *Flash Gordon*, share a basic narrative structure with Westerns, another distinctively American literary category. Both genres offer outsized tales of rugged individualism, where a quick gun makes everyone equal. Both are set in new frontiers with distant outposts in lawless lands. Both rely on trusty steeds (whether horses or spaceships) that have names and some inherent personality. And both tell stories about Americans' cultural aspirations to explore and be independent and inventive. Equally and perhaps most important, both genres also rely on stereotypes that define who should do the exploring—almost always white, male, expansionist "pioneers."

Stories of gender and race are deeply intertwined with spaceflight imagination. And in the examination of memorabilia and playthings, those changing

INTRODUCTION

depictions can be seen to shift over time. Like Westerns, space science fiction stories reflect the values and fascinations of the culture that created them, not because they act as some kind of cultural mirror, but because the people who created them were products of their eras, weaving their understanding of the world around them into what they created.

From providing an escapist fantasy during the Great Depression to the space craze that greeted the first human flights in the early 1960s and into the twenty-first century, spaceflight has been a persistent and recurring theme in American culture, tapping into foundational ideas about national identity. This is true not only in fictional depictions but also in real programs. As space policy expert Linda Billings has chronicled, American spaceflight advocates often evoke national mythology, drawing upon elements including "frontier pioneering, continual progress, manifest destiny, free enterprise, rugged individualism, and a right to life without limit." Such arguments seek to remind people of how spaceflight efforts align with national ideals.

The connections between flight and American identity are not only illustrated in the collections at the National Air and Space Museum, but they are also an inextricable part of the Museum's own history. When the building on the National Mall opened in the bicentennial year of 1976 as a birthday present to the nation, its message was clear: being an American meant being a citizen of the country that invented the airplane and landed humans on the Moon. As visitors walked into the founding design of the Milestones Hall, the Wright brothers' original 1903 Flyer, the first heavier-than-air aircraft, hung above them. Literally and figuratively, the Museum's layout suggested, every subsequent accomplishment in flight radiated out from this American invention. Just inside the door was a real, touchable Moon rock, still owned by NASA as part of the lunar samples returned during six successful lunar landings completed between 1969 and 1972. Across the room was *Columbia*, the Apollo 11 command module. It carried astronauts Neil Armstrong, Buzz Aldrin, and Michael Collins to and from the first human landing on the Moon. (Collins later became the Museum's director, and he planned and opened the new building.)

The symbolic importance of flight for American national pride was well known—and, in 1976, self-evident. No one needed to explain the Moon landings to audiences that had just watched them on television a few years prior. Indeed, even the flight of the *Spirit of St. Louis*, the iconic aircraft in which Charles Lindbergh

made the first solo transatlantic flight from New York to Paris, remained within many visitors' living memory. After all, the time from Lindbergh winning the Orteig Prize in 1927 to the Museum building's opening in 1976 was only forty-nine years. And the Museum's labels did not mention, let alone define, the Cold War. Everyone alive was actively living in the midst of that social, political, economic, and cultural struggle between communism and capitalism. The decades-long conflict (1947–89) was waged by the Soviet Union and United States through proxies and technological demonstrations, lest the "cold" battles escalate into a "hot" shooting war between two nuclear-armed superpowers. But in 1976, defining that context remained unnecessary. It would have been like explaining water to a fish. People were immersed in it.

In a way, though, that is what historians try to do: explain the water to the fish. Historians unpack and examine the everyday circumstances that create change and continuity in life, telling stories about people, politics, economics, science, technology, and culture in ways that allow us to gain new insights into the past—and our own time. For the past decade and a half, I have been privileged to work as a curator at the Smithsonian Institution. At the National Air and Space Museum, I work with two dozen fellow curators to collect the right artifacts to preserve the history of aviation and spaceflight. Specifically, I curate what we call the Social and Cultural History of Spaceflight collection. (Curators deal with three-dimensional artifacts, while the Museum's archivists and librarians organize and handle audio and video recordings as well as books, magazines, and other paper records.) I am responsible for the memorabilia of actual spaceflight accomplishments, as well as the Museum's space science fiction artifacts. Simply put, these objects represent the ways that spaceflight has been imagined and remembered. These artifacts of the Space Age—everything from toys and games to clothing and patches, medals and awards, buttons and pins, and comics and trading cards—enhance the story about spaceflight told by the Museum's collection of hardware and technologies. In my years at the Smithsonian, I have become increasingly convinced of the power of examining artifacts in telling a historical story.

Many of the artifacts examined here are toys, playful expressions of technologies or people connected with real or imagined spaceflight. Scholars have long explored the many meanings of both toys (as material culture) and play (as cultural practice). In addition to examining the extensive scholarly literature on

INTRODUCTION

the social and cultural history of toys and play, in the long decade during which I was learning my way through the Museum's collection, I also became the mother of three active children. As their toys and energetic play filled every corner of my house, I gained a fresh perspective on the toys and games in the Museum's collection. In 2009, historian Robin Bernstein introduced the idea of "scriptive things." Bernstein describes people's interactions with things as a historically grounded dance, a set of interactions shaped by form and function but open to the agency and interpretive performance of individual users. Toys are particularly rich scriptive things; by definition, they invite creative play. From the scholarly literature and my lived experience as both a parent and a onetime child, I reexamined how playthings should be understood.

Toys are cultural artifacts that can be analyzed according to their manufacturer, materials, and marketing, but they also need to be considered for the ways that they are used by consumers, usually young ones. Form guides function; social context shapes use. What point of view does the player take when holding a toy ray gun? How do the floor plans of suburban housing support the sale of elaborate playsets? Which characters become figurines and which do not? Ray gun toys, multipart playsets, and action figures not only invite actions from prospective players, but they also convey cultural contexts within them that reflect the era of their creation.

Likewise, fictional characters draw upon the social preoccupations of their times. Who can be the hero? Who represents a sufficiently threatening enemy? Aliens depict difference, standing in as either projections of contemporary fears or reflections of the biases of the day. Toys often reinforce those perspectives, carrying assumptions about the point of view that could be acted out through play. Likewise, the reality of who could be an astronaut—the ultimate space hero—also changed over time in ways that reflected social, political, and cultural contexts.

Reexamining the history of spaceflight enthusiasm using both popular and material culture reveals a fundamentally American tale of commerce, technology, society, and culture. It also illustrates the tremendous changes in popular culture formats. From newspapers and nickelodeons to world's fairs and amusement parks, comic strips and movie serials, radio programs and novelty premiums, television and commercial toys, these changes now include the Internet and streaming media. Arguably, the business models and transmission methods of

popular culture changed more in the twentieth century than any other time in human history. Over time, fans also actively shaped their experiences. Building communities meant finding like-minded enthusiasts through clubs, conventions, or the Internet. Whether shared and collective or isolated and individualistic, consumption was not passive.

Through conventions ("cons," in the lingo of their participants) or the costuming done by fans (known as "cosplay"), science fiction enthusiasts often communicate their fandom through material things. Purchasing, owning, giving, or displaying branded T-shirts, buttons, jewelry, mugs, bags, stamps, costumes, comics, or books serves to express one's affinity for one franchise or another. As home entertainment systems developed, even films or television could be purchased as three-dimensional things sold in the consumer marketplace. In the era before streaming services, assembling a personal science fiction library meant collecting videodiscs, videocassettes, DVDs, Blu-ray discs, or other media formats. Of course, using memorabilia to analyze enthusiasm for space-themed science fiction pushes the analysis toward mass media representations (comic strips, comic books, films, television, etc.) rather than short stories, novels, or other printed fiction. Although science fiction literature has been extremely influential, it rarely generated three-dimensional memorabilia or commercial tie-ins. (Think about how few Isaac Asimov action figures you've seen.) Space science fiction fandom has many material connections.

Likewise, affinity for actual spaceflight also inspired souvenir collection. When millions of people watched launches or visited space-related sites (such as NASA's Kennedy Space Center, for instance), many commemorated that connection with a memento: a pin or mission patch, a T-shirt or mug. Unlike other historical events that might reveal their significance after the passage of time, spaceflights were recognized in the moment as self-evidently historic. Even those working in the aerospace field wanted tangible evidence to demonstrate that they had been present.

Examples of these material expressions of spaceflight enthusiasm have been included in many of the new exhibits developed for the Museum's revitalization. The Museum's building on the National Mall has undergone an immense transformation that began in 2018 and will lead to a fully rebuilt edifice by 2026. Popular culture artifacts tell key stories in galleries throughout the reimagined space. They punctuate exhibits about the race to the Moon, the ongoing Space Age,

INTRODUCTION

our satellite-enabled world, current human spaceflight, and even planetary exploration.

Using artifacts as evidence, this book examines how spaceflight both real and imagined shifted in form and meaning over the course of the twentieth and twenty-first centuries. In each era, many Americans sought to hold a little piece of that history as a physical thing. These objects had meanings that were shaped by their creation as a product of their times and refashioned in their use by their owners. For Americans, spaceflight has been a site of exploration, aspiration, and imagination as well as conflict, conquest, and exclusion. America's enduring fascination with spaceflight has both echoed and reinforced shifting race relations and gender roles, changing economic conditions, and the evolution of popular and mass culture. Using things to examine how and why spaceflight's popularity evolved unpacks a complex history of the American experience.

CHAPTER 1

Buck Rogers, Ray Guns, and the Space Frontier

The colorful assortment of ray gun toys spread out on the table looked ready to play with, but my job was to use them to tell a story. As my first exhibit assignment, I was curating a display case of space science fiction toys in the McDonnell Space Hangar at the National Air and Space Museum's Steven F. Udvar-Hazy Center. Eight glass shelves awaited my choices.

The project was a nice way for a new curator to learn by doing. To fill the display, I first scoured the Museum's database. Collections staff pulled my selections out of storage and laid them out for review. Working with an exhibit designer, I arranged and rearranged the artifacts on a tabletop with a taped outline that marked the exact dimensions of each shelf. Rejected choices went back into storage. I grouped and repositioned the toys that remained. As each shelf came together, we took pictures and copious notes to capture the design, noting where mounts would need to be constructed or labels positioned.

For a time, the toy ray guns confounded me. I did not want our exhibit to look like a gun rack. Nor did I want visitors to turn the corner and find themselves looking down the barrel of a gun, even a toy one. Nothing worked. Finally, the exhibit designer had the idea to remove a shelf and hang the ray guns directly on the back wall of the case. Colleagues would later point out that we had re-created a classic armament display pattern, arrayed in a circle like spokes on a wheel, each ray gun aimed at the case's main label. There I stated one of the earliest versions of an idea that became this book: "Space-themed science fiction shares many characteristics—and playthings—with that other great American genre, the Western."

BUCK ROGERS, RAY GUNS, AND THE SPACE FRONTIER

On the shelf below that arrangement, we displayed an example of the very first three-dimensional Buck Rogers toy gun, the hugely successful XZ-31 Rocket Pistol produced in 1934 by Daisy Manufacturing of Plymouth, Michigan. In the excitement that greeted its release and the holiday price wars that broke out over it, the unpretentious artifact represented a material link between the cultural popularity of spaceflight and the centrality of the Western in the stories that Americans tell themselves about who they are. The toy embodied the way that imagined spaceflight gained popularity in the 1930s because it tapped into a specific vision of American national identity forged much earlier.

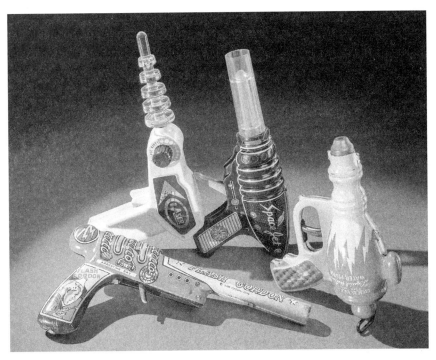

Four toy ray guns from the National Air and Space Museum's space popular culture collection illustrate the varied colors, shapes, and designs exhibited in this kind of toy. From top left, clockwise, Laser Gun Toy, Taiwan, c. 1970s–80s; "Space Super Jet" Toy Gun, Japan, c. 1960s–70s; XZ-44 Liquid Helium Toy Water Pistol, USA, 1936; and Flash Gordon Arresting Ray Pistol Toy, USA, 1952. Photo courtesy of the National Air and Space Museum / Eric Long, WEB1188722—011.

BUCK ROGERS AND **FLASH GORDON**

Buck Rogers first appeared as a character in the pulp magazine *Amazing Stories* in August 1928. Then called Anthony Rogers, he starred in Philip Francis Nowlan's story "Armageddon 2419 A.D." Knocked unconscious, the blond hero awoke in the twenty-fifth century to find America under attack from "Mongol" hordes, reflecting long-standing anxiety about the "yellow peril," anxiety rooted in shifting nineteenth- and twentieth-century Western fears that Asian immigration and influence would overwhelm white dominance of the world. In the story, women, including the female lead, Wilma Deering, were equals, flying by means of gravity-defying jumping belts. Together, the remaining Americans defended their territory.

Despite the futuristic setting, Nowlan's character remained largely earthbound in that tale, only later taking on space quests. Rogers was not the first space adventurer, either. The very same issue of *Amazing Stories* contained one part of a serialization of Edward E. Smith's novel *The Skylark of Space*, with Smith's heroic spacefaring inventor, Dick Seaton, pictured on the cover wearing a flying suit. But generations of fans remember Buck Rogers, not Dick Seaton or his ship *Skylark*, because Nowlan received an offer that gave his character a new life. National Newspaper Service president John F. Dille suggested that the story would make a great comic strip—with just one small change. Renamed "Buck Rogers," a nod to the contemporary popularity of Westerns, Nowlan's strip, illustrated by Dick Calkins, debuted on January 7, 1929.

The timing was perfect. The adventure strip was just emerging as a form. Previously the realm of humorous material only—they were known, after all, as "funnies"—newspaper comic strips evolved into a new form in the late 1920s. Instead of publishing panels drawn only to elicit a laugh, newspaper began commissioning artists and writers to draw serials, strips that featured recurring characters carrying out stories that continued across multiple installments. The same month that *Buck Rogers, 2429 A.D.* debuted, Metropolitan Newspaper Service began publishing *Tarzan*, based on Edgar Rice Burroughs's famous character.

Readers immediately accepted this new style of comic, and adventure strips began to have long runs. After being renamed *Buck Rogers, 2430 A.D.* in 1930, Nowlan and Calkins's comic strip eventually became *Buck Rogers in the*

25th Century, simply so that the far-future date in its title would not have to be adjusted every year.

Buck Rogers quickly found new forms. Nowlan published a second short-story adventure about Rogers, "The Airlords of Han," in the March 1929 issue of Amazing Stories. The syndicated comic strip led to success in other popular culture forms, including a Buck Rogers color Sunday strip beginning in 1930 and a radio program in 1932. Another iconic character emerged. Created to compete with—and cash in on—that success, Flash Gordon began fighting another Asian enemy, Ming the Merciless, in comic strips in 1934. When both series spawned movie serials later in the 1930s, Olympic swimmer and actor Larry "Buster" Crabbe, who had already portrayed Tarzan on the silver screen, played first Flash Gordon in 1936 and later Buck Rogers in 1939.

In the depths of the Great Depression, fans of Buck Rogers and Flash Gordon could follow their favorite characters' exploits in comic strips, Sunday strips, comic books, and film serials. Children could join Buck Rogers's "Solar Scouts" or Flash Gordon's fan groups and imagine themselves undertaking similar adventures. Commercial sponsors for the radio programs tied their brands to these space adventure heroes, solidifying those consumer relationships with trinkets available in exchange for some product wrapping and a dime. The eponymous hero became so well known that the term "Buck Rogers" became a common slang term for "futuristic."

In the 1930s, the craze for imagining spaceflight through fantastical comic-based characters emerged as the nation and the world plunged into an economic recession that would end only with the outbreak of another world war. Just months after Buck Rogers debuted on the funny pages in 1929, the headlines of national newspapers carried news of the Wall Street crash of October 29, known as Black Tuesday. Space-themed adventures caught the public imagination at a time when Americans needed some distraction and when the means of disseminating and consuming popular culture—newspaper comic pages, inexpensive dime novels, movie theaters, and radio sets—already existed in sufficient supply to carry those messages. From their innocuous origins on the newspaper comic pages, Buck Rogers and Flash Gordon established the form of a new, recognizably American, kind of space imagination. Stories of space adventurers riding rocket-propelled vehicles into the space frontier became so accepted that no one questioned the various elements of these tales or why those elements fit together.

The archetypes of space adventures that developed in the 1930s shared many characteristics with Westerns, playing out core notions about American identity in imagined adventures that drew on contemporary events and figures. In both, justice was ensured by a hero with a gun. Ray gun toys illustrate both the contemporary popularity of space-themed stories and the serious social and cultural assumptions embedded in their seemingly playful point of view.

IMAGINING SPACE AS A PLACE

Before *Buck Rogers* appeared on the scene, space adventures had not yet settled into the structures that shared so many commonalities with Westerns. The most influential spaceflight stories actually began in France, a nation enamored of flight since the first balloon ascensions by the Montgolfier brothers and others in the 1780s. At first, such stories were largely a literary phenomenon, part of the birth of a new genre in the nineteenth century, science fiction. These tales found eager reception around the world through translations and silent film.

The idea of space-based places as destinations for exploration has a long history that can be traced, at least in part, to the French science fiction author Jules Verne. Although many writers had imagined fantastical trips to the Moon, the first of them being the Roman author Lucian in about 125 CE, Verne's tale of a lunar expedition, *De la Terre à la Lune* (*From the Earth to the Moon*), was one of the first to suggest a conceivable voyage to the Earth's nearest neighbor. Published in French in 1865, the novel first became available to English-language readers in 1867. Scribner, Armstrong & Company of New York produced a beautifully illustrated version with detailed full-page engravings in 1874. In the book, Verne imagined a group of Americans shooting a complex projectile that would take them on a five-day trip to the Moon.

Throughout the novel, Verne reinforced the realism of the Moon flight by offering scientific explanations for the main characters' choices. For instance, the novel included considerable detail given about the construction, materials, and features of the projectile and the cannon. Verne specified how the shock of the launch would be dampened inside the projectile, how the air would be chemically scrubbed of the inhabitants' poisonous exhalations, and even how the vehicle would be tested before the flight. As befitted an adventure story, the spacefarers equipped themselves with both scientific instruments and weapons

as "precautions" against the unknown. After a dramatic countdown, the novel ended with a cliffhanger: the projectile orbiting the Moon.

The book's dramatic ending left readers unsure about the travelers' fate, allowing Verne up to publish a sequel, *Autour de la Lune* (*Around the Moon*). Some English-language editions later combined both pieces into one book sold as *The Moon Voyage* (1877). When compared to the actual lunar missions run by the National Aeronautics and Space Administration (NASA) in the late 1960s and early 1970s—which, as Verne had imagined, also launched from Florida, carried three travelers, and splashed down in an ocean—Verne's novels seem prescient. More important, Verne's persuasive vision of a human mission to a space-based destination influenced generations of artists, scientists, and engineers.

In particular, Verne's tales of lunar travel helped inspire French filmmaker George Méliès's innovative spaceflight tale *A Trip to the Moon* (1902). Like Verne's novel, the silent film showed adventurers flying to the Moon aboard a large metal projectile shot by a giant cannon. Méliès's space travelers were elderly bearded astronomers wearing star-studded academic robes and tall scholars' caps. Female dancers carried their telescopes and pushed the projectile into the cannon. Unlike Verne's space adventurers, however, these travelers reached their destination. The image of the projectile lodged in the eye of the man in the Moon has long been iconic.

Méliès's visual depiction of the Moon as a landscape inhabited by aliens reinforced the idea that space-based places could be rock-solid settings for stories. The film's depictions drew inspiration from H. G. Wells's *The First Men in the Moon* (1901) for the idea of alien lunar inhabitants called Selenites after the Greek goddess of the Moon, Selene. Méliès's astronomers battled humanoid Moon dwellers before being captured and brought to their lunar palace. Reinforcing the otherworldliness of the lunar setting, *A Trip to the Moon* used filming tricks and other special effects to make objects—and Selenites—appear and disappear instantly. Theatrical effects added to the film's visual appeal and storytelling. When the astronomers escaped, they inadvertently brought one of the Selenites back to Earth with them. In one of two scenes that were lost for decades, the astronomers paraded the alien through the streets to the dedication of an immense statue in the astronomers' honor.

Méliès's vision of an occupied lunar surface was projected for audiences in France and around the world. *A Trip to the Moon* was easily understood regardless

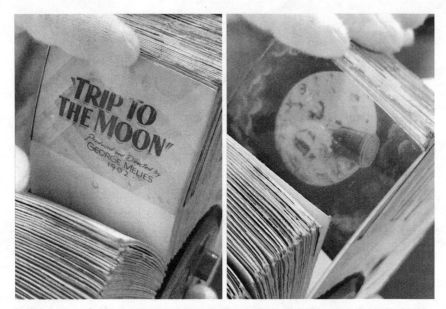

A mutoscope reel of *A Trip to the Moon* held by the Archives of the National Air and Space Museum illustrates another way that viewers might have watched Méliès's imagined lunar voyage. Each card's image is reversed, most noticeably in the iconic frames of the Moon with the projectile in its eye. Photo by the author, courtesy of the National Air and Space Museum.

of language because it did not contain title cards other than an introductory one. It was not only distributed by Méliès but also widely pirated by other film companies. Notably, Thomas Edison's laboratory in West Orange, New Jersey, reproduced the film in copies that so dominated the American market that *A Trip to the Moon* became better known in the United States as an Edison and not a Méliès production.

Méliès's *A Trip to the Moon* also existed as a mutoscope reel. Mutoscopes were large, stationary motion-picture devices consisting of coin-operated metal cabinets that could show a short portion of a single film to a single viewer. In the early years of motion picture technology, such "peep show" devices drew the ire of newspapers and reformers, but they also allowed individual film viewing. Unlike Thomas Edison's Kinetoscope, which wound a long strip of film through a viewing cabinet, a mutoscope held a large reel of cardboard cards, each containing a single frame of the film, mounted vertically like densely packed spokes around a large

hub. When a viewer inserted a coin and turned a crank, the cards shown in quick succession created the illusion of motion using the same principle as a flipbook.

For many viewers, mutoscopes would have been a way to experience Méliès's vision of astronomers flying to the Moon (and other moving pictures) before and even after theaters became dedicated sites for group movie watching. Mutoscopes and amusement arcades became regular additions to urban cityscapes in the 1890s. They persisted well into the 1930s and even into the 1960s in rural settings such as fairgrounds. Mutoscope viewing helped popularize Méliès's vision of a lunar voyage as a formative element of American spaceflight stories.

POPULARIZING LUNA PARKS, RAY GUNS, AND ROCKETS

The vision of spacebound places as destinations also became institutionalized in many American cities in the first decades of the twentieth century. Together, these became the constituent elements of a particularly American space science fiction that emerged in the late 1920s. At the same time that Méliès's film was being imported, an American fad for Moon-themed amusement parks took off. Frederic Thompson and his business partner, Elmer "Skip" Dundy, debuted a new ride called "A Trip to the Moon" at the Pan American Exposition in Buffalo, New York, in 1901. For fifty cents, twice the cost of other rides at the Exposition, passengers entered a large building housing the airship *Luna*, an imaginative vehicle that consisted of a large hull with six flapping wings on either side—an ornithopter—suspended inside a giant room. As the hull rocked and visitors felt artificial wind blowing in their faces, they saw illuminated images of Buffalo, then North America, and then Earth drop down as they seemed to pass through a storm, creating the dramatic illusion that they were flying up into space. Thompson patented the ship's design, including the devices that facilitated its illusions. Considering the patent application materials, rocketry historian Frank Winter concludes, "Although an amusement device, it may well have been the first 'spacecraft' ever patented." Thompson's imagined trip to the Moon ended with visitors leaving *Luna* to explore two rooms representing a cavelike lunar surface.

To make the imagined Moon seem more exotic, Thompson employed actors with dwarfism or gigantism to embody the Selenites. To depict the diminutive Selenites as even more alien than contemporary short-statured entertainers on

public display or in the circus, the actors' costumes featured rows of long spikes. The third and final room of "A Trip to the Moon" contained the Palace of the Man on the Moon, with samples of green Moon cheese and average-sized dancing "Moon maidens." In this context, anyone other than average-sized men could be rendered as alien. The unusual cast proved to be a popular part of the experience. When Secretary of State John Hay visited, he gave Thompson twenty dollars to tip the actors. Visitors enjoyed the overall experience so much that Thompson made plans to open the ride at another site after the exposition closed.

The racial homogeneity of Buffalo's crowds would have reinforced the sense of uniformity among the visitors versus the "alien" actors. At the turn of the twentieth century, fewer than two thousand African Americans lived in Buffalo, New York, a city with a total population of more than 350,000. Although African Americans could have been among the eight million people who visited the exposition, they would have had to plan very carefully. After an effort to start a "Negro hotel" in Buffalo failed, local African American leaders organized to provide Black visitors to the exposition with lodging in individual homes. To counter the explicitly racist exhibits "Darkest Africa" and "Southern Plantation," they also arranged for the display of the "Negro Exhibit" that W. E. B. Du Bois developed for the Exposition Universelle in Paris in 1900. On balance, however, African Americans were not included in the exposition's visions of the future. Likewise, Thompson's next site for "A Trip to the Moon," Coney Island, also featured racially segregated bathhouses and sections of beachfront.

Thompson's new ride helped make Coney Island a cornerstone of New York City amusements. In 1902, in addition to a smaller version of the ride that toured the country, Thompson rebuilt "A Trip to the Moon" at businessman George C. Tilyou's Steeplechase Park. A strip of oceanfront land within easy reach of Brooklyn and New York City, Coney Island had grown since 1895 from a rural beach destination to a site of affordable amusement parks serviced by trolley lines. Enclosing the attractions within fences as distinct parks had not only generated revenue through ticket sales but also assuaged reformers by shutting out prostitution and gambling. After one season, Dundy and Thompson left Steeplechase Park. They leased nearby Sea Lion Park, transforming the site into the iconic Luna Park, which was much imitated.

Thompson created extravagant spectacles to publicize Luna Park. First, he had the "Trip to the Moon" ride dragged to the new location by Topsy the elephant.

In reality, the ride was built almost entirely anew. Before Luna Park opened in 1903, however, Topsy became the subject of another infamous stunt. After being badly abused by her alcoholic keeper and going on a rampage, Topsy was too dangerous to keep. Thompson had the elephant put down in a public electrocution recorded by the Edison Kinetograph Department, making sure that signs for Luna Park appeared in the film. Showings of *Electrocuting an Elephant* (1903) brought additional publicity to the site.

Centered on the Moon-themed name and the "Trip to the Moon" attraction, Luna Park at Coney Island featured international pavilions and amusement rides, surrounded by thousands of electric lights. Together Dreamland, Steeplechase, and Luna Parks made Coney Island what historian John Kasson has called "the unofficial capital of the new mass culture" at the turn of the century. Despite persistent racial segregation, Coney Island became celebrated for having men and women of different classes, ethnicities, and backgrounds enjoying the affordable diversions together. Conductor and American march king John Philip Sousa even composed a waltz extolling the romance of summer days at Luna Park.

Success bred imitators. In the first years of the twentieth century, dozens of American towns hosted traveling carnivals featuring space-themed attractions. The Bostok-Ferari Mighty Midway Carnival Company included a "Trip to the Moon" sideshow in the carnival it sent throughout the Midwest and the American South in 1901. Other carnival companies featured "Trip to the Moon" attractions in their traveling shows the next year. Almost sixty carnivals featured Moon- or Mars-themed attractions before 1915. Such traveling shows introduced thousands of summer fairgoers to the idea that space-based places such as the Moon or Mars could be envisioned as destinations.

Moreover, in that same timeframe, Luna Parks became a nationwide and international fad. Fred Ingersoll, a developer in Pittsburgh, Pennsylvania, built his first Luna Park in the city's Oakland neighborhood in 1905. Inspired by Coney Island's model, thousands of electric lights decorated the park. Ingersoll quickly turned that success into another Luna Park in Cleveland, Ohio. He then created a chain of forty-two more sites across the United States and around the world, including locations as far away as Australia. Other developers copied his idea. Ingersoll even changed the names of his chain to Ingersoll's Luna Parks to distinguish his properties from other attractions jumping on the lunar bandwagon. Some of Ingersoll's parks existed for only a few years until his business failed.

Nonetheless, in the first years of the twentieth century, dozens of American cities included Luna Parks, sites associated with fun and imagination.

Such visions of trips to an inhabited Moon resonated at a time when scientists were also debating (and debunking) the idea of an inhabited Mars. H. G. Wells's famous imagination of a Martian invasion, *War of the Worlds*, was first serialized in the United States in *Cosmopolitan* magazine in 1897 before being published as a full novel. But the idea that Mars might harbor inhabitants was more than just a dystopian tale of otherworldly invaders. In 1906, Boston astronomer Percival Lowell published *Mars and Its Canals*, a popular book based on work that he had begun publishing in the scientific literature eleven years earlier. Observations of lines on the Martian surfaces made at his observatory in Flagstaff, Arizona, led Lowell to speculate that these marks were not natural phenomena but rather the creations of intelligent life. Newspaper accounts made the topic a matter of popular discussion. At Coney Island, Thompson even recast "A Trip to the Moon" in the latest trappings of "Mars mania."

Wells's visions of an inhabited Mars also introduced another significant idea: the Heat-Ray. The alien weapon featured in Wells's fictional vision of a Martian invasion was an early expression of the idea that eventually became the ray gun. The Martian tripods that emerge to attack Earth in *War of the Worlds* could destroy objects at a distance using directed heat. As Wells described, "This intense heat they project in a parallel beam against any object they choose, by means of a polished parabolic mirror of unknown composition, much as the parabolic mirror of a lighthouse projects a beam of light." Although the large weapons Wells described were fixed to the Martians' vehicles, the idea of a handheld weapon that could wield unspecified destruction at a distance via a ray or beam held appeal. Writer Victor Rousseau first used the term "ray gun" in a science fiction story in 1917. Ray guns—or rocket pistols, blasters, or phasers—would have a long association with space-themed science fiction.

At the time, both the scholarly debates and related fictional accounts about inhabited planets had real effects on actual scientists and engineers. Robert H. Goddard, the physics professor who would later develop the first successful liquid-fuel rocket engine, had a copy of Verne's *From the Earth to the Moon* in which he had written comments in the margins in his childhood—marginalia that included not only personal reactions but also corrections to some of Verne's equations. But the writer who first fired Goddard's imagination about spaceflight

was H. G. Wells. At age seventeen, in 1898, Goddard wrote in his notebooks that he had started thinking about spaceflight when he read two science fiction novels that were being serialized in *The Boston Post*: parts of Wells's *War of the Worlds* and Garrett P. Serviss's *Edison's Conquest of Mars*. An imaginative child with a bent for experimentation, Goddard had a vivid vision while sitting in a cherry tree of a "device" rising up on its way to Mars. This imagination of a possible space vehicle moved him so profoundly that for the rest of his life, he referred to that date as "Anniversary Day." Propulsion became his passion.

Goddard demonstrated that unlike solid-fuel Roman-candle type rockets, which had limited power and range, liquid-fuel rockets had greater—and potentially scalable—thrust and capacity. Goddard's report to the Smithsonian Institution, one of his funders, mentioned the idea that rockets could travel great distances, even through space. That report, titled "A Method of Reaching Extreme Altitudes," was dated 1919 but released in 1920. Goddard explained rocket flight and speculated about hitting the Moon with one. The Smithsonian's press release emphasized that rockets could reach the Moon—a suggestion that caught public attention and caused a flurry of newspaper coverage.

Public excitement over the implications of Goddard's rocketry work was one of several key developments in the 1920s that created fertile ground for the space-themed adventures that later appeared in comic strips. Moreover, it confirmed the rocket as the preferred means of imagined space travel. Beginning with space-themed stories published after 1920, rocket propulsion eclipsed ornithopters, cannon projectiles, and other fictional means of reaching space and became a key piece of the Buck Rogers archetype.

New ways of disseminating popular culture also came of age in the 1920s. The rise of radio networks offered a way for listeners across the country to experience the same programs. Inexpensive pulp magazines and novels also flourished. Initially, the most popular genres featured in those pages included Westerns, romances, and detective stories, more so than space-themed stories. Then, in 1926, Hugo Gernsback began publishing *Amazing Stories*. This pulp magazine dedicated to science fiction stories became the eventual site of Nowlan's first Rogers story in 1928. Science fiction pulps not only provided outlets for writers to reach readers but also created social connections. Many pulp magazines encouraged participation—as well as loyalty—through dedicated sections of the magazines

that shared readers' letters, reactions, and suggestions. Some readers even used the addresses of published letter writers to start their own correspondence with like-minded fans entirely outside the purview of the magazine. Pulps inspired and created organized fan clubs.

When Dille picked Nowlan's story to produce as a comic strip, he hoped to draw such fans to his newspapers. He may also have wanted to tap into the German rocket fad in the United States in the late 1920s. Hermann Oberth, another aspiring rocketeer who had grown up reading Jules Verne, published *Die Rakete zu den Planeträumen* (*The Rocket into Planetary Space*) in 1923. Oberth also consulted on Fritz Lang's *Frau im Mond* (*Woman in the Moon*) in 1929. Together, these visions of possible spaceflight helped to spark interest in the subject in the United States, creating the conditions that allowed Dille's publication of Nowlan's comic strip to flourish. The four major elements that characterized most subsequent American space science fiction—planets and moons as destinations, ray guns as potent weapons, rockets as spacefaring vehicles, and narrative/characters based on Westerns—first came together in *Buck Rogers*.

CREATING *BUCK ROGERS*

As imaginative as it must have seemed in the late 1920s, the original *Buck Rogers* comic strip was also very much a reflection of its time. Launched only a decade after the end of World War I, the strip imagines a futuristic world that is reeling after a major war. In the initial storyline depicted in the short story and the first comic strips, the two time periods blend together. After getting knocked out by gas in a mine an unspecified time after mustering out of the Air Service at the end of "the World War," the character of Buck Rogers awakes amidst a battle in the American wilderness to find Wilma Deering under attack. The vision of a woman alone, fighting off attackers while flying through the air, offers the main character (and the readers) the first sign that the hero has awakened in a very different time. After he joins in her fight, Rogers shows her his Air Service button, earned in World War I, as proof that he is one of the good guys. The illustrations provide other visual evidence, showing Rogers flying patrol in an open cockpit aircraft and wearing a World War I aviator's characteristic jodhpurs. *Buck Rogers* illustrator Dick Calkins's own flying experience in World War I remained so

important to him that he signed the first *Buck Rogers* comic strips as "Lt. Dick Calkins, U.S. Air Corps."

Anti-Asian stereotypes appeared throughout the first *Buck Rogers* comic strips. The very first line uttered by Wilma Deering in the original *Buck Rogers in the 25th Century* comic strip is a racial epithet. Wearing a tunic and tights, she leaps in midair and fires her rocket pistol at distant attackers while shouting, "Half Breeds!" That the newspaper syndicate thought this was an appropriate opening to an adventure strip shows how mainstream such language was at the time. The explicit term "half breeds" appears in three of the first four strips, while the final panel of the fourth strip introduced readers to two of the silk-robed Asian villains, one with a long, straight "Fu Manchu" mustache.

Such bold and inaccurate stereotypes drew on the prevalent bias against Asians in the United States at the time. The Immigration Act of 1924 not only limited the number of Eastern and Southern Europeans who could be admitted to the country, but it also created an outright ban on immigration from Asia. *Buck Rogers* was not the only comic strip to draw on contemporary events that way. In 1934, cartoonist Milton Caniff started *Terry and the Pirates* at the behest of newspaper publisher Joseph Patterson. The hero of that strip, Terry Lee, goes to China with journalist Pat Ryan, seeking a lost gold mine. Once there, however, they find themselves working with a Chinese guide named George Webster Confucius, called "Connie," and battling numerous villains, including Terry's archenemy, the Dragon Lady, a pirate queen. The Dragon Lady character played on a stereotype based on the real existence of pirates in the South China Sea at the time. Although *Terry and the Pirates* eventually dealt with the contemporary disputes between China and Japan in its plots, thus making some distinctions among Asians and reflecting existing political conflicts, *Buck Rogers* and *Flash Gordon* tapped into fears about the "yellow peril" through simplistic Asian-inspired villains.

Calkins's depictions of Wilma Deering, who was introduced in the first strips as a "girl soldier" and developed throughout the franchise as Buck Rogers's ally and love interest, drew directly on contemporary images of the well-off white women adopting new fashions and physicality along with the vote in the years after World War I. Deering's close-fitting flying helmet covered her forehead almost to her eyebrows, resembling the flapper's bell-like cloche, a trendy hat of the day. Underneath it, Deering's hair was cut in a fashionable short bob. Her characteristic costume of long tights worn under a tunic skirt also echoed the

contemporary turn. Deering's clothing looked much closer to the straight, free-hanging silhouette of the day than to the dresses worn just a decade earlier, when floor-length dresses with defined waistlines were still the standard.

The character's futuristic fashion had its roots in a contemporary moment. As the Depression began in 1929 and deepened into the 1930s, well-off white women's involvement with sports—either through collegiate physical education programs or through golf, tennis, swimming, or the Olympics—affected the everyday clothes they wanted to wear. Casual ready-to-wear fashions became a hallmark of American manufacturers. Fashion historian Rebecca Arnold has analyzed the growth of this sportswear, called "the American look," created in the years between 1929 and 1947. Arguing for "the growing importance of sportswear as an identifiably American form of dressing," Arnold asserts that "in the 1930s and 1940s, its style was associated with career women, college girls, and increasingly, with busy housewives" who shared "a need for relatively cheap clothes that were adaptable to active lifestyles." In the period on which Wilma Deering's character was being created and defined, lithe athleticism became the fashion, emphasizing movement. Calkins often drew Deering in dynamic poses (flying or jumping) that emphasized her freedom of motion. Deering's standard outfit evoked the tennis dresses that contemporary female athletes wore when competing at Wimbledon or other competitions.

The stories that Nowlan wrote and Calkins illustrated imagined a world full of new technologies: jump belts that used "inertron" or "reverse weight" to propel the wearer upward, dirigible-like craft that glided quietly above the Earth propelled by "repellor rays," and terrible "disintegrator beams" used to destroy whole cities in just hours. With the horrors of World War I still close in people's memory, *Buck Rogers* offered imagined stories of rebuilding from a terrible war amid a new world of technological wonders. Initially, in the first comic strips, the action remained largely earthbound in the embattled American countryside. Indeed, *Buck Rogers*'s creators hoped that readers might start following the strip because of a hometown cameo. Early strips explicitly mentioned Pittsburgh, Pennsylvania; Columbus and Cincinnati, Ohio; Tacoma and Seattle, Washington; and Portland, Oregon.

Some strips attempted to explain the technologies with detail and even root them in the real history of rocketry. In the 1930 series "Tiger Men of Mars," Wilma Deering's younger sister, Sally, and another love-interest character, Illana, have

been kidnapped. Rogers's first action in his pursuit is to visit "R. H. Stoddard, the rocket expert whose ancestor worked with Max Valer." The first name is an easily recognized play on the name of Robert H. Goddard, the American inventor of the liquid-fuel rocket. The second is a close misspelling of the surname of Austrian rocket pioneer Max Valier, who cofounded the German Verein für Raumschiffahrt (VfR, Society for Spaceship Travel). The verisimilitude extended to other details. Another strip included an annotated cutaway of an imagined spaceship. These views labeled the various fictional pieces and their uses. Dr. Huer, the bald scientist with a mustache who invented new technologies to help Buck Rogers, was also reputed to be modeled on Goddard. In real life, Goddard and his wife, Esther, appreciated the resemblance and were flattered by it. According to Goddard's biographer, David Clary, when Goddard worried about one of his experiments, Mrs. Goddard reassured him by quoting Dr. Huer's well-known line, "Now don't you worry, the old doctor will take care of that."

By 1932, fans could find *Buck Rogers* not only in the newspaper but also on the radio in a program sponsored by Kellogg's of Battle Creek, Michigan. To promote the new program, producers advertised that *Buck Rogers in the 25th Century* boasted sound effects created using "marvelous new techniques." Visualizing these otherworldly adventures required leaps of imagination. As a print advertisement implored potential listeners, "Just imagine the changes! Rocket ships zooming at light speeds. People flying with degravitator belts. Interplanetary travel. Wars among the stars. Countless thrilling wonders that the future may well bring." Such ideas painted vivid pictures in listeners' minds. Young fans of the programs naturally wanted to meet these radio stars, and in 1935, the presidents of thirty-eight Buck Rogers Clubs from across the country went to New York to meet actor Curtiss Arnall, who voiced Buck Rogers.

Many young listeners joined the fan clubs associated with the radio programs and enjoyed the rewards that came with them, called premiums. Premiums were small prizes sent to listeners in exchange for sending in a coin and a wrapper from a sponsored product. In the 1930s, the Buck Rogers Solar Scouts offered metal badges, pins, and whistles as tokens of children's fandom. Radio program sponsor Cocomalt, a brand of enriched chocolate-flavored milk additive, for instance, offered three different levels of badges for the Solar Scouts. Girls could join the Solar Scouts, too, and sponsors also offered a few special girls' premiums such as a Wilma Deering pendant on a chain, though the regular

premiums were intended to interest boys more. Made to be mailed inexpensively, premiums tended to be flat or small. For instance, metal strips printed to look like rings could be shipped flat and then shaped around the receiver's finger. Such items, and the adventure serials that promoted them, were a deliberate business strategy to influence a new category of consumers: children.

IMAGINING A GUNFIGHTER (SPACE) NATION

Beginning with *Buck Rogers*, the archetypical American space adventure began to have a cast that echoed the characters that commonly appeared in Westerns. The hero—white, muscular, brave, and true—led a small band of compatriots through a series of adventures, relying on his trusty steed, or in this case, spacecraft. Buck's counterpart and love interest, Wilma Deering, was a female lead with moxie and a distressing tendency to get captured. The two leads were often accompanied by a loyal sidekick who was often a youth or somewhat alien. For Buck Rogers, his young sidekick, Buddy Deering, Wilma's younger brother, first appeared in 1930 in a Sunday strip, which often advanced a separate story from the one told in the daily strips. Finally, the group had an older doctor or scientist, in this case Dr. Huer, who lent wisdom and expertise to solving their problems. Together, the group encountered a series of adventures set on a frontier.

The characters in the rival *Flash Gordon* comic strips, marketed to newspapers by the King Features Syndicate beginning in 1934, likewise hewed to the conventions set by Westerns (and by *Buck Rogers*, of course, the popularity of which served as incentive and inspiration). *Flash Gordon* was written by Don W. Moore, who was lured away from editing adventure, detective, and mystery stories for the *Argosy-Allstory Weekly* in New York. Promised twenty-five dollars a week, he began writing a space adventure strip drawn by Alex Raymond. In Moore's strip, the leading trio is Flash Gordon, his beautiful female lead and love interest, Dale Arden, and Dr. Hans Zarkov, the scientist and inventor who sparks the adventures when he kidnaps Gordon and Arden to the Planet Mongo. Once in space, the heroes join the fight against Ming the Merciless. In 1936, those comic strip characters first appeared in movie theaters in a thirteen-part serial produced by Universal Pictures.

BUCK ROGERS, RAY GUNS, AND THE SPACE FRONTIER

Beginning in the 1920s and into the 1950s, most movie theaters, whether movie palaces or neighborhood theaters, featured a single main screen. The kiddie matinee on Saturday afternoons was a loop of continuous showings: a first feature, a second feature, cartoons, newsreels, and movie serials. For one entrance fee, patrons watched whatever was playing until they decided to leave or had seen all of the elements once or more, yielding the expression, "This is where I came in." After the opening credits of a movie serial, text on the screen reminded viewers of the past week's action, and cliffhanger endings preceded a final card urging viewers to return next week for a new chapter.

For the two *Flash Gordon* movie serials in 1936 and 1938, actors Buster Crabbe and Jean Rogers, who played Flash Gordon and Dale Arden respectively, bleached their hair to fit the leading roles. Caucasian actor Charles Middleton portrayed Ming, a character set apart as alien in appearance through costume and makeup, with an elaborate, high-collared cape framing his bald head, pronounced arched eyebrows, long goatee, and Fu Manchu mustache. In the first chapter, "The Planet of Peril," Ming's lecherous ogling of the white, blonde Arden prompts Gordon to defend her virtue, initiating the first big fight scene. Ming's daughter, Princess Aura (played in the movie serials by Priscilla Lawson), immediately takes a liking to Gordon, but her alien nature, denoted in part by her high, arched eyebrows, ultimately makes her unsuitable for the hero.

In addition to drawing on Westerns for their core cast of characters, American science fiction also adopted the genre's reliance on personal firearms. From the very beginning, one of Buck Rogers's most significant weapons was a basic pistol. Within the first ten comic strips, after establishing that he was telling the truth about being a stranger from the past, Deering's Alleghany Org (short for organization in the strip's lingo) made Rogers a member by presenting him with a rocket gun. In movies, comic strips, and even on radio programs, most spacefaring heroes carried a pistol of some sort, a convention established early in these franchises and continued in space science fiction for decades to follow. In addition to *Buck Rogers* and *Flash Gordon*, think about the phasers of *Star Trek* beginning in the late 1960s and the blasters of *Star Wars* beginning in the 1970s.

Ray guns have been ubiquitous in space-based science fiction adventures. The imagined weapons varied wildly in shape, size, color, and configuration and yet all remained instantly identifiable as rocket pistols or ray guns. Of course, all kinds of characters carried guns in the era in which *Buck Rogers* and *Flash*

Gordon originated. In the 1930s, toy departments and drug stores sold cowboy-styled six-shooters, a Signal Pistol from the detective comic strip *Dick Tracy*, and various pop guns and sparking gun toys modeled on real weapons, including machine guns and double-barrel shotguns.

And yet, having pistols as a fundamental part of space adventures was in some ways an odd choice. Logically, firing a projectile or damaging ray inside a spaceship threatened destruction for all on board. Moreover, handguns were close-range weapons, not a commonsense choice in the vastness of space. The pervasive presence of sidearms in space adventures had little to do with their practicality in the conflicts that 1930s space heroes encountered. Rather, rocket pistols or ray guns evoked the archetype of the Western hero and his connection to a particular theory of American national identity as forged in the frontier experience.

Historian Frederick Jackson Turner first suggested his frontier thesis at a meeting of the American Historical Association in 1893, the same year as the famous Columbian Exhibition. Turner observed that, according to the then recently released 1890 Census, the American frontier had "closed": no more unexplored, unsettled land existed in the contiguous United States. This, he argued, had profound implications for the future of the United States because the experience of the frontier shaped a unique identity: "American social development has been continually beginning over again on the frontier. This perennial rebirth, this fluidity of American life, this expansion westward with its new opportunities, its continuous touch with the simplicity of primitive society, furnish the forces dominating American character." Turner's characterization of the growing United States conveniently discounted the presence of native peoples already living on the continent and reduced them to an obstacle to white encroachment.

Immediately after the American frontier closed, it began to be mythologized. *The Virginian* (1902) by Owen Wister is considered to be the first cowboy novel, with a cattle-ranching cowboy as the literary hero. A tale of a rugged Eastern hero transplanted into the American West, where he romances a gentle schoolmarm and reluctantly participates in—and wins—a gun fighting duel, *The Virginian* set many of the conventions for the Wild West/cowboy genre. In the initial *Buck Rogers* comic strips, the hero also drew upon a version of that mythology. As he struggled through a desert to rescue Wilma Deering from her Mongol captors in one of the very first *Buck Rogers* installments, Rogers encouraged himself not to give in to defeat by picturing a Conestoga wagon train and giving himself a pep

talk, "But the 'never-say-die' spirit of my pioneer ancestors urged me to carry on." Another early storyline in the Buck Rogers comic strips had Rogers working with a Navajo "org" and a white-hatted cowboy to rescue Deering from a Mongol city, translating the Western frontier into his futuristic adventure.

PLAYING THE HERO WITH ROCKET PISTOLS

When youthful fans wanted to imagine themselves as a hero, the first piece they needed was a sidearm. Hold a toy rocket pistol or ray gun sold as the hero's weapon, and one immediately embodies the hero himself. Rarely, if ever, were children given the playtime tools to imagine themselves as the foreign/alien villain, or even as other members of the ensemble. Early ray gun toys reinforced a cultural assumption that young white boys, the desired audience, could not be expected to envision the world through other perspectives, a posture that inherently reinforces the universality of masculinity and whiteness. When considering the *Buck Rogers* and *Flash Gordon* toys produced, the outsized popularity of the rocket pistols that created a holiday craze in 1934 reflected not only a clever marketing triumph but also represented broader social assumptions of the time.

The first guns available to *Buck Rogers* fans in 1933 were actually paper or cardboard. These simple two-dimensional printed heavy paper toys could "fire" with a flick of the holder's wrist that released a paper "explosion," a literal drawing of the discharge from the barrel's end. Paper or cardboard Buck Rogers guns quickly became available as mailed premiums, play kits, or giveaways.

As the comic strip and radio program gained popularity, Daisy Manufacturing Company proposed a metal toy pop gun. Cass Hough, a Daisy sales manager who later became its president, remembered that he had a particular interest in the new *Buck Rogers* comic strips. He, like illustrator Dick Calkins, was also a licensed pilot, a relatively unique distinction at the time. Hough became a driving force behind the first three-dimensional ray gun toy. As he recalled years later, "In looking at some of the pilot strips, it occurred to me that here was a fertile field for some 25th century 'armament' to be sold to boys and girls who read the Strip." Daisy was well known for making BB guns that shot small metal pellets. In the early 1930s, however, the company added futuristic space guns to its product line.

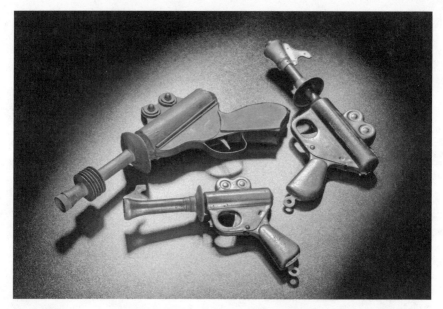

The progenitor of all ray gun toys that followed, the Buck Rogers XZ-31 Rocket Pistol by Daisy Manufacturing (upper right) caused a Christmastime sensation in 1934. From top left, clockwise, an early Buck Rogers rocket pistol, the XZ-31, and the XZ-35 "Wilma Deering" Rocket Pistol of 1935. Photo courtesy of the National Air and Space Museum / Eric Long, 200711–2759.

Creating the new toys required some adjustments. As drawn in the comic strips, the Buck Rogers's rocket pistol was too intricate to reproduce as a pressed metal toy. Daisy executives asked *Buck Rogers* writer Philip Nowlan and illustrator Dick Calkins to redesign the guns, holsters, and helmets drawn in the comic to match their three-dimensional toys. The plan worked. Advertisements for the XZ-31 emphasized that the plaything was "reproduced line for line, even to its distinctive sound—ZAP!"

In the patent application filed on April 24, 1934, for the "toy gun," Daisy Manufacturing Company's representatives suggested that in addition to the technical innovations found in the toy, the proposed pop gun's novelty arose from the comic strip character's power to inspire children. The invention, the patent asserted, consisted of "simulation of a gun such as used by a widely advertised pictorial fictitious character and supposed to possess extraordinary powers, thus making a strong appeal to the imagination of youth." The toy's action created its

sound. The metal pop gun could be "cocked" by pivoting the handgrip to trap air inside the toy. Pulling the trigger then released that air, resulting in a loud pop. According to the patent description, the upward flange decoration also had a purpose; it made the toy louder. Specifically, that forward fin served as "a megaphone which projects the sound of the report in a forward direction." Before the first patent was even issued in July 1935, Daisy filed a second patent application refining the toy's design with a simplified construction for less expensive production. This toy gun was even louder, the patent application promised: "when fired [it] produces an exceptionally loud report."

Daisy's promotion of the XZ-31 Rocket Pistol focused on department stores. As Hough recalled, in 1933 he convinced Detroit's J. L. Hudson department store to use *Buck Rogers* as the theme for its Christmas displays, executed by constructing a set of extraterrestrial figures and a rocket ship prop that children could sit in to imagine themselves flying in space. Hough then borrowed those props for the 1934 American Toy Fair to sell the toy to other shops. Despite real doubts from Daisy's leadership about spending so much energy in this direction, they allowed Hough to follow his hunch. Macy's flagship department store in New York City finally bought in, negotiating a one-week exclusive marketing agreement. That advertising campaign yielded two thousand eager buyers on the first day the toy was sold. But once Macy's exclusive agreement ended, the wild popularity of the metal fifty-cent toy gun sparked a price war between Macy's and Gimbels department stores. Macy's sold it for forty-nine cents, following its general practice of selling slightly below market price. To compete, rival Gimbels dropped its price. Macy's countered, and the competition was on. At one point, Gimbels reportedly offered a two-for-nineteen-cents deal, well below the manufacturing cost.

The box for the XZ-31 Rocket Pistol read, "Be a space man—carry a *Buck Rogers* Rocket Pistol." The first costumes available for *Buck Rogers* allowed children to look like their heroes too. Sackman Brothers of New York developed Buck Rogers and Wilma Deering playsuits for the 1934 Christmas season. A holster and helmet were also available. Both the gun and the helmet allowed their owners to act out their hero's space adventures and imagine new ones. Certainly, children remained capable of playing against type or of subverting expectations in how they chose to imagine their own storylines. But it remains unlikely that any child imagined the toy gun as anything other than a gun—or the costume as some other character.

SPACE CRAZE

By Christmastime 1934, Macy's organized the holiday toy display at its flagship store around the space-themed comic strip characters. In the toy department, Macy's shoppers found a *Buck Rogers*–themed Toyland, complete with a railway that carried sixty paying passengers at a time through a landscape inspired by the comic strips and ending at an interplanetary spaceship. The excitement extended beyond New York City. In addition to special corners and displays around the country, one newspaper reported that in Lynchburg, Virginia, a department store celebrated the Christmas season by having a Buck Rogers character actor instead of a Santa Claus.

Not all of Buck Rogers's early adventures were in outer space, and not all of the toys for the 1934 Christmas season required players to embody the hero's stance. A board game set that came with three different boards for ninety-eight cents included an Atlantis-themed game in addition to one called "Cosmic Rocket Wars." And Louis Marx & Company offered two wind-up metal rocket toys, the Rocket Police Toy and the Patrol Ship Toy. They advertised that this "flashing roaring speeding sky police patrol rocket ship . . . shoots out harmless sparks as it darts across the floor."

Although Wilma Deering playsuits were available in 1934, young girls had to wait a year after the boys' gun toys hit the market before they could fully begin to imagine themselves as the character by purchasing and playing with a scaled-down toy rocket pistol in 1935. Inspired by the XZ-31's success, and driven by the economic need to produce a smaller and less expensive toy in tough financial times, Daisy created the XZ-35 Buck Rogers Rocket Pistol Toy, identical in every way to the original metal Buck Rogers gun except for its reduced size. They named this smaller version for Deering.

In summer 1935, Daisy further tapped into Deering's popularity to promote the expanding toy line with a national campaign. Alice Hirschman, an actor dressed as Deering, would fly into local airports, sponsored by local toy sellers across the country, for a personal appearance promoting the sale. Children could meet her at the airport, buy the toys, and have the boxes autographed. By then, Daisy began producing new variations almost yearly.

INVENTING NEW WAYS TO PLAY

In 1935, the *Los Angeles Times* used the new Buck Rogers XZ-38 Disintegrator Pistol as the centerpiece of a holiday subscription drive. The newspaper's promotion built on the paper's inclusion of the *Buck Rogers* Sunday strip that same year. In advertisements placed during Thanksgiving week, early December, and just after Christmas, the newspaper promised to reward the sale of a "new two-month daily and Sunday subscription" with a XZ-38 toy gun. The campaign was aimed at children themselves; the ad noted that prizes would only be given to "boys and girls 18 years of age and under who secure subscriptions through their own efforts." Notably, however, the copy in all three advertisements assumed that the target audience would be male, stating, "Every red-blooded boy will want this futuristic prize of the 25th Century A.D."

The Los Angeles newspaper also offered a Buck Rogers "Midget Caster" set as a prize, available just in time for Christmas, in exchange for "1 new paid-in-advance three-month subscription" to the paper. Advertised as "scientific," the kits manufactured by Rappaport Brothers of Chicago allowed children to melt lead into metal molds to create small, paintable models of their favorite comic characters and vehicles. Available at different levels (Electric, Miniature, and Junior), the kits could also be supplemented with additional molds. The Home Foundry Manufacturing Company offered a comparable casting set for the *Flash Gordon* characters.

In the midst of the Great Depression, kits like these that allowed children to create—and even sell—their own toys may have seemed like a better deal than the simple purchase of a manufactured toy that only one or two children in a family would ever enjoy. Allowing children to melt and mold lead, however, evokes an era with very different expectations about the crafts that a child, likely a boy, might undertake. Such casting kits were similar in this way to contemporary patterns for balsa wood model airplanes that require significant cutting and assembly. Both counted on adult participation to complete the project in a well-equipped home workshop (or well-supervised kitchen table). Both would have been seen as ways to encourage boys to be independent, handy, and industrious.

By the late 1930s, some of the toys offered had diversified. The XZ-44 Liquid Helium Toy Water Pistol from 1936 could suck in water and squirt it out, bit by bit. In 1937, Tootsie Toys of Chicago created die-cast metal versions of two of the spaceships pictured in the *Buck Rogers* comic strips. The Buck Rogers Battle

Cruiser and the Buck Rogers Venus Duo-Destroyer each featured small rollers built into the toy that allowed players to thread a long string or cord through the vehicle to make it seem to fly as the ends were raised or lowered. "After a little practice," suggested the Tootsie Toy box, children could "try 'whipping' the cord" to shoot the rocket between two children or toward an anchoring door or chair. Other toy manufacturers were quick to produce imitators.

In order to compete with *Buck Rogers*, the toys created for *Flash Gordon* tended to be literally and figuratively flashier. The designs drew inspiration from artist Alex Raymond's drawing style demonstrated in the *Flash Gordon* comic strips. Take, for example, the Flash Gordon Signal Gun from 1935. Available for forty-nine cents, the red metal gun contained a flint near the end of the muzzle, which created a small shower of sparks when the trigger was pulled. At once both bulbous and sleek, the streamlined metal toy was produced by American manufacturer Louis Marx & Co., the same company that would later produce Rock'em Sock'em Robots and Big Wheel tricycles. Headquartered in New York City, the company produced all of the Flash Gordon toy guns. In 1935, in a Walgreen's drugstore advertisement placed in the *Chicago Daily Tribune*, the copy accompanying a tiny image of the space-themed sidearm boasted that the play gun "screams like a siren as it shoots out flashing sparks!" And in a nod to the plaything's wide appeal, the testimonial continued, "Every boy and many girls will want this exciting but harmless toy."

The advent of World War II dampened enthusiasm both for space-themed comics and for the toys and amusements they inspired. Because of wartime rationing, the materials required for the pressed metal toys that had been so popular in the 1930s, even during the lean days of the Great Depression, could no longer be obtained by toy manufacturers. As a part of the war effort, Daisy turned from making metal toys to creating 37mm canisters used in antitank guns. For the toy market, they offered just a wooden popgun. And although the *Buck Rogers in the 25th Century* comic strip remained in newspapers until 1967, the cultural appetite for otherworldly space heroes diminished in the 1940s. The strip's producers did attempt to keep it relevant. In 1944, Richard S. Yager of the National News Service wrote to President Franklin Delano Roosevelt, asking his permission to depict him in a set of *Buck Rogers* comic strips. In this particular series, Buck Rogers would travel to a planet with technology that allowed users to compare the minds of people in the past. In the proposed strip, FDR's

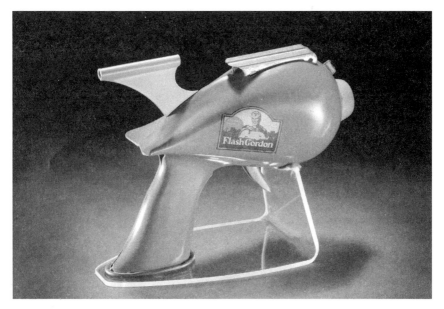

American manufacturer Louis Marx & Co. produced this streamlined *Flash Gordon* toy signal pistol, made of tin-plated steel, in 1935. Photo courtesy of the National Air and Space Museum / Eric Long, NASM201400–4378.

mind would be compared favorably to the minds of the United States' wartime foes, Hitler and Tojo. The White House granted permission. But such attempts to tie fantastic space adventures to current events could not change the fact that the nation's attention had turned from futuristic fantasies to wartime realities. Likewise, the original Luna Park, which had declined in quality and cleanliness in the decades after its originators died, burned down in 1944 and was never rebuilt.

Buck Rogers comic strips continued after World War II, with different authors taking the reins at times. Murphy Anderson, who later made his name drawing for National Comics/DC Comics, spent two years early in his career drawing a *Buck Rogers* newspaper strip. In 1948–49, Rick Yager, who had drawn a 1939 series of strips called *Martians Invade Earth* with Phil Nowlan, took sole ownership of a new *Buck Rogers* strip story called "Battle on the Moon." Having originated as a futuristic land-based character with many different kinds of adventures, Buck Rogers became almost solely identified by the late 1940s as a space-themed hero.

Daisy toy ray guns soon were influenced by the newest fearsome power: atomic energy. In 1946, Daisy produced a new version of the XZ-38 Disintegrator

Pistol, updating it with three available finishes (blued steel, plain steel, or gold) and renaming it the Buck Rogers Toy U-235 Atomic Pistol. *Buck Rogers* illustrator Dick Calkins helped with the design and promotion. The same toy was reissued two years as the U-238 Atomic Pistol, with a holster. Likewise, in 1948, the Budson Company of Chula Vista, California, advertised a Flash Gordon Air Ray toy gun with a sparking flint disc in the muzzle as "the most amazing toy of the atomic age!" After the late 1940s, however, Daisy stopped producing new Buck Rogers toy guns. The excitement for such toys seemed to have run its course. The recurring and durable motif of spaceflight faded briefly before reemerging in a new cultural context in the next decade.

THE LEGACY OF *BUCK ROGERS*

During the height of the Great Depression, the space-based adventures of *Buck Rogers* and *Flash Gordon* resonated with an American public hungry for inexpensive escapist entertainment. Based on those two comic strip empires, a new, particularly American form of space science fiction emerged, with characters and narrative devices that drew heavily on American Westerns and reflected contemporary depictions of women and people of color. In particular, these adventures took place in space-based settings, reached by humans in rocket ships. The four major characteristics of such tales—as we have seen, outer space places as destinations, ray guns as everyday accessories, rockets as the preferred transportation, and storylines and characters based on Westerns—became so ubiquitous in American storytelling about spaceflight that most tales told after the 1930s either deliberately began from or played against this structure.

One of the unquestioned legacies of this new form was the common presence of rocket pistols or ray guns in almost every space science fiction franchise. When examined, this seemingly incongruent element reveals the ways that science fiction creators tapped into fundamentally American stories about national identity, rooted in the gunslinger heritage of cowboy tales. Play versions of these weapons then filled toy chests across the country. The social and cultural assumptions embedded in their point of view illustrated how ordinary and uncontested such values remained. Ray guns became so ever-present in science fiction that the term "raygun gothic," coined by science fiction writer William Gibson, came

to describe a kind of futuristic midcentury design aesthetic adopted in hotels, restaurants, and roadside signs.

The legacy of *Buck Rogers* was evoked decades later when NASA introduced its first group of astronauts to the public at a press conference in Washington, DC, on April 9, 1959. The men who were poised to take the next step into space not only talked about their military flying experience and their hopes for the new program, but they also remembered their favorite childhood spacefaring characters. Asked if he had ever thought about flying into space before NASA announced Project Mercury, Walter M. "Wally" Schirra responded by citing his youthful interest in space adventure comic strips and novels. "All of us in this room have probably read comic strips, such as *Buck Rogers*, *Flash Gordon*, Jules Verne routines," he answered. "And if we had interest in reading things like this, obviously we had intentions of following something like this in our lifetimes. I will readily admit that I didn't think it was coming this soon."

CHAPTER 2

Space Forts, Television, and the Cold War Mindset

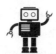

When I arrived at the Museum's storage facility to inspect a 1950s playset for an upcoming display, I found a pleasant surprise. Usually the Museum's collections staff just pulls an artifact from storage and has it waiting in its box. That's not what happened this time. Instead, I found that my colleagues had completely unpacked the Space Patrol Rocket Port and assembled the pieces on a worktable. The metal wall segments with lithographed rock formations had been assembled into a fence. The blue headquarters building stood in the middle of the enclosure. But it was the plastic figures and accessories—carefully placed around, on top of, and behind the central metal building, little astronaut figurines poised for action, waiting to battle miniature aliens with cannons and missiles—that really made me smile. Someone had enjoyed their storage retrieval assignment! Even museum professionals could not resist the set's playful appeal.

I already knew this was a special toy. When businessman and entrepreneur Michael O'Harro donated his collection of science fiction artifacts to the Museum in 1993, he initially hesitated to include the Space Patrol set. After all, it had been his personal childhood toy. Rich backdrops for imaginative play, Marx playsets evoked strong nostalgic feelings from those who loved them as children. As a collector of toys and memorabilia, O'Harro had amassed thousands of hard-to-find artifacts that he donated happily when the excitement of acquiring them was gone. But this set conjured boyhood memories of arranging the pieces and directing the figures in countless battles between astronauts and aliens. When he did finally decide to give it to the Museum, he included one

SPACE FORTS, TELEVISION, AND THE COLD WAR MINDSET

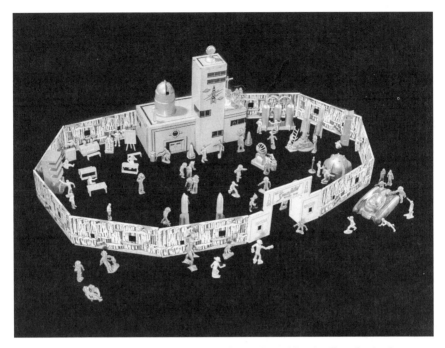

Louis Marx & Company manufactured this Space Patrol Rocket Port Set in the mid-1950s. Toymakers turned their popular Western fort sets into space-themed playthings by simply changing the lithography and adding new figures and accessories. Photo courtesy of the National Air and Space Museum / Mark Avino, NASM2022-01928.

extra accessory: the Space Patrol membership card that he had filled out as a twelve-year-old child.

Space forts embodied one of the many overlaps between science fiction and Westerns. Just as the planet-hopping adventures of *Buck Rogers* and *Flash Gordon* became a commonly imitated storyline for space adventures, so too the fort/space station offered a convenient backdrop for fictional space exploits. Rather than feature heroes flying from place to place, space station-inspired tales focused on the defense and maintenance of a single location. Space stations functioned as Western-style outposts on a different kind of frontier. The natural storylines of their play—defending territory against dangers that could come from without or within—resonated with a mindset preoccupied with invasion and subversion. Beginning in 1947, the Cold War between the United States and the Soviet Union was waged within each nation's borders, in national policy,

and via displaced conflicts around the world. Cold War threats also found allegorical expression in the monsters and aliens of many 1950s movies. Fort playsets such as O'Harro's reflected that tension.

Whether the playset was a space station featuring astronauts and aliens or a Western fort with plastic "cowboys and Indians," the figures in many of these toys represented an oppositional us-versus-them mindset. In addition to paralleling contemporary Cold War geopolitics, that opposition also echoed American race relations in the 1950s. In that decade, landmark court cases such as *Brown v. the Board of Education of Topeka* (1954), brought on behalf of African American schoolchildren by lawyers of the NAACP (National Association for the Advancement of Colored People), began the process of desegregating schools. Protestors organized a bus boycott in Montgomery, Alabama, in December 1955 after Rosa Parks was arrested. They walked for a full year until a federal court ruling desegregated public transportation in both Montgomery specifically and Alabama generally. As protests and court cases sought change, resistance and opposition also spread. And yet, throughout this period, the casts of space-themed television and movies looked far more like racially restricted suburbs than the integration sought by the civil rights movement. Space shows were not unique; most films and television shows were overwhelmingly white in this era. Although spaceflight programs and films depicted futuristic possibilities, in the 1950s, most fictional visions of spaceflight did not include people of color other than as villains.

In the 1950s, American enthusiasm for spaceflight, which had been eclipsed by the exigencies of wartime in the 1940s, came back in new peacetime forms. The Buck Rogers archetype established in the 1930s via comic strips, movie serials, and radio programs skipped to a new generation, becoming a staple of youth-oriented programming on the emerging medium of television. Wild adventures in fantastical locations no longer dominated the genre. Even shows without much investment in scientific accuracy tended to focus on space-based places a bit closer to home, often recognizably in Earth's solar system. If the heroes were white (and mostly male) while most villains remained nonwhite (and sometimes female), the moral tone of the adventures could also be described as black-and-white, with unblemished heroes and dastardly foes. Drawing on a visual vocabulary established during the 1930s, space-themed films and television conflated depictions of race or ethnicity with being alien or having ill intent. At a time when the

dawn of actual spaceflight raised the very real question of who could fly in space and who could represent the United States in this new endeavor, space-themed movies, television, and comic strips both employed and reinforced stereotypes based in postwar white, suburban identity.

CAPTAIN VIDEO

The Buck Rogers archetype forged in the 1930s translated easily into the new medium of television. In the early years of television, both Westerns and space adventures ruled the airwaves. In program after program, a Western-styled cast of spacefaring heroes—with ray guns at the ready—boarded named rockets to travel to space-based places for adventures. Not all televised space adventures were simple Westerns transposed into outer space, and writers and producers also drew on other narrative styles to distinguish their shows. Nevertheless, certain key elements, especially the general cast of characters, often had a core consistency. The troupe usually starred a handsome male lead, often the title character. His sidekick added youthful enthusiasm that needed to be tempered by the hero's steadiness. A doctor/scientist advised the hero and sometimes provided technological solutions to that episode's problem. A beautiful woman (or sometimes two) often rounded out the group. Not only was racial diversity absent, but differences as subtle as having a brunette actor rather than a blonde one could also distinguish a character as different, ethnic, or even alien.

One of the very first children's space programs, *Captain Video and His Video Rangers* (1949–55), ran for six seasons on the DuMont network after its first episode on June 27, 1949. Called TV's first space opera, *Captain Video* offered its young viewers—referred to as video rangers—space adventures combined with Western interludes. Like many early television programs, the show was broadcast live. To fill out the length or cover set changes, *Captain Video* regularly included short clips of Westerns from the DuMont catalogue, shown as if playing on a television screen. Switching the audience's focus to a cowboy movie clip in the middle of the program saved production costs for the weekday evening broadcast. In addition, at a time when television was still new, showing ever-present television screens seemed futuristic. Each episode began with a dramatic introduction announcing the title character. As theatrical music boomed, an announcer intoned:

Captain Video! Captain Video! Electronic wizard! Master of time and space! Guardian of the safety of the world! Fighting for law and order, Captain Video operates from a mountain retreat with secret agents at all points of the globe. Possessing scientific secrets and scientific weapons, Captain Video asks no quarter—and gives none—to the forces of evil. Stand by for Captain Video and his video rangers!

In each of the variations on the show's introduction, as the words "Captain Video" appeared on screen in a lightning script, the announcer recapped the hero's previous exploits, drawing young viewers back into the adventures.

Captain Video's cast presented a variation on the Buck Rogers archetype. Broadway actor Richard Coogan initially played the strong lead character, a hero who wore a military-style uniform along with a crash helmet topped with aviator's goggles and carried a Space Age sidearm or ray gun. However, the program's low budget and demanding daily performance schedule meant that actors frequently left the show, quickly replaced by other performers. Actor Al Hodge took on the lead role in 1950. Throughout the show, the teenaged character known only as the Video Ranger (played throughout the run by Don Hastings) aided the hero in his battles. The silver, pointy rocket ship *Galaxy* carried the team from place to place, flying horizontally with flames spewing out the finned back end before landing vertically on the planet of the hour. *Captain Video* depicted outer space as inhabited locations that could be visited. The action often began on Earth, but the show's leads also encountered human-looking aliens populating other planets in Earth's own solar system, including Mars and Pluto.

In a show with an all-white cast, makeup and wardrobe conveyed the visual markers indicating ill intent or alien nature. Villains included the scheming scientist Dr. Pauli (played first by Bram Nossen and later with relish by Hal Conklin) and numerous other alien enemies. The aliens looked entirely human, distinguished by costumes that included capes, hats, and headdresses that evoked foreignness. Key elements of costume and makeup used to characterize Asian supervillains in 1930s reappeared. For instance, to designate the mustachioed Dr. Pauli as the antagonist, Conklin's eyebrows were enhanced with makeup so that they peaked sharply in a devilish way. Some of the other alien villains sported the same darkened, angularly arched eyebrows, an echo of the exaggerated villainous look of Ming the Merciless from the *Flash Gordon* movie serials in

the 1930s. Although Dr. Pauli's character was not supposed to be alien, just nefarious, Conklin took advantage of the cosmetic exaggeration. During closeups of his scheming, he delighted in emoting enthusiastically. Such performances built the reputation of kiddie space shows as melodramatic.

Although adults also watched, *Captain Video* launched the craze for children's television space programs. Multiple commercial sponsors offering premiums aimed at youngsters marked the program as juvenile. In fact, the very first half-hour episode of *The Honeymooners* used *Captain Video* as the very symbol of childishness. In "TV or Not TV," originally aired on October 1, 1955, impatient bus driver Ralph Cramden (Jackie Gleason) and his goofy neighbor, trash collector Ed Norton (Art Carney), split the ownership of a television, only to disagree when Norton commandeers the set to watch *Captain Video* instead of Cramden's choice, a movie. As Cramden looks on exasperatedly, Norton enthusiastically greets the children's character ("I am ready, O Captain Video!") and pledges his allegiance as a video ranger while wearing an outlandish play space helmet.

Television itself was also in its infancy. Early television programming repurposed formats based on vaudeville or radio. For instance, news broadcasts showed an announcer reading the news as originally written for radio or print, sometimes interspersed with newsreel footage or stock film from military sources. For comedic or dramatic performances, such as *Captain Video*, actors played live on stages. Such programs were intended as one-time performances, much like radio shows. Reruns had yet to emerge as worthwhile sources of entertainment or profit.

The business models that came to define television programming took time to solidify. For instance, the DuMont Network, *Captain Video*'s creator, defined itself primarily as a manufacturer of TV sets. DuMont produced programs largely to persuade families to adopt the new form of entertainment. In 1950, fewer than one out of ten American households owned a television set. DuMont executives hoped that appealing shows would build demand. In total, Americans purchased 70 million sets in the decade of the 1950s so that by 1960, almost nine out of ten American homes included a television. Because so little television programming was filmed and saved, much of what still exists from the early 1950s was preserved using a kinescope recorder, a special film camera that recorded a television screen as the program played. Even so, DuMont executives actually destroyed *Captain Video* kinescope recordings rather than pay to store them. Instead, they cashed in by reclaiming the films' silver content.

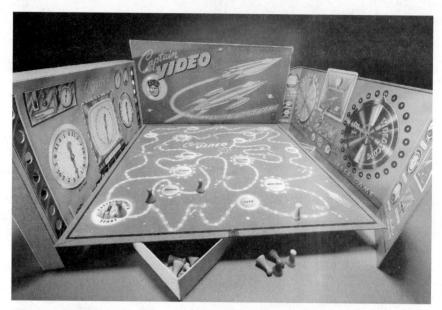

The standup cardboard control panel from Milton-Bradley's *Captain Video* game included illustrated dials just for effect, but players could use two "Videoscope" selectors to reveal instructions that affected gameplay. Photo courtesy of the National Air and Space Museum / Eric Long, NASM2021–06534.

Producers just did not think viewers would watch episodes more than once. But they did hope that consumers would buy associated products. In 1950, Milton Bradley sold a *Captain Video* board game. As befits a program in which the hero invented gadgets to aid his cause and foil his enemies, the game included a folded cardboard panel colorfully printed with multiple dials, gauges, and viewscreens in addition to a standard flat game board. This extra piece stood up, creating a mock control panel with two working dial selectors that directed the players' actions. It was the first of many space-themed spinoff toys. As Library of Congress librarian and toy historian Frederick J. Augustyn Jr. argues, Milton Bradley's *Captain Video* game "proved a prototype for other games geared to the outer-space craze of the 1950s and 1960s."

SPACE PATROL

Captain Video may have started the fad for kiddie space television, but other shows strengthened the trend. *Space Patrol* was a great example. Like *Captain Video*, each episode of *Space Patrol* (ABC, 1950–55) opened with a voiceover. The announcer proclaimed, "Space Patrol! High adventure in the wild vast reaches of space; missions of daring in the name of interplanetary justice; travel into the future with Buzz Corey, commander in chief of the Space Patrol!" *Space Patrol* began in 1950 as both a local television program in Los Angeles and twice-weekly radio program on ABC's radio network, where it soon gained a national audience. Viewers followed the adventures of the rocket-borne police force that operated from Terra, a manmade planet located between Earth and Mars. The show's major spacecraft, a pointed rocket with long fins called *Terra IV*, and later *Terra V*, shared the planet's name.

The general pattern of *Space Patrol*'s characters followed the Buck Rogers archetype. Ed Kemmer starred as Buzz Corey, the bold, competent, and ever-popular leader of the Space Cadets, accompanied by the young and humorous sidekick Cadet Happy (Lyn Osborn). Security Chief Major Robbie Robertson (Ken Mayer) served as the elder advisor, contributing technological acumen and wise counsel. *Space Patrol* historian Jean-Noel Bassior summarized Robertson's demeanor as "steady and concerned, like a favorite uncle." The Space Age police force wore uniforms with tunics bearing emblems on the chest and peaked, military-style hats. Two women also featured in the regular cast, sporting feminized versions of the uniform with skirts.

The two female leads in *Space Patrol* played rather different roles. Actor Virginia Hewitt portrayed Carol Carlisle, the blonde daughter of the Secretary General of the United Planets. She is both a scientist and Buzz Corey's love interest. In many ways, Carlisle's character echoed the space heroines of the radio age and comic pages: beautiful, intelligent, inventive, and yet distressingly susceptible to capture. In a different vein, actor Nina Bara portrayed the single-named character Tonga. She was initially an "unfriendly alien," but early in the series Corey's "mind-altering machine" transforms her into a "valued member of the crew." Her appeal to the opposite sex is so strong that, in one episode's ending joke, when the Space Patrol secretary accidentally puts her own boyfriend on the phone with

Tonga, the two almost instantly make a date. Throughout the series, Tonga's brunette hair set her apart as exotic and initially alien.

Space Patrol aired live and was also the first television program filmed before a live audience, adding to the technical challenges of the frequent performances. The cast learned new scripts for each fifteen-minute daily show, later adding the double dose of a thirty-minute live broadcast every Saturday. Even with cue cards posted out of the camera's view, the task of mastering so much material challenged the actors. Although it was dynamic, live television, which accounted for 80 percent of network shows in 1953, had inherent limitations. Actors could forget lines, miss cues, or simply freeze, requiring the rest of the cast to improvise to keep the episode going. Especially important for a space show, the special effects also had to be done in the moment. As a result, even with a significant production budget and talented staff, some effects appear campy, especially in retrospect. Nonetheless, what viewers remembered was the television magic the show created for its youthful audience. After all, no one had seen anything better on this new medium. In the end, the resulting appeal was broader than expected. Although it was designed as a children's show, *Space Patrol* eventually counted adults as the majority of its audience.

Commercial promotions aimed at youthful postwar consumers and their families capitalized on that enthusiasm. Fans of *Space Patrol* could even dream of winning a giant rocket ship. In 1953, the show's two main sponsors, Weather-Bird Shoes and Ralston-Purina, backed an amazing promotion, the Ralston Rocket. The thirty-five-foot-long metal rocket ship was modeled on the *Terra IV*, complete with consoles full of switches and blinking lights. Towed by its own tractor-trailer, the rocket ship–styled clubhouse, along with $1,500, were the grand prize in a "Name the-Planet" contest. Space Patrollers were encouraged to find special coins in cereal boxes or collect them from purveyors of Weather-Bird shoes to accompany each contest entry. Participants submitted names for villain Prince Baccarratti's mysterious Planet X (which, in an extended storytelling arc, had invaded Earth's solar system). To promote the contest—as well as Ralston-Purina cereal, Weather-Bird shoes, and the program—the Ralston Rocket toured the country, attracting long lines of children ready to trade a cereal box top for ten seconds inside the ship. Actually, one massive rocket circled the eastern half of the United States and another one took a western route, with the duplication a closely guarded secret. For a year, the Ralston Rocket tapped into the excitement

for fictional space travel to attract families to their local shopping centers and supermarkets. In the end, with his suggestion of "Caesaria," ten-year-old Ricky Walker of Washington, Illinois, won the rocket, the money, and the envy of Space Patrollers across the nation.

Throughout the early 1950s, the ongoing popularity of space-themed programs also inspired the resurrection of established space heroes, including *Flash Gordon* and *Buck Rogers*. For one season, ABC broadcast a live TV program of *Buck Rogers* (1950–51), for which no kinescope recordings survive. In 1954, a version of *Flash Gordon* (1954–55) was filmed in West Germany and France for syndication. By the mid-1950s, most television networks included a kids' space-themed show in their lineup.

Such programming flourished on early television for several reasons. In part, businesses followed trends. When network executives and movie studio heads saw success in a genre, producers rushed to create similar projects. Second, and just as important, in an era dominated by campaigns against Communism, television producers often gravitated toward topics that seemed politically neutral. Beginning in the late 1940s, concerns about Communist influence in Hollywood that had begun in the late 1930s resumed. Hearings before the House Un-American Activities Committee and blacklisting focused on the entertainment industry were in full swing by the late 1940s. Then, in February 1950, Senator Joseph McCarthy's prosecutions of suspected Communists and sympathizers known as "fellow travelers" began with his famous speech claiming to have a list of known Communists in the State Department. In contrast, space-themed shows aimed primarily at children seemed to offer distinctly apolitical entertainment. (Comedies and variety shows, two other popular types of contemporary programming, also shared political neutrality.) Finally, the audience for children's programming was literally and figuratively booming. Beginning in 1946, the number of babies born increased every year, peaking with 4.3 million births in the United States in 1957 and driving economic and cultural trends for years to come.

PROJECTING SUBURBIA INTO SPACE

Seemingly apolitical offerings nonetheless conveyed clear messages about who could play the hero, the villain, or even the helpless prisoner. In that way, popular culture both reflected and reinforced contemporary stereotypes. Such depictions

also echoed social trends, including the exclusionary composition of suburbs during the broad era of white flight. Scholars have identified white flight as a dual phenomenon: occurring first in the 1920s and 1930s as white city-dwellers relocated within cities to stay in predominantly white neighborhoods, then expanding in the post–World War II years to include the mass exodus to suburban neighborhoods. Residential developments remained segregated because of racially restrictive covenants and simple bias. The real estate practice known as redlining, literally drawing lines on a map around neighborhoods that developers wanted to keep uniformly Caucasian, reinforced the homogeneity. In her analysis of the "containment ethos" of the postwar suburbs, historian Elaine Tyler May has argued convincingly that such housing developments promoted new values, including rigid gender roles, nuclear family structures, and uniform racial identity. In the 1950s, the artificial racial uniformity in neighborhoods or communities that had been created by white flight, redlining, and Jim Crow laws was reinforced by cultural images on television or in film. Having white heroes and either nonwhite, alien, or female villains in popular culture drew upon stereotypes rooted in postwar suburban identity.

One example can be seen in the revival of the *Flash Gordon* daily newspaper comic strip, drawn by Dan Barry beginning in 1951. Although the Sunday strip continued throughout the 1940s, *Flash Gordon* creator Alex Raymond stopped drawing the daily one in 1943, and the daily strip ended altogether the following year. In the daily strips that began again in the 1950s, however, Flash Gordon and Dale Arden engaged in their heroics in Earth's solar system rather than primarily in invented places such as the Planet Mongo. Strips from 1951 and 1952 follow their adventures from a prison space station orbiting Earth to the cloud surface of the planet Jupiter and eventually to the icy surface of Jupiter's moon Ganymede.

All the principal characters in the *Flash Gordon* strip were white—and almost all were men. Even the prisoners held in the space station penitentiary were white. Big Moe, the thick-necked heavy who leads a prison break that threatens Gordon's mission, appears less educated or possibly ethnic by virtue of his colloquial speech, as when he discovers what the scientist's ray gun can do: "Y'mean t'say we can just *walk* outa here through that hole—as easy as that?!" The aliens, however, appeared as devils, seductresses, or diminutive figures. On Ganymede, Gordon encountered the evil queen Marla, whose depiction recalls

the Asian-styled villains from the 1930s, and her subhuman prime minister, Garl, described as having "a physique like a gorilla." Gordon's escape from Garl segued into encounters with Lucifan, king of Tartarus, leader of a race of dark-skinned, devil-horned knights.

The depictions of female characters also reflected the narrowing of acceptable roles for white women in the 1950s. In the 1930s comic strips and movie serials, Dale Arden is Flash Gordon's love interest and fellow adventurer. In the first sixteen strips of the *Flash Gordon* daily strips from the early 1950s, however, Arden appears eight times but speaks only two lines, both encouragements to Gordon, before she is kidnapped. She reappears in the twenty-first strip, bound to a chair and gagged, a damsel in distress. The adventures continued without her. Readers saw Arden carried off unconscious in May 1952, and the character did not reappear until January 1953. In the interim, the alien Marla accompanies Gordon. Where Arden is loyal and encouraging, Marla uses her sexuality to try to trap Gordon into marriage or trick his crew into creating perfume, flowers, gowns, and even a castle for her using a matter converter. When Arden finally reappears and the group returns to Earth, her first thoughts are about homemaking: "Maybe this time Flash will settle down here for good!" When Gordon embarks instead upon the time travel adventures that finish the series, Arden stays behind.

Another striking example of postwar racial homogeneity is *When Worlds Collide* (1951). Well-known science fiction director George Pal was a producer. Chesley Bonestell served as technical advisor and contributing artist on the film. Even before he began working on movies, Bonestell had already made a name for himself in architectural circles by helping to design the art deco façade of New York City's famous Chrysler Building. He then became well known as a space artist. In 1944, he published in *Life* magazine a series of realistic paintings of Saturn as viewed from its moons. His strikingly realistic style earned him work creating film backdrops.

Based on a novel published by Philip Wylie and Edwin Balmer in 1932, *When Worlds Collide* tells a tale about a Space Age ark. The opening scenes of the film make the analogy explicit with biblical quotes about Noah and the flood written in calligraphy. The film's plot has all of humanity in jeopardy. As the story begins, pilot David Randell (Richard Derr) hand-carries observations from a white South African astronomer to New York City. There, leading scientists confirm his

dreadful prediction: an errant star called Bellus is headed for Earth's solar system, pulling the planet Zyra with it. Not only would the star's approach cause deadly tidal waves, earthquakes, and floods, but just days later, the star itself would obliterate Earth altogether. The only hope is to build massive spacecraft to carry a few people, livestock, supplies, and a microfilmed library to the trailing planet Zyra as it passed. Although the lead scientist, Dr. Cole Hendron (Larry Keating), testifies before the United Nations, other scientists fail to believe him, and world governments refuse to act. Leading the effort to build an escape rocket himself, Hendron accepts money from Sydney Stanton (John Hoyt), a rich, disabled businessman who uses a wheelchair. Stanton is not being generous; he wants to use his influence to select the final passengers. Hendron takes the money but refuses Stanton's supervision, offering him just one seat on the rocket, a limitation foreshadowing a dramatic conflict in the film's climax. In the meantime, in a subplot that sets up the movie's conclusion, Hendron's daughter Joyce (Barbara Rush) finds herself falling in love with Randall.

The racial imagery throughout *When Worlds Collide* is striking. The UN representatives are pictured as diverse world leaders wearing distinctive national clothing and speaking different languages as they communicate through translators. But after those world leaders dismiss the danger, viewers see the effort to build, supply, and launch the rocket as accomplished entirely by white Americans with no visible ethnic indicators. In addition, when the UN finally acknowledges the coming apocalypse in a televised address, the audience shown watching the announcement is a multigenerational white family sitting in a general store with a pot-bellied stove in the foreground—a deliberate throwback to a rural economic and social community, isolated from urban concerns.

The ultimate occupants of the rocket, drawn by lottery from the thousands who worked on the project, are all white people. In a dramatic turn, Hendron stays behind and refuses entry to Stanton and his wheelchair, conceding both of their seats to younger, able-bodied travelers. In the final scenes, rows of young men and women—as well as a small boy and a dog, who have each been rescued from the early destruction caused by Bellus's approach—ride to salvation dressed identically in brown anoraks and black knit hats. Various storylines throughout the film emphasize romantic relationships between the chosen travelers, subplots that allow the audience to gain comfort with the awareness that the characters' main mission will be to repopulate the human race. In the end,

through a series of plot twists, the lead couple stepping out onto Zyra's lush and habitable surface, depicted in a Bonestell painting, is Joyce Hendron and David Randell. Neatly matched pairs of men and women emerge from the rocket, ready to begin their new lives together. In addition to the emphasis on heterosexual, able-bodied reproduction, the racial uniformity of the group cannot be missed.

The racial casting of the film was not remarkable at the time. In 1951, both filmmaking and movie watching were still largely segregated. Hollywood's studio system accommodated the separations rampant in both northern cities and southern states. In reaction, between about 1915 and the early 1950s, a separate film industry created approximately five hundred race films aimed at African American audiences and exhibited at midnight screenings at all-white southern theaters or neighborhood movie houses in the North. In the years before and after *When Worlds Collide*, activists contested racial inequality in the United States actively and publicly. Throughout those struggles, most of the depictions coming out of Hollywood—whether space-themed or not—ignored this reality.

Films like *When Worlds Collide*, which suggest that only white people mattered in space or in the future, became a core element of the popular culture science fiction canon. Years later, when viewers remarked on the racially integrated crew of men and women depicted on the original *Star Trek* television series (NBC, 1966–69), it was because they recognized the visual contrast with earlier depictions. Interestingly, the designers for *Star Trek II: The Wrath of Khan* (1982) included a subtle reference to *When Worlds Collide* in their set design. When the crew of the *Enterprise* beams into the underground Genesis chamber on the planetoid Regula, two of the cargo containers in the background are labeled "Bellus 4" and "Zyra," direct references to the earlier film. The allusions suggest that the producers respected the earlier film as part of the recognized canon of science fiction film.

THRILLING (BUT REALISTIC) INTERPLANETARY ADVENTURES

Although space science fiction's depictions of race and gender did not prompt much commentary at the time, the genre's reputation as child-oriented had real, if unintended, consequences for contemporary spaceflight advocates. Because

of the popularity of kiddie space programs, promoters of actual rocketry found themselves forced to contend with a cultural bias against space topics. During the 1950s, the phrase "Buck Rogers" no longer evoked something aspirationally futuristic but rather suggested a childishly fantastical vision of spaceflight—the opposite of serious research projects or fiscal responsibility. The Eisenhower administration's secretary of defense (and former General Motors president), Charles E. "Engine Charlie" Wilson, commonly derided space-related military research in the mid-1950s as "this Buck Rogers nonsense." To change that perception, a group of well-informed spaceflight advocates set out to turn popular culture to their advantage by promoting how realistic and achievable human spaceflight could be.

In *Space and the American Imagination*, Howard McCurdy argues that these men, whom he calls "space boosters," self-consciously used popular media to present human spaceflight as realistic and achievable, in marked contrast to the period's fantastical science fiction. As a part of this effort, well-credentialed spaceflight enthusiasts, including such notables as science popularizer Willy Ley, rocket engineer Wernher von Braun, and the aforementioned artist Chesley Bonestell, tried to compete with fanciful television programs by depicting spaceflight as feasible. For instance, in 1949, Ley collaborated with Bonestell to publish a book, *The Conquest of Space*. In four chapters illustrated with Bonestell's evocative paintings, the book explains the principles of practical rocketry before offering a tour of the planets, speculating about how they might be explored. Works like this came to be known as "speculative nonfiction," imaginative but plausible stories that might never come true exactly as written or depicted but that were nonetheless rooted in real science and engineering.

For instance, Bonestell advised on and provided artwork for *Destination Moon* (1950), George Pal's independently produced movie. Directed by Irving Pichel, the film is based on a story and screenplay by Robert Heinlein. It depicts a privately funded mission to the Moon complete with special effects that won an Academy Award. The film combines realism with earnest persuasion and education. Specifically, in the first half of the film, the viewing audience learns about the technical aspects of building and preparing the rocket. First, an assembled group of industrialists views an explanatory film, a movie within the movie, starring the cartoon character Woody Woodpecker explaining how rockets work. Then, midway through the film, the scientists hastily launch their rocket early

to avoid unnecessarily cautious government regulation. In their haste, they lift off with a replacement radio operator, Joe Sweeney (Dick Wesson), on board. With his pronounced Brooklyn accent, the distinctly ethnic working-class character serves throughout the rest of the film as a narrative device, allowing the other cast members to explain technical details to him, and thus also to the viewing audience. The resulting film became an iconic depiction of imagined spaceflight and a tool in the ongoing effort to sell the viewing public on the endeavor.

The space boosters even lent their expertise to children's programming. Willy Ley served as a technical advisor for *Tom Corbett, Space Cadet* (1950–55), boosting the television show's reputation as "easily the most scientifically accurate" of the kiddie space shows. Set in the year 2350 at the Space Academy, the show follows a group of young cadets who fly a rocket ship named *Polaris* while preparing for duty in the Solar Guard, a kind of planetary police force. The show imagines a future in which humans have colonized Venus, Mars, and Saturn's moon Titan. Although Ley's advice helped to steer the writers away from some of the more egregiously unrealistic plot twists, the melodramatic drama still ended each episode with a cliffhanger, followed by the announcer's reminder to "tune in . . . at this same time for the thrilling interplanetary adventures of Tom Corbett, Space Cadet!" The show struggled to find a permanent home, appearing on a different network each season: CBS, ABC, NBC, and DuMont before a final season on NBC.

The cast of characters for *Tom Corbett, Space Cadet* broke with some of the conventions of contemporary space television. Unlike other shows that focused on an adult hero with a youthful or comical sidekick, *Tom Corbett* featured an equitable trio of cadets. Handsome veteran actor Frankie Thomas Jr. was in his thirties when he played the heroic teen lead character, accompanied by Al Markim as the single-named Astro, a young scientist and engineer who hailed from a Terran colony on Venus. Jan Merlin portrayed the boastful Roger Manning, a talented cadet who often created tension within the group, teasing Astro about his Venusian heritage and prompting Corbett to intervene. For the first two seasons, the program also had a regular female character, actor Margaret Garland as Dr. Jane Dale. As one of the Academy professors, Dale teaches the cadets (and worries during their adventures) while also inventing key technologies including the rocket ship's hyperdrive. Unlike other women appearing in comics and

popular culture in the 1950s, she does not require rescuing any more than any other character, although she tends to stay behind during adventures.

As was the practice in early television, the show's sponsors played a prominent role—and, in the case of *Tom Corbett, Space Cadet*, connected the program to real cutting-edge aviation. In addition to being announced at the show's outset ("Kellogg's Corn Flakes brings you . . ."), the sponsor's advertisements were sometimes integrated into episodes. In one, when Tom Corbett's little brother, Rocky, is caught by the commandant staying over at Space Academy, USA, they immediately sit down to a breakfast of the brand-named cereal. During the show, Kellogg's also sponsored an honor roll of aircraft and pilots named for one of its high-energy cereals, Pep. One episode that aired in 1951 featured the Douglas *Skyrocket*. Two subsequent episodes highlighted individual jet pilots: Bill Cochran of Grumman Aircraft and Jack Bade of Republic Aviation. In particular, Bade's flight in a Republic F-84 *Thunderjet* got the full melodramatic children's program treatment. F-84s were described by the announcer as "the screaming eagles of the skies. Roaring, zooming, tearing through space, faster than the speed of sound. . . . Look at them go! Wow!"

Tom Corbett, Space Cadet was not the only program connecting its space adventures to innovative flying. A *Space Patrol* episode from 1954 featured US Air Force *Starfighter* pilot Tony Lavere doing a Chex advertisement. When President Eisenhower later directed NASA to select the first astronaut candidates from the ranks of military-trained jet test pilots, the link between high-performance aviation and space launches would have seemed logical to *Tom Corbett*'s youthful fans.

One of the most influential visions, however, was a series of illustrated articles that appeared in *Collier's* magazine in response to symposia beginning in 1951 at the Hayden Planetarium in New York City as well as in San Antonio, Texas. Written by real experts (including Ley, von Braun, astronomer Fred L. Whipple, and space medicine professor Heinz Haber), and compellingly illustrated by Bonestell, Fred Freeman, and Rolf Klep, these important articles offered realistic descriptions and visualizations of possible space exploration. Largely the same group of advocates also participated in creating special episodes for Walt Disney's weekly television program. Designed to promote the California Disneyland, three space-themed *Wonderful World of Disney* television episodes suggested that human spaceflights would soon provide regular transportation to

orbiting space stations—and beyond. In particular, "Man in Space," which originally aired on March 9, 1955, includes a model of a nuclear-powered, rotating space station inspired by von Braun's ideas and built for the television program.

Famously, some of these same men also collaborated with Walt Disney himself in the planning and promotion of his new amusement park, Disneyland. The signature element of the Tomorrowland park was a "Rocket to the Moon" ride inspired by Ward Kimball's interpretations of von Braun's ideas for a lunar voyage. Such an attraction might seem like a revival of turn-of-the-century space-themed public amusements, but Disney himself would have objected to the comparison. Although the new park might have been compared to Coney Island, Disney regarded the clean, family-friendly amusement park as a direct rebuke to that tawdry predecessor. In addition, he conceived of the physical park as intimately tied to the new medium of television. The park's layout evoked a filmmaker's perspective on simpler times, deliberately constructed to be a nostalgic escape from the era's Cold War tensions.

The spaceflight enthusiasm of the 1950s did not unfold as a simple, smooth transition from childish fiction to speculative nonfiction. Bonestell's realistic paintings in *Life* magazine existed as early as 1944, and outlandish depictions continued to find receptive audiences well into the 1960s. As hard as spaceflight enthusiasts worked to convince the public that funding human flights could be reasonable, they never fully dislodged some of the stereotypes established by the kiddie television shows. Throughout the decade, popular depictions of space topics embraced both plausible and fantastic depictions, a duality that was reinforced in many homes through space-themed toys.

PLAYING WITH SPACEFLIGHT

Evidence of spaceflight realism in the early 1950s can be seen in the repackaging that Daisy Manufacturing gave to one of its classic Buck Rogers ray gun toys. On the outside, the rocket pistol design from the 1930s got a new colorful paint scheme. Packaged in a cardboard frame that doubled as a holder, the set contained a lithographed metal target, the toy gun, and two darts that ended in suction cups. A player could aim the projectiles at the square, metal "rocket target," which featured small, illustrated orange and gold explosive bursts labeled for either twenty-five or seventy-five points. Ten different rocket illustrations also

decorated the target. These images included real vehicles that had become well known during and after World War II, such as the V-1 cruise missile and the V-2 rocket used by Germany and the American WAC Corporal, as well as realistic-looking but imaginary rocket-powered aircraft. The bottom of the target included the curved arc of Earth, featuring the distinctive shapes of three Great Lakes and Michigan, Daisy's home state. With this repackaging, Daisy transformed a toy that dated from the birth of the American fascination with comic strip spaceflight into a plaything that drew its appeal from references to real rocketry.

Unlike the ray guns from the 1930s, which were made of metal and their accessories crafted in leather, fabric, or cardboard, new toys in the 1950s often included plastic pieces. Injection molding, a relatively new manufacturing technique, allowed toymakers to make inexpensive figurines in a variety of poses. Along with themed metal buildings, the static figures populated toy sets that could include dozens of pieces and nonetheless remain affordable enough for mass consumption. Take, for instance, the Space Patrol Rocket Port set that introduced this chapter. As we have seen, it was manufactured by Louis Marx and Company, the New York toy company that had created metal Flash Gordon ray gun toys in the 1930s. The business originated in 1919 as a toy brokerage run by two brothers, Louis and David. By 1955, Marx had become the largest toy manufacturing company in the world, and Louis Marx graced the cover of *Time* magazine.

Although the company manufactured many kinds of toys, it became famous for playsets: three-dimensional backdrops (including decorated metal buildings called "tin lithos" in the business) populated by plastic figurines. One of the earliest was a farm set with assorted animals. Many popular sets featured two sides of a conflict, such as the Merry Men versus the King's knights in a Robin Hood set from 1957 or opposing Civil War soldiers in the Battle of the Blue & Gray. Drawing upon the ongoing popularity of Westerns, many Marx playsets featured forts. One Marx employee dubbed the company's Fort Apache set, which included "Indians" in a pitched battle with US cavalrymen, "the king of the sets." New lithography and figurines reimagined those Western-style fort playsets as set in outer space.

As interpreted through toys, however, the different space-themed television shows lost their individuality. Marx not only sold a Space Patrol space fort but also created an almost identical Official Tom Corbett Space Academy set. Both sets included wall segments and a boxy metal headquarters building in different colors, but the accessories and figures changed with the branding. Changing the

name above the fort's gateway entrance and the corresponding name on the external box completed the transformation. Marx sold many versions of the same toy.

T. Cohn, Inc., produced a similar toy, the Superior Space Port, also known as the Captain Video Space Port. It included metal fort walls to surround a two-floored central headquarters building. That backdrop was designed to be populated by Interplanetary Space Men and Supersonic Space Ships made by the Lido Toy Company. The Lido space men were available in sets—but also as premiums included in Post Raisin Bran as "Captain Video Space Men." For both Marx and Cohn/Lido, the combination of molded plastic figurines with lithographed metal structures created toys with appeal and playability.

The wide array of toys produced by manufacturers reflected the rapid expansion of the middle class amid the economic growth of the 1950s. The Serviceman's Readjustment Act of 1944, also known as the GI Bill, provided tuition benefits and low-cost mortgages to returning servicemen. Access to affordable education, business loans, and home ownership allowed a generation to pursue financial stability. As the Baby Boom began, demographic dominance also brought outsized attention to kiddie culture during the 1950s. Eventually, advertisers began to use television to reach young people as a market force with power to influence family buying patterns. Children and families who benefited from these economic shifts could afford large collections of playthings.

Multipart playsets also fit the lifestyles being fashioned in new suburban homes. Beginning in 1947, the building firm Levitt & Sons founded the first mass-produced planned community in the United States at Levittown, New York. Such residential plans featured single-family homes rather than row houses or apartments, reshaping daily life for the white, middle-class families who had access to living there. Expanded suburban floorplans with individual bedrooms as well as living rooms and outdoor spaces allowed children to assemble multipart toy sets and even to leave the myriad pieces set up for extended play without inconveniencing the rest of the family. Moreover, children could acquire more than one set. By the 1950s, Marx's marketing explicitly appealed to children to acquire as many as possible. Indeed, the copy on the side of the original box for the Louis Marx Space Patrol fort set read, "one of the many MARX toys—have you all of them?" Acquiring several playsets or even combining their elements in creative ways was part of the toys' appeal.

Whether the forts were Western or space-themed, assembling the walls and positioning the central building was just setting up. Real play involved manipulating the figurines and accessories. Forts inherently suggested attacking and defending an enclosure besieged by outsiders. Such us-versus-them enmity resonated with a Cold War mindset. Like the black-and-white morality of television shows of the era, so too Marx playsets offered figurines that featured clear heroes and enemies. The embedded racism can be startling. The Jungle set introduced in 1957 came with stereotypical figurines representing pith-helmeted white explorers and bug-eyed African natives. Spacemen and aliens served as space-themed versions of the equally popular Western "cowboys and Indians" figures. In an era defined by so many polar oppositions—between capitalism and communism, or between civil rights advocates and reactionary segregationists—many playsets reflected that sense of a world divided into opposing forces. Even accounting for the possibility of children choosing to mix the sets or otherwise disrupt the binary that defined the playthings, such depictions had lasting effects on the self-image of those depicted as enemies.

For those with fond childhood memories of these toys, however, nostalgia remains powerful. From 2000 until 2016, a Marx Toys museum existed in Moundsville, West Virginia. A dedicated magazine, *Playset*, has been entertaining fans of Marx and other playsets with detailed images and stories since 2002. And the editor of *Playset* self-published a detailed, two-volume local history of the men and women who made Marx run. Marx figurines have even inspired a book of postmodern photography and a reflective work of literary nonfiction. The little molded figures cast a long historical shadow.

FORBIDDEN PLANET

Another type of space toy with a lasting impact was the space robot. In 1954, Ideal Novelty & Toy Company introduced "Robert the Robot," later confirmed by a prominent toy encyclopedia as the "first robot toy to hit the domestic market." Interestingly, the toy predated by two years the introduction of the famous "Robby, the Robot," character in *Forbidden Planet* (1956). In the film's opening titles, the iconic character merits its own full-screen credit as the anchoring cast member: "And introducing Robby, the Robot." Toys inspired by the film's character became so popular that many knock-offs appeared after the film's release. But

the movie's lasting influence came from its strong narrative and creative visualization of realistic spaceflight. The film was nominated for an Academy Award for special effects and cited by *Star Trek* creator Gene Roddenberry as influential.

The first film to suggest a human-made spacecraft that could travel faster than the speed of light, *Forbidden Planet* featured an Earth crew heading into deep space on a mission. In the initial scenes of the film, United Planets cruiser C-57D travels to the fourth planet around the Altair star to check on the status of a scientific mission that had landed twenty years earlier aboard a ship called the *Bellerophon*. Of the entire *Bellerophon* crew, they find only two survivors: Dr. Edward Morbius (Walter Pidgeon) and his daughter Altaira (Anne Francis). In this resetting of Shakespeare's *The Tempest*, their encounter becomes a cautionary tale about giving oneself over to technology.

The film's homogenous cast breaks somewhat from the classic Buck Rogers archetype due to the absence of a standard female lead in the space crew. Still, the film's basic structure consists of a heroic male–led crew visiting a space-based place on a spaceship with guns at the ready. Commander J. J. Adams (Leslie Nielsen) travels away from the ship to meet the surviving explorer, bringing along a small team including the ship's doctor, Lieutenant "Doc" Ostrow (Warren Stevens), and Lieutenant Farman (Jack Kelly). A voiceover about the "United Planets" ship suggests that either Earth has become unified or that the exploratory crew represents an Earth alliance with several planets. Regardless, the crew remains homogenous: all young white men.

The situation they find on Altair IV prompts the addition of the final *Buck Rogers* element, ray guns. When Morbius warns them not to land, they proceed anyway—but only after Adams cautiously advises his crew: "Standard 'class A' security will be maintained upon landing. And until further notice, all hands will wear sidearms." The weapons protect the crew in several situations but ultimately fail to stop the "Monster of the Id" and can be rendered useless by Robby's powers.

The only woman in the entire film is Altaira, known also as Alta, the young adult daughter of Morbius and his wife, another scientist who died of natural causes shortly after the expedition landed twenty years earlier. Portrayed as hopelessly naïve and alluring, unschooled in the ways of love and yet inordinately concerned with pleasing men, Alta remains literally barefoot throughout the film. When Adams catches Farman kissing her, he reprimands her for being

ignorant of his crew's overt male sexuality, especially Farman, whom Adams calls a "space wolf." In scolding Alta about her obliviousness to her own sexual appeal, he highlights the contrast between her dangerous sexuality and his crew's voracious masculinity. He explains, "It so happens that I am in command of 18 competitively selected, super-perfect physical specimens, with an average age of 24.6—who have been locked in hyperspace for 378 days!" Later in the film, Alta's inexperience astonishes Adams when he finds her skinny-dipping in a pond, unashamed of her own nakedness. When she kisses Adams passionately, however, she loses her innocence, and thus her protection from the planet's wild animals. Much to Alta's surprise, Adams has to disintegrate a leaping tiger—a projection of sexual desire—with his sidearm in order to protect them.

Despite the scarcity of female characters, gender serves as a theme in *Forbidden Planet*. Even Robby the Robot, the hulking mechanical assistant built by Morbius, evokes the question. After the crew lands, Robby speeds into view aboard a vehicle driving across the planet's surface at breakneck speeds, a sign of the robot's superior mechanical reaction times. Upon arriving, the robot introduces itself, explaining that it speaks 187 languages in addition to English, concluding: "For your convenience, I am monitored to respond to the name 'Robby.'" Nonetheless, the cook asks a pointed question: "Hey, Doc, is it a male or a female?" Robby answers, "In my case, sir, the question is totally without meaning," but that does not settle the question. The crew comments on Robby's motherly intentions, and Robby is seen arranging flowers and caring for the home.

The rest of the film's plot reveals that Morbius had been taking advantage of ancient, native Krell technology buried deep below the planet's surface. His experiments with two thousand centuries of technology unleash the deadly "monsters from the Id." In the dramatic climax of the film, when the monster emerges again and Morbius orders Robby to kill it, Robby goes into a self-destructive loop, recognizing that the aphysical beast is a manifestation of Morbius's darkest impulses. With this revelation, Adams tries to convince Morbius of the horrible truth: "We're all part monsters in our subconscious! So we have laws and religion." But Morbius cannot be saved. The film ends with another assertion of heterosexual family formation: Alta in the arms of Captain Adams, headed back to Earth.

In retrospect, the powerful science fiction storytelling of *Forbidden Planet* appeared at a key point in the 1950s, just after many of the kiddie television series

went off the air and just before the real Space Age began. In both fiction and reality, spaceflight enthusiasm was about to enter a new era.

JAPANESE TIN TOYS

The growing excitement about spaceflight made American consumers a good audience for international products for years to follow. Notably, Japan became a source of inexpensive space-themed toys created for international export. Tin toy production began in Japan around 1947, tapping an international market for "penny toys" attractive for their low cost. By the late 1950s, however, Japanese firms gained a reputation for selling creatively designed, complex playthings with moving parts and lights that competed successfully with Western toymakers. By 1962, Japan exported $83 million in toys each year. Much of that output came from a literal cottage industry. During World War II, to evade Allied bombing, many Japanese manufacturers distributed their machinery among workers' houses, creating what American strategists called "shadow factories." After the war, however, some workers bought the machinery, creating *kanei-kogyo*, home-based family industries producing electronics and parts for consumer goods as well as tin toys. Larger corporations packaged and exported the finished goods.

Beginning in the 1950s, many of those toys had Space Age designs or packaging. Some were obvious. For instance, a blue metal "Moon Rocket" produced by Yonezawa Toys, one of the biggest manufacturers of tin toys, echoed the long pointy shape inspired by V-2 rockets. Although the wheels on the toy's side oriented it horizontally like a racecar when it was played with, on the box, the rocket stood upright on its fins in a deep craggy lunar crater with Earth in the sky above. The rubberized tip on the actual toy's nose suggested that the manufacturer expected it to withstand active play. In addition to rocket ship toys, however, manufacturers cashed in by adding a touch of spaceflight to other playthings.

Yoshiya (also known as Kobe Yoko Ltd.), which specialized in mechanical or windup toys with fanciful designs, produced the "Space Whale Ship PX-3," which combined a windup whale with Space Age illustrations and packaging. When wound using the key embedded in its right side, the googly-eyed metal whale undulated forward, its mouth opening and closing, small red fins flapping. But the toy's lithography made the whale double as a spaceship with a cockpit on its back, carrying a robot and an astronaut inside. Other details included an antenna-laden

satellite on a starry blue background near its tail and three stars above the toy's name, "PX-3." On the striped tail with a ringed planet pictured on it, the English-language name "Pioneer" made the toy suitable for export to the United States.

Asahi Toy Co., a major builder of mechanical and battery-powered toys, sold a space-themed dog. Rather than being a tribute to the actual canines launched by the Soviet Union throughout the 1950s, the blue and red metal toy featured flapping ears, a moveable mouth, googly eyes, and a spring-motion tail. On the external battery box, a version of the space dog stands on a craggy moon or planet surface facing a spacesuit-clad astronaut. Asahi manufactured the toy, and Cragston Corporation, a New York-based firm that specialized in imports from postwar Japan, distributed it.

Japanese companies used manufacturer's marks on the toys and packaging to identify the makers without listing foreign names in obvious places. For instance, on a silver space robot toy made by Nomura, clearly designed to imitate *Forbidden Planet*'s Robby the Robot, the mark "Japan" is hidden out of sight on a metal plate between the legs. Nonetheless, poor translations sometimes betrayed the toys' origins. For instance, in addition to the space whale, Yoshiya also made a "space elephant" toy that came in a box labeled with mistranslations. Regardless of the errors, the English labeling aimed at American consumers. As tin toys expert Michael Buhler summarizes, "The Japanese were chiefly interested in the American market and consequently nearly all their toys reflect American culture in one way or another."

One subset of Japanese-made space toys took advantage of a cultural overlap. In American markets, humanoid toys that looked like robots with human faces, such as the Rosko robot toy by Nomura, sold well as spacemen. In fact, the toy's English-language box has the word "astronaut" prominently displayed. But in Japan, this same form could be interpreted as robots with human hearts. Created by artist Osamu Tezuka in 1952, *Mighty Atom* or *Astro Boy* was a manga series about an android boy with human emotions. Toys that offered variations on that idea of a robot with a human soul did double duty, appealing to Japanese fans while remaining marketable to Americans as stylized astronauts. As the Space Age began, such toys became even more popular.

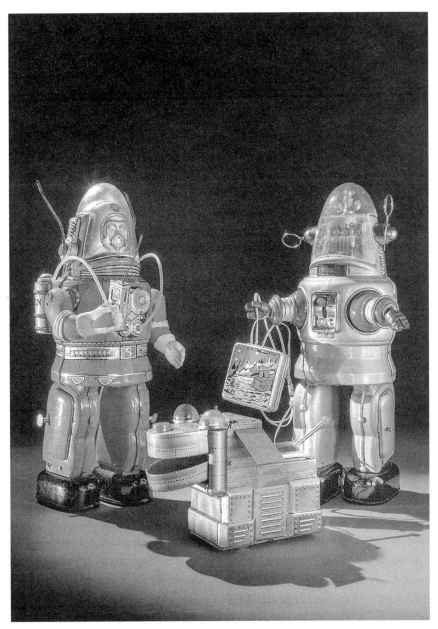

Japanese-made tin toys include a red Rosko robot by Nomura, a battery-operated space dog by Asahi Toy Co., and an imitation "Robby" robot toy, also by Nomura. Photo courtesy of the National Air and Space Museum / Eric Long.

THE *SPUTNIK* MOMENT

When the Soviet Union launched an artificial satellite, *Sputnik*, on October 4, 1957, the transition to the dawning Space Age was less of a surprise than is often thought. Both the United States and the Soviet Union had declared their intentions to launch an artificial satellite as a part of the International Geophysical Year (IGY), an international scientific effort intended to foster research. As a result, interested scientists had some time to plan. Social anthropologists Margaret Mead and Rhoda Métraux intended to measure the impact of a forthcoming satellite launch on American society. Instead, the initial survey planned to establish a baseline against which they could measure change was just being administered when *Sputnik* launched. As a result, Mead and Métraux asked approximately five thousand people about their reactions to the satellite and other events in that historical moment. They found that *Sputnik* often ran second to other concerns for many Americans, including civil rights and even a hotly contested World Series in which the Milwaukee Braves beat the New York Yankees in a decisive seventh game. Any shock at the Soviets' beating the United States into space took longer to develop.

Two additional events elevated concerns. In response to Soviet Premier Nikita Khrushchev's excitement about *Sputnik's* success, Soviet engineers scrambled to fulfill the order to develop a much larger (1,121 lbs. or 508.3 kg) second satellite for the anniversary of the Bolshevik Revolution just a month later. *Sputnik 2* carried both a rudimentary life support system and a canine passenger, Laika. That launch on November 3, 1957, alarmed American military leaders because, in the midst of the Cold War between two nuclear-armed superpowers, successful launches also demonstrated a nation's ability to deliver nuclear warheads. In the third part of this historical sequence, the US attempt to launch the *Vanguard TV-3* satellite failed in a spectacular launchpad explosion on December 6, 1957. The press dubbed it "Flopnik." The bent, broken halves of the failed satellite became a key artifact of US space efforts. In fact, when the National Air and Space Museum's building on the National Mall opened in 1976, visitors entered the *Apollo to the Moon* exhibit by passing a figure of Uncle Sam holding the broken *Vanguard* satellite in his outstretched hand, a symbol of how failure inspired innovation and, in time, the successful US lunar missions.

The first American success in the new space race finally occurred in the middle of the night on February 1, 1958. After midnight, confirmation finally came

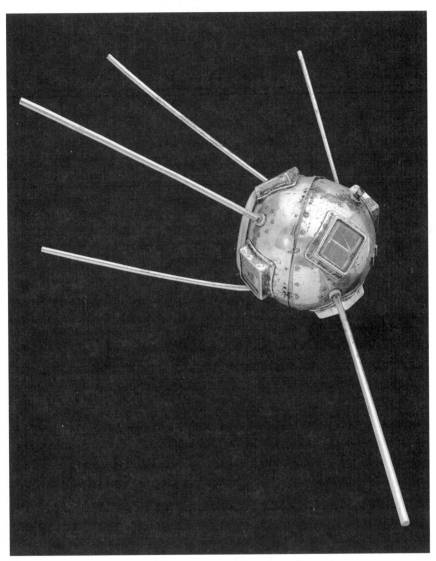

The cracked *Vanguard* TV-3 satellite became an artifact displayed and interpreted at the National Air and Space Museum as a key failure that motivated US space efforts. Photo courtesy of the National Air and Space Museum / Eric Long, NASM 2006-2092-03.

that the American satellite *Explorer I*, boosted by a Jupiter C rocket, had reached orbit. In addition to official confirmations by military sources, astronomy enthusiasts around the world helped to track the various satellites. Harvard astronomer Fred Whipple, director of the new Smithsonian Astrophysical Observatory in Cambridge, Massachusetts, organized Project Moonwatch, a citizen science project mustering amateurs with small telescopes to track early satellites worldwide.

By the time the first satellite launches began, the popular culture campaign organized by spaceflight advocates had succeeded. The public had come to see spaceflight as realistic, fundable, and worthwhile. The result was measurable, a fundamental change in public opinion. When asked in December 1949 by the Gallup Organization, the well-known public opinion poll company, about whether humans would reach the Moon in the next fifty years, 70 percent of those polled said no. Only 15 percent thought it was possible, with another 15 percent answering that they had no opinion on the matter. By October 1957, however, when asked a similar question, whether humanity would reach the Moon within twenty-five years, 41 percent of respondents believed it would happen, with 25 percent saying it would take longer than twenty-five years and 34 percent not sure. By the late 1950s, the ongoing efforts of space boosters had combined with real events to shift the national conversation. Space historian Roger Launius has called this change in public opinion "one of the most critical components of the space policy debate of the 1950s." People still enjoyed fantastical visions of spaceflight, but they also understood that they would likely see some of those fictions become reality within the next few years.

Advertisers responded to the shift. In 1959, Kraft Foods imitated Ralston-Purina's *Space Patrol* promotion, but this time with the support of an actual aerospace company. To promote its marshmallows, Kraft offered a huge twenty-nine-foot-long rocket mockup as the grand prize in another naming contest. Unlike the Ralston Rocket, which was made by a Los Angeles prop maker, Kraft promoted Aerojet-General Corporation as the engineers of its "Life-Size Aerojet Training Space Ship." Authenticity was the hallmark. According to Kraft's advertisement, Aerojet-General Corporation had created "propulsion systems for the Space Age—NASA Vanguard and Able, Navy Polaris, Air Force Titan, Army Hawk, the famous Aerobee sounding rockets and many others." The unnamed vehicle was not a toy, but a child-oriented simulator with consoles for a pilot, navigator, propulsion engineer, and instrument engineer. Ralston's promotion had

culminated in an individual child's winning the vehicle. But the unwieldly prize was too much for any individual family and was reportedly sold for scrap and lost to history. In contrast, the Kraft promotion stipulated in the fine print that the winner would receive $5,000 cash and that Kraft would "donate the Aerojet-General Training Space Ship to a recognized organization in the winner's community." By providing a whole town or neighborhood with a simulator, the contest emphasized preparing children for the coming era of spaceflight.

The dawning Space Age also influenced the contemporary aesthetic of home goods, including light fixtures, fabric patterns, and furniture. Across the country, beginning in the late 1950s, midcentury modern design became all the rage. Characterized by geometric elements including starbursts, closed curves, and sharply angled lines, the style repurposed the shapes and textures embodied in satellites such as *Sputnik* and *Vanguard*. Silver-spoked light fixtures played with

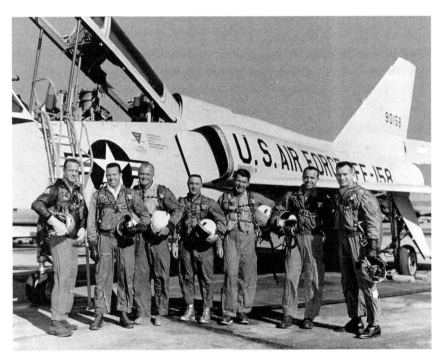

The military jet test pilots selected to be NASA's first astronauts, lined up in alphabetical order: M. Scott Carpenter, Gordon Cooper Jr., John H. Glenn Jr., Virgil I. "Gus" Grissom, Walter M. Schirra Jr., Alan B. Shepard Jr., and Donald K. Slayton. Photo courtesy of NASA.

the design elements found in satellites with swept antennae. In architecture and design, the Googie style combined futurist elements including parabolas and boomerang shapes with angled starbursts to evoke movement. One well-known example, the neon star-topped "Welcome to Fabulous Las Vegas" sign, went up in 1959.

For its part, the US government responded to the new Space Age by founding a centralized civilian agency, NASA. President Dwight D. Eisenhower created the new government entity in 1958 by transforming the administrative structure of the National Advisory Committee on Aeronautics (the NACA) from a purely research organization into the backbone of an operational effort to launch satellites, explore the planets, and fly humans in space. NASA also selected its first group of astronauts, a highly qualified group of military test pilots, in April 1959. The group included representatives from various military services (including three Air Force pilots, three Navy aviators, and one Marine aviator). At the time, the homogeneity of the group was considered an indication of the high quality of the men selected, all at the top of the pyramid of military jet test flying. As a practical matter, the talented members of the group looked so much alike that they sometimes lined up in alphabetical order so that the photo captions would not misidentify them: Carpenter, Cooper, Glenn, Grissom, Schirra, Shepard, and Slayton.

They were indeed remarkable men who quickly became national celebrities. The Mercury Seven astronauts signed an exclusive deal with *Life* magazine, allowing them and their families to be profiled in the popular photo magazine. The press deal also allowed the first seven astronauts to provide some financial security for their families at a time when traditional insurance companies would not underwrite their lives. On September 14, 1959, the astronauts themselves appeared on the magazine's cover as a group, followed a week later by their wives. As readers learned about the children, home lives, and hobbies of the men who would become the first human beings in space from the *Life* magazine on their coffee tables, they might also have seen listings in *TV Guide* for two new television shows about different aspects of human spaceflight that debuted that same fall.

THE SPACE AGE ON TELEVISION

In the autumn of 1959, two new dramas appeared on American television, each realistically addressing the challenges of going into space. On NBC, *The Man and the Challenge* (1959–60) drew inspiration from Air Force Colonel John Paul Stapp's well-publicized rocket sled experiments; the series featured a fictional doctor/researcher whose scientific experiments probed the limits of human endurance. On CBS, *Men Into Space* (also 1959–60) depicted the realistic adventures of Colonel Edward McCauley, head of a fictional American space program. Aimed at adults and executed with the cooperation of the Department of Defense, *Men Into Space* offered a fact-based depiction of space flight in the near future. Both programs were products of Ziv Television Programs, Inc., an independent Midwestern company that specialized in creating productions that could be sold to different television networks (a practice known as first-run syndicated programming).

The company's owner and creative head, Frederick Ziv, believed that television audiences wanted realistic programs because of his earlier success with *Science Fiction Theater* (1955–57). Produced with Ivan Tors, who would later produce *The Man and the Challenge*, *Science Fiction Theater* began each episode with a science experiment, the principles of which inspired the drama that followed. Starting with real science allowed technically savvy industry sponsors, such as Conoco in Dallas, Texas, to support the show. As a result, the production team included a six-person research department with a $75,000 budget for fact checking. The formula worked. For each of its seventy-eight episodes, *Science Fiction Theater* was always first or second in the ratings.

In the late 1950s, adult dramatic programming became the new trend on television. *Gunsmoke* (1955–75) and *Bonanza* (1959–73), long-running Westerns aimed at adults, both began in this period. Six other adult westerns appeared in 1955–56, followed by eighteen the next year. Their successes created a boom. In the 1959–60 season, thirty programs set in Western locales appeared on the air. Ziv's productions for that season aimed not only to capitalize on the trend toward adult genre programming but also to capture the contemporary interest in space exploration sparked by the launch of *Sputnik* and the dawn of the Space Age.

The Man and the Challenge was originally titled *Challenge*. But after the quiz-show scandals of 1958 and 1959, Ziv's producers feared that viewers might mistake it for a game show. In an era when the business model for television

depended upon keeping viewers' attention with general audience programming so that they did not change the channel, that was too big a risk for a network program. As a result, when the thirty-six black-and-white half-hour episodes aired on Saturday nights at 8:30 p.m., the new title emphasized the central character, Dr. Glenn Barton (George Nader) of the fictional Human Factors Institute. The opening sequence imagines Barton as akin to Colonel Stapp, who famously tested the human body's reactions to acceleration and deceleration by strapping himself into a rocket-propelled sled with water brakes (a project that put Stapp on *Time* magazine's cover in 1955). Because each week's episode addressed a problem based on contemporary research on human physiology, the drama did not feature conventional villains. Rather, Barton battles the limits of human frailty as he tests subjects against the predicted rigors of spaceflight.

Despite its not being set in outer space, human spaceflight colored the whole series. In an episode titled "Experiments in Terror," when Barton finds himself the unwitting subject of several tests of his reactions, nerve, and bravery, the doctor overseeing the tests explains: "We need . . . highly specialized men, who will one day land on the Moon and neighboring planets. Who can withstand pain, terror, cold, heat, hunger, sleeplessness, weightlessness, and isolation." Likewise, when Barton subjects two elite pilots to the unusual endurance test of driving in a daylong cross-country stock car race, he explains, "They were willing to try to undergo any experiments deemed important for space progress." Scripts reveal that an even greater number of spaceflight references appeared in the early versions. Used to justify the action in initial drafts, explicit references to spaceflight sometimes dropped out of episodes in the final filming or editing. This was especially true once the show's premise had been established. In later episodes, the action sequences required less supporting explanation. Spacesuits appeared in only one episode, "The Visitors," in which three experimenters, including Barton, field-test "planet suits" in a desert. The imagined prototypes featured large helmets with elaborate antennae, which convince trespassing poachers that they are aliens. Trapped in their suits and pursued by the hunters, the men have to rely on their wits until their rescue.

Throughout its run, *The Man and the Challenge* explored the question of what kind of person had the physical and mental toughness to open the new space frontier. In the first major scene of the first episode, "Sphere of No Return," Barton shoots a hole in a spacecraft simulator inside a pressure chamber, explaining

in voiceover: "One danger man will have to face in space is a sudden puncture of his spaceship by a meteorite." When one of the two male test subjects fumbles to plug the hole with a large suction device, Barton identifies the problem as not the device but the man: "Mason panicked." Demonstrating the cool competence that defines the series' lead character, Barton completes the repair. Mason, who otherwise passed all preliminary tests, leaves the program. The show even explored whether women might be well suited for spaceflight. As Barton's character explains in "Sphere of No Return," "if there are going to be colonies in outer space, the pioneers can't all be men." In the episode, Barton tests his assistant, Miss Allen (Joyce Meadows), during a date at an amusement park, where he surreptitiously times her reactions on different rides. Barton then tests Allen alongside Cory, a male subject, in a pressure chamber and a high-altitude balloon flight.

The question of women's physical capabilities recurred several times throughout the series. In an episode titled "Escape to Nepal," Barton includes Marilyn Sidney (Joan Granville), an expert laboratory technician and linguist, in his high-altitude mountain-climbing expedition because "one day women might be indispensable in spaceflight." Although Sidney makes sandwiches and coffee as the group climbs, she also demonstrates her value to the expedition through her linguistic skills. Barton tests women again in "Astro Female." The show ends with Barton's conclusion, "When the chips are down, the so-called 'weaker sex' is a myth."

The Man and the Challenge's explorations of capability were metaphorical as well as literal. In the episode "Maximum Capacity," Barton works with three world-class American male skiers to answer the question, "Are skiers better qualified to function and survive among certain extreme conditions?" Quickly, however, the episode reveals itself to be about spaceflight—and national spirit. When a skier fears a slope called Madden's Ridge, described as "a steep three-thousand-foot drop," Barton appeals to a national need for psychological toughness:

> Let's change the name of Madden Ridge. Let's call it outer space. We gonna give that up too without a try? We weren't the first with jets. We weren't the first with a satellite. Somebody else was.... Or are we just going to keep on being second best from here on in?

A need for a particular kind of toughness, both physical and metaphorical, expressed in terms of national prestige, remained paramount.

SPACE CRAZE

The late 1950s and early 1960s were a historical moment of gender anxiety. The rigid gender roles asserted after the end of World War II seemed to be breaking down amid the first tremors of what would become the second wave of the women's movement. Aspects of 1950s suburban life created a masculinity crisis, including fears of "Momism," insipid "organization men," and bureaucratic softness. The reactions to the Sputnik moment that called for a return to American frontier ideals also underscored cultural concerns about a loss of toughness.

The reassertion of masculinity became a central message of some *The Man and the Challenge* episodes. In "Odds Against Survival," Barton brings three prominent scientists and their wives aboard a nuclear submarine to rescue them from faked nuclear annihilation. As the scientists slowly adjust to their confinement (which was the real test: determining how people would endure extended confinement after a nuclear blast), one henpecked man learns to assert himself. Only as he takes on a more traditional manly role is he able to help save the group—and his marriage. Still, headstrong, unyielding cockiness is explicitly identified in several episodes as undesirable. In "White Out," Barton exposes one of the test subjects as overly assertive. Likewise, in an episode titled "Hurricane Mesa," a test pilot's successful adaptation to a clerk's job demonstrates that careful record-keeping will be just as vital as human risk-taking in the new Space Age. Finally, an episode about testing subjects in a floating spacecraft awaiting an ocean rescue, "Men in a Capsule," reinforces the importance of psychological screening. The strength and toughness needed for spaceflight must be a tempered masculinity, not uncompromising machismo.

Barton's character exemplifies a masculinity that is fit, capable, daring, and flirtatious—but in the end married to his work. Yet, privately, actor George Nader met his life partner, Mark Miller, in 1947. They set up a household together, remaining together as a couple for fifty-five years until Nader's death in 2002. Nader's identity as a gay man would not have been known publicly when *The Man and the Challenge* aired; he and Miller only came out in 1986 after the death of their dear friend, Rock Hudson, from AIDS. The emphasis on heterosexuality in his performance as Dr. Glenn Barton—and indeed the core assumption of straightness—seems somewhat ironic in retrospect. Nonetheless, in the form of weekly adventures, *The Man and the Challenge* allowed television viewers some insight into fictionalized aerospace testing.

MEN INTO SPACE

For its part, *Men Into Space* imagined a functioning military human spaceflight program. The Department of Defense agreed to support *Men Into Space* as long as script approval was included. Captain M. C. Spaulding of the US Air Force Ballistic Missile Division served as a technical advisor. Artist Chesley Bonestell developed the program's space concepts. The final credits for *Men Into Space* acknowledged the Defense Department as well as the Air Force's Air Research and Development Command, the Office of the Surgeon General, and the School of Aviation Medicine. Although the cast initially dressed in real pressure suits (the first episode credits note that "space suits worn in outer space sequences [were] provided by the United States Navy"), the show switched to fictional costumes as a practical matter.

Men Into Space featured a rotating cast of various support crew (astronauts and other scientists) making repeated missions to the Moon, led by Colonel Edward McCauley (Bill Lundigan). After an opening montage of stock footage of a V-2, a captured German liquid-fuel rocket, and glimpses of the fictionalized characters who would be the program's heroes, a voiceover explains the program:

> The story you are about to see has not happened, yet. These are the scenes from that story. A story that *will* happen as soon as these men are ready. This is a countdown. A missile is about to be launched. It will be the XMP-13. "XMP" meaning eXperimental Moon Probe. A missile that will carry three human beings into outer space.

The depiction of McCauley reinforced the centrality of the white suburban experience for 1950s America. At the very beginning of the show, viewers see McCauley's family nervously waiting for him. In fact, in the first lines of dialogue of the show, McCauley gives his colonel's insignia to his son Pete (Charles Herbert) to hold until he returns from his space mission. The music swells as McCauley kisses his wife, Mary (Angie Dickinson), goodbye. McCauley's interactions with his family throughout the series reinforce the humanity of the men going into space—and the main character's return to his suburban home when he is not flying.

In addition to learning something about realistic plans for spaceflights and the risks that could be faced, viewers watching these episodes heard rationales for going into space. Within the first few minutes of the first episode, a newspaperman asks McCauley straight out: "Why?" McCauley's reply evokes British mountaineer George Mallory's famously simple answer about climbing Mount Everest: "Because it's there." McCauley tells the press conference: "If a mountain [exists], somebody has to climb it. The mountains on the Moon just happen to be a few hundred thousand miles higher. Let's call it a way of life. . . . Let's say science is a way of life." In the second episode, "Moon Landing," after a briefing, the chairman of the president's space committee questions the cost: "Do you know how many billions are being spent to get you four men up there?" "Yes, sir, I do," McCauley replies, "And I believe it is a good investment." McCauley's colleague, Dr. Russell, quickly offers a more philosophical rationale for the flight:

> Well, nothing stands still, Senator. Life began in the sea, groped onto the land, and with intelligence and time, it staggered into the sky. Now we are leaping into space. We are ready. Spaceflight is only a natural, inevitable step in evolution. We have to go sooner or later. We might as well make it sooner.

The rationales given for pursuing spaceflight seem self-evident: it is there, it is worth it, and it is the natural next step. Within the context of the show, the desire to fly into space does not require detailed explanations. Spaceflight is even worth the ultimate sacrifice. In the dramatic climax, Dr. Russell collapses from injuries sustained during the trip. After his death, as his last request, the crew leaves him on the lunar surface. Later, Russell's mother reassures McCauley that her son died satisfied to have reached the Moon.

As the series progressed, the plots for *Men Into Space* shifted to emphasize a series of emergency scenarios that Department of Defense reviewers determined to be believable. The rescue of a rogue spaceship, the defusing of a nuclear powerplant on an unmanned missile, a collision between a spaceship and a refueling tanker, and a runaway satellite all put McCauley and his crewmen to the test. Week after week, despite significant risks, McCauley and his various compatriots persist in advancing the space program, which include an orbiting space station and regular crews stationed on the Moon.

SPACE FORTS, TELEVISION, AND THE COLD WAR MINDSET

Women in *Men Into Space* serve primarily to express fears unacknowledged by men. When a lead researcher's wife questions the safety of flying a nuclear-powered rocket in "Lost Missile," her husband dismisses her question before it can be answered, saying to McCauley, "Now, isn't that just like a woman?" In an early episode, "Moon Landing," McCauley offers the astronauts' wives the back-handed compliment that as a man he would not be able to endure such worrying; he would much rather fly to the Moon than sit home watching the risky venture. When they are not reflecting the emotion of the drama, however, women represent dangerous distractions. In an episode titled "Moonquake," an astronaut preoccupied by worries about his wife, who has been in an automobile accident, puts the crew in danger. Likewise, in "First Woman on the Moon," the only episode of *Men Into Space* with a woman shown going into space, Renza Hale, the wife accompanying her scientist husband on a mission, causes problems for the crew when she refuses to acknowledge the need for her own protection.

In *Men Into Space*, Colonel Ed McCauley exemplifies contemporary masculine ideals. In addition to being a calm, deliberate leader of men and model military officer, he is a faithful husband and family man who buys his son a model rocket because he missed a little league baseball game while out on a mission. In fact, Bill Lundigan, the actor who played McCauley, sometimes asked for script changes when he thought that the character was too noble, worrying that he was too perfect to be believable.

Both shows proved short-lived. Because networks began taking more direct control of production, independently produced network television soon vanished. As a result, *The Man and the Challenge* and *Men Into Space* each ran for only one season. The shows illustrated the dramatic potential of taking spaceflight seriously and the earnest tone of spaceflight education through television. In addition, they continued the trend that 1950s science fiction had of erasing nonwhite experiences. Neither show included any people of color in major roles. As the decade ended and real human spaceflight seemed imminent, however, both shows carried out part of the national cultural conversation about the kinds of people who would represent the nation in opening that new frontier.

CHAPTER 3

John Glenn, the Apollo Program, and Fluctuating Spaceflight Enthusiasm

Some of its painted details were worn, but the glossy black *Friendship 7* cookie jar was nonetheless in good shape—and a great addition to the collection. The two-part ceramic vessel, fashioned like John Glenn's *Friendship 7* Mercury spacecraft, had been sold between 1962 and 1968 in five-and-dime and department stores. Would the Museum want it? I had seen more perfect versions of the McCoy Pottery jar before. But when in late 2007 a physician named David McMahon contacted the National Air and Space Museum, offering to donate this memento of his childhood, I knew that his was the one that should be at the Smithsonian.

McMahon remembered that his family shared the widespread enthusiasm sparked by John Glenn's success on February 20, 1962. His father had served during World War II with the Manhattan Project at Oak Ridge, Tennessee. After 1947, the elder McMahon worked in aerospace propulsion engineering and managerial positions in Hartford, Connecticut, at United Aircraft Research Laboratories, which later became United Technologies Research Center. By the early 1960s, the younger McMahon recalled, "our family had 'space fever.'" He elaborated, recollecting how his family came to own the object,

> Our family was thrilled with John Glenn's first U. S. orbital mission, and a few days later in the local Woolworth Department store a display appeared of these cookie jars, celebrating the event. My mother, who was a consummate Toll-House cookie baker, bought the jar for my father to celebrate (full of her chocolate-chip cookies) and we all stuffed ourselves, taking turns removing the top of the Mercury capsule and

pulling out cookies. . . . The jar stayed in our family's kitchen for the next 25 years, well into the shuttle era, and was then retired to a place of honor in a spare room.

The years of use showed. The teal paint that should have highlighted the rectangle around the words "Friendship 7" was largely gone. White rings on the lid had scrapes from hands retrieving cookies over the years. I knew that pristine examples of this exact container existed elsewhere, including an almost flawless one in the hands of a private collector. But in this case, the object's gentle wear and tear told an additional story that added value for the Museum. That personal experience of the early Space Age, in addition to the well-loved object itself, was what I wanted to capture.

More than most areas of the Museum's collecting, the Social and Cultural History of Spaceflight subsection relies on individual donors. For aircraft, spacecraft, or astronaut equipment, donations typically come from manufacturers, airlines, military services, or NASA, with offers to transfer these items to the collection. But much of the ephemera of spaceflight resides in people's closets, family rooms, and attics. As a result, collecting memorabilia means preserving not only the manufacturing history of how these objects came to be but also the record of the object's ownership and use, what curators call provenance. Those personal connections enrich the objects, building our understanding of how real people responded to the technological and political achievements of spaceflight. In the case of this cookie jar, the spirit of McMahon's family suffused the piece. As I worked with our staff to arrange for the jar to be shipped to the Museum in 2008, several people joked that the acquisition seemed incomplete without some of his mother's freshly baked cookies. The memory of its use seemed integral to its history as part of the outpouring of public enthusiasm for Glenn's flight.

Beginning in 1961, visions of human spaceflight became real when the Soviet Union and the United States made the first piloted missions. As salvos in the Cold War, those flights, launched atop rockets initially designed for warheads, were repurposed as demonstrations of technological prowess. On board, NASA's astronauts, extraordinary men trained as military test pilots, reflected Americans' self-conception as a nation of explorers. The flights and the public reactions to them occurred within a long tradition of how spaceflight had been imagined.

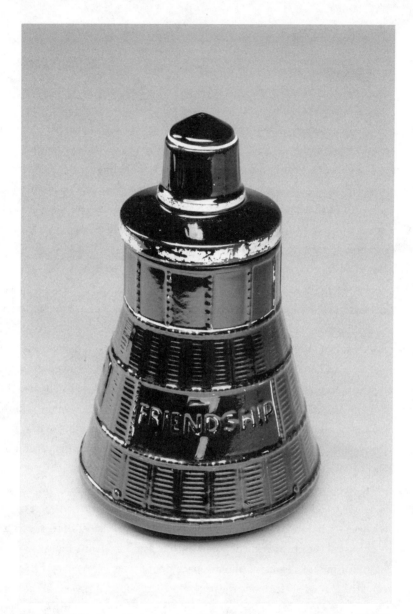

This *Friendship 7* cookie jar, made by McCoy Pottery in celebration of NASA astronaut John H. Glenn Jr.'s flight as the first American to orbit the Earth, became a feature of David McMahon's childhood. Its appearance reflects its active use by a family excited about spaceflight. Photo courtesy of the National Air and Space Museum.

Despite Glenn's triumphal orbits, public interest in spaceflight fluctuated in the 1960s, its attention diverted by contentious domestic politics and foreign policy crises. While the second wave of the American women's movement took form and the civil rights movement continued the fight for African American equality, the space program sometimes seemed like an afterthought. If anything, even as the 1960s saw a boom in material expressions of enthusiasm for spaceflight, spaceflight itself fell in and out of touch with the mood of the nation.

KENNEDY'S NEW FRONTIER

The decision to send astronauts to the Moon, which shaped spaceflight enthusiasm for years to come, had its roots in the frontier mythos. Indeed, it was Kennedy's rallying cry. When he accepted the Democratic Party's nomination as candidate for the presidency on July 15, 1960, then-Senator Kennedy famously invoked the frontier: "I believe the times demand new invention, innovation, imagination, decision. I am asking each of you to be pioneers on that New Frontier." For their part, the eager young men who came to Washington to pursue those goals after the election called themselves "new frontiersmen." Space became a vital part of that vision.

The first Soviet human spaceflights prompted Kennedy, now president, to look for ways to respond with adequate strength. Yuri Gagarin's single orbit as the first person in space on April 12, 1961, came just five days before the very public US failure in the Bay of Pigs invasion of Cuba by covertly trained Cuban exiles. A week after Gagarin's flight, Kennedy sent a memorandum to his vice president, Lyndon B. Johnson, who chaired the Space Council. Kennedy asked, "Is there any other space program which promises dramatic results in which we could win?" In response, Johnson and NASA suggested several options, with a lunar landing at the top of the list. When Kennedy famously announced his choice before a joint session of Congress—"landing a man on the Moon and returning him safely to the Earth"—it was an audacious move. At the time, NASA's actual human spaceflight experience totaled just fifteen minutes twenty-eight seconds, the duration of Alan Shepard's suborbital mission. The lunar landing decision illustrated how deeply Kennedy felt the imperative to exhibit strength, not weakness, in the Cold War.

Other possible "firsts," such as putting the first woman or first African American astronaut in space, did not earn a place on Johnson's list. Although some

aeromedical tests had been performed on women in 1959, the first real physical examinations of women pilots for possible astronaut fitness began in 1960. After months of planning, record-setting pilot Jerrie Cobb flew to the Lovelace Foundation in Albuquerque, New Mexico, in February 1960 to take the physical examinations designed to screen NASA's Project Mercury astronaut candidates. When the lead physician, William Randolph "Randy" Lovelace II, announced Cobb's success publicly in August, press coverage appeared in newspapers and magazines across the country. Jacqueline Cochran, famous as a businesswoman, pilot, and head of the Women Airforce Service Pilots (WASP) during World War II, supported the costs for Lovelace to expand the privately funded project. Cochran's public appeal for additional volunteers appeared nationwide in the *Parade* magazine inserts in Sunday newspapers on April 30, 1961, just two days after Johnson signed his "Evaluation of the Space Program" memorandum. Policymakers never really considered a women's program, however.

Some months after the lunar landing declaration, the idea of an African American astronaut was recommended more officially. On September 21, 1961, the legendary journalist Edward R. Murrow sent a short inquiry about the subject to NASA Administrator James Webb. Murrow had earned his international reputation as a war correspondent during World War II and then followed his long career at CBS by becoming the head of the United States Information Agency in 1961. In that capacity, he asked Webb, "Why don't we put the first non-white man in space?" The second line of the succinct two-line missive outlined his rationale in the language of the time, "If your boys were to enroll and train a qualified Negro and then fly him in whatever vehicle is available, we could retell our whole space effort to the whole non-white world, which is most of it." In his answer, Webb stated that the current group of Mercury astronauts were all that the program needed at the time. In later interviews on the subject, however, he dismissed the idea as "inconsistent with our agency's policies." After years of lagging behind Soviet space achievements, the US space program did not chase firsts.

The racial integration of NASA had barely begun in 1961. Julius Montgomery began his professional career working on missiles at Cape Canaveral in the mid-1950s and quietly desegregated the Florida Institute of Technology in 1959. In California, Shelby Jacobs joined Rocketdyne in 1956 as an engineer working on rockets contracted for NASA. He transferred to NASA contractor Rockwell in 1961. But until the mid-1960s, most NASA centers in the South or otherwise did not seek

out Black professionals. Likewise, qualified graduates of historically black colleges and universities (HBCUs) chose not to seek employment in the Deep South in the midst of white resistance to the civil rights movement. After all, within two weeks of Alan Shepard's flight as the first American in space, the Freedom Riders, racially integrated groups that challenged segregation by traveling together through the South, were viciously attacked in three separate cities in Alabama. The violence continued throughout the summer of 1961, as mobs in multiple cities assaulted them, and in response, more activists joined, replacing those injured or jailed. What qualified African American engineer who had options would choose to move to the South at that time?

At the same time that actual space travel seemed hopelessly distant from the harsh realities of African American life, the album *The Futuristic Sounds of Sun Ra* appeared in October 1961. The recording continued the fantastical, space-themed jazz that Sun Ra and his band, the Arkestra, had developed in Chicago in the late 1950s. Born Herman Poole Blount in Birmingham, Alabama, the pianist and composer changed his name in the early 1950s to Le Sony'r Ra and later became known simply as Sun Ra. Inspired by his oft-told-tale of a visionary trip to Saturn (and, some said, his youthful fandom for *Buck Rogers* and *Flash Gordon*), the band's theatrical stage shows included costumes that blended Egyptian imagery with Space Age inflections to imagine an otherworldly existence. This early expression of what later became called "Afrofuturism" projected a proud identity that proactively imagined a future centered on Black people and the African diaspora. Through performances and recordings, the avant-garde music of Sun Ra's Arkestra reimagined the cultural enthusiasm about spaceflight that otherwise excluded African Americans.

GODSPEED, JOHN GLENN

The American public paid attention to the space race as a race and responded to a victory with excitement. After Alan Shepard's suborbital flight, Gus Grissom's repeat suborbital mission reinforced American competence. But orbital flight was an order of magnitude more complex. Not until John Glenn made three orbits around the Earth did the United States achieve parity with what the Soviet space program had done with Yuri Gagarin's single-orbit flight ten months earlier. Pulitzer Prize–winning historian Walter McDougall called the reaction to Glenn's

flight "a national catharsis unparalleled in the quarter century of the Space Age," greater even than the acclaim for the first American satellite, the first space shuttle mission, "or even the landing on the Moon." The immediate, enthusiastic, and far-reaching reactions kicked off the fullest flowering of the space craze of the early 1960s.

The enthusiastic reaction to Glenn's flight was heightened by concerns over its riskiness, which were reinforced by its many delays. The Atlas launch vehicle being prepared for Glenn's orbital flight—originally designed to launch a nuclear weapon, not a person—was much less reliable than the Redstone rocket that had boosted Shepard and Grissom into space. As the *Los Angeles Times* noted, only five out of eight of the Atlas test launches had been successful, as opposed to 96 percent success rate for the Redstone. The risks were so pronounced that one television interviewer asked Glenn, "Now, major, if you do come back from orbit . . ." Glenn replied, "You mean, *when* I return, don't you?" In the end, Glenn's flight was delayed or rescheduled more than ten times before the successful launch and recovery on February 20, 1962.

Just how many people stopped to watch or listen to Glenn's flight became a news story in its own right. Five thousand people watched coverage of Glenn's mission on a giant television screen in New York City's Grand Central Station. Updates on his progress were applauded on the floor of the US House of Representatives. California officials working on the state's budget adjourned to watch the flight. Likewise, the Canadian House of Commons suspended work for a half-hour to watch. Southern Bell Telephone reported that virtually no telephone calls were made in the hour starting about twenty minutes before the launch.

The excitement about Glenn's success—from government officials and everyday citizens—was immediate. While Glenn was still in orbit, the governor of Kentucky signed a commission making the astronaut a Kentucky Colonel. Congressman Silvio Conte of Pittsburgh called on Congress to mint a gold medal to present to Glenn. A city in Maine renamed a street in his honor. The Virginia Legislature, claiming Arlington resident Glenn as its own, passed a resolution commending Glenn for his courage. Excited about the name of the aircraft carrier serving as a recovery ship for Glenn's mission, the town of Randolph, Vermont, granted honorary citizenship to Glenn and the entire crew of the USS *Randolph*. Finally, in Cleveland, six babies born during the mission were named after John Glenn by their parents, including a set of twin boys named John and Glenn.

GLENN, APOLLO, AND FLUCTUATING ENTHUSIASM

Individuals could literally buy into the space craze created by Glenn's flight. The US Post Office orchestrated the well-planned release of a commemorative postage stamp. Anticipating a great demand, 120 million copies of the special four-cent stamp celebrating the mission were prepared in secret and shipped to post offices around the country for release on the day of the launch. The Post Office in Boston sold "about 20,000 between 4 and 6 pm," reported the *Boston Globe*. Within two days, another 100,000,000 had been ordered to be printed to satisfy the shortages reported. Where there were enough stamps available, some post offices stayed open extended hours to meet the demand.

Souvenirs of the flight also appeared, including several commemorative buttons. One notable example in the Museum's collection featured a lenticular image that seemed to move when it was tilted forward and back. The holder would see a Mercury capsule "blast off" in a puff of smoke from the Florida coastline and then appear to arc over Glenn's helmeted head as stars twinkled in the background. The border on the edge read, "Around the World in 89 Minutes." On the attached ribbon, gold type proclaimed: "John Glenn America's First Astronaut in Orbit."

In addition to the everyday souvenirs, one jeweler created a special commemorative jewelry charm for Glenn's wife, Annie Glenn, and for the Smithsonian National Air Museum, as it was named then. The Oriol Jewelry Manufacturing Corporation of Chicago created a custom 1.25-inch 14K gold medallion with two semiprecious stones to celebrate Glenn's flight. When Museum director Philip S. Hopkins thanked Oriol, he cautioned that the charm might not be displayed because "the Glenns have received several thousand beautiful gifts in honor of the historic orbital flight." Whether or not Hopkins's estimate reflected an accurate count, Oriol was certainly not alone in trying to create a material connection with Glenn.

As human beings began flying in space, a new market for space-related memorabilia emerged in the United States. In addition to buttons, there were also lunchboxes, coin banks, card games, and toys. Businesses also saw an opportunity to incorporate the new excitement about human spaceflights into their appeals. For instance, in the 1950s, Duro Pattern & Mold Co. of Highland Park, Michigan, retooled the space-themed metal mechanical coin banks it manufactured. Duro's initial designs in the 1950s evoked fantastical and speculative imaginings of spaceflight: the "Mercury," "Strato," "Flying Saucer," and "Satellite." In all of these, spring-loaded mechanisms shot pennies, nickels, or dimes into slots,

storing the change. Duro marketed the space-themed banks as giveaways or premiums for financial institutions. Customers who opened accounts, particularly savings accounts for children, could take home a mechanical coin bank emblazoned with the institution's name on a sticker or adhesive-backed nameplate.

Beginning in 1961, however, Duro altered its products to capitalize on the excitement about the first human spaceflights. New "commemorative" versions of the Satellite bank celebrated the flight of the first American in space, Alan Shepard. An extra metal ring added to the Moon on Strato banks commemorated Shepard's flight on the top side and Glenn's mission on the ring's bottom. Likewise, Duro created commemorative versions of the Destination Moon bank. That patented design originally had a blank ring around a cratered Moon resting atop an upright rocket. In the early 1960s, however, the blanks were replaced with either Shepard/Glenn rings or an alternate version, noting the success of *Ranger 4* in 1962 as the first US spacecraft to reach the lunar surface.

The economic prosperity of the 1960s, characterized by the widespread availability of consumer goods and increasing disposable income, fostered a market for souvenirs. Manufacturers capitalized on this interest through the production of consumer items—mostly ephemeral objects intended to be sold at low prices in keeping with their short expected lifetimes. Space memorabilia answered the public's demand for physical things that could document the owner's role as a witness to history. By receiving or buying a space artifact or an item bearing a space exploration image or symbol, the owner expressed a sense of support for the space effort.

In the case of Glenn's flight, the excitement continued for weeks. On the first weekend after the mission, staff at the Museum of Science and Industry in Chicago anticipated that thirty thousand to forty thousand people would visit its already-popular space display, which included a Mercury spacecraft and spacesuit. In Washington, DC, Glenn participated in a celebratory parade less than a week after the mission. On March 1, an estimated 4 million people attended the tickertape parade in New York City. In April, the House of Representatives of the United States passed a unanimous resolution suggesting that February 20 of every year be celebrated as John Glenn Day. In May, for Mother's Day, Glenn's mother, Clara Sproat Glenn, was named "World Mother of 1962," an honor even higher than the usually awarded "American Mother" of the year.

GLENN, APOLLO, AND FLUCTUATING ENTHUSIASM

Enthusiasm for Glenn's flight even found form in common household objects. In addition to the McMahon family's cookie jar that opened this chapter, the Museum holds a space-themed blanket that was used by Mark E. Dixon during his childhood. The tan bedcovering features brightly colored images of various space scenes from the early 1960s. Rockets and satellites orbited around a central image of Glenn entering a kaleidoscopic *Friendship 7*. Depicted in wildly different scales, the colorful pictures conveyed more fervor than accuracy.

Mark Dixon's mother purchased this colorful bedroom blanket depicting NASA astronaut John Glenn entering *Friendship 7*, along with other spacecraft, missiles, and satellites from the early 1960s. Ever practical, she hemmed the sides to make it fit his childhood bed. Photo courtesy of the National Air and Space Museum.

Dixon remembered the blanket covering his bed in Grand Rapids, Michigan, across the room from his brother's matching one, from the time that that the two blankets were acquired in the mid-1960s until he left for college in 1969. Years before she purchased the blankets, his mother also organized a space-themed science fair at his grade school in 1958. The photograph in the newspaper clipping he saved showed her watching him don an oversized papier-mâché space helmet. Mrs. Dixon—and perhaps, many parents at the time—hoped that learning about spaceflight would inspire her kids. Her son pointed out, however, that in the photo he sported a Western-styled shirt and string tie, emblematic of his real passion at the time: cowboys. Regardless, when Dixon wrote to the Museum to offer this blanket as a possible artifact, he suggested, "It seems to me to be an interesting example of how Americans took the space program to heart in the mid-1960s."

SWEPT UP IN THE SPIRIT OF THE SPACE AGE

The broader impact of the Glenn-era space craze can be seen in two significant developments in gaming and amusements that originated in the period and endured for years afterward. The first, videogames, innovated an entirely new form of entertainment using Space Age tools. The second, an amusement park, used the excitement about new spaceflight developments to start a new business that actually recalled much older forms of spaceflight enthusiasm. Both took the contemporary interest in spaceflight in new directions that became enduring parts of American culture.

In 1961 and 1962, a group of eight engineering students at the Massachusetts Institute of Technology (MIT) created one of the very first videogames, *Spacewar!* They were trying to demonstrate the capabilities of a new computer, a Digital Equipment Corporation (DEC) machine called a PDP-1. The 9-kilobyte computer, intended as an educational tool, came with a typewriter console, a paper tape reader, and a distinctive round viewscreen mounted in a hexagonal case. Inspired by the dawning Space Age, Steve Russell recalled thinking at the time that, "It would be neat if someone built a spaceship trainer, because [lay]people didn't understand how spaceships coast." Using mathematical routines provided by Alan Kotok, Russell designed the basic game, which allowed two players to fly spaceships on the viewscreen, shooting torpedoes at each other until one player won. Russell showed the game to his friends and housemates, most of whom had

significant experience designing direct-current circuitry from their time in MIT's Model Railroad Club. They liked it and began to contribute improvements.

Significantly, the various architects of *Spacewar!* worked to incorporate aspects of the real physics and engineering associated with spaceflight into the game. Group member Peter Sampson transformed the randomly generated stars in the original programming into a starfield based on actual astronomy. Dan Edwards recompiled the code, freeing up space for the innovation that made the gameplay engaging: simulating the gravity of a supermassive star in the center of the screen. Russell emphasized that he wanted *Spacewar!* to teach players something about orbital mechanics. Players who did not compensate for the central star's gravity to master stable orbits or slingshot maneuvers tended to lose.

Spacewar! also began a long tradition in videogame design of layering fantastical elements into the gameplay. The missiles defied the central star's gravity because the group could not figure out how to fit the gravitational pull calculations into the programming. To make the game easier to play, they also added a "hyperspace" feature that allowed a player's ship to disappear and reappear at a random place on the screen. If a player used that feature too often, however, the ship could explode. When asked about their inspiration, the group credited their love of science fiction, including the work of E. E. "Doc" Smith and Japanese science fiction monster movies from Toho Studios. After all, Jack Dennis, who led the computer lab that held the PDP-1, also served as the faculty advisor for MIT's Science Fiction Society. In the long history of videogames, *Spacewar!* marked the first of many imaginative space adventures played out in this new medium.

The MIT group's innovation never became a commercial product. Rather, the inventors of *Spacewar!* presented the game to DEC as open-source code in 1962. Impressed by the innovation, DEC engineers delivered copies of the game with subsequent PDP-1 computers. In addition to offering an entertaining way to show off the machine's capabilities, *Spacewar!* provided a quick and easy means for checking whether the apparatus had been assembled correctly. At the time, running through all a new computer's functions could take days. With *Spacewar!*, if the game worked, the engineers knew that the system had been installed correctly. Only fifty-three PDP-1 computers were ever released nationwide. Yet, in the early 1960s, if you were working in a computing laboratory, you likely knew about and enjoyed playing *Spacewar!*

SPACE CRAZE

At the same time that MIT's students were creating electronic simulations of rocketry, propulsion, and missiles, two businessmen in Brooklyn literally bet their business on the broad public appeal of spaceflight. In 1962, Dewey Albert and his son, Jerome, founded Astroland as an amusement park constructed on 3.1 acres of boardwalk property in Coney Island, New York. Dewey Albert's business partnerships actually began as early as 1957, and the park was initially to be called Wonderland. But according to Carol Hill Albert, Dewey's daughter-in-law and the final owner of the park, which closed in 2008, the two businessmen were "swept up in the spirit of the Space Age."

The first amusement ride installed at the park captured the contemporary moment even as it also recalled the heyday of Luna Park's "Trip to the Moon" almost sixty years earlier. Initially called the Cape Canaveral Satellite Jet and later renamed the Astroland Rocket, the seventy-one-foot-long, six-ton ride looked like a giant science fiction rocket with three long stabilizing fins. Inside, as many as twenty-six occupants sat in fixed seats arranged in rows, as if in a commercial airliner, facing a movie screen at the front. Once the door closed and the ride began, they experienced the sound and motion of a rocket launching on an imagined three-minute trip to the Moon. Mounted on hydraulic lifts, the whole apparatus tipped up and down during the simulated flight. The Alberts may not have intended the new installation to be a callback to Luna Park's founding attraction from 1903, but they almost certainly knew about the iconic early twentieth-century park, which existed until 1946 on the parcel across the street from Astroland.

In constructing their new space-themed park, the Alberts sought directly to evoke the successes of the first Project Mercury flights. One of the early rides, initially called "The Colonel Glenn Sky Ride" and later the "Mercury Capsule Skyride," transported visitors across the park in high-flying gondolas. From their vantage point high above the park, riders could enjoy views of the ocean, boardwalk, and neighboring amusements. The space theme continued in the "Tower to the Stars" or "Astrotower," a slowly rotating observation deck that ascended and descended a tall central tower. Beginning in 1963, a huge entranceway sign high above Surf Avenue greeted visitors and beckoned to passersby. The overall design owed as much to the futuristic aesthetic of the day as to any connection to actual spaceflight.

Space Age styles featuring rounded shapes and curved edges created from plastics, metal, and other modern materials built on midcentury modernist

For years, the Astroland entrance sign, pictured here in January 2009, greeted visitors to the space-themed amusement park in Coney Island, New York. The National Air and Space Museum acquired one of the lighted rotating stars from the sign. Photo by the author, courtesy of the National Air and Space Museum.

trends. In the 1960s, businesses ranging from dry cleaners and restaurants to hotels and motels incorporated space themes in their names or signage. Owners hoped that invoking spaceflight would be good for business. The broad appeal of space themes for children also inspired everything from coin-operated storefront rides to playground equipment. Large metal playground climbers from the 1960s and 1970s came in shapes modeled to look like rockets, flying saucers, or more realistic spacecraft. This roadside Space Age became part of daily life across the country in the 1960s.

BARBIE AND G.I. JOE DRESS FOR SPACE

As the final Mercury flights ended and NASA's Project Gemini missions began, the cultural conversation about who could represent the nation in space

continued. The issue had been raised in 1959 in speculative television shows and continued in media coverage about early women's astronaut fitness testing. Rather than these earnest considerations, however, the new family situation comedies of the 1960s used space settings to put a fresh spin on domestic comedy in ways that both reinforced and poked fun at the social status quo. At the same time, in real life, some white women and an African American man put themselves forward as possible spaceflight participants. Despite their efforts, NASA officials never seriously considered expanding the astronaut corps in this way, but the publicity around those tentative investigations influenced both television writers and toymakers.

For one season beginning in the fall of 1962, Hanna-Barbera, an animation studio that specialized in television production, created *The Jetsons*. The show, the first program aired in color on ABC, centered on a futuristic white family living in space (without any explanation of why they had left Earth). Part of the show's fun was the visualization of ultramodern technologies, from video telephones and food-dispensing machines to robotic maids and flying cars. Although initially aired on Sunday nights in prime time, not in a time slot aimed at children, the show's plots avoided social commentary. Rather, as popular culture scholar Christopher Lehman has argued, *The Jetsons* focused on "rehashing standard television sitcom fare." Its comedy offered a not-so-subtle reinforcement of nuclear family dynamics. George Jetson was a lovable suburban father, bedeviled by malfunctioning technologies and often outmatched by his job and family. "Jane, his wife," as the show's title sequence musically summarized her, loved fashion and shopping. Despite household technologies, including Rosey the Robot, performing most of her domestic tasks, she needed frequent breaks. She also had trouble mastering basic skills. In the 1963 episode "Jane's Driving Lesson," her reckless driving so terrified her instructor that he returned to his previous career as a lion tamer. The episode's joke that women were terrible drivers, in this case, of spaceships, offered a subtle nod to the ongoing debate about whether women belonged aboard spaceflights. After its only season, reruns of *The Jetsons* became a part of Saturday morning cartoon offerings, impressing a generation of children with its optimistic vision of future technologies.

In the same television season, Lucille Ball's new star vehicle, *The Lucy Show*, debuted for the first of its eventual six seasons on CBS. The show was produced by Desilu, the company that Ball cofounded with Desi Arnaz. By late 1962, Ball

was one of the only women to head a major Hollywood production company, having bought out her ex-husband Arnaz's share. *The Lucy Show* centered on Ball's character, Lucille Carmichael, as a widow with two children joining households with a divorced friend, Vivian Bagley, played by *I Love Lucy* co-star Vivian Vance. In the sixth episode, titled "Lucy Becomes an Astronaut" (1962), the two women attend a lecture about a "Women in Space" program. In the show's narrative, Carmichael and Bagley had been ensigns in the WAVES (Women Accepted for Volunteer Emergency Service), a real women's branch of the Navy Reserve during World War II. While learning about the program, the two women inadvertently volunteer for a twenty-four-hour isolation experiment. Their success makes the local newspaper's front page: "Local Women Succeed in Twenty-Four Hour Space Effort," an echo of the real press coverage of contemporary women's tests.

When Carmichael boasts too much about her isolation test performance, however, Bagley decides to teach her a lesson by tricking her into thinking that she has been chosen to be the "first lady astronaut." As Carmichael panics in the spacesuit that she had been sent, the scene showcases Ball's talent for physical comedy. In the show's denouement, Carmichael gets a phone call revealing the joke, but her friends do not know it. Immediately, she turns the tables on them by feigning resignation about spaceflight's inherent dangers until they feel so guilty that they admit their deception. Ball's final speech returns to Carmichael's boastful tone: "Now imagine what a thrill it would be to be the first lady astronaut. And there I'd be, zooming into space! Just me and the stars and the universe! That sounds plenty A-Okay to me. Making history, advancing science." In exasperation, Bagley shuts the helmet's faceplate as Carmichael keeps gesticulating. The episode's comedy showcases Ball and Vance's chemistry and physicality. At the same time, it highlights two incongruent realities of the day: the social discomfort about women as possible astronaut candidates paired with the awareness that women had performed exceptional national service as recently as World War II.

The Lucy Show's astronaut episode aired within months of congressional subcommittee hearings investigating whether NASA was discriminating on the basis of sex. After Lovelace's privately funded examinations of women's possible fitness for spaceflight were canceled in 1961, Jerrie Cobb, the first woman to pass those tests, lobbied actively in Washington for the project to be resumed. The public hearings convened in July 1962 were as far as she got, however. After

Cobb and another test subject, Jane Hart, testified on the first day, NASA astronauts John Glenn and M. Scott Carpenter, as well as project funder Jacqueline Cochran, testified on the second day that NASA should control astronaut qualifications. Because no women were military-trained jet test pilots, a career path barred to them, women could not meet those standards. The subcommittee chairman abruptly canceled the planned third day of hearings. Following the successes of Glenn's flight and with NASA actively planning the future lunar landing effort, lawmakers hesitated to suggest the additional goals of including women astronauts.

Likewise, NASA officials passed on the opportunity to add African American pilot Ed Dwight to the astronaut corps. Dwight completed the advanced Air Force flight training that often served as a gateway to spaceflight. But his admission to that program was due to political influence. Although the precise story of Dwight's initial selection remains a subject of debate, in the early 1960s, someone in the Kennedy administration, likely Attorney General Robert F. Kennedy, requested that the Air Force recommend an African American pilot for astronaut training. Because the service had its own human spaceflight program, beginning in 1962 the curriculum of its advanced test pilot training program, the Aerospace Research Pilot School (ARPS), included some classes related to spaceflight. By the spring of 1963, Dwight's inclusion in the elite program made national news in African American newspapers. A filmstrip starring Dwight became a popular selection for NASA's Spacemobile, a transportable educational program, to show African American schoolchildren. Dwight was one of twenty-six applicants recommended by the Air Force to NASA. Despite the political pressure to consider Dwight and the excitement in African American newspapers about his potential, in 1965, when NASA chose applicants to train further, two members of Dwight's class moved on, but he did not. Dwight initially took being passed over quietly but later complained publicly, and outside of the military chain of command, about his treatment and subsequent assignments.

The June 1963 flight of the first woman in space, the Soviet Union's Valentina Tereshkova, raised the issue of women astronauts again in the United States, but not in a way that made a difference. In a three-page spread in *Life* magazine, playwright and politician Clare Boothe Luce criticized male decision makers for failing to seize the opportunity to accomplish this first. The accompanying photographs publicized for the first time the identities of the thirteen women

GLENN, APOLLO, AND FLUCTUATING ENTHUSIASM

who had been ready to undertake another phase of astronaut fitness tests under Randy Lovelace's auspices. Despite the flurry of media interest, however, nothing happened. After all, Betty Friedan's consciousness-raising book *The Feminine Mystique* had only just appeared in February 1963, a scant four months before Tereshkova's flight. The consciousness-raising groups and political organizing that made up the second wave of the women's movement in the United States were still in the future. The feminist political groups needed to bring pressure on the issue did not yet exist.

Although NASA was not ready for women or people of color as astronauts, some toymakers' imaginations of space travelers were more inclusive. In the mid-1960s, Barbie dolls had an official astronaut outfit, and G.I. Joe came in a special set as a Mercury astronaut complete with a space capsule. Both toys became possible, however, only because their makers reinvented the very idea of dolls. In 1959, after watching her daughter play with paper dolls and baby dolls, Mattel cofounder Ruth Handler created the Barbie doll, named after her daughter Barbara, to allow players to imagine themselves as an adult, a "single career girl." Initially presented as a teenaged fashion model, Barbie could be dressed in different outfits that were sold separately (or sewn at home). For its part, competitor Hasbro developed a twelve-inch articulated doll called G.I. Joe in 1964. To sell the toy to boys, Hasbro coined a new name: "action figure." Initially, the toy, billed as "America's movable fighting man," came in four different versions: soldier, sailor, marine, or pilot.

Both Barbie and G.I. Joe included space themes through accessories. In 1965, Mattel introduced a new addition to Barbie's growing collection of aspirational career clothes, a "Miss Astronaut" outfit. The matte gunmetal gray jumpsuit came with brown leatherette gloves and boots, a white plastic space helmet, and a small cloth American flag. Likewise, in 1966, the G.I. Joe action pilot line came out with an accessory set that included a Mercury-styled space capsule and a spacesuit. By 1967, a shiny silver spacesuit and spacewalking accessories could also be purchased separately for the action pilot figure. Incidentally, Hasbro created an African American version of the G.I. Joe action soldier figurine in 1965. Although Hasbro never sold the elements together as a set, pieces could have combined to create an African American G.I. Joe astronaut, since the marketing plans for Barbie and G.I. Joe allowed the purchase of outfits as well as of the basic figures.

SPACE CRAZE

In 1966, Mattel introduced a line of toys centered on Major Matt Mason, a fictional astronaut who explored the Moon. Initially Mason was the only figurine, a six-inch toy made of flexible rubberized material built over a wire frame so that it was bendable. The figure's white spacesuit also served as its body, since it was not intended to be dressed or redressed as a part of play. The dark ridged joint sections reflected contemporary designs for possible real spacesuits. The three-story hexagonal "space station" playset suggested a permanent lunar base, a kind of Space Age boy's dollhouse. Most memorably, the Major Matt Mason line of toys included wonderfully imaginative vehicles. A motorized space crawler allowed the figurine to sit in a trailer propelled using two sets of rotating spokes. The character's many accessories included a "space sled" that looked like a hovering standup scooter and a "Uni-Tred" space tractor that towed a "Space Bubble." In that last vehicle, a weighted chair suspended inside a clear plastic globe allowed the action figure to sit upright as the surrounding contraption rolled along the imagined lunar surface. Although each figure came with one vehicle, really enjoying the toy line meant purchasing enough vehicles, figurines, and accessories to combine in different ways. The playable vehicles were the stars of this line, which invited children to imagine traversing and inhabiting the Moon.

The Major Matt Mason line eventually included a more diverse crew of space explorers as well as a series of aliens and other antagonists. In addition to Mason, the Space Mission Team set included two Caucasian astronauts in different colored spacesuits and Callisto, a green-skinned "mysterious alien." But the full line also included Major Matt Mason's "space buddy" Jeff Long, an African American astronaut sold as a solo figurine. The cardback for Long described the figure as having the specialty of "Space Scientist-Rocketry." Notably, the Jeff Long figurine was available in the toy line but not included in the group playsets. Moreover, players choosing their tokens for the "Major Matt Mason Space Exploration" board game that was introduced in 1967 had only white choices: Major Matt, Sergeant Storm, Lieutenant Len, and Captain Chuck. By the mid-1960s, toymakers had started creating options for African American youth to purchase but did not expect other children to play as those characters. In later years, the inclusion of alien figures shifted the emphasis in the Major Matt Mason toy line from realistic speculative lunar exploration to science fiction, a development echoed on contemporary television.

Lost in Space (1965–68) reimagined *The Swiss Family Robinson* in a space setting. Set in the distant future of 1997, the show told the story of a family setting out to colonize a planet around Alpha Centauri. In the first episode, however, the machinations of Dr. Zachary Smith (Jonathan Harris) sent the ship off course, marooning the family and their robot. A series of interplanetary adventures followed as they tried to return home. Originally the ship was to have been named *Gemini 12*, but that was rewritten to *Jupiter 2*, perhaps to distance the futuristic show from current events.

Lost in Space continued the trend from the 1950s of depicting futuristic spaceflight as homogenously white. The Robinson family, Dr. Smith, and most of the guest stars who appeared in the program's three seasons did not include any people of color. At least one African American actor did appear on screen, but viewers would not have known. In the original unaired pilot, which was later repurposed for the first-season episode "There Were Giants in the Earth" (original airdate October 6, 1965), the one-eyed, boulder-throwing Cyclops was played by African American actor and National Football League star Lamar J. Lundy Jr. In addition to his occasional acting roles, Lundy played defensive end for the Los Angeles Rams (and was part of the renowned "Fearsome Foursome" defensive line with Merlin Olsen, Deacon Jones, and Rosey Grier). Significantly, Lundy's face was never shown. Although the role took advantage of his remarkable six-foot-seven-inch height, in the final shots, camera tricks and editing made the character appear eighteen feet tall. In a continuation of the well-established practice of conflating differences in physicality and race with being alien, one of the only Black actors included in the series literally played a nonhuman monster.

BUILDING NASA

As Americans enjoyed popular culture visions of spaceflight on television and toy store shelves, NASA engineers and astronauts worked to build the capacity to carry out President Kennedy's lunar landing goal. This meant completing the transformation of NASA from a young organization cobbled together from existing military and civilian aviation and space research centers into a fully developed infrastructure that could support lunar missions. In the 1962 fiscal year, NASA's budget increased by almost 90 percent (totaling even more than the agency had originally requested). It doubled again the next year. The agency

built new facilities, hired workers, and contracted with companies to produce the hardware and components of the new systems. Doing so created new communities centered on space work. After President Kennedy was assassinated in Dallas, Texas, on November 22, 1963, President Lyndon B. Johnson used the memory of the martyred president to maintain support for lunar landing missions. By fiscal year 1965, NASA's budget reached an all-time high of $5.25 billion, more than 4 percent of the federal budget. The Space Age was at its peak. Throughout the 1960s, the people who participated in that work marked their enthusiasm with memorabilia that celebrated their personal roles in this history-making endeavor.

From the very first human spaceflights, astronauts understood that people would be interested in space-flown objects. In 1961, during his Mercury flight aboard *Liberty Bell 7*, astronaut Gus Grissom brought rolls of vintage Mercury dimes, minted between 1916 and 1945, intending to distribute them as souvenirs. As long as the objects did not interfere with mission objectives, NASA did not attempt any formal regulation. With Project Gemini, the missions became more complex. Flown in two-person spacecraft launched atop Titan II rockets, the Gemini astronauts carried out ten crewed missions in 1965 and 1966. Each helped develop different skills, techniques, and capacities that would be necessary for a lunar landing, including spacewalks, rendezvous and docking, and long-duration spaceflight (which included eating in space). After astronaut John Young smuggled a corned-beef sandwich aboard Gemini 3 as a good-natured prank in 1965, however, NASA officials instituted stricter rules about what could be brought into a spacecraft. The first crewed Gemini mission also inspired some other changes. As a reference to his Mercury spacecraft *Liberty Bell 7*, which sank in 1961, Grissom dubbed the Gemini 3 spacecraft the *Molly Brown* after *The Unsinkable Molly Brown*, which was both a Broadway play (1960) and a feature film (1964) about Margaret Brown's survival aboard the ill-fated RMS *Titanic*. NASA officials did not appreciate the pointed joke. After Gemini 3, they declared, astronauts could no longer name their own spacecraft. As a result, spacefarers started thinking about other ways to personalize their missions.

Drawing on the tradition of insignia patches that identified military units, Gordon Cooper designed a patch for his Gemini flight with Pete Conrad. Gemini 3 demonstrated that the spacecraft worked; Gemini IV (which switched the official designations to Roman numerals) included the first American spacewalk. Conrad and Cooper's Gemini V eight-day mission tested endurance: of the fuel

cells, the spacecraft, and the astronauts themselves. Anticipating their long expedition, Cooper created a patch depicting a covered wagon, the prairie schooner that carried white settlers into the frontier during nineteenth-century periods of westward expansion. The design featured their names and the notation Gemini 5 (without the style change). On the wagon's pokebonnet cover, they emblazoned the words "8 Days or Bust." Although he approved the patch, NASA Administrator James Webb asked them to remove the explicit "8 days" goal to manage expectations. He worried that an early return would be interpreted as a failure. As a result, the final approved version of the Gemini 5 mission patch had a

NASA astronaut Gordon Cooper's original mission patch design for Gemini V included "8 Days or Bust" in red lettering on the central Conestoga wagon. The final approved design changed that to a blank white cover. The astronauts designed mission patches, which became popular commercial souvenirs, for every subsequent mission. Photo courtesy of the National Air and Space Museum / Eric Long, NASM 2005-36188-04.

clean white cover on the wagon. The emblems had not been created in time to appear in the publicity photographs of the crew taken before the mission, but in images of the two jubilant astronauts aboard the USS *Lake Champlain* after their recovery, mission patches can be clearly seen on their spacesuits just below their name tags.

Every subsequent NASA mission included a mission patch designed by the crew. The pictorial designs often included the astronauts' names as well as symbols that illustrated the spirit or mission goals of the flight. After Gemini V, designs were created retroactively for all of the human spaceflight missions, including the two earlier Gemini flights and all six of the Mercury missions. Commercially produced copies of embroidered mission patches quickly became affordable, popular, and collectible souvenirs.

Other space workers also wanted mementos of their roles in historic missions. NASA employees and space contractors often received commemorative items such as lapel pins, tie tacks, desk ornaments, or more substantial objects to foster morale, support work quality, and sustain momentum. Employee rewards or recognitions also came in the form of presentations that included flown or unflown space memorabilia. This type of space memorabilia offers one indicator of the widespread impact of the space program on a significant segment of the American workforce.

THE CAPE VIEW FIFTH GRADE CLASS

One couple created a very personal way to commemorate their participation. In the early 1960s, Toni Foster and her husband, Robert L. "Bob" Foster, an engineer who worked for McDonnell Aviation, the contractor that built NASA's Mercury and Gemini space capsules, had a tradition. Whenever Bob completed a project, he gave Toni a new charm for her charm bracelet. These space-themed tokens celebrated the end of significant professional projects and offered a gift to make up for being away so much during intense periods of work. The charms also recognized how she contributed to his career by taking care of their children and home, allowing him to spend time away as chief engineer on Project Mercury and operations manager on Project Gemini. Although the bracelet is now missing its clasp and is too short to be worn, the charms hanging from the delicate gold links tell an important story about the people who made human spaceflight happen.

GLENN, APOLLO, AND FLUCTUATING ENTHUSIASM

In the 1950s and 1960s, charm bracelets with individually acquired charms were a fashionable and common piece of jewelry for middle-class women to own. Most women used the gold or silver open-link bracelets to accumulate individual attachments one by one, sometimes as gifts and often to mark special events. The six 14K gold charms that Toni Foster collected included: a Redstone rocket, two engraved jeweler's blanks, a Mercury capsule (with retropack), a Gemini capsule

Toni Foster's bracelet features charms given to her by her husband, Robert "Bob" Foster, an engineer who worked for McDonnell Aviation during the Mercury and Gemini projects. Charms include Mercury and Gemini spacecraft as well as Redstone and Atlas rockets. The ones given by her students illustrate the communities that supported space work. Photo courtesy of the National Air and Space Museum / Eric Long, NASM 2006-793-07.

(distinguished by dual hatches), and an Atlas rocket. The engraved pieces were presented to Mrs. Foster by classes at the Florida schools where she taught. The octagonal jeweler's charm reads "Thank You Mrs. Foster," with "1st Grade"/"62" on the reverse. The heart-shaped one reads "Cape View 5th Grade Class," with "1967" on the reverse.

As much as the tiny golden space capsules and rockets symbolized how engineers' wives and families supported space work, the presents from students illustrated the larger communities that grew up around this new workplace. In support of Bob's work, the Fosters relocated with their children to Cape Canaveral, the launch site of NASA's new human spaceflight program. When technical workers—including NASA employees, company contractors, and military personnel—moved to serve America's space needs, new communities formed. Between 1950 and 1960, Brevard County, the Florida county that included NASA and Air Force installations at Cape Canaveral, grew faster than any other, exploding from 23,653 people to 111,435 in only ten years, an astonishing 371 percent growth rate. *Time* magazine called it the fastest growing county of 1962.

The children of those aerospace workers crowded the local schools. By 1964, the thirteen schools that existed in Brevard County in 1950 had grown to forty-six, and its 117 classrooms expanded to number 1,473. Women played a strong role in turning this runaway expansion into something more cohesive. As Charles D. Benson and William Barnaby Faherty report in their history of Apollo launch facilities, while men built spacecraft, women built communities. Churches and parent-teacher associations grew up to support the new populations. Women created theater programs and musical groups as well as recreational and hobby clubs. For her part, in the 1966–67 school year, Mrs. Foster taught fifth grade at Cape View Elementary, which opened in 1964. The heart-shaped engraved charm presented by her students was likely the last addition.

In retrospect, Toni Foster's bracelet represented much more than a private gift from a husband to a wife. The unique piece of jewelry illustrated the vital role played by the wives of the engineers who worked long hours to meet the deadlines required for space projects. At the same time, it served as a material reminder of the larger communities in which space work was embedded. Entire families uprooted their lives, moved to new places, and sacrificed time with loved ones to support the national effort to put astronauts into orbit. Developing high-tech spacecraft relied not only on engineers and technicians but also on the growth of

everyday municipal institutions, including grocery stores and grade schools. One expression of American enthusiasm for spaceflight can be found in the communities that grew up in the 1960s around space sites in Florida, Texas, California, Alabama, and New York State, to name just a few.

Some of those locations also became tourist attractions. As historian Emily Margolis has deftly analyzed, family vacations to various space sites became a part of the middle-class automotive vacation boom of the 1960s. Launches had always drawn crowds of onlookers. Even when there was not a launch imminent, or the site did not have launch facilities, however, such locations drew crowds. Tourists wanted to visit the places that they had read about in newspapers or seen on television during spaceflight coverage. Such sites attracted overwhelmingly white audiences, however, because the realities of travel for Black families made recreational destinations in the Jim Crow South less attractive. Several significant space centers—the Marshall Space Flight Center in Huntsville, Alabama; the Manned Spacecraft (later Johnson) Center near Houston, Texas; and Cape Canaveral, later Cape Kennedy, in Florida—existed in areas where white communities often policed any nonwhite people using intimidation and violence. All-white "sundown towns" in those regions and elsewhere displayed literal signs warning people of color that being within the municipal limits after sundown would be punished, either legally or likely with violence. Travelers seeking safer passage often relied upon *The Negro Travelers' Green Book*, a yearly guide with information on welcoming lodgings, restaurants, and other facilities. In Orlando, Florida, within driving distance of the space coast, only two hotels made the list. African Americans were not barred from space sites, but where they were located heavily skewed the populations who visited.

For white tourists, visitation at the Kennedy Space Center (KSC) in Florida boomed in the mid-1960s. In response to demand, and with an eye toward educating the tax-paying public about their work, NASA officials responded by creating new ways to tour the facilities. In 1965, NASA began allowing drive-through tours on weekends and holidays. A frequent launch schedule kept the public's attention. After the dual launches of Gemini 6A and Gemini 7 in December 1965, NASA successfully launched five more Gemini missions in 1966. In July of that year, contractor Trans World Airlines began operating formal daily bus tours of KSC. Just six months later, on January 27, 1967, NASA held a special ceremony to recognize the 200,000th visitor to take the guided tour.

Tragically, that milestone would not be the day's biggest news. Hours after the celebrated tourist left KSC, as a long afternoon of spacecraft systems testing continued on the launchpad into the early evening, a fire broke out in the Apollo 1 command module. All three astronauts aboard—Gus Grissom, Ed White, and Roger Chaffee—died. The program had been on a tight schedule. Apollo 1 had been scheduled to launch just three weeks later, on February 21, 1967. Thousands of letters of sympathy and encouragement arrived at the Kennedy Space Center, so many so that one of KSC's regular news releases was dedicated to them in February 1967. The release highlighted the letters sent by children from across the country: "The youngsters are sad, but in their sorrow they ask that the space program continue—to bigger and better achievements."

The Apollo 1 fire prompted a major reevaluation of how the program was being run and what changes needed to be made to reach the Moon. Despite the significant pause in public activities as these investigations and recommendations took place, public interest in KSC continued. By the end of June 1967, the number of visitors to have taken the guided tour reached 400,000. Later that same year, KSC opened a new visitor center, complete with a parking lot that held eight hundred cars. By adding the new facility, KSC officials sought to make the space center a destination that could compete with other Florida attractions.

Yet, in the mid-1960s national and world events overshadowed spaceflight news. Beginning in 1965, US troops became actively involved in the ground war in Vietnam. By 1966, steady escalations of American troop levels—which reached 250,000 in April and continued to grow—provoked widespread protests. In June, *The Feminine Mystique* author Betty Friedan and Yale law professor Pauli Murray joined other women in founding the National Organization for Women (NOW) after the Equal Employment Opportunity Commission (EEOC) charged with adjudicating the 1964 Civil Rights Act refused to address the issue of separate job listings for men and women. In July and August, race riots occurred in Cleveland, Ohio, and Lansing, Michigan. Amid all of this, evidence of sustained interest in spaceflight can be found in the work-based communities, themed memorabilia, and popular culture of the time. In addition, two of the most influential fictional visions of life in space originated in this historical moment.

WAGON TRAIN TO THE STARS

No one observing the beginnings of *Star Trek* (1966–69) could have envisioned what a cultural force the three-season television show would become. Produced by Desilu, the show was approved by Lucille Ball herself. Show creator Gene Roddenberry pitched the concept as akin to a popular Western about settlers on the American frontier: "*Wagon Train* to the stars." Roddenberry's initial spacefaring crew included a female first officer, Number One (Majel Barrett). In an unusual move, after NBC rejected *Star Trek*'s first pilot ("The Cage") as "too cerebral," the network allowed Roddenberry and Desilu to shoot a second pilot ("Where No Man Has Gone Before"). When Roddenberry rethought the show, playing up the action and recasting the captain, he also added another futuristic element, a racially diverse cast. The reconstituted crew of the starship *Enterprise* suggested in its appearance that 1960s-era integration efforts had succeeded. African American singer Nichelle Nichols portrayed communications officer Lieutenant Uhura, while Japanese American actor George Takei was helmsman Sulu, whose presence in the bridge crew ran counter to the stereotypical treatment of Asian characters as science fiction villains. Leonard Nimoy played Mr. Spock, a half-human, half-Vulcan alien. With those choices, Roddenberry's vision offered a stark contrast with the all-white world that had been presented in most science fiction television in the 1950s and before.

Star Trek's new vision found a home at NBC for several reasons. Beginning in the late 1950s, NBC emphasized color television programming, a strategy to promote the sale of color television sets by its parent company, RCA. When Roddenberry and his production team reenvisioned the pilot, they appealed to NBC's interest in broadcasting in full color. The gray, tan, and green uniform tunics used in the first pilot were replaced with vibrant red, green, and blue ones. Large blocks of color—whether bright alien skies on other planets or washes of filtered light on interior set walls—became characteristic of the show's distinctive minimalist aesthetic. *Star Trek* debuted on NBC in the fall of 1966, the first season for which all three major television networks aired their primetime offerings in color.

NBC promoted the new show at the 24th World Science Fiction Convention in Cleveland, Ohio. Less than a week before *Star Trek*'s first broadcast episode, "The Man Trap," aired on September 8, audiences there enjoyed previews of both pilots. A sign in the lobby invited attendees to "Join the Space Age, Go! Go! Go! with

[the] Star Trek Kick-Off." Roddenberry appeared in person. In addition, female models hired by the studio wore costumes used in filming *Star Trek* episodes in the "Futuristic Fashion Show." None of the show's actors attended because, at the time, science fiction conventions did not involve television or movie stars. Attendees clamored to meet writers and artists, not actors. By the next year, however, at the 25th World Science Fiction Convention in New York City, *Star Trek*-themed drawings appeared in the art show, and some fans wore homemade *Star Trek* costumes. NBC executives had been right to think that they might find potential fans at these gatherings.

Throughout the three-season run, viewers liked the show's characters and its plots, which were aimed at adults. Scripts by recognized science fiction writers such as Theodore Sturgeon and Harlon Ellison and newcomers such as David Gerrold and D. C. Fontana addressed contemporary social and cultural issues in the guise of space-based escapades. In the second season, adding Russian ensign Pavel Chekov (Walter Koenig) projected the idea that Cold War tensions would be overcome in the future. Producers hoped Koenig's good looks and mop-top haircut, reminiscent of pop heartthrobs such as the Beatles or the Monkees, would appeal to young female viewers. In the third season, the episode "Plato's Stepchildren" (original airdate November 22, 1968) included one of the earliest interracial kisses shown on network television, a forced embrace between Lieutenant Uhura and Captain Kirk (William Shatner) orchestrated by a race of curious aliens. Nichols herself recalled how powerful the show's depiction was: "And that [*Star Trek*] was done right at the crux of the [civil rights] movement . . . and he [Roddenberry] took it, in one fell swoop, and tore it all apart and threw it away."

One encounter revealed to Nichols herself just how influential her character was. Near the end of the first season, frustrated by her limited role, Nichols told Roddenberry that she wanted to leave the show to return to musical theater. As she recalled, "[Roddenberry] said, 'Take the weekend and think about this, Nichelle. If you feel the same way on Monday morning, you can go with my blessings.'" The next evening at a fundraiser for the NAACP, she met Martin Luther King Jr., who introduced himself as a fan of the show. When Nichols confided her imminent departure, Dr. King reacted. "And he said, 'You cannot do that. . . . This show is changing the way people see us, and see themselves. And the manner in which they're seeing the world.'" *Star Trek*'s vision of men and women of

different races working together made it one of the few programs that he and Coretta let their children watch. Nichols remembered that King argued, "You're showing them [racial integration]. The manner in which you have created your role is essential to that change." He said to me, "Besides, you're the chief communications officer; you're fourth in command.... This is not a Black role; this is not a female role. Anybody can change that. If you leave, it will erase everything that you've done." The extraordinary timing surprised Nichols. After the encounter, Nichols remained for the show's full run.

Her decision had long-lasting implications that reverberated years into the future. Nichols recalled, "I later found out that there were dozens, I guess hundreds, of young white kids in the South who were not allowed to watch that show. And families. And who came together and watched it anyway." Comedian Whoopi Goldberg recalled years later that Nichols's role had made a significant impression on her as a young African American girl, "You could see Black people on television, but you never saw Black people in the future until Gene Roddenberry put a beautiful Black woman on that show. And not just a beautiful Black woman, but a beautiful Black woman who was the communications officer. She wasn't cleaning [somebody's] house." In retrospect, the show's use of people of color was limited. As media studies scholar Daniel Bernardi has argued, actors such as Nichols and Takei served mainly as "background color" for the white leads. For audiences unaccustomed to seeing characters that looked like them depicted in futuristic settings, however, even that small change was significant.

Despite *Star Trek*'s eventual long-term influence, in the moment, the show was almost canceled twice. The first time, the Smithsonian Institution helped to save it. Roddenberry had become friends with Frederick Clark "Fred" Durant III, the National Air and Space Museum's assistant director for astronautics. Durant, who had a keen interest in the popular culture representations of spaceflight, acquired a copy of *Star Trek*'s second pilot for the Museum's film archives in August 1967. In response, some months later, Roddenberry sent Durant a telegram, thanking him: "The honor the Smithsonian bestowed on us helped greatly in the renewal of Star Trek for another season. Thanks for all your help." The assistance had been needed. In 1967, partway through *Star Trek*'s second season, Lucille Ball sold Desilu to Gulf+Western, which became Paramount Television. As a result, the show lost its principal studio-executive advocate.

Getting a third season required a different strategy. When NBC hesitated to pick *Star Trek* up again, Bjo (Bee-joh) and John Trimble, science fiction fans (and friends of Roddenberry) spearheaded a "Save Star Trek" letter-writing campaign. They used their own personal mailing list of fellow science fiction fans to address 150 letters that they copied using a Ditto machine (a rudimentary copier) at their house. Each letter asked the recipient to write to NBC supporting the show—and then send requests to like-minded friends. In addition, the Trimbles asked for any mailing lists that could help expand the call. As they continued to send appeals, hundreds and then thousands of fans wrote to support the show. The multiplying chain letters soon generated enough correspondence that the network announced a third and final season. When *Star Trek* was moved to a time slot on Friday evenings, however, a time when its young adult audience would be unlikely to be home watching television, Roddenberry left in protest his role as the show's producer. Nonetheless, with three completed seasons, *Star Trek* had enough episodes for syndication, so that the program could be broadcast on stations across the country outside of prime time. In the end, the show's influence would reverberate far longer and more powerfully than any could have imagined.

2001: A SPACE ODYSSEY

Another pathbreaking vision of spaceflight, *2001: A Space Odyssey*, debuted in 1968, setting a new standard for science fiction effects and cerebral storytelling. At the same time, it boosted interest in an ongoing promotion by one of the world's biggest airlines. Famously, the iconic film originated when director Stanley Kubrick decided that his next picture would be a well-made (that is, high-budget) science fiction film. He reached out to science fiction writer and two-time British Interplanetary Society president Arthur C. Clarke. They met for the first time in New York City in 1964 on the same day that the New York World's Fair opened across town. Based on their extended conversations, Kubrick chose to adapt several of Clarke's short stories, including "The Sentinel," which was about "the finding—and triggering—of an intelligence detector, buried on the Moon aeons ago." For the next two years, the two men worked to make the story into a novel and screenplay. In the end, the screenplay credited both authors, while the accompanying novel, which deviated from the film's plot in places and came out shortly after the film did, carried only Clarke's name. Numerous technical consultants,

including aerospace engineer and author Frederick I. Ordway III, lent authority to the production.

Kubrick signaled his intention for the film to be epic from its first frames. It opens with an overture: several minutes of black screen backed by the film's score. The story begins in prehistory with a mysterious appearance of the film's iconic monolith. After using a bone to kill and eat meat, the protohuman, Moon-Watcher, uses the same bone tool to defend territory and kill a rival. Kubrick's famous cut from the tossed bone to the orbital flight of a cylindrical spacecraft introduces a possible near future in space.

Not everyone appreciated the film's deliberate pacing and artistic choices, but *2001* became an iconic spaceflight film because of its detailed and layered depictions of realistic-looking space travel, achieved with scale modeling, mobile sets, and innovative effects. One enthusiastic review called it "a projection as unreal and as convincing as the awesome realities of present-day NASA and JPL projects." Indeed, Kubrick's vision revolutionized the genre of space travel cinema. After disembarking from the Pan Am clipper onto the rotating space station, Dr. Heywood Floyd (William Sylvester) immediately encounters several technological innovations that seemed likely to exist in the near future. These include voiceprint identification at customs, video phone calls in a phone booth, and multiple language translators available on demand. Kubrick reinforced the sense of a realistic speculative future by featuring well-known companies, including Bell Telephone, Hilton hotels, and Howard Johnson's restaurants in space. *2001* showed space travel as both pedestrian (with sandwiches and coffee to pass the time during a shuttle ride to the Moon site) and transcendent (as graceful vehicles danced in space to strains of a Strauss waltz). Clarke relished the film's verisimilitude. He recalled in an article about making the project, "As I watched our film astronauts making their way over the lunar surface towards the ominously-looming bulk of the Sentinel, while Stanley [Kubrick] directed them through the radios in their spacesuits, I remembered that within five years, at the most, men would *really* be walking on the Moon."

2001's realism served as the backdrop for gripping dramatic action that culminated in a cinematic conclusion rich with symbolism. After showing astronauts in spacesuits investigating the monolith buried on the Moon, the film cuts to the *Discovery 1*. From the two astronauts watching a BBC report about their own mission, the audience learns that three accompanying astronauts are also

on board in suspended animation. Dr. David Bowman (Keir Dullea) and Dr. Frank Poole (Gary Lockwood) have only one active companion: HAL 9000, a machine intelligence and compelling narrative character. The astronauts' questions about a piece of equipment that HAL says will malfunction set up the final conflict. HAL becomes suspicious of the humans' motivations and dedication to the mission. As the action climaxes, periods of utter silence in the soundtrack punctuate HAL's murder of the three hibernating crewmates and open defiance of Bowman. After disabling HAL, Bowman goes through the Star Gate to begin the final sequence. Following a surreal interlude in a neoclassical room, he is reborn as the Star Child, which represents the next step in human evolution.

After some initial trepidation by critics and executives from MGM, the film became acclaimed and influential. According to the British *Daily Cinema*, the film made eighty-five lists as either the best picture of the year or one of the ten best. Filmmaker James Cameron, who later made the blockbuster movies *The Terminator* (1984), *Aliens* (1986), *Titanic* (1997), and *Avatar* (2009), credited *2001* for inspiring his interest in filmmaking. He remembers going eighteen times to see *2001* as a teenager growing up in Canada. Inspired by what he saw, he started constructing his own filming models in his basement, experimenting to re-create the effects that he had seen on screen.

Other viewers were also excited about the possibilities of everyday lunar travel. Playing off the company's appearance in *2001*, between 1968 and 1971, Pan Am issued more than 93,000 "First Moon Flights" Club cards to space enthusiasts eager to make a reservation for the first commercial flight to the Moon. Issued at no cost, the cards were numbered in the order they were issued. The club originated from a waiting list said to have started when Gerhard Pistor, an Austrian journalist, went to a Viennese travel agency in 1964 requesting a flight to the Moon. The agency forwarded his request to Pan Am, which accepted the reservation.

Jeffrey Gates recalled that he requested his Pan Am reservation for a flight to the Moon in 1969, after the Apollo 11 landing. Actually, the twenty-year-old Gates asked for two seats, one for him and one for his wife. He was not yet married, however. When the agent balked at making a reservation without a specific name attached, Gates reasoned with her. By the time Pan Am was flying to the Moon, he argued, he would surely be married. They compromised on a second reservation booked in the name of "Mrs. Gates." Years later, long after he was

Jeffrey Gates requested this numbered "First Moon Flights" Club card and a second one for his future wife from Pan American Airlines in the late 1960s. He donated it to the Museum in 2016. Photo courtesy of the National Air and Space Museum.

happily married and working as a Smithsonian employee, he donated his card to the Museum.

Reinforced by the company's depiction in 2001, the idea that Pan Am would be flying to the Moon seemed believable, a logical next step for the globe-circling carrier. For years, Pan American Airlines was the leader in international flights. The back of the "First Moon Flight" Club card reminded subscribers that "Pan Am makes the going great." In bullet points below the tagline, the text outlined the airline's achievements: "first in Latin America; first on the Atlantic; first on the Pacific; [and] first 'round the world." The airline always said that the first flight to the Moon was expected to depart in 2000, a year that, like 2001, sounded very far in the future in the late 1960s. Unfortunately, the company stopped taking Moon flight reservations in 1971 when financial troubles made it too difficult to keep up with new requests. (Pan Am ceased operations in 1991.) The dream of purchasing a ticket for spaceflight just as easily as one might buy a seat on a commercial airliner continued to be a fiction, not reality.

SOUVENIRS OF SPACE

As prospective passengers requested their seats aboard a future Moon flight and 2001 played in theaters across the country, NASA engineers and astronauts worked to resume efforts to land humans on the Moon. Overall, the extraordinary achievements of the Apollo Program sparked an explosion of material remembrances, from elite collectibles to everyday souvenirs. Nevertheless, the physical record of the Apollo Program, especially memorabilia, should not be read as accurately reflective of the nationwide popularity of the program. The popular culture material record of the Moon landings shows just how much the cultural phenomenon of spaceflight and the core concerns of the daily lives of most citizens fell in and out of step with each other.

For both Project Gemini and the Apollo Program, the NASA Astronaut Office commissioned exclusive mementos available only to be purchased through them, not sold to the general public. For the Gemini flights, a series of small Fliteline medallions made for each of the missions carried the mission patch design on the front (obverse) and remained undecorated on the back (reverse) so that the flights' dates could be engraved afterward. For Apollo 7 in October 1968, the Robbins Company of Attleboro, Massachusetts, began creating slightly larger precious metal commemorative medallions exclusively for the NASA astronaut office. These numbered medallions used the highly symbolic mission patch designs created by the astronauts themselves to dictate the size and shape of the medals. For the first Apollo crewed flights, the largely blank reverse would be engraved with the mission's dates after they returned to Earth. For Apollo 11 and the rest of the planned lunar landings, the design of the reverse included places to engrave the specific dates of the mission's launch, lunar landing, and return dates. After they were flown in space, the returned medallions became precious mementos denoting the bearer's close connections to that particular flight.

The two piloted Apollo lunar missions in the fall of 1968 caught the public's attention, but they had to compete with everything else that was happening during that tumultuous year. In January, the Tet offensive in Vietnam, a massive assault timed to disrupt the truce expected around Tet (the lunar New Year), ended in a North Vietnamese defeat—but it discredited the American propaganda that the communists were weak and almost defeated. By February, CBS News anchor Walter Cronkite assessed the war as "mired in stalemate." His

This "Neil Armstrong for President" button represents the kind of memorabilia expressing excitement for Apollo 11 that could have been available to any interested buyer in celebration of the first successful human landing on the Moon in 1969. Photo courtesy of the National Air and Space Museum.

influential opinion lent credence to doubts about US strategy. In April, the assassination of Martin Luther King Jr. in Memphis sparked protests and riots in more than one hundred cities across the nation, leading to property damage, injuries, and deaths—expressions of the increasing despair of those living in neglected cities. Just two months later, in June, Democratic presidential hopeful Senator Robert Kennedy was assassinated after a campaign event in Los Angeles. In August, the contentious National Convention of the Democratic Party in Chicago saw fights on the convention floor and riots in the streets outside as police

descended on and beat antiwar protestors. Midway through the Apollo 7 mission in October, American sprinters Tommie Smith and John Carlos drew attention to the struggles for racial justice at home by raising their gloved fists in a Black Power salute on the medal stand at the Olympic Games in Mexico City. In November, the Soviet lunar probe *Zond 6* returned the first color pictures of the Moon, taken during a flyby. The Cold War competition for spaceflight achievements continued apace, but for many people, spaceflights were just one of many newsmaking events.

Against this backdrop, NASA officials made a bold decision as the year 1968 came to a close. Because the lunar module would not be ready to fly on time, Apollo 8 was launched in December to circle the Moon using only the command and service modules. Although photographs of Earth in space had been taken before, the release of the Apollo 8 "Earthrise" image—a color photograph of Earth in the distance with the Moon in the foreground, taken by a person—landed on the front pages of newspapers around the world. Searching for some good news amid a year full of strife, *Time* magazine named the three Apollo 8 astronauts as the "men of the year" for 1968.

Many assume that most people overwhelmingly supported the Apollo Program as the first human Moon landing drew near. But statistical studies from the time do not bear that out. Attitudes recorded in public opinion polls of the day show that, especially when the cost of the program was included in the question, the majority of national survey respondents answered "no" when asked whether it was worthwhile. According to William Sims Bainbridge's independent analysis of Harris polls from 1967 and 1969, support for maintaining contemporary NASA funding levels in order to land to a man on the Moon varied only slightly between 33 percent in February 1967, a negligible difference of 32.9 percent two months later, and 30.4 percent in January 1969. Moreover, the overall NASA budget began to shrink by 1967, before any of the piloted Apollo missions left the ground. At the Grumman Aerospace Company, which built the lunar modules in Bethpage, New York, layoffs began as early as the winter of 1967. By April and May 1969, as Apollo 9 tested all of the Apollo spacecraft together in low Earth orbit and Apollo 10 flew a full "dress rehearsal" lunar mission, minus only the landing, the aerospace workforce that had been assembled to construct the instruments of the Apollo Program had already been feeling the pain of job losses for some time.

GLENN, APOLLO, AND FLUCTUATING ENTHUSIASM

As the Apollo 11 mission attracted worldwide attention, it also provided a stark contrast to the pressing concerns of the day. As the launch approached, the Rev. Ralph Abernathy saw the opportunity to use the historic launch-day gathering to draw attention to the Southern Christian Leadership Conference's (SCLC) continued campaign for civil rights and economic justice. After the death of its charismatic leader, Martin Luther King Jr., the previous year, Abernathy, who became the new SCLC president, continued to push for the core values that had invigorated the previous campaigns. On the day before the launch of astronauts to walk on the surface of the Moon, Abernathy brought twenty-five African American families and two mule-drawn wagons to the gates of the Kennedy Space Center in Florida in full view of the press corps. When juxtaposed against the appearance of the Poor People's Campaign, the dedicated effort embodied in the planned spaceflight became a stark counterexample to the nation's unwillingness to tackle the complex issues of racial segregation, income disparity, and crumbling infrastructure. As Hosea Williams explained, "We do not oppose the moon shot.... Our purpose for being here is to protest America's inability to choose human priorities." NASA Administrator Thomas O. Paine met Abernathy's group in person just outside the NASA gates. After a civil exchange, Paine invited the group to attend the launch and to "hitch your mule wagons to our rockets" in the hopes that the space program's success would spur national efforts to solve other problems. When Apollo 11 rose from the launchpad the next day, Abernathy was in the viewing stands at Paine's invitation.

In addition to the souvenirs that observers might have collected, memorabilia became a key element of the actual Apollo missions themselves. In the runup to Apollo 11, the mission that landed the first human beings on the Moon on July 20, 1969, NASA officials concentrated on planning the landing itself and the first walk on the lunar surface, but they also considered how the achievement would be commemorated through material observances. Several symbolic acts were planned in an attempt to balance the mission's inherently dual nature as a national triumph and a human achievement. As a part of their historic first walk on the Moon, Neil Armstrong and Buzz Aldrin retrieved the full-sized American flag that had been tucked into a special holder alongside the lunar module's ladder, mounted it on a special flagpole with an upper arm to support it lengthwise, and planted it in the lunar soil. A law passed by the US Congress later in 1969 affirmed that the gesture conveyed national pride but not possession or

conquest. In addition, a small silicon disk (1.5 inches in diameter) containing messages from seventy-three heads of state and four US presidents was placed on the Moon's surface. A plaque affixed to the lunar module's leg also served as a permanent marker of the achievement. As designed, the lunar lander's base became the launchpad from which the astronauts left the Moon. Because that portion of the vehicle was left behind after the upper segment blasted off to rendezvous with the waiting command and service module, it held the famous plaque that read, in capital letters: "Here Men From The Planet Earth/First Set Foot Upon the Moon/July 1969, A.D./We Came in Peace for All Mankind." The plaque also carried the signatures of all three Apollo 11 astronauts and President Richard Nixon. While the astronauts were on the lunar surface, they read the plaque's message aloud to the considerable public audience watching and listening back on Earth.

Many in that audience wanted a souvenir to mark their witness to the achievement. But seeking to understand the popular excitement about spaceflight through a study of memorabilia, especially souvenirs of the Apollo Program, reveals several inherent contradictions. Such objects were both valuable and ubiquitous. Because the Space Age coincided with an explosion in affordable consumer products after World War II, space memorabilia were widely available. Souvenirs for Apollo 11 included buttons, pins, pennants, mission patches, bumper stickers, key chains, T-shirts, sweatshirts, and drinking glasses, to name just a few mementos. By definition, most ephemeral or short-lived objects only become valuable (either monetarily or sentimentally) after most people fail to recognize their worth, increasing the scarcity of the few pieces that avoid disposal. The tendency to judge anything associated with Apollo as inherently precious—both as a historical artifact and as an appreciating collectible—meant that a lot of it was saved.

The significance of the Apollo Program was immediately apparent. Even the venerable Arthur C. Clarke, who served as a special consultant for CBS's live coverage of the Apollo 11 mission, saved souvenirs in his archives. In addition to preserving his CBS and NASA briefing materials, he kept a *Mission Moon '69* booklet from the Kennedy Space Center. On the inside cover, its text reminded readers of the importance of such keepsakes: "This documentary as well as other items are now available as valued mementos of the occasion. You will want each of the series which are destined to become the 'Collector Items' of the future." Clarke also preserved copies of contemporary news coverage including issues of *Time*

and *Newsweek*, a *New York Times* special supplement, and the famous *New York Times* front section from July 21, 1969, headlined in declaration-of-war type, "Men Walk on Moon." People recognized that they were watching history being made. Both participants and observers held onto souvenirs as evidence of their presence. As a result, assessing the volume of available Apollo Program memorabilia tallies more evidence than accurately reflects the real public popularity.

Material objects also embodied the cultural exchanges that occurred following the astronauts' safe return. After Apollo 11, the astronauts, their wives, and a team of support staff embarked on a presidential goodwill world tour organized by NASA, the United States Information Agency, and the United States Department of State. Between September 29 and November 5, the Project Giant Step entourage visited twenty-four countries, with an additional stop in Canada in December. The demanding tour encompassed a worldwide exchange of honors executed through medals, plaques, awards, and even Moon rocks. The US group carried three presentations for dignitaries: mounted replicas of the lunar module plaque, replicas of the Goodwill Message microform disc (presented with a magnifying glass and framed photograph), and color photographs that the astronauts signed as needed. In return, the governments at each stop almost always presented some gift or honor, often intended to express a connection, such as presenting the astronauts keys to the city or a national medal. Many of these talismans were accepted on behalf of the US government by the State Department and shipped back to the United States. Some honors, however, were directly for each astronaut and became theirs. One staff member traveling with the group worked solely on tracking gifts.

As six more Apollo missions flew to the Moon and back in the late 1960s and early 1970s, spaceflight figured in American culture as both a transcendent expression of national pride and a potent symbol of deep social division. As Neil Armstrong reflected years later, he deliberately chose not to comment on contemporary politics or social issues: "I was certainly aware of the traumas that the country was experiencing at that time, and I believed that those problems were ones with which I was poorly equipped to contribute. They were outside my experience, outside my training, and I've always believed that however attractive it might be to get into areas that are interesting, you shouldn't do it if you're not qualified."

SPACE CRAZE

Armstrong may have been politically astute to hold himself apart from controversial issues, but that very separation between the space program and the turmoil of the times fueled others to use spaceflight as the symbol of deliberate disconnection. In 1970, for instance, poet Gil Scott-Heron recorded the spoken-word piece "Whitey on the Moon." Released on his debut album, *Small Talk at 125th and Lenox*, the piercing critique of racial inequality, urban poverty, drug addiction, rising prices, inadequate medical care, and generalized urban poverty contrasted the Black narrator's plight with the national expenditure required to land white astronauts on the Moon.

> Was all that money I made last year
> for Whitey on the Moon?
> How come there ain't no money here?
> Hmm! Whitey's on the Moon.

Scott-Heron was not alone in seeing spaceflight as a symbol of national apathy and misguided priorities. The audiences for these critiques held fundamentally different views of the Moon landings than the consumers who were snapping up commemorative items. The Apollo era illustrated the great disconnect between enthusiasm for spaceflight and the concerns of the day.

In the 1960s, Americans' enthusiasm for spaceflight remained an undeniably persistent and recurring cultural theme, even as many other movements, events, and tragedies competed for people's everyday attention. But that cultural enthusiasm had limits. Americans celebrated Glenn's Cold War triumph, enjoyed space-themed television and movies, and spent money on astronaut toys. But, especially as the decade of turmoil highlighted the stark disparities of urban poverty and social division, when pollsters asked, most people answered that the cost of the lunar landing program seemed too high.

Eventually, shrinking budgets forced NASA to rearrange the Apollo schedule and cancel the final three Apollo missions entirely. NASA emerged from the Apollo Program without a clear mandate for what next steps into space should follow the first steps on the Moon. The energy that would reinvigorate spaceflight enthusiasm eventually emerged from an unexpected place, science fiction fandom. In the years after Apollo, small but passionate groups of science fiction fans came into their own, redefining how spaceflight was both imagined and executed.

CHAPTER 4

Star Trek, Star Wars, and Burgeoning Fandoms

I gaze in puzzlement at the *Star Trek* Mr. Spock ear tip shown on my computer screen. Digging through the Museum's artifact database almost always raises new questions. I know that the Social and Cultural History of Spaceflight collection includes a few *Star Trek* pieces donated in the late 1970s. The record identifies them as "true scale replicas," which made sense. At the time when those pieces were donated, copies would have been considered more than sufficient to represent themes in popular culture.

As I prepared an online course about *Star Trek* in 2018, however, I wanted to feature authentic artifacts. What story could this replica tell? The information in the record was spare, only descriptions and dimensions. So I emailed one of the donors, Doug Drexler, the Academy Award–winning makeup artist and visual effects specialist. He answered right away with characteristic excitement, "Wow! Holy cow! That just blows me away! I can't believe it! We donated that stuff in 1976 when we were there doing the Star Trek Poster Book article."

Drexler gave the replica prop to the Museum years before he became a television and movie professional. In the 1970s, he was an avid fan, writing an article for the *Star Trek Giant Poster Book*, an eight-page monthly magazine published between 1976 and 1978. Cleverly printed on a single folded sheet of paper, the magazine's reverse side formed a poster when opened fully. For the June 1977 issue, Drexler, Ron Barlow, George M. W. Snow, and Anthony Frederickson visited the still-new National Air and Space Museum building to see the *Star Trek* studio filming models in the collection. During their visit researching the magazine article, Drexler, Barlow, and Frederickson donated three pieces that they created: a phaser, a communicator, and the Spock ear tip that first caught my attention.

This foam rubber replica prop of a *Star Trek* Vulcan ear tip was donated to the Smithsonian National Air and Space Museum by Douglas Drexler, Ron Barlow, and Anthony Frederickson. Their visit and this donation grew from a surge in fan enthusiasm in the 1970s for the canceled television program. Photo courtesy of the National Air and Space Museum.

At the time, the Museum collected the fan-made replicas because having copies helped to build the collection.

As I considered them years later, I realized that these artifacts represented some of the first pieces of tribute memorabilia crafted in the lean years before first NBC and then Paramount turned their full corporate attention back to *Star*

STAR TREK, STAR WARS, AND BURGEONING FANDOMS

Trek. The Spock ear tip in particular was the kind of accessory, which professionals called a makeup appliance, that a fan could use to dress up as the character for a convention. It was more than just an imitation, created in homage to a three-season television show from the late 1960s. Rather, it told a broader story about a historical moment when science fiction fandom came into its own.

In many ways, the early and mid-1970s represented a lull in the widespread public enthusiasm about spaceflight. Apollo 17 commander Gene Cernan left the last footprints on the Moon in 1972 at the end of the lunar landing program. The next major American human spaceflight vehicle, the Space Transportation System (more familiarly the space shuttle), was originally slated to fly in 1979 but experienced significant delays. In the meantime, NASA created the Skylab orbital workshop program using modified Apollo hardware and flew the Apollo–Soyuz Test Project (ASTP) mission. Major advances in planetary exploration spacecraft opened up new vistas on nearby worlds and inspired new ways of thinking about the Earth itself. But these events did not create the groundswell of excitement in public awareness sparked by earlier human spaceflight.

In histories of the twentieth century, the 1970s are often remembered as a crisis-ridden decade dominated by political and economic malaise, a shadow of the more dynamic and turbulent 1960s. In contrast to the previous decade's expanding economy that supported many new programs, including US efforts in the space race, the 1970s was an era that grappled with limits. Economic and political shocks constrained post-Apollo spaceflight efforts. More so, however, cultural pessimism dominated, reinforced by Watergate, pollution, fear of nuclear war, oil shocks, and stagflation. Historian Alexander C. T. Geppert summarized the common view of the 1970s: "disillusionment set in." Yet, as Geppert's own work helps to illuminate, the post-Apollo period can be better understood as a complex era of transition. Globalization developed, inspired by the cultural reenvisioning provided by the Earthrise and Whole Earth photographs, scaffolded by the satellites that revolutionized telecommunications and other functions, and driven by political needs for international cooperation. Moreover, many inventions that profoundly affected people's daily lives—including personal computers, the Internet, and GPS—originated in the 1970s.

Likewise, the American space craze underwent a period of transition and transformation. Even though it largely went quiet, spaceflight enthusiasm persisted in this complex time in ways that alternately resisted and embraced the

predominant disenchantment. Notably, a dispersed but powerful network of *Star Trek* buffs developed. Embracing the show's inherent optimism in contrast to contemporary moments of deep cynicism, these networks of enthusiasts built traditions that forever changed how viewers celebrated their favorite shows and movies. Those new traditions gained additional energy when the public response to George Lucas's unexpected blockbuster *Star Wars* forced industry executives to reexamine science fiction as a genre. Moreover, the merchandise associated with that film fundamentally changed how licensed toys and memorabilia were created and marketed. In the 1970s, space science fiction fans became a cultural force, and the selling of popular culture transformed the business of fandom.

STAR TREK LIVES!

The persistence of Americans' excitement about spaceflight throughout the twentieth century hinged on its malleability. Just as *Buck Rogers* solidified the basic form and archetype of American science fiction in the late 1920s and 1930s, *Star Trek* offered a fresh take on that formula in the 1960s. Even with some new variations, however, the space adventure's cultural roots in the Western remained clear. As one influential fan summed up the program's core appeal: "Star Trek was very good 'space opera' (a starship instead of a horse, phasers instead of six-shooters, and a walk-down on Tau Ceti instead of the O. K. Corral, etc.)." Gene Roddenberry's vision of humanity exploring the stars, coupled with the Vulcan philosophy of IDIC (Infinite Diversity in Infinite Combinations)—a radical expression of equality—gave *Star Trek* an optimistic bent. The show did not suggest that all problems had been solved, but it depicted a potential future without scarcity in which people worked to build a better society. In the early 1970s, the program's fans went to great lengths to connect with others who shared their passion.

The public response expressed by *Star Trek*'s supporters never reached the level of widespread excitement seen after John Glenn's orbital flight in 1962. But *Star Trek*'s devotees created an ardent niche fandom. Although not broad, it was deep and, from early on, organized. As its coordinators (often women) forged links with newsletters, fanzines, and mailing lists, far-flung pockets of enthusiasts became a national force. *Star Trek* became a greater force after it was canceled than it had been when it first aired.

STAR TREK, STAR WARS, AND BURGEONING FANDOMS

Star Trek's fan base took form during the show's initial run and persisted even after the end of the third broadcast season. Reflecting on those years, an early fan newsletter summarized the fledgling movement, "For three years after *Star Trek*'s demise, *Star Trek*'s fandom has grown. Individual pockets of fans across the world thought they were the only ones left." Despite that perception of isolation, the makings of an esoteric and eccentric network existed. As the same publication reflected, with some affection, the show's followers were "a vast, complicated, highly interesting, volatile group of people." The growing community built its links through in-person gatherings and by circulating newsletters and other homegrown publications. In the 1970s, the membership of fan clubs remained necessarily local, geographically limited by the reasonable distances that people could travel to attend. Newsletters reached farther. Enthusiastic followers also started various *Star Trek* fan-based magazines, called "zines," with hand-drawn illustrations and other informal touches, in which they could share their excitement with like-minded supporters during the show's initial run and afterward. These typewritten missives compiled updates, news, poetry, and illustrations, along with, in some cases, original fan-authored fiction.

Given the technology available, producing and distributing newsletters and fanzines required a lot of work. Initially, editors and authors arranged columns using a typewriter, and then copied the layouts using mimeographs or ditto machines to produce small batches for distribution. By the early 1970s, however, instant offset printshops made better-quality reproductions affordable enough for some hobbyists. Reduction printers fit more text onto fewer pages, which reduced mailing costs. The final sheets still had to be stuffed into envelopes or stapled into packets, however, before being labeled and stamped to deliver via mail. Distribution did not necessarily end there. Recipients might keep their copies—or pass them along to fellow fans. Even given the demands of creating them, it is estimated that more than a hundred fanzines existed by 1972.

In January of that year, the first *Star Trek* fan convention assembled at the Statler Hilton Hotel in New York City. This "con" was the first one convened in the format that later came to characterize such gatherings, especially with stars as featured guests. Elise Pines and Joan Winston organized the gathering with the intention of sharing their love of *Star Trek* with two hundred or so fellow fans. But before the meeting even began that Friday, at least that many people were already lined up outside, waiting for hours to be the first in the door. By Sunday,

three thousand people had purchased tickets. The organizers eventually stopped charging admission because they could not keep up. Once inside, attendees mixed and mingled, watched a special showing of "The Cage," and viewed a *Star Trek* blooper reel. Show creator Gene Roddenberry and noted novelist Isaac Asimov appeared, speaking to fans and answering questions. The official *Star Trek* fan club also enrolled its first members at that gathering, creating a sanctioned national organization in addition to the myriad local groups that already existed.

In January 1972 as well, George Christman founded the first chapter of the Star Trek Association for Revival (STAR) in Ann Arbor, Michigan. It sought to bring *Star Trek* back to television using the same kind of mailing campaign that had helped secure the program's third season. The first issue of the group's newsletter, *Star Borne*, included instructions for writing to NBC and Paramount using personal appeals, not petitions or form letters, for maximum effect. As it had before, the campaign worked. *Star Trek* went into syndication later in 1972. According to Thomas, that corporate decision "can be attributed solely to the efforts of the show's fans." In reruns, the entertaining program found new audiences, creating a second generation of viewers. Within a few years, as new fans joined those who had watched in first run, disparate viewers coalesced into a fledging community.

A group of volunteers called the *Star Trek* Welcommittee provided key logistical support for the growing fan base. As founder Jacqueline Lichtenberg explained in 2015, "Today, people don't understand that 'fandom' was a web of social networks of organizations with constitutions, dues, bylaws, and internal publications, organizations of adults." Lichtenberg got the idea for an orientation committee from a similar group operated by the National Fantasy Fan Federation, a correspondence club for science fiction and fantasy aficionados that began in 1941. Founded in the summer of 1972 and initially chaired by Jeanne Haueisen, the Welcommittee served as a "central information center to answer fans' questions about *Star Trek*, and provide new fans with complete information about *Star Trek* and *Star Trek* fandom." The Welcommittee was not a club itself but an organized network of volunteers who supported clubs and other fans. It was a substantial effort. By December 1973, the service organization included one hundred volunteers working in twenty-three states.

The exuberance of the group's tagline—"Star Trek Lives!"—highlighted the grassroots movement's determination to remain optimistic in cynical times. To sustain that energy, fans sought connections. In the early 1970s, supporters

interested in collecting *Star Trek*–related memorabilia had limited options. They could obtain scripts or film clippings from Gene Roddenberry's mail-order company, Lincoln Enterprises, or they could seek out specialty sellers through mail-order catalogs or in-person displays at conventions. The Welcommittee's directories listed relevant books, upcoming meetings, and the contact information for various merchandise purveyors. Just as important, however, the Welcommittee maintained long lists of active clubs and zines. The tightly spaced entries included mailing addresses, along with details about required dues and other requirements for joining. The "Star Trek Directory" published in October 1973, for instance, listed a hundred and eleven active clubs, including thirty-eight different chapters of STAR. In the same issue, fans could learn how to obtain copies of eighty-eight different active zines through the mail. Recognizing that fan efforts also disbanded regularly, the same directory listed twenty-seven out-of-print zines and twenty-four defunct clubs.

The economy of *Star Trek* fandom ran on volunteers' time and myriad small donations. Many of the entries in the typed directories included specific information about required dues or requested contributions. Payments as small as a quarter or fifty cents could be sent by check or money order to offset expenses. Fees could also be paid by enclosing the equivalent monetary value in uncanceled US postage stamps. Although many newsletters and zines relied on bulk mailing rates to keep costs down, sending first-class stamps defrayed correspondence costs. Indeed, good fan etiquette called for writers to include a self-addressed stamped envelope (SASE) with any requests or inquiries to avoid burdening the volunteer providing the reply.

In addition to participating in a local fan group or reading newsletters and zines, attending conventions became a signature part of the *Star Trek* fan experience. Like the New York convention, these get-togethers built on the traditions established by literary science fiction or comic book conventions. Many were regionally focused and fan-organized. For instance, Bjo and John Trimble, who led the "Save *Star Trek*" campaign in the late 1960s, organized Equicon (named for its timing near the vernal equinox) as a West Coast *Star Trek* convention in Los Angeles in 1973 and 1974. The atmosphere at conventions—whether organized around general science fiction or *Star Trek* specifically—tended to be friendly. Families were welcomed, and Equicon offered babysitting. In that convivial environment, *Star Trek* fans also created new traditions. For example, participants

who wanted to show off their costumes outside of the scheduled parades began the practice of wearing them on the convention floor throughout the meeting. Even as costumed convention-goers began to feed outsiders' stereotypes about the unbridled enthusiasm of diehard fans, NASA recognized the group as a receptive audience. The space agency sent representatives and displayed a lunar lander model at the very first *Star Trek* convention in New York City.

Some fan organizations also recognized the overlapping interests of real and imagined spaceflight. One of the first issues of *Menagerie*, a zine that published some of the first *Star Trek* fan fiction, included advertisements for both Klingon Empire appointment calendars and 8 × 10 Apollo 11 photographs. Fans who might have ordered either (or both) probably did not live near many others who shared their tastes. Thanks to the hard work of volunteer organizers, however, a fledgling network of clubs and mailings connected them with other fans.

DYSTOPIAN VISIONS

Even when *Star Trek* was still on the air, the cultural mood of the nation began to move away from the show's fundamental optimism. In the late 1960s and early 1970s, many films took a decidedly dystopian turn. As political upheavals shook public confidence in authority and national institutions, several science fiction films featured cynical outlooks on human nature and space exploration's potential.

The *Planet of the Apes* movie series began in 1968. In the first installment, a lost astronaut, George Taylor (Charlton Heston), crashed on a strange planet two thousand years in the future. Stripped of his status as an astronaut, his human dignity, and even, for a time, his voice, Taylor battled the injustices inherent in the rigidly hierarchical ape society. In the final reveal, he confronted the reality that he had in fact returned to Earth, which had been devastated by nuclear holocaust. The dystopian vision was humanity's own fault. The series continued in four sequels, released every year between 1970 and 1973. The stories resonated with audiences. The movies did well in theaters, and again when replayed on television. In fact, inspired by the films' ratings, two television shows briefly aired. Although most of the action in the *Planet of the Apes* franchise did not focus on space travel, the allegorical tales of human-ape interactions began with human astronauts traveling across space and time, allowing the writers to examine contemporary issues in alien settings. Conflicts between humans and apes

entertained audiences even as the plotlines commented on Cold War concerns about nuclear weapons and contemporary race relations.

In the early 1970s, ongoing social and political clashes escalated in new ways. First, President Nixon announced in April 1970 that the highly unpopular war in Vietnam would expand into neighboring Cambodia. Then, during a Kent State protest against the Cambodian campaign, National Guard troops shot four students to death. That same month, the frustration of African American communities at persistent inequalities once again drew national attention when police shot and killed two students during protests at Jackson State College, a historically Black institution in Mississippi. In 1971, the *New York Times* published the leaked report that became known as the "Pentagon Papers." The in-depth history of the US role in the Vietnam War revealed that the White House and United States government had actively deceived the American people about the motivations for and extent of that conflict. In a cultural period rife with betrayal and deception, the intrepid optimism and earnest derring-do that characterized an earlier generation of space science fiction adventurers seemed out of step with current events.

Instead, science fiction films sounded alarms about contemporary concerns. In 1972, Bruce Dern starred in *Silent Running*, a movie influenced by the burgeoning environmental movement and the first Earth Day, which convened nationwide on campuses and in communities on April 22, 1970. Directed by Douglas Trumbull, who did the special effects for Stanley Kubrick's *2001: A Space Odyssey*, the film imagines space freighters carrying the remnants of various ecologies because all plant life on Earth has been pushed to extinction by human engineering. When the ships' skeleton crews receive the order to destroy the protected environments, however, Dern's character, Freeman Lowell, responds violently. Although his actions ultimately prove self-destructive, they reflect the helpless rage of confronting an eroding natural world.

Silent Running was just one of several films that depicted dystopian visions of technology run amok. In 1973, Charlton Heston starred in *Soylent Green*, a film that portrays the grisly compromises required for humanity to survive after environmental devastation. That same year, *Westworld* told a dark tale about the perils too much personal freedom and runaway computer technology, set on a fantasy robotic Western ranch.

The dystopian turn in science fiction drew strength from the earnest tropes established in earlier decades. In 1974, a student film gained national exposure by

deliberately subverting those heroic conventions. John Carpenter, who became a prolific film director, and Dan O'Bannon, whose many writing credits later included the screenplay for *Alien* (1979), collaborated at the University of Southern California film school on a satirical student film titled *Dark Star*. After its enthusiastic reception at the Los Angeles International Film Exposition, the movie had a limited theatrical release. Rather than an earnest crew of space adventurers, the absurdist *Dark Star* centers on four astronauts who bomb unstable planets, destroying them. No shiny, technologically advanced spacecraft, the titular *Dark Star* is falling apart. The crew's requests for repairs, supplies, and upgrades are continually denied. Rather than face dire circumstances, *Dark Star*'s astronauts battle mundane concerns such as the lack of toilet paper. Captain Powell, their leader, has been killed by a short-circuit in his chair. Lacking a greater purpose, they fill the boredom between their destructive missions with senseless pranks and repetitive stories.

Dark Star takes the audience's expectations for heroic space adventures and presents instead an absurdist comedy. When one of the *Dark Star*'s intelligent bombs is stuck outside, ready to explode, the crew consults Powell, who has been kept onboard in cryogenic stasis. His advice is, "Teach it phenomenology," the philosophical study of consciousness. When peppered with questions such as "How do you know you exist?," the bomb eventually disarms itself to go back inside to think. By the film's end, each member of the remaining crew is summarily dispatched, either shot out of the airlock or blown in opposite directions by the bomb's eventual explosion. In a scene that pays homage to Kubrick's *Dr. Strangelove* (1964), the final survivor rides a piece of debris like a surfboard to a nearby planet. When home video watchers rediscovered the movie in the 1980s, the dark comedy became a cult classic. O'Bannon's *Alien* later transformed his student vision of workaday spaceflight into a compelling horror movie.

PROBLEMS IN ORBIT

As pessimistic imaginings of space technologies played on television and movie screens, NASA launched the orbital space station Skylab in 1973. It made more news for coping with problems than for its many successes. After the final Apollo missions were canceled due to budgetary restrictions, NASA officials sketched out ambitious plans for using modified Apollo equipment for lunar and orbital

missions. Ongoing funding constraints resulted, however, in scaled-back plans. Skylab repurposed the third stage of a Saturn V lunar launch vehicle, turning the liquid hydrogen tank into living quarters. The program's final form prompted an outcry from the agency's own astronauts because the station's limited capacity and the decision to include only one scientist on each crew meant that many newly selected scientist astronauts would never fly in space. Disgruntled astronauts reacted to the Skylab announcement as "only the last in a string of disappointments that began unraveling almost a year ago," beginning with the loss of the final Apollo missions. The compromise mission did not elicit the public excitement previously generated by human spaceflights, either.

It was hard to generate enthusiasm when news reports covered problem after problem. When the Skylab Orbital Workshop launched on May 14, 1973, its mission was almost fatally compromised from the start. The micrometeoroid shield, which also functioned as a sunshade, ripped away during launch, tearing off one main solar panel and jamming the other shut. Overheating and underpowered, the laboratory seemed uninhabitable. The first three-astronaut crew, which launched May 25, successfully deployed a makeshift solar shield and cut free the solar panels. The press characterized the accomplishments as "a victory of man over balky machine." The clever engineering fixes made the station operational, but during the next two crewed missions, media coverage of problems with space sickness and crew schedules overshadowed their successes with ongoing medical experiments or solar astronomy observations.

The reduced public excitement even made news in its own right. At the end of the third and longest mission, the *New York Times* reported that "television pictures of the splashdown and the arrival of the astronauts on the carrier were not broadcast by network television, on the grounds that public interest had diminished greatly." On the same page, a short notice reported that a Skylab postage stamp had been announced by the US Post Office. Yet no design or release information had been decided. In contrast to the Apollo Program, which was celebrated in myriad souvenirs, Skylab generated few mementos.

What little memorabilia existed, such as patches and commemorative medallions, attempted to communicate the program's goals, but inconsistencies marred the attempt. The three Skylab patch designs reflected the station's objectives: understanding human adaptation to spaceflight while observing the Earth and Sun from space. The emblems used confusing numerical designations, however.

NASA's operations dubbed the launch of the station itself as Skylab 1, designating each of the subsequent crewed flights as 2–4. The patch designs incorrectly labeled the astronauts' flights 1–3. In addition, Skylab souvenirs used both Arabic and Roman numerals: I, II, and 3. These small details probably did not affect public perceptions in any significant way, but they reflected the sense that popular interest remained low. In the Apollo Program, such discrepancies would have been called out for correction, if not by NASA then by fans of human spaceflight who followed the program closely.

The final Skylab mission was also overshadowed by the news of the day. In October 1973, Vice President Spiro Agnew resigned after facing charges of corruption and pleading no contest to one count of tax evasion. An oil embargo begun by the Organization of Arab Petroleum Exporting Countries (OAPEC) in October 1973 caused shortages, high prices, and gas lines in cities and towns across the country. By the next August, President Richard M. Nixon himself resigned after a series of Congressional hearings investigating what became known as Watergate. That process uncovered the sordid details of the cover-up of a burglary at the Democratic National Committee headquarters in Washington's tony Watergate building complex. As much as the base criminality, the foul language and calculated obfuscation revealed on secret White House tapes broke the trust that many Americans had in their national leadership.

RESPONDING TO THE FANDOM GROUNDSWELL

Even as the nation's politics roiled, new interest in *Star Trek* emerged. After years of pressure from fans, Paramount finally responded with *Star Trek: The Animated Series* (NBC, 1973–74), a children's show. Employing writers who had worked on the live-action show and using the voice talents of almost all the original cast members, the animated series showcased new stories as well as plotlines that served as sequels to original series' episodes. Twenty-two episodes aired over two seasons, aimed at the broad swath of *Star Trek*'s audiences and not just kids. Beginning with *Star Trek*'s return to television, local pockets of fandom began to find more public outlets.

The creation of the first officially licensed *Star Trek* playthings tapped into a market eager for branded merchandise. During 1974, New York–based Mego secured a license to produce *Star Trek* toys. The toy company already made eight-inch-tall

Mission patch designs from the three human Skylab missions that flew in 1973 and 1974 illustrated the crews' efforts to understand human adaptation to spaceflight while observing the Earth and Sun from space. Oddly, the memorabilia called the crew missions I, II, and 3, despite NASA's numbering the Skylab crewed missions as 2–4. Photos courtesy of NASA.

fashion or action dolls that competed with Mattel's Barbie or Hasbro's G.I. Joe. The first *Star Trek* figures included Captain Kirk, Mr. Spock, Dr. McCoy, Mr. Scott, and an unnamed Klingon. Players could use the action figures to imagine their own adventures, either with or without the coordinating playsets. The Mission to Gamma VI set offered players a plastic mountain stage to use as a site and backdrop for play. The vinyl Enterprise playset cleverly unfolded from a rectangular carrying case into a facsimile of the famous starship's bridge, complete with a plastic captain's chair and a spinning chamber that simulated the show's iconic transporter. Overall, the dolls and playsets encouraged players to imagine themselves as the directors of the action, not as embodying the characters themselves.

Notably, Mego's *Star Trek* figures failed to capture the cast's racial and gender diversity. Although the initial lineup included one alien and Mr. Spock (who

was half-alien and half-human), all the figures were male, and three of the five were white. An additional doll depicting Lieutenant Uhura was issued later. No other female or nonwhite characters were created in the 1970s. The full range of Mego's *Star Trek* line eventually included eight additional aliens: the Keeper, a Neptunian, Gorn, Cheron, Romulan, Talosian, Andorian, and Mugato. Drawing on the show's depiction of those characters as the monster of the week, none of the figures carried individual names, just species identifications. Moreover, with the notable exception of Mr. Spock, who was presented as part of the main cast of heroes, all the alien characters represented adversaries. The Other was still the enemy. In the end, the toys were a hit, and Mego's investment returned great dividends.

As *Star Trek* returned to television and appeared on toy store shelves, the Smithsonian's National Air and Space Museum decided to appeal to the show's fans. Fred Durant of the Museum's astronautics department had already acquired a copy of the show's pilot episode in the late 1960s during *Star Trek*'s initial run. In 1974, the Museum acquired from Paramount the eleven-foot studio model of the *Star Trek* starship *Enterprise*. During the show's filming, the two-hundred-pound static model had been filmed using a moving camera to create the iconic shots of the vehicle flying through space. As the final artifact in the *Life in the Universe?* exhibit, the model illustrated imaginative visions of future travel and complemented other examples of science fiction sprinkled through some of the Museum's new exhibits.

Durant hoped that the popular culture reference would attract visitors to the Museum's displays, which were then exhibited in the Smithsonian's Arts and Industries Building. At the time, the Museum's new dedicated building was still being constructed down the street on the National Mall. As planned, *Life in the Universe?* eventually became one of the inaugural exhibits in that new space. The Museum's curators saw imagination about spaceflight as an integral part of the story. They planned several references to science fiction in the *Rocketry and Spaceflight* exhibition. Curators also acquired several models of fictional vehicles from *2001: A Space Odyssey* assembled from box model kits. In addition, the Museum also acquired some small *Star Trek* props—including spacecraft models and several Tribbles. The curators even briefly expressed interest in collecting fan newsletters and zines. After fans learned of the request, the enthusiastic response quickly became overwhelming. After collecting some examples of

As the final artifact in the *Life in the Universe?* exhibit, seen here as installed in 1976 in the National Air and Space Museum's new dedicated building on the National Mall, the eleven-foot *Star Trek* starship *Enterprise* model used the show's resurgent popularity to illustrate an imaginative vision of future space travel. Photo courtesy of the National Air and Space Museum.

both newsletters and magazines, Durant wrote to Bjo Trimble asking her to tell the fan community, "We really do not need any more help."

Star Trek fans also sought each other out. In 1975, two brick-and-mortar outlets opened, providing a physical outlet for memorabilia as well as a meeting place. First, in May 1975, Chuck Weiss and Sandy Sarris opened a dedicated Star Trek store together in Berkeley, California. The couple had met at a San Francisco Star Trek fan club gathering, fell in love, and started organizing fan activities. After a convention that they organized at a local high school attracted a thousand more people than the site could hold, they built on that success with an unlicensed Star Trek retail store, called the Federation Trading Post. They sold posters, bumper stickers, buttons, T-shirts, and books, including the popular Starfleet Technical Manual. The store became a site for enthusiasts to connect with information, merchandise, and each other. Even as fans celebrated their shared interests, however, the outside world could be sharply unkind. When a People magazine article reported on the couple's success, the headline read, "For Star Trek Freaks, Chuck and Sandy Keep the Enterprise Sailing."

At the same time, Ron Barlow, the managing editor of Nostalgia Press and Monster Times as well as Inside Comics, had been thinking about founding a Star Trek fan store in New York City. When he discovered in a conversation with Chuck Weiss that they had both dreamed the same dream, they decided to collaborate rather than compete. In October 1976, Barlow and his partner, Doug Drexler, opened their Federation Trading Post in midtown Manhattan. The New York shop initially struggled. To boost sales, Barlow and Drexler purchased a thirty-second commercial on a local television channel to be aired during showings of Star Trek and Outer Limits. After that, fans found them.

The two stores—called West and East by their owners—also operated a mail-order catalog business rooted in the California store and advertised in New York. Several similar businesses coexisted in different parts of the country at the same time. Barlow and Drexler's New York–based store sold the same kinds of memorabilia that the California one did, with the addition of fan-created pieces. The shop's shelves and cases contained stained-glass models of the Enterprise, replica weapons, individual Tribbles, and realistic-looking uniform costumes.

When customers brought homemade creations to the store to show them off, the owners asked them whether they could make enough to sell. As Drexler and Barlow provided an outlet for craft-based memorabilia created by fans, they also

built a reputation as providers of replica props or costumes for local television stations or *Star Trek*–themed presentations. Although both the East Coast and West Coast shops were short-lived, they became significant ways for fans to find validation for their hobby. As Drexler recalled, "No one suspected the militant, aggressive, creative, fandom groundswell that was building."

GROWING PUBLIC INTEREST

While *Star Trek* fans were finding each other in shops in New York and Berkeley, NASA officials were connecting with former adversaries for a new cooperative space venture. The Apollo–Soyuz Test Project, which launched in July 1975, demonstrated the malleability of spaceflight as a geopolitical tool. After the Apollo Program and Skylab ended, with the Space Shuttle Program still being developed, the time seemed right for next steps in space. As the relationship between the United States and the Soviet Union temporarily warmed, the vehicles originally used to carry out Cold War aims became the tools of a new kind of space diplomacy.

Rather than showcase their respective technological capabilities on a proxy Cold War battlefield, ASTP illustrated the nations' newfound détente. The joint human spaceflight project conducted by the Soviet Union and United States began with an exchange of letters between the heads of the two space agencies in 1970, which eventually resulted in 1972 in a formal agreement for a joint venture. In the end, NASA chose three astronauts, Thomas P. Stafford, Donald K. "Deke" Slayton, and Vance D. Brand, to fly an Apollo command/service module into space to dock with Soyuz 19, flown by Soviet cosmonauts Alexei Leonov and Valeri Kubasov.

Planning for the cooperative mission represented a momentary new direction in national spaceflight practices. Significantly, the training took place in both the United States and the Soviet Union. The Soviet cosmonauts and their compatriots learned English and trained alongside Americans at the Kennedy Space Center in Florida and the Johnson Space Center in Houston, Texas. The American astronauts and associated officials also learned Russian and traveled to Soviet facilities at Star City for joint training. In earlier years, even the location and existence of Soviet missile and space sites, let alone any information about systems or techniques, had been state secrets. Whether or not the broader viewing public paid much attention beyond the news announcement of the event,

when Stafford and Leonov shook hands in July 1975 through the docking mechanism that linked their spacecraft, the symbolism of the moment rang clear. The success of ASTP demonstrated that the crash programs hastened by Cold War circumstances could take on new motivations and goals.

As the former military men and Cold War rivals Leonov and Stafford led a joint venture that cemented a lifelong friendship between them, a radically different take on spaceflight was taking shape back on Earth. During the summer of 1975, funk musician George Clinton worked in recording studios in Detroit, Michigan, and Hollywood, California, to orchestrate his own interpretation of spaceflight themes for Parliament's *Mothership Connection* album. The band first formed in the early 1960s as the Parliaments, a doo-wop group. But by the 1970s, the group had expanded in number and in musical style. At one point, Clinton had reformed the band as The Funkadelics in response to a contract dispute, but later it later readopted the name Parliament. Over time, Parliament-Funkadelic became an umbrella moniker for a band in which dozens of supporting musicians came and went. Parliament became known not only for its danceable musicality but also for the band's otherworldly stage shows. The group's outrageous costuming reflected its exuberant spirit. At Clinton's suggestion, the band members worked to embody characters that told a story. Clinton recalled that the band's turn to spaceflight imagery grew out of the creative process that followed the release of the album *Chocolate City* in April 1975. The lead track, "Chocolate City," a tribute to Washington, DC, imagined a cast of African American celebrities in the White House, an unlikely scenario at the time. Clinton later recalled that for their next album, he started thinking about, "Where else would you not find Black people?" His answer was outer space.

Clinton and Parliament mined the imaginary of spaceflight for irreverent, psychedelic fun. In a series of albums beginning with *Mothership Connection* and continued on to *The Clones of Dr. Funkenstein* in 1976, Parliament built what became known as the P-Funk mythology, a set of spacey characters and themes developed through the band's concept albums and live performances. Working in the absences created by the legacy of Black exclusion from science fiction, they invented a new mythos, rooted in Blackness and funk music. In their stage shows, long trippy sets culminated in the dramatic descent toward the stage of a large metallic Mothership prop, the centerpiece of a pyrotechnic and light show.

Parliament's reframing of spaceflight themes upended conventions. The alien was no longer Other but a celebrated Us.

Parliament was not the only African American musical group experimenting with space themes in public performances at the time. The trio of Patti Labelle, Nona Hendryx, and Sarah Dash evolved from being a stylized girl group known as the "Sweethearts of the Apollo" into a disco/rock/soul/funk band simply called Labelle. Having changed their initial image from matching dresses to jeans and Afros, the group later began working with Broadway fashion designer Larry LeGaspi to create fabulous silver, space-themed costumes for their shows. LeGaspi developed looks for both Labelle and Parliament, as well as the iconic face paint and stage costumes worn by the rock band KISS. Decades later, Clinton's and Labelle's positive futuristic visions rooted in the African diaspora were called Afrofuturism.

As Parliament's fans embraced the P-Funk mythology in venues all over the country, another group of enthusiasts coalesced on college campuses and at NASA centers. The inspiration for their excitement for permanent human space colonies began with charismatic physicist Gerard K. O'Neill, a Princeton University professor. While teaching introductory physics in 1969, O'Neill challenged his advanced students to question whether "an expanding technological civilization" should remain limited to living on a planet's surface. Their investigations consumed the entire term. Assuming only contemporary technology would be used, they began calculating how large a space station could be constructed. As they collaborated on the calculations—figuring how much metal and how many launches would be needed as well as how much soil and water would be required—O'Neill was impressed by the results. It seemed possible.

Intrigued, O'Neill developed the idea over the next four years, with colleagues and friends suggesting technical refinements. He hosted a conference at Princeton in the summer of 1974, funded by the university and Stewart Brand's Point Foundation. In response to news coverage, O'Neill recalled, "A wave of public awareness and interest began to spread." He got so many letters from enthusiasts that he began publishing newsletters rather than answering each inquiry individually. He outlined his plan in a scholarly article, "Colonies in Space," which appeared in *Physics Today* in 1974.

The influential article described in precise mathematical detail the construction of coupled-cylinder space stations and how they would function, permitting

day and night cycles, terrestrial-style land features, and enough agriculture to sustain the space colony's population. O'Neill backed each assertion with calculations demonstrating the capacity and limits of the suggested system. Inspired by his vision, Carolyn Meinel Henson and her then-husband Keith contacted O'Neill, who invited them to his Princeton Conference on Space Manufacturing in 1975. Shortly thereafter, the couple cofounded the L5 Society. The group's unique name came from a gravitationally stable point in the Earth-Moon system, a LaGrange or libration point. L5 was the point that O'Neill named as a good location for space colonies. The utopian idea that space-based solutions could be found for pressing socioeconomic problems sparked a new grassroots movement organized around making that future possible.

Early members joined because they believed in the project's idyllic promise—a stark contrast to the dystopianism of the day. Reflecting from the perspective of twenty years later, one of L5's proponents reflected, "It is difficult today to realize the excitement that was generated in the early years of the L5 Society.... L5 members at the time thought that they would really get the chance to personally live in space within their lifetimes." O'Neill hoped that humanity's extraterrestrial expansion could solve Earth's overpopulation problems, and L5 Society members looked forward to witnessing the proposed solutions in person. In the first issue of the newsletter, published in September 1975, the group declared, "Our clearly stated long range goal will be to disband the Society in a mass meeting at L5."

To spread its message, the group used some of the same techniques that science fiction fans had. Getting the word out required physical mailings, directed to recipients by typed address lists. The Hensons publicized their new organization using the attendance roster from the Princeton summer gathering as well as another address list from O'Neill. They also distributed a four-page newsletter publicizing the endorsement of the L5 idea by Rep. Morris Udall (D-AZ), then a presidential candidate. In its early years, the L5 Society sought to expand its membership. Just as many science fiction fans redistributed the publications that they received to other enthusiasts, the L5 group encouraged members to share the monthly newsletter with like-minded friends.

O'Neill's ideas about space colonies received serious consideration at NASA and additional publicity from his own writing. Beginning in the summer of 1975, NASA sponsored a series of formal investigations into the architecture and

aesthetics of long-duration spaceflight. Shortly after O'Neill's Princeton gathering, a ten-week study convened at NASA's Ames Research Center, cosponsored by the American Society for Engineering Education and Stanford University. The resulting report featured colorful artists' renderings of possible colonies, each teeming with suburban-style life that was carefully organized inside spheres, columns, or doughnut-like rings, each called a torus. Similar studies on space manufacturing followed in 1976 and 1977. O'Neill's book *The High Frontier* (1976) tied his concept of space colonies to powerful American narratives about exploration. He wrote, "We now have the technological ability to set up large human communities in space: communities in which manufacturing, farming, and all other human activities could be carried out. Substantial benefits, both immediate and long term, can accrue to us from a program of expansion into that new frontier."

Other notable authorities soon joined the chorus, including novelist Isaac Asimov, who wrote about the idea in *National Geographic*. Paintings by space artist Pierre Mion illustrated Asimov's piece, reinforcing the vision. In 1977, *Time* magazine writer and editor Frederic Golden and CalTech professor and science writer T. A. Heppenheimer each published books explaining possible human space colonies. They found receptive readers. By the early 1980s, the *L5 News* mailing list numbered almost ten thousand recipients. In an era characterized by widespread cynicism, O'Neill's optimistic visions fueled a grassroots movement of spaceflight advocates.

A MUSEUM ON THE MALL BY THE BICENTENNIAL

The summer and fall of 1976 saw two other expressions of spaceflight enthusiasm come into national view that had been quietly building (or being built) for years. First, the National Air and Space Museum's new dedicated structure on the National Mall opened. The celebration was timed as a high point of the nation's bicentennial. Second, the rollout of the first space shuttle orbiter, a flight test vehicle, occurred as another bicentennial commemoration. In both cases, an outsized public response shaped the occasions in ways that the planners had not fully anticipated.

When the Smithsonian's newest building opened on July 1, 1976, some of the visitors streaming through the doors were likely L5 Society members or P-Funk devotees. Thousands of other visitors joined them, eager to see the displays of

aviation and spaceflight achievements. Having the Museum building's grand opening on the bicentennial celebration weekend illustrated the centrality of exploration and flight to American national identity. To complete the construction in time for that deeply symbolic deadline, Museum director and Apollo 11 command module pilot Michael Collins recalled that he spent years proclaiming his own version of President Kennedy's three-part mandate for the Apollo Program. Rather than a man on the Moon by the end of the decade, Collins campaigned for a Museum on the Mall by the bicentennial. The grand opening reminded Americans that they were citizens of the nation that had invented the airplane and landed astronauts on the Moon.

Delivered amid the pageantry of the ceremonial ribbon cutting, President Gerald Ford's remarks linked American innovation in flight to the frontier ideal in American national identity.

> The amazing American achievements in air and space tell us something even more important about ourselves on Earth. The hallmark of the American adventure has been a willingness, even an eagerness, to reach for the unknown. For three and a half centuries, Americans and their ancestors have been explorers and inventors, pilgrims and pioneers, always searching for something new. . . . Nor could Americans be confined to the Atlantic seaboard. The wide-open spaces have lured Americans from our beginnings. The frontier shaped and molded our society and our people.

Ford's uncritical vision linking the frontier experience to national ingenuity echoed the particularly American form of space imagination that emphasized rocket-propelled expansion. After Ford's speech, the ribbon cutting exhibited its own space-themed flair. The Jet Propulsion Laboratory in California relayed a transmission from Viking 1 in orbit around Mars to Washington, DC. The interplanetary signal activated a replica Viking lander arm to split a ceremonial red, white, and blue ribbon, opening the exhibition space.

Americans' enduring enthusiasm for flight could not be better illustrated than by the excitement generated by the Museum's unveiling. As Ted Maxwell and Tom Crouch stated in a history of the institution, "To say that the Museum was an instant success is to understate the matter." Sixty-five thousand people

visited on July 4 alone. Within the first month of its opening, attendance reached as high as 87,000 people in one day. The first full year of attendance totaled an astounding 9.6 million visits—an average daily attendance of 26,000 people. The size of the crowds both thrilled and surprised the Museum's staff, which had not dared to hope for such a robust response.

Even as Smithsonian officials were adjusting to the new attraction's popularity, NASA officials worked to respond to a surprise of their own: *Star Trek* fans set their sights on naming the flight test vehicle being prepared for the Space Shuttle Program. NASA had planned to unveil the new orbiter in a public ceremony on Constitution Day, September 17, as a continuation of the bicentennial celebrations. In keeping with the event's timing, OV-101 (orbital vehicle 101) was to be named *Constitution*. The shuttle was not space-ready, but it could undergo test landings. Before launching a brand-new design that would land on a runway like an airplane, engineers needed to know whether it would work. Fortunately, test landings did not require working engines or other components that were significantly delayed. The September rollout was a significant milestone for a program that was already behind schedule.

Instead, *Star Trek*'s burgeoning fandom revealed its strength when the show's fans made a very public—and successful—appeal to the White House to name the flight test vehicle *Enterprise* rather than *Constitution*. As they had in the past, fans organized a letter-writing campaign to convey their desires. Unlike the earlier "Save Star Trek" campaign, which had been Bjo and John Trimble's idea, for this effort, the Trimbles were the implementers but not the originators. But they were not surprised by the fans' response.

The couple was well aware of the popularity of the *Star Trek* starship *Enterprise* as a character in its own right. When the Trimbles answered fan mail for Lincoln Enterprises, Gene Roddenberry's private company, the fictional vehicle got its own letters. Bjo even recalled signing "autographed" photographs of the ship. Others also recognized the imaginary vehicle's celebrity status. As Ron Barlow said in an interview about the merchandise sold at the Federation Trading Post, "The star of the show is the Enterprise. More buttons, pictures, paraphernalia, photos of the Enterprise are sold than anything else. Next in line is Spock, then Kirk and down through the rest of the cast." The charm of naming a real spacecraft for the beloved character inspired an outpouring of interest.

Thousands of fans flooded NASA and the White House with written appeals. As before, chain letters alerted fellow enthusiasts to add to the effort.

Less than two weeks before the planned unveiling on Constitution Day, President Ford and NASA officials announced the choice of the popularly requested name. During the White House meeting, Ford recalled that during his time in the US Navy, his vessel serviced an earlier aircraft carrier with the same moniker. He confessed, "I'm a little partial to the name *Enterprise*." The decision represented a significant break with American human spaceflight tradition. Previously, the astronauts themselves or in rare cases, the vehicles' manufacturers, named individual spacecraft. Allowing public input in naming the first orbiter connected the new vehicle to popular excitement about spaceflight. Although *Enterprise* never flew in space because design changes made retrofitting it too expensive, the first new orbiter in this transformative spacecraft line bore a name beloved by countless science fiction fans.

Privately, *Star Trek* creator Gene Roddenberry worried that the show's enthusiasts might have overstepped. After all, in his mind, the decision to call the entire new class of real spaceflight vehicles "space shuttles" already came rather close to the name of *Star Trek*'s fictional shuttlecraft. He repeated this point of confusion several times in a September 1976 letter composed the week after the White House announcement. Writing to his old friend Fred Durant at the Museum, Roddenberry confided that he had been "quite upset over the change of the Shuttlecraft name to 'Enterprise.'" He worried that people would think that he had orchestrated the campaign to gain publicity for himself or the studio. He assured Durant, "Not only would [I] not toy with the space program, but [I] have also strongly recommended to Paramount that they seek no publicity advantage in the naming of the Shuttlecraft. . . . I will be present at the rollout since I was long ago invited there and consider it a momentous occasion. But I certainly will not be making speeches about our starship or movie."

Although NASA officials may have been upset at having their naming rights usurped, in the end, they capitalized on the turn of events. Almost all the original cast members (minus only William Shatner) appeared at the vehicle's ceremonial rollout in Palmdale, California. The image of the television stars standing with the next generation *Enterprise* gave the Space Shuttle Program a much-needed boost of good publicity.

(*Left to right*) NASA Administrator James D. Fletcher greets luminaries from television's *Star Trek* (1966–69), including DeForest Kelley (Dr. "Bones" McCoy), George Takei (Mr. Sulu), James Doohan (Mr. Scott), Nichelle Nichols (Lt. Uhura), Leonard Nimoy (Mr. Spock), Gene Rodenberry (show creator), US Rep. Don Fuqua (D-FL), and Walter Koenig (Ensign Pavel Chekov) at the rollout of the space shuttle orbiter *Enterprise* in Palmdale, California, on September 17, 1976. Photo courtesy of the National Air and Space Museum, NASM NASA-76-HC-765.

When NASA acquiesced to the public's naming request for *Enterprise* in 1976, science fiction fans constituted a reliable but limited base of popular support. By the end of the next year, however, American enthusiasm for spaceflight suddenly took new forms. In retrospect, 1977 represented a kind of annus mirabilis for spaceflight imagination. Ambitious planetary exploration spacecraft carried humanity's first messages to the cosmos—and into the popular imagination. At the box office, blockbuster profits from *Star Wars* (1977) and *Close Encounters of the Third Kind* (1977) inspired Hollywood executives to reinvigorate several

dormant science fiction properties. In addition, new forms of merchandising reinvented how Americans expressed their excitement through material objects. These trends both revived and reshaped the genre. At the same time, NASA officials harnessed the power of science fiction imagery to recruit a more diverse class of astronaut candidates for the Space Shuttle Program. By the end of the decade, spaceflight enthusiasm would never look the same again.

VOYAGER AND THE COSMIC OCEAN

In 1977, NASA launched two Voyager spacecraft from Earth to explore the solar system's outer planets. Their ambitious missions took advantage of a favorable planetary alignment and built on exploration research programs that had begun in the 1960s. In addition to scientific instruments, each planetary probe also carried a golden phonograph record encased in a decorative aluminum cover etched with a symbolic message. The symbols showed the location of Earth's solar system along with rudimentary instructions for using the enclosed stylus to play the contents. Born of an optimism that life might exist elsewhere in the universe and recognizing that Voyager represented one of humankind's first concrete missives beyond our own solar system, the spacecraft represented, as Carl Sagan famously stated, a "bottle [thrown] into the cosmic ocean." The paths of the spacecraft and their discoveries excited the scientific community, but the images and sounds included on the gold-coated copper records caught the public imagination.

The messages contained on the Voyager interstellar records expanded upon earlier thought experiments about communication without language. Working with fellow Cornell professor Francis Drake, author of the Drake equation used to calculate the probability of radio-communicative life in the universe, astronomer and astrophysicist Carl Sagan realized that the Pioneer 10/11 spacecraft launched in 1972 and 1973 to fly by Jupiter and Saturn would be the first human-built objects on trajectories and with enough speed to leave the solar system. The scientists had already been wrestling with the problems of language-based communication. Humans do not all speak the same tongues, they reasoned, and they use many alphabets. Could someone communicate without any of it? Sagan, Drake, and others started conducting thought experiments, sending each other symbolic messages through the mail without an explanatory "key," testing

whether they could decode them blind. Inspired by that idea, they designed an illustration explaining some rudimentary truths about Earth and humanity.

In the end, the image included on the Pioneer spacecraft contained a simple message conveyed in artwork done by Linda Salzman Sagan, then Sagan's wife. Two human beings, a man and a woman, each drawn naked, illustrated humanity without any culturally specific clothing, sized in reference to the spacecraft. Symbols along the bottom edge indicated that these beings lived on the third planet in their solar system, with a map locating that solar system relative to fourteen neighboring pulsars. Other symbols provided a key for understanding the message. Sagan called the plaques included on the planetary probes "visual greeting cards."

The Voyager interstellar record expanded upon the Pioneer plaques, compiling images, sounds, and music officially selected by a committee led by Sagan onto two sides of an LP record. (The disk was designed to be played at half speed to allow for twice as much storage capacity.) The content included analog recordings of images evoking human life on Earth. In addition, they included spoken greetings in fifty-five languages, representing 65 percent of the world population at the time. Ann Druyan curated the music selection. A committee that included Carl Sagan, Linda Salzman Sagan, Frank Drake, Alan Lomax, Druyan, and Jon Lomberg worked with producer Timothy Ferris and sound engineer Jimmy Iovine to finalize the selections. "Sounds of Earth" represents an early example of world music. Druyan consulted ethnomusicologists to select laudable examples from Western classical music (one of Bach's *Brandenburg Concertos*, for instance), along with music from around the globe, including Navajo and Chinese music, folk songs from Benin in West Africa, and an Indian raga. To illustrate recent music and the sounds of modern life, the records included "Johnnie B. Goode" by Chuck Berry. The compilation even includes humpback whales' song, only recently recorded. The final soundtrack carried humanity's message out to the outer planets—and into the popular imagination.

The popular response of those inhabiting the Earth was overwhelmingly positive. Despite attempts to keep the project quiet before the launches, rumors that the spacecraft included a message from humanity got picked up by reporters. In anticipation, CBS newsman and popular commentator Charles Osgood composed a poem in favor of including music on the spacecraft. Almost a month before the first launch, the *Wall Street Journal* broke the news that musical

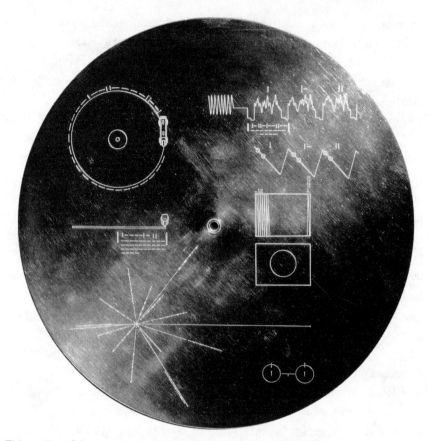

This replica of the engraved cover for the *Sounds of Earth* record, which was included on the Voyager planetary exploration probes launched in 1977, exists in the Museum's collections. The cover featured symbols that would allow an intelligent recipient to decode the location of Earth's solar system as well as instructions for using the enclosed stylus to play the phonograph record. Photo courtesy of the National Air and Space Museum, NASM 9A03167.

recordings would be on the planetary probes. Hundreds of letters poured into the project scientists in response. Although some criticized the effort, most expressed support and praise for how the project represented humanity. In addition to the positive coverage in the traditional press, the Voyager golden record even inspired a late-night comedy sketch performed on *Saturday Night Live* (SNL) on April 22, 1978. In a comedy segment titled "Next Week in Review," episode host Steve Martin and cast members Dan Aykroyd, Jane Curtin, and Laraine Newman

played psychics predicting the next week's news. According to Martin's off-the-wall character, Cocua, the aliens who had found the record had sent a message: "Send more Chuck Berry." The effort to compile a sampling of human creativity humanized the scientific project of exploring the solar system's outer planets. But the launch of Voyager was only part of how spaceflight enthusiasm took new forms in 1977.

STAR WARS

When *Star Wars* opened on May 25, 1977, the film offered cutting-edge special effects, a compelling adventure, and a new variation on the Buck Rogers archetype. The story centers on a blond hero, Luke Skywalker (Mark Hamill), who discovers his place in a galactic battle through the aid of a wise older mentor, Ben "Obi-Wan" Kenobi (Alec Guinness). Together with two robots called "droids," C-3PO and R2-D2, they assemble the rest of the core cast—Han Solo (Harrison Ford) and Chewbacca (Peter Mayhew)—in order to rescue Princess Leia Organa (Carrie Fisher). The scenes in the Mos Eisley cantina, in which Skywalker and Kenobi first book passage aboard the *Millennium Falcon*, deliberately evoke a cinematic Old West saloon, populated by a motley crew of movie monster aliens. Together, the assembled cast boards a named ship to complete their quest in a variety of space-based places.

Star Wars creator and director George Lucas linked the strength of the Western-inspired narrative formula to public excitement about spaceflight. When the Smithsonian's National Air and Space Museum hosted a dedicated *Star Wars* exhibit for the twentieth anniversary of the film in 1997, the online version of the exhibit began with a quote from Lucas identifying the movie's inspiring effect regarding real spaceflight: "I have a strong feeling about interesting people in space exploration. . . . And the only way it's going to happen is to have some kid fantasize about getting his ray gun, jumping into his spaceship, and flying into outer space." Notably, Lucas identified three of the major elements of the Buck Rogers archetype as the core of that connection.

Star Wars deliberately evokes film tropes from the 1930s. According to *The Star Wars Album*, published by Ballantine Books in 1977 to accompany the film's release, "Star Wars writer-director George Lucas was heavily influenced by both Flash Gordon and Buck Rogers." Indeed, the book speculates that the casting

of Grand Moff Tarkin (Peter Cushing), the movie's intended lead villain before Darth Vader (David Prowse) stole the show, was directly influenced by Lucas's memories of Charles Middleton's portrayal of Ming the Merciless in the Universal Studios weekly serials of *Flash Gordon*. According to *The Star Wars Album*, "Lucas has taken great pains to inject old-time movie magic back into Star Wars." Robots R2-D2 and C-3PO evoke comedic duos like Laurel and Hardy, the book suggests. Luke Skywalker resembles Johnny Weissmuller as Tarzan. Swordplay with lightsabers pay tribute to swashbuckling scenes played by Errol Flynn, Tyrone Power, and Basil Rathbone. *The Star Wars Album* compares Princess Leia Organa to a stereotypical female lead, characterizing her as a damsel in distress.

Contemporary reviewers drew the same parallels. *Newsweek*'s film writer likened the movie to "old Saturday serials" and "great old comic strips." In addition, he noted with odd specificity that Carrie Fisher's "great figure" evoked "the friendly voluptuousness we all remember in girls like *Buck Rogers*' Wilma, *Flash Gordon*'s Dale and *Mandrake the Magician*'s Princess Narda." *Time* magazine's reviewer called *Star Wars* "a combination of *Flash Gordon*, *The Wizard of Oz*, the Errol Flynn swashbucklers of the '30s and '40s and almost every western ever screened."

For all of the mainstream reviewers who extoled the return to classic moviemaking, however, there were also African American newspaper writers who recognized old stereotypes. Writing for the Boston-area *Bay State Banner*, Kay Bourne highlighted in her movie review the painful historical resonances of the scene in which the Mos Eisley bartender refused to serve the two droids. Although she noted that "Black actors don't seem to have any of the major roles," she acknowledged that "black people don't seem to have been lost in space either." Walter Bremond, who reviewed the movie for the San Francisco weekly *Sun Reporter*, disagreed vehemently. His review stated flatly that, "'Star Wars' is one of the most racist movies ever produced." Bremond contrasted the film's "brilliant special effects and colorful scenes that are simply loved by kids," with the glaring absence of people of color as main characters. "Apparently those who made 'Star Wars' believed that Black people will be extinct in the future, or maybe they felt that we will be left on Earth while they move on to new worlds." Lucas's homage to the film heroes of his childhood replicated the exclusionary whiteness inherent in the 1930s archetypes. "The Black child," Bremond concluded, "see[s] no likeness of themselves in that future world."

STAR TREK, STAR WARS, AND BURGEONING FANDOMS

Star Wars became a blockbuster, a term that had recently been popularized in association with Steven Spielberg's *Jaws* from 1975. Dazzled by the cutting-edge special effects, fans loved the movie's fresh take on the Western space adventure formula. In Washington, DC, the film set a new opening-week record at the historic Uptown theater. In a somewhat new phenomenon, people returned to theaters to watch the film multiple times. Graphic designer Michael Okuda recalled that in 1977, he and his friends saw *Star Wars* at the Cinerama Theater in Honolulu "almost every Friday night for most of that summer, and many times throughout the following year." Nationwide, the success of *Star Wars* fed a season of unprecedented box office revenues. That film's record-setting weekly gross receipts made up a sizable chunk of those totals. The outsized box office hit also became a cultural phenomenon, reshaping significant aspects of the film business, including movie merchandising.

Before *Star Wars* changed expectations, full-length movies rarely spawned toys. Comic strips, radio series, and television programs had the commercial staying power to drive product sales, but typically, individual films came and went too quickly to support much merchandizing. When George Lucas and 20th Century Fox offered the rights to make toys for their upcoming science fiction adventure, most companies therefore did not see the potential. Various accounts of the story recall that Mego Corporation, which might have seemed like a great fit given its success with *Star Trek* playsets and figurines, either declined at the Toy Fair in New York City in February or failed to return a phone call from Lucasfilm in time. Instead, just a month before the film was released, Cincinnati-based Kenner Toys got the license to produce *Star Wars* toys.

Significantly, the company's designers reinvented the action figure. Kenner's creative director, Bernie Loomis, suggested shrinking the toys from the eleven- or twelve-inch size originated by Mattel's Barbie and Hasbro's G.I Joe. Instead, *Star Wars* action figures would be "small enough to fit in a child's hand." The resulting 3.75-inch toys had lower prices than the larger figures. Indeed, implicit in the figurines' design was the idea that children would collect them to reenact scenes with multiple characters and not purchase just one larger figure to dress, undress, and playact adventures. Although Kenner also created a line of larger twelve-inch-tall figures, the smaller toys became so popular that other toymakers adopted the size as an industry standard. Hasbro relaunched G.I. Joe in the smaller size in 1982.

But the fast timeline between the film's breakout summer and the winter gift-giving season did not give Kenner enough time to produce products. In a true story that has become legend in toy marketing, Kenner managed the looming holiday shortfall by selling an "Early Bird Certificate Package" in the fall and winter of 1977. The idea was so unconventional that traditional department stores such as J. C. Penney and Sears declined to participate. But smaller regional stores saw an opportunity. Available for sale only between the initial announcement in September and the end of the promotion on December 31, the packages primarily contained mail-in rainchecks. Returning the certificates put the holders on a list to have a set of four action figures (Luke Skywalker, Princess Leia, R2-D2, and Chewbacca) mailed to them before they became available in stores in the spring of 1978. Also included in the package were a *Star Wars* Club membership card and some stickers, tangible expressions of the recipient's excitement for the movie. Significantly, the Early Bird Certificate Package also included a cardboard display illustrating all twelve forthcoming action figures. Labels printed on the cardboard stage showed where each one went, an enticement to purchase complete sets as soon as they were produced.

Kenner's ploy worked. Thousands of people spent between seven and ten dollars apiece for as many as 300,000 of the packages, buying the mere promise of toys to be delivered later. The strategy allowed Kenner to survive the interval between the movie's initial excitement and their actual production capacity. What followed was a buying frenzy. *Star Wars* sold $100 million worth of toys between 1977 and 1978. The first-generation sequels, *The Empire Strikes Back* (1980) and *Return of the Jedi* (1983), built on that momentum.

The toys' wide appeal accounted for some of their success. As author and toy historian Sharon Scott explained, "Although Princess Leia was the only female character among the original line of figures, her presence was enough to encourage boys and girls to play with *Star Wars* toys together." The resulting sales figures were astounding. During the run of the three movies in the original trilogy, Kenner sold an average of 22 million *Star Wars* toys each year. According to one accounting, "The average kid owned 11 *Star Wars* toys, and Kenner enjoyed an unprecedented 80- to 85-percent market penetration." Director George Lucas, who traded a significant portion of his directorial salary on *Star Wars* for the rights to any sequels and negotiated the full rights to all the merchandizing in a subsequent contract, seemed uncommonly prescient in retrospect.

STAR TREK, STAR WARS, AND BURGEONING FANDOMS

The packaging of *Star Wars* toys encouraged consumers to buy entire sets. This was not new. In the 1950s, the Louis Marx Company, producer of *Flash Gordon* and *Space Patrol* playthings, asked, "Have you all of them?" on its boxes. But *Star Wars* toys did more than just ask the question; Kenner provided a visual catalog on its packaging. Action figures came mounted in individual plastic bubbles on printed cardboard cards. The first cardbacks depicted all twelve available figures (and three vehicles plus an action figure stage). As the available roster expanded, the number of toys pictured increased. Other accessories also encouraged purchases. Beginning in 1979, Kenner produced carrying cases for the mini action figures. These began as simple rectangular carriers, although later examples from the early 1980s came shaped like busts of Darth Vader or C-3PO. Each one contained plastic trays divided into different-sized compartments. Significantly, printed inserts showed where the figures should go. The carrying cases also included stickers to label the slots with the names of particular characters. The implication was that consumers should buy enough to fill each space and avoid having empty slots.

Populating the toy line with so many different figures also affected how children played with them. Overseeing any subgrouping of the characters, players could reenact scenes from the films or invent new ones. The figurines could stand reasonably well, and in addition, the feet had small indentations or holes that allowed them to be positioned on play sets or on flat bases studded with little pegs. As a result, children could easily stage scenes with multiple toys at once. The toys' design did not push players to embody the hero. Certainly, the main character remained undeniably male, white, and blond, and the overarching conflict still centered on the opposition between the dark and light sides of the Force. But a broader range of individualized characters shared the storytelling spotlight. Unlike the diametrically opposed sets of aliens and spacemen that populated playsets in the 1950s, which were visually identified by color as inalterably on one side or the other, the universe of *Star Wars* toys included dozens of figures that were not easily categorized. Boys and girls could play with all kinds of aliens, droids, or humans. Such roleplaying did not necessarily shift the focus away from the main characters entirely, but the wide range of possible characters broadened how players encountered the Other.

In the end, *Star Wars* toys not only shaped the market for producing new material goods, but it also helped to create the pop culture memorabilia market. As toy historian Scott records, "In 1985, after producing more than 100 figures

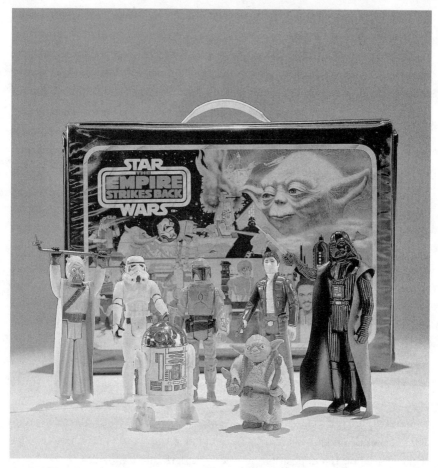

The interior of the carrying case for action figures such as these ones from the *Star Wars* sequel *The Empire Strikes Back* (1980) encouraged its owner to collect all of the figurines that fit the various individually labeled and sized slots. Photo courtesy of the National Air and Space Museum / Eric Long.

from George Lucas' intergalactic epic, Kenner quit producing *Star Wars* toys." The resulting scramble for existing toys revealed a new market: collectors. Writes Scott, "The *Star Wars* figures introduced the concept of collectible toys. When vintage *Star Wars* toys in good condition became quite expensive, consumers began to realize that other toys in good condition might be valuable over time as well. From the 1980s onward, it became common for Americans to purchase toys and keep them for collectible purposes."

STAR TREK, STAR WARS, AND BURGEONING FANDOMS

The same marketing tactics that encouraged multiple purchases when the toys were initially produced also facilitated collecting. *Star Wars* action figures could be identified and dated based on the number of figures shown on the cardbacks. Indeed, the cardbacks themselves, even without the corresponding packaging bubbles or related toys, became collectors' items. This new kind of toy collecting also popularized the idea that "mint-in-box" items are more monetarily valuable than those used for play.

The long-standing effects of the success of *Star Wars* toys can be seen in how prospective summer blockbuster films have been merchandized ever since. The unexpected juggernaut fundamentally reshaped the relationship between media companies and product manufacturers. Movie houses selling licenses to upcoming releases gained the upper hand, demanding higher prices for the rights to create branded merchandise. Kenner's experience also rewrote production schedules. Eager to avoid a predicament like the one that Kenner faced in 1977, toymakers and film companies reorganized their timelines to ensure that licensed merchandise would be ready well in advance of likely summer blockbuster movies.

In addition to all the changes to movie merchandizing ushered in by *Star Wars*, the popular response to the film made movie studios and production companies reconsider space science fiction as a potentially profitable genre. The release of Steven Spielberg's *Close Encounters of the Third Kind* (1977) in November only reinforced the trend. Suddenly, space stories seemed viable. Gene Roddenberry had been working with Paramount executives on a new television series called *Star Trek: Phase II*. In response to the material that was being produced and after the successes of the summer blockbusters sank in, Paramount revamped the venture. Rather than aim for a fall television series, the project became a major motion picture. In addition to spending $46 million on its production—the most money spent on a film at the time—Paramount doubled down on the investment by "blind-booking" the promised movie into theaters for the 1979 holiday season. That commitment meant that if the studio did not meet the promised December 7 opening date, it would owe theater owners cash totaling close to $35 million. In the end, Paramount debuted the movie at a neighborhood theater in Washington, DC in order to hold the world premiere party at the still relatively new National Air and Space Museum building on the National Mall. The investment paid off. *Star Trek: The Motion Picture* (1979) grossed $82 million.

Other entertainment executives also saw the success of *Star Wars* as a model to be imitated. On television, Glen A. Larson's *Battlestar Galactica*, a project that he had been shopping for years, finally appeared on ABC for the 1978–79 season. The show began with a film-length episode played on television, followed by weekly appearances. After its cancellation the next spring, diehard fans briefly sparked its revival as a follow-on television program, *Galactica 1980*, which lasted just ten episodes. Despite the short total run, the two series inspired a cult following. Universal also tapped Larson to revive the *Buck Rogers* franchise with a television film. *Buck Rogers in the 25th Century* (1979) appeared in theaters nationwide in March, followed by a weekly television program that aired on NBC for two seasons between fall 1979 and spring 1981. In addition to comic books and novelizations, Mego produced two different lines of action figures, Milton-Bradley created a board game, and other merchandise was sold, including a lunchbox.

In the revival of *Buck Rogers*, however, the racially defined enemies that originally defined the character and his universe proved untenable. The new series turned its attention from the Mongol hordes to the highly sexualized Princess Ardala (Pamela Hensley) in the first season. In the second season Rogers (Gil Gerard) worked not only with Colonel Wilma Deering (Erin Gray) but also with the bird-person Hawk (Thom Christopher). The revival of *Flash Gordon* also took a very different tone, abandoning the Asian stereotypes included in the "yellow peril" versions from the 1930s. After a long period of development, a new film of *Flash Gordon*, featuring a soundtrack played by legendary rock band Queen, appeared in 1980. The decision to play the whole thing as a campy sendup subjected the film to significant criticism at the time—and made it a cult classic. From *Battlestar Galactica* to *Flash Gordon*, fans found new characters and storylines to admire in the years after *Star Wars* debuted.

INCLUSIVE SPACE

While these projects were in development, major changes were also underway in NASA's astronaut corps. To take advantage of the space shuttle orbiters' forthcoming capabilities, NASA recruited a new class of prospective astronaut in the late 1970s. The agency's desire to have a more diverse group reflected changes in the social, cultural, and legal environment. The 1964 Civil Rights Act barred segregation in public places as well as job discrimination based on race, color, religion,

sex, or national origin. By 1966, NASA had its own sweeping antidiscrimination policy, which included not only race, gender, and creed (among other factors) but also physical handicaps, a basis for discrimination not fully addressed nationally until the Americans with Disabilities Act of 1992. Although progress was slowly being made in dismantling discrimination in many sectors at NASA, the most visible face of the agency remained entirely white and all male. Agency leaders wanted the astronaut corps to look more like the face of America. What few expected was that the best method of promoting that vision would draw upon the widespread popularity of space science fiction.

NASA officials hoped that changing the application requirements would lead to more diverse applicants. As planned, space shuttle missions required two very different kinds of astronauts. Mission specialists with backgrounds in science, engineering, medicine, or mathematics would conduct experiments, while pilot astronauts, still drawn from aviation backgrounds, would command and fly the missions. NASA officials knew that the search for pilot astronauts was unlikely to yield demographically diverse applicants. Both military and commercial pilots remained largely homogenous in race and especially gender. The ban on women flying military aircraft, in place since the end of the Women Airforce Service Pilots program in 1944, had only just been lifted in 1974 for the Navy and Army and in 1976 for the Air Force. Those changes had occurred too recently to prepare applicants with enough experience for the astronaut corps. Moreover, the first women had only just entered the US military academies in the fall of 1976 as a result of a law signed in 1975 by Gerald Ford; in 1977, they were still three years away from graduation. In contrast, the fields from which mission specialists were likely to emerge included more women and people of color. But when agency officials checked the demographic information included in the applications that had been received by February 1977—only months before the proposed astronaut selection—the files did not indicate the kinds of diversity that the agency needed. Of the 1,500 applications submitted, approximately thirty identified as Black or people of color, and only seventy-five were women. NASA clearly had a problem.

To improve the numbers before the new class was announced, NASA administrator James Fletcher contacted *Star Trek* actress Nichelle Nichols, whom he had just seen at the *Enterprise* rollout. He suggested hiring her to conduct a public relations campaign on behalf of astronaut recruitment. Nichols was a great fit to promote new vision for real spaceflight. Just a couple of years earlier, she had

become interested when NASA sent aerospace engineer Jesco von Puttkamer to a *Star Trek* convention in Chicago where she was appearing. As she recalled years later, "The moment I heard him speak, I was hooked."

From that point on, Nichols began talking about both *Star Trek* and real spaceflight in her speeches. She got so invested that she became a National Space Society board member. In her first appearance in that capacity, she challenged NASA officials to "come down from your ivory tower of intellectual pursuit, because the next Einstein might have a black face—and she's female." As she told me, she did not know at the time that many in NASA's leadership, including Administrator James Fletcher, were in her audience.

When Fletcher met with her to discuss the public relations campaign, Nichols pressed the NASA administrator about the agency's commitment: "I said, if I take this on, and this becomes [real], I'll be your worst nightmare.... I intend to speak before Congress for this, and to all the newspapers and all the television [stations].... I'm going after people with PhDs in physics, chemical engineering.... And these people, I will not insult by trying to convince them of something that is not possible." She warned Fletcher that if the final selection group did not include any of the people she recruited, she would protest directly to Congress in person. Nichols agreed to help because she saw the problem. During her visits to NASA in preparation for the campaign, Nichols remembered that she saw diverse people, "working in every level of the agency, from maintenance to management. *Except* for astronauts."

Although the official NASA contract was with Nichols's company, Woman in Motion, the six-month public relations campaign focused on Nichols's personal celebrity as a fictional television spacefarer. The image of the woman who played Lieutenant Uhura in a NASA jumpsuit caught the interest of the press and public. Nichols visited aerospace companies, NASA sites, and the Pentagon looking for qualified applicants in the existing workforce. She spoke in person on campuses and to organizations across the country, seeking out audiences that might contain likely aspirants. In Chicago, for instance, she served as the keynote speaker at an awards dinner organized by the National Organization for the Professional Advancement of Black Chemists and Chemical Engineers. As illustrated by the annotated map of the contiguous United States that she included in the final report, Nichols made thirty-four stops between February and the beginning of June. In addition to the interviews with local radio, television, and newspapers,

Nichols made national appeals via outlets that included *Good Morning America* on ABC and *People* magazine. The scripts for the various public service announcements that she recorded for radio and television broadcast ended with the appealing tagline, "Space is for everyone."

Nichols's encounters confirmed the source of NASA's recruitment problem. Thanks to *Star Trek*, the public could easily picture a crew of men and women of different races in space. But many simply did not believe that the agency was really interested in opening those roles. As Nichols concluded in her final report, "There were no applications because there was no trust." During various appearances, college and university students warned her that NASA was using her. She told them, "I know. And I'm using NASA too. But if you don't apply, then they are right. If you qualify and you really wanted to [apply] and you don't apply, then they are right." Nichols's campaign helped change perceptions and NASA's astronaut corps.

According to the summary statistics that Nichols reported, of the eight thousand submissions that the agency received, nearly fifteen hundred were from women. The numbers for applications from African Americans and Asian Americans also improved. Several prominent mission specialists directly credited their decisions to become astronauts to Nichols's campaign. In particular, Mae Jemison, a physician who joined NASA in 1987 and became the first African American woman astronaut, stayed in touch with Nichols for years. When the large class of thirty-five new astronaut candidates was announced on January 16, 1978, they included six white women, three African American men, and one Asian American man. The media could not get enough of them. One of those women, Kathryn Sullivan, recalled that the excitement about the diversity in the group led the new astronaut class to conclude that the press thought they were "ten interesting people and twenty-five standard white guys." Regardless, for NASA, a focus on astronaut profiles also gave the media something to focus on while the dates for the first flights by the Space Shuttle Program slipped into the 1980s.

CAPRICORN ONE AND *ALIEN*

As the 1970s ended, popular depictions of spaceflight conveyed a pervasive sense of disillusionment. The era's cynicism permeates *Capricorn One*, a feature film released by Warner Brothers in June 1978. Writer and director Paul Hyams said

he had the idea for the film in 1972 but could not get it funded until after Watergate made stories about deceit and corruption more relevant. The thriller depicts a space mission to Mars executed as a complete fraud. As mission control monitors a real launch, a NASA official extracts the unwitting crew, played by James Brolin, Sam Waterston, and O. J. Simpson. After the astronauts are whisked away to a secluded location and the conspiracy revealed to them, Dr. Kelloway (Hal Holbrook) appeals to the crew to perpetrate the deception: "Nobody gives a crap about anything anymore. People close their garages and triple-lock their doors, hide under their beds. They're even afraid to turn on their television sets for fear of what they might find out on the evening news. There's nothing more to believe in. You want to blow this whole thing wide open? God knows what it might do to everybody." As reporter Robert Caulfield (Elliott Gould) investigates various inconsistencies, the astronauts plot their escape, and the conspiracy begins to unravel. The film ends with a series of suspenseful chase scenes and the imminent revelation of the vast conspiracy underlying the deception.

Likewise, Ridley Scott's *Alien* (1979) offers a dystopian vision of spaceflight. Part of what made the film so successful—in addition to the pacing and effects that delivered shockingly memorable moments—was the way that it deliberately subverted the conventions of the space adventure genre. Working with Ronald Shusett to write the script, Dan O'Bannon turned the genre disruption he had practiced in *Dark Star* from satiric to terrifying. Indeed, *Alien* includes several scenes that are so memorable as to be evoked in just a few words: the "facehugger" and the "chest-burster." Critics had mixed opinions about the film, but it performed well with audiences during a movie season that *Newsweek* dubbed, "America's Scary Summer." *Alien* broke the *Star Wars* record for opening, earning $8.5 million in select theaters before opening nationwide.

O'Bannon and his cowriters deliberately wrote characters that were not clearly identified by race, ethnicity, gender, or other presuppositions. *Nostromo*'s workers are a racially integrated cast of men and women working together, not because it illustrated some futuristic ideal, as it had in *Star Trek*, but as a motley, workaday group thrown together by the requirements of their jobs. In this depiction, the adventure and heroics of space exploration transform into the tedium and drudgery of long-haul trucking, driven by profit for the benefit of an impersonal and uncaring Company. Both the casting and the set design reflect this. The actors are collectively almost a generation older than the fresh-faced, earnest

young heroes depicted in kiddie space television shows in the 1950s. The workspace is lived-in. *Nostromo* is not powered by a faster-than-light engine that skips across space, but rather with sleeping pods that hold the crew in suspended animation as they endure the long flights. These are working-class stiffs trading time away from their homes and families for their salaries. Indeed, in the incident that sets up the film's action, when the master computer, Mother, awakens the crew to investigate an unexpected signal, some of their first conversations are squabbles about their shares in the mission's profits. The contrast with the earnest cohesive crews usually depicted in American space science fiction is deliberate.

The film also breaks with the Buck Rogers archetype and thus upends audience expectations by making the hero a woman: Warrant Officer Ellen Ripley (Sigourney Weaver). By the middle of the action, the alien has dispatched all the white male leads. Only the African American chief engineer, Dennis Parker (Yaphet Kotto), and two white women, navigator Joan Lambert (Veronica Cartwright) and Ripley, remain to fight. Weaver's performance established a new female character type, not a sidekick/love interest nor a femme fatale, but a real female science fiction action star.

Although the inclusion of Kotto's character does disrupt the all-white space crew, *Alien* follows convention by casting the film's only other Black actor as the alien. The initial vision for the creature called for a transparent or translucent costume in order to avoid the "man-in-a-rubber-suit syndrome" that undercuts believability. Scott's idea for the kind of body type that would fill the costume had a rather disreputable inspiration, however: "a photo of the notorious German film director Leni Riefenstahl standing next to a very tall Nubian." After the team considered and rejected contortionists, football players, and wrestlers in their search for otherworldly physicality, someone associated with the production discovered six-foot-ten Nigerian visual artist Bolaji Badejo in a London pub. Badejo's slender build and choreographed movements turned his Blackness and physical difference into something literally alien, much as six-foot-seven Lamar Lundy played the Giant Cyclops in *Lost in Space*. Like Lundy, Badejo remained obscured by the costume, which was finally made opaque. Moreover, the alien did not get much screen time, a deliberate choice to build suspense and tension.

Despite the film's R rating for violence, gore, and language, Kenner created branded toys for children, including an eighteen-inch doll of the main creature. Plans for figurines of the human cast never came to market, however. The

company best known for producing baseball cards, Topps, created a set of collectible *Alien* trading cards. By showing scenes from the film or the cast photographed in character, the cards reinforced the depiction of well-worn blue-collar space workers, not eager young cadets.

While the 1970s witnessed the transformation of science fiction fandom from a disparate network of small, local groups into a national force and the success of *Star Wars* transformed movie merchandizing, in actual spaceflight, the Space Shuttle Program's delays had real consequences. Proposals to boost Skylab to a higher, more stable orbit, thus extending its life, required the new vehicle. Cosmic bad luck doomed the orbital laboratory, fueling a popular response that reflected the time. Increased solar activity warmed the Earth's upper atmosphere, expanding it slightly. The resulting increase in drag hastened its deteriorating orbit. By summertime in 1979, it became clear that the spacecraft would fall to Earth uncontrolled. On the ground, the media debated the chances that debris might hit a populated area.

If there was such a thing in the 1970s as what later became known as meme culture, Skylab's fall became that. Stores sold posters with cut-out protective helmets that could be assembled from the thin cardboard pieces. T-shirts and hats with bull's-eyes became a joke. Flimsy plastic hard hats hit store shelves as novelty costume items, ostensibly to protect wearers from the plummeting spacecraft. Johnny Carson, the host of *The Tonight Show*, capitalized on the trend, performing a satirical sketch in favor of letting Skylab fall. As the orbital laboratory scattered across the Indian Ocean and Western Australia in August, its demise became a running joke. It would take the early success of the space shuttle to revive spaceflight enthusiasm in a new form for a new audience: the children who became known as Generation X.

CHAPTER 5

Generation X, the Space Shuttle, and Promoting Education

In the mid-1980s, one of the most popular toys of the decade joined forces with a government-endorsed effort to interest schoolchildren in spaceflight. Cabbage Patch Kids, dolls that had names and adoption certificates, became the "it" toy of the holiday season—and the cause of physical fights in toy stores—after they were introduced in 1983. By 1985, a new version of the doll carried the endorsement of the Young Astronaut Program, a private sector program coordinated by the White House and NASA to promote children's interest in spaceflight. The dolls in white spacesuits and plastic helmets arrived in cone-topped cylindrical silver boxes reminiscent of science fiction rockets. One such "Kid" was presented to President Ronald Reagan at the White House on October 17, 1985. Another, named Christopher Xavier, flew into space aboard the Space Shuttle *Challenger* on October 30, 1985, returning to Earth on November 6. For a new exhibit about the space shuttle, International Space Station, and future human spaceflight, I wanted to acquire the space-flown doll to illustrate how the shuttle program used toys to attract students' attention.

I started my search by emailing NASA's Johnson Space Center (JSC), which kept track of shuttle payloads. At first, my research raised more questions than it answered. According to the Memo of Authentication from STS-61A, the Official Flight Kit (OFK) included "1 doll," designated to be "returned to Headquarters of Young Astronaut Program." No information existed beyond that. The nice people at Babyland General, the official Cabbage Patch Kids headquarters in Cleveland, Georgia, were surprised at my inquiry. They believed one or both dolls were at the Smithsonian. My searches showed that was not the case. The space-flown doll

SPACE CRAZE

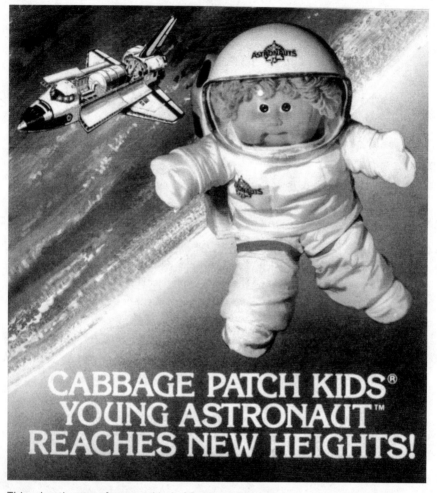

This advertisement for a new kind of Cabbage Patch Kid, one sponsored by the Young Astronaut Program, brought the excitement for the dawning space shuttle era together with the wildly popular 1980s doll. Image courtesy of Original Appalachian Artworks, Inc.

was not held by the National Air and Space Museum or the National Museum of American History.

I never found either the space-flown doll or the one used in the presidential ceremony. In May 2011, the Reagan Library confirmed that its records showed that one Cabbage Patch Kid had been received on October 17, 1985. Rather than

add it to the presidential gifts collection, however, the White House gave it to charity. Somewhere in 1985, a child who got a sought-after Young Astronaut Cabbage Patch Kid from a toy drive unknowingly got the very doll that had been presented to the president.

I am still sorry that the exhibit did not include one of the Cabbage Patch Kids because they embodied key features of the period's spaceflight enthusiasm. Just as the Space Shuttle Program's astronaut corps included both men and women of different races, the Young Astronaut "Kid" was available as either a boy or girl, with a variety of hair shades and different skin tones. The original Kids had been handcrafted soft sculptures created by artist Xavier Roberts. Between 1982 and 1989, Master Toy Licensee at the time, Coleco, replicated his artisanal process by using computers to assign different eye, hair, and skin colors to each figure. The uniqueness of each doll fueled the Cabbage Patch Kid phenomenon. Likewise, the spaceflight enthusiasm of the 1980s embraced both boys and girls of different backgrounds.

More, the dolls illustrated the era's explicit outreach to youth. With the beginning of the Space Shuttle Program, several individuals and organizations worked to transform popular interest in spaceflight into supportive structures for a generation perceived to be at risk. Observing a growing cohort of latchkey children, with many being raised in single-parent homes, policymakers worried about threats to those children's futures. Beginning in 1981, First Lady Nancy Reagan introduced her "Just Say No" campaign against drug use. At the same time, the emergence of AIDS (acquired immunodeficiency syndrome) raised the stakes for teen sex or intravenous drug use. By 1985, Tipper Gore helped found the Parents Music Resource Center, which issued parental advisory labels warning against sex and violence in rock or rap music lyrics. Rather than issue warnings, spaceflight proponents aimed to inspire the next generation, and commercial brands sought to associate themselves with the cause. The Reagan administration welcomed that combined effort as it worked to put spaceflight on a private footing. Especially in the early 1980s, spaceflight enthusiasm became an explicit goal of policymakers and innovators alike. For fans, being excited about real and fictional spaceflight in the 1980s also meant participating in active campaigns for change, not just passive consumption and admiration.

LOOKING FORWARD TO THE SPACE SHUTTLE

In the early 1980s, the cohort born between 1964 and 1980 gained prominence as a receptive audience for appeals about spaceflight. First called the "baby bust" of the 1970s, and later the "twentysomethings" of the 1990s, they became best known as "Generation X." This generation first encountered NASA's human spaceflight program through repurposed Apollo hardware. The oldest Gen Xers saw the three Skylab missions in 1973 and 1974 and the Apollo–Soyuz Test Project's orbital détente in 1975. Almost none of them remembered seeing the Apollo moon landings. If anything, Generation X grew up hearing about Space Age excitement while awaiting America's next-generation space vehicle.

The space shuttle was a reusable launch vehicle that was properly called the Space Transportation System, the initials for which, STS, formed its mission designations. The spacecraft's basic form had been set in the 1970s as a result of many compromises in cost, function, and form. When assembled for launch, the final design had three pieces: a white delta-winged orbiter, an external fuel tank (ET), and two solid rocket boosters (SRBs). "Space shuttle" could mean the full launch configuration (including the ET and SRBs)—sometimes called a "full stack"—but many people used the term to mean the orbiter alone. The reusable orbiter featured a large payload bay in the back for satellites or science experiments, as well as a middeck and flight deck in the front that could carry as many as eight astronauts. With wings and wheels, it launched like a rocket and landed like a glider. Flights were originally planned to occur almost weekly. Planners hoped that reusing the same hardware would dramatically reduce costs while the system's reliability would increase access, opening low Earth orbit to business opportunities as well as government programs.

After the initial rollout of the Space Shuttle *Enterprise* in 1976 and its three test flights in 1977, a significant delay occurred before the first launch in 1981. In the interim, commercial products took some liberties with their imagination of what the new system might deliver. For instance, in 1977, the King Seeley Thermos Company, best known as the manufacturer of brand-named insulated bottles, issued a metal Space Shuttle Orbiter Enterprise lunchbox. The front showed an artist's rendition of OV-101 (orbital vehicle 101) during a mission. The payload bay doors are open, and three astronauts float above it in space, tethered to the orbiter but otherwise unsecured. On the back of the lunchbox, the full stack lifts

off from Launch Pad 39-A, framed on a monitor with computerized numbers counting down on the left-hand side, as if the viewer were a mission controller. The orbiter's nose and the white external tank in that view suggest that the image derived from early system concepts.

Some of the lunchbox's depictions exaggerated what the vehicle might do. On one side, two different orbiters approach a massive space station emblazoned with the number "7," suggesting that it is one of many. The bottom picture was the most fantastical. A spacesuit-clad but untethered astronaut rides a craggy red asteroid, cowboy-style, while attaching a large clamp to pull the rock into the nearby orbiter. Another payload bay clamp grapples a different asteroid. The rear stabilizer of the futuristic orbiter carries the name "Asteroid Mining Co." The artist's depiction envisioned possible uses beyond even the most ambitious hopes for the orbiters' commercial applications.

This King Seeley Thermos lunchbox from 1977 imagines the Space Shuttle *Enterprise* supporting multiple spacewalks far beyond the payload bay. A side panel shows a complex space station, #7. Until the space shuttle began flying in 1981, many commercial products reflected little understanding of the vehicle's actual capabilities. Photo courtesy of the National Air and Space Museum.

The popular film *Moonraker* (1979) also capitalized on the hype surrounding the upcoming vehicles, even as the script took significant liberties with the orbiter's capabilities. Inspired by the success of *Star Wars*, the eleventh James Bond film (and the fourth starring Roger Moore) devoted a large budget to putting Ian Fleming's iconic British secret agent in a space-themed adventure. The first frames show a space shuttle orbiter called *Moonraker* being stolen from the back of a 747. Powered by the vehicle's three main engines (which, in reality, required the external tank to function), the orbiter flies away and seemingly crashes.

In this spin on a science-fiction tale, the supervillain playboy Hugo Drax (Michael Lonsdale) deploys assassins marked as different by their race or physicality. As Bond begins to unravel Drax's diabolical plan to poison humanity in order to repopulate the Earth with superhumans, a maniacal Asian henchman named Chang (Toshiro Suga) tries but fails to kill him. Chang's replacement, the assassin Jaws (played by Richard Kiel, who was more than seven feet tall) pursues Bond throughout the rest of the film, even following him into space. In contrast, the people selected by Drax to repopulate the Earth—pairs of attractive young white men and women—seem oddly reminiscent of the space ark passengers depicted a generation earlier in *When Worlds Collide* (1951). Although the beautiful women who surround Drax are white, technicians of different races operate the workstations when Drax launches multiple orbiters from his secret lair in the Amazon. *Moonraker* presents an odd mashup of fictionalized visions of the forthcoming launch system, which was slated to carry integrated crews of men and women, combined with the Bond film series' standard tropes. In the end, moviegoers enjoyed the mix. *Moonraker* earned $33.9 million at the box office, positioning it one of the top ten films of the summer and making it the highest-earning Bond film to date.

A PRO-SPACE ORGANIZATION AND A STORIED LAUNCH

Fictional adventures did not satisfy spaceflight advocates, who had begun to express frustration as they waited for the next American human spaceflight. In the lull before the space shuttle began flying, the oldest members of Generation X attempted to exert their influence. In the fall of 1980, a handful of students at the Massachusetts Institute of Technology (MIT) founded Students for the

Exploration and Development of Space (SEDS). The multicampus student group quickly formed chapters at Yale University and George Washington University, joining the founding chapters at MIT and Princeton. In 1981, the group's president, Peter Diamandis, published a brief call-to-arms in *Omni* magazine. Printed in the magazine's "Forum" section, the letter appealed to fellow college students, warning them that the "steady deterioration of the US space program's goals and budget endangers our future." Diamandis called on college students across the country to organize their own chapters of SEDS with the ultimate goal of creating a "national student pro-space organization."

Things finally began to change in 1981, when NASA launched STS-1. It was a daring mission. The first time that the vehicle ever flew in space, a crew was aboard. The engines had been fired on the launchpad, and *Enterprise* had tested the landing system, but the full vehicle had never flown. When astronauts John Young and Robert "Bob" Crippen launched on April 12, the United States achieved a human space flight for the first time since the Apollo–Soyuz Test Project flights of 1975, almost six years earlier. The flight completed thirty-six orbits of the Earth before returning to land at Edwards Air Force Base in California, which offered more leeway for a first orbital landing than Florida's runway would.

Both the launch in Florida and the subsequent landing in California drew huge crowds. Joe D'Agostino, shuttle operations support manager at what became NASA's Armstrong Flight Research Center, remembered how the local community turned out, "In addition to our employees and those of Rockwell, [the] people of the Antelope Valley who saw Shuttle *Columbia* towed down the streets of Lancaster on the way to Dryden for the ferry flight to Kennedy now came out to see it return from space." The parking area created on the dry lakebed at Edwards Air Force Base contained hundreds of cars, campers, and recreational vehicles. Officials estimated that at least 200,000 and as many as 300,000 people saw the first space shuttle mission touch down on April 14, 1981. Radio and television carried the news. As space shuttle missions continued thereafter, launches and landings became collective social and cultural events, attended or viewed by thousands of people who expressed their excitement for spaceflight by showing up to witness it in person.

Crippen recalled being impressed by the public reaction when he returned, "Everywhere we went, we felt the sense of pride the country had. People everywhere felt they were a real part in it, not just in this country, but abroad as well,

from Europe to Australia. It was out there, from small towns to big cities." Likewise, Young, who walked on the Moon in Apollo 16 in 1972, thought that the public response after STS-1 was especially enthusiastic: "We had parades in Apollo where nobody came except the people who were in the parade. . . . But we had parades all over the country after STS-1 and there were all kinds of people there."

Some of those enthusiasts solidified their excitement through souvenirs. Among the memorabilia from the first shuttle launch was *Space Shuttle—A True Space Adventure*, a limited-edition record specifically for children. Produced by Kid Stuff Records, the album contained "actual conversations broadcast from outer space between astronauts Crippen and Young and mission control as well as a special message from the President of the U.S. Ronald Reagan." The record itself was a "picture disc." Instead of black vinyl, the disc carried photographs on both sides: the front showed the first launch of *Columbia*, and the back showed the orbiter in space. Such picture discs did not render great sound quality, making them better suited to being framed as decorations or saved as collectibles.

Other tributes allowed the public to relive the historic moment in different ways. The rock band Rush was so inspired by watching the launch from the VIP seating in Florida that it recorded a song that incorporated mission transmissions. "Countdown!" appeared on the album *Signals* in 1982. IMAX cameras captured the launch and landing for a film that became *Hail, Columbia* (1982). And film of *Columbia*'s launch also became one of the first images broadcast on MTV (Music Television). The new network, which debuted on August 1, 1981, used a montage of the *Columbia* launch mixed with Apollo footage. Edited to include a neon-colored MTV flag and accompanied by electric guitar riffs, space imagery became the channel's initial station identification. MTV's innovative branding, overseen by creative director Fred Seibert, linked the new all-music channel to spaceflight achievements because MTV represented a giant leap in television.

Diamandis's spaceflight advocacy group fed off the growing excitement. SEDS chapters sprang up on other campuses. In 1982, less than two years after the group's founding, the organization held its first conference in Washington, DC. That meeting drew college students from across the country to hear high-profile speakers including Rep. Newt Gingrich (R-GA) and NASA Deputy Administrator Hans Mark. The organization's growth then expanded to include younger members. At its second conference, the SEDS executive board discussed beginning a "Junior SEDS program." By 1984, brochures for SEDS, which billed the group as

the "world's largest student space enthusiast organization," included provisions for founding affiliate chapters at high schools. Despite having originated in frustration about the pace of the American space program, SEDS's attitude remained positive. The organization was optimistic about the future of spaceflight and the role of the United States in that future, especially if private development could be encouraged alongside government efforts.

LEARNING YOUR WAY AROUND THE ORBITER

Soon after the first space shuttle flight, publishers began to produce new materials for young people dreaming about a future in space. In 1982, Little, Brown published Wayne McLoughlin's *The Space Shuttle: A Complete Kit in a Book* as a part of its "Build It Yourself Series." The full-color perforated cardboard pieces came in a book with detailed instructions for assembling them into a miniature orbiter (complete with cargo bay doors that opened and shut). The book's explanations offered high hopes for the real vehicle's reusability, imagining orbiters being refurbished for new missions as quickly as every seven days. The book also touted the kit's educational potential, "The builder, whether an adult hobbyist or a twelve-year-old space enthusiast, is assured of an entertaining and educational experience while gaining a glimpse of the future and the exciting new frontiers of space." Readers / assemblers could literally get their hands on the new technology.

Likewise, *The Space Shuttle Operator's Manual* offered readers a chance to immerse themselves in the new vehicle's details. Two curators from the Smithsonian's National Air and Space Museum wrote the highly successful book as a step-by-step guide. The *Manual* took a reader through shuttle missions from launch to landing. Diagrams illustrated common actions as lists of tasks; foldout charts delineated each switch on the flight deck consoles. The book offered everything that a young enthusiast could want to know about the orbiter's systems as well as explanations of the many acronyms and bits of jargon used by those in the shuttle program.

The appeal of *The Space Shuttle Operator's Manual* lay in its intimate, first-person address to the reader, who was invited to imagine himself or herself participating in a real mission. For instance, after an explanation of the vehicle's basic parts and flight profile, the explanation of launch procedures began, "You and the rest of the crew board the Shuttle about two hours before launch." Each

timeline of mission events contained a transcript of the voice transmissions that would accompany each step, with the lines labeled *G* for Ground Controller and *Y* for You. The introduction to chapter 6 read simply, "The Space Shuttle will fly many different missions. Here are five that you can fly." The book's open invitation for readers to imagine themselves volunteering for a space mission illustrated a common theme in space education efforts in the early 1980s, emphasizing familiarity with the technical details of the hardware to stoke enthusiasm.

Likewise, the *Shuttle Challenge* board game from 1983 linked specified knowledge to the ability to thrive in a space-based future. The instruction booklet provided in this game produced by Futuristic Toys of Webster, Texas, included pages of facts about spaceflight history. After studying the guide, players moved their pieces around the board by answering questions correctly. Presumably, knowing about space history would prepare kids for life in an era of more frequent flights and even orbital infrastructure. "With the dawn of the Shuttle Era," the booklet informed players, "we have just begun to realize the richness of space and its valuable resources. As we move toward the Space Station Era, space will now become our work place and our home."

A space shuttle toy even appeared in Steven Spielberg's blockbuster film *E.T.* (1982). In the movie, a model of an orbiter hangs from the ceiling in the bedroom of the film's main character, a young boy named Elliott (Henry Thomas). The model often appears above and behind the character, especially as he contemplates the squat, living, extraterrestrial he found in his California backyard and lured upstairs into his bedroom closet. The film's plot relies upon the overstretched and inattentive but well-intentioned parenting of Mary (Dee Wallace), Elliott's divorced working mother. Her children have become accustomed to fending for themselves, even to the point of dealing single-handedly with a lost alien. In 1982, millions of children lived in the 5.9 million female-headed households with one or more children under eighteen years of age. Screenwriter Melissa Mathison's script for *E.T.* juxtaposes the realities of Elliott's family life against the material abundance of their suburban subdivision. In addition to the large pile of stuffed toys in which the alien hides in one famous scene, the character's playthings also include a globe and other educational toys. These assets help the alien learn English and provide the raw materials for an interstellar communications device. Having a space shuttle model in Elliot's room reinforces the viewer's

impression of the character as the kind of curious, clever child who might help an alien call home.

Of course, the ultimate immersive experience for shuttle enthusiasts was Space Camp. The US Space Camp opened its doors in 1982. It was based at the US Space and Rocket Center in Huntsville, Alabama, the town made famous as "Rocket City, USA" because of the presence of the von Braun rocketry team based at the NASA Marshall Space Flight Center. Space Camp offered young people, and eventually adults, an experience of testing and training much like real astronauts.

The fun derived from the realism. Assigned a role as a particular crew member at the beginning of the week, campers simulated a space shuttle flight on the last day of the camp. Together they followed a scripted mission, being graded on their adherence to the protocols appropriate for each position. In preparation, campers' daily agendas included lessons on scientific principles, experiment protocols, space history, and astronomy as well as the technology of the shuttle itself. By 1985, the US Space Camp had developed an advanced curriculum to interest the students who had already completed the basic Space Camp experience—some, more than once. The core text for the advanced campers was a binder that included the NASA *Space Shuttle News Reference*, a complete technical briefing about the Space Transportation System. In-depth familiarity with the technical details of the orbiter's systems remained a central theme. Beginning with small groups in the early 1980s, Space Camp has hosted tens of thousands of children over the years.

AN OPERATIONAL FLEET, OPEN FOR BUSINESS

NASA organized actual shuttle missions in ways that reinforced the impression that spaceflight might become more accessible. Beginning on STS-3 in March 1982, NASA offered cargo space for private purchase with the appealing, almost vacation-like name of "Getaway Specials." For a fee of $10,000 each, NASA would include in a space shuttle launch a private payload that fit inside a specially designed five-cubic-foot container. The space-flown contents were returned to customers after the mission. Part of the appeal of these payloads was that they made launch services available to small companies, schools, and even individuals. Although NASA restrictions meant that most cargoes were scientific experiments or educational projects, some artists applied to fly their works in space as

well. The initiative supported the Reagan administration's business-minded philosophy of encouraging private enterprise.

The biggest step in making spaceflight more accessible occurred when the Space Shuttle Program shifted from experimental to operational status. When STS-4 landed on the concrete runway at Edwards Air Force Base in California in 1982, the end of *Columbia*'s fourth mission marked that transition, what *Science News* called "the graduation exercise" for the shuttle. Half a million people attended the outdoor celebration. On the richly symbolic date of July 4, punctuated by the Space Shuttle *Challenger*'s taking off on a 747 (on its way to Florida for its first mission), President Reagan delivered a major address outlining his administration's space policy. Those plans included an ambitious schedule of regular shuttle flights, along with several military space initiatives. With the first *Challenger* flight, the program began regularly scheduled missions with the aim of fulfilling the promise to be "America's primary orbital workhorse." Within a year, NASA had become confident enough in the repeatable services of its "space truck" that the agency began using the slogan, "We Deliver." The shift from experimental status had real consequences for how the shuttle program was conducted.

NASA both encouraged and bought into the fullest implications of the shuttle's operational status. Indeed, once the first four experimental flights had been completed, shuttle orbiters became shirtsleeve work environments, even during launch. After STS-4 and until *Challenger*'s destruction in 1986 fundamentally changed American piloted launch procedures, space shuttle astronauts did not launch in protective pressure suits or spacesuits. Rather, they wore in-flight garments consisting of Velcro-trimmed pants and matching jackets. Protective helmets were the only nod toward possible launch problems. Such conditions reflected the belief that the regularly operating spacecraft marked the beginning of an everyday Space Age, in which spaceflight had become routine, normalized, and perhaps even domesticated. Flying more diverse space crews, including both men and women of different races and backgrounds, reinforced that message. Most of those astronauts were mission specialists, a new category of official NASA astronaut who functioned primarily as researchers, not as pilots.

The public reaction to the announcement that Sally K. Ride would be the first American woman in space was far more enthusiastic than what either she or NASA expected. Reporters flocked to get her story, and Ride appeared on the covers of *Ms.* magazine and *Newsweek*. Finally, on June 18, 1983, the crowd at

GENERATION X, THE SPACE SHUTTLE, AND PROMOTING EDUCATION

This enameled STS-7 emblem, crafted as a pendant rather than a lapel pin, illustrated the expectation that women as well as men would want souvenirs from the mission, which included the first American woman in space, Sally K. Ride. Photo courtesy of the National Air and Space Museum / Eric Long.

and around the Kennedy Space Center watching STS-7 launch swelled to numbers estimated at 500,000. Signs cheered, "Ride, Sally Ride." Although the public flurry was more subdued for the flight of the first African American in space, the launch still drew attention. When Guion S. "Guy" Bluford flew into space aboard STS-8 at the end of August that same year, the dignitaries on hand for the launch included the president of the National Urban League and basketball star Wilt Chamberlain. The flights' memorabilia also reflected NASA's awareness that women as well as men would be following the missions. In addition to the

standard enameled lapel pin of the mission emblems, pendants were also created to be worn as necklaces.

The presence of payload specialists who worked with specific experiments or other cargo reflected NASA's increased willingness to open missions to crew members outside of the agency's own astronaut corps. In November 1983, STS-9 carried European Space Agency (ESA) astronaut Ulf Merbold into space to work with ESA's Spacelab. Almost a year later, on August 30, 1984, aboard STS-41D, Charles D. "Charlie" Walker, a McDonnell Douglas engineer, became the first nongovernmental civilian to fly in space, tending a device for which he shared a patent. Described in a press kit from 1985 as "NASA's newest breed of workers in space," payload specialists were "career scientists and engineers . . . identified and selected by their peers to fly into space and conduct experiments. After the mission, they return to their previous position at the institution sponsoring their research." Such cooperation with private companies supported efforts to encourage business interests in space. The White House hosted a major one-day meeting about space commercialization on August 3, 1983. Business partnerships also became an integral part of the White House's outreach to youth.

THE YOUNG ASTRONAUT PROGRAM

As new demographic and societal trends raised alarms in the 1980s, some people responded by creating space-themed programs that preached a metaphorical gospel of the redemptive power of spaceflight. Objectively, more than any cohort before it, Generation X grew up as children of divorce, with working parents. Specifically, in 1983, one out of every five children, and more than half of all African American children, lived in a one-parent household—an increase of 69 percent since 1970. As described retrospectively in 1990 by *Time* magazine, this generation, "grew up in a time of drugs, divorce and economic strain. They virtually reared themselves. TV provided the surrogate parenting." In addition to orchestrating the previously mentioned interventions about drugs, sex, and rock and roll lyrics, policymakers worried about the state of the nation's educational system. President Reagan's National Commission on Excellence in Education issued a report in 1983 with a title that summed up its conclusions: the United States was "A Nation at Risk." Average tests scores had slipped. Colleges, universities, and the military were having to provide remedial education, especially in math

and literacy. Writing in stark terms about "a rising tide of mediocrity" and equating the decline to "an act of unthinking, unilateral educational disarmament," the report warned that American schools were not preparing students for success in an emerging information age.

At the same time, a technological revolution in household conveniences signaled a changing economy. Telephone answering machines, videocassette recorders, videogame systems, microwave ovens, and personal computers all gained widespread adoption in this moment. In January 1983, *Time* magazine named the computer as its "man of the year" for 1982. Future jobs, commentators argued, would be white-collar opportunities in fields involving computers, lasers, fiber optics, and genetic engineering—or even spaceflight. The unionized industrial or manufacturing trades that sustained earlier generations were disappearing.

The need to protect—indeed, to save—this vulnerable cohort spurred individuals into action on many different fronts, including spaceflight education. Tapping into contemporary enthusiasm about the new Space Shuttle Program, these projects argued, could help to save this young generation by inspiring their education. The rationale circled back on itself. Preparing students for life in a technologically sophisticated future required familiarizing them with the very spacecraft about which they were presumably already excited. The first such program was the Young Astronaut Program.

In October 1983, Pulitzer Prize–winning journalist Jack Anderson approached President Reagan with his idea to get children excited about science, math, and technology; the president authorized the project the next summer. The Young Astronaut Council, which Anderson chaired, coordinated between NASA, the White House, and the private sector. The goal was to prepare young people for life in the Space Age. By 1992, the organization was "the largest, space-related, educational youth organization in the world." In keeping with the Reagan administration's belief in private initiatives rather than public or government programs—or, as Anderson explained it to his readers, to prevent the organization from becoming "another barnacle-encrusted government bureaucracy"—the council was supported by private corporations. Corporate sponsors included Adidas, Commodore International computers, Martin Marietta Aerospace, M&M Mars, Pepsi-Cola, Safeway Stores, and Xerox.

The new organization was announced at a White House ceremony on October 17, 1984. With the seventeen newest astronauts just selected by NASA in

attendance, Reagan greeted an audience of dignitaries and children on the South Lawn. His speech echoed the formal letter written to dedicate the group: "In order to maintain our position of leadership in the world of high technology, we need to rekindle the spirit of scientific adventure and help nurture it in our nation's schools." New members of the Young Astronaut Program pledged to raise their grades in math and science, learn about space, and support other members of the group. At the ceremony, child actress Drew Barrymore, well known for her role in E.T., read the membership pledge aloud. Barrymore then handed Reagan a baseball cap bearing the Young Astronaut Program logo. Ever aware of the power of a good photo opportunity, Reagan immediately put it on and wore it throughout the ceremony.

The program aimed to attract a wide audience. Photographs showed African American, Asian American, Latino, and white boys and girls on the stage with the president. In the new everyday Space Age, interest in spaceflight would be broadly inclusive. As Anderson explained to the readers of his newspaper column, the Young Astronaut Program would not exclude anyone: "The preliminary response indicates that girls are as enthusiastic as boys about the program. Handicapped children are also welcome." Within the first month after Reagan's kick-off event at the White House, invitations to form chapters went out to 77,000 elementary and junior high schools. The Young Astronaut Council also distributed curricular materials to "all categories of schools, including rural and inner city, gifted and handicapped, public and private." Many responded. Within a year of its founding, 50,000 inquiries had been received and more than 3,700 chapters were operative. Even without any explicit outreach outside the United States, sixty international chapters were founded in seventeen nations during the organization's first year.

The successful debut led to another White House celebration. On October 17, 1985, one year after the South Lawn kickoff, 250 invited guests enjoyed an invitation-only executive briefing and reception. The guest list included singer John Denver, Apollo 11 astronaut Buzz Aldrin, ABC news anchor Hugh Downs, NASA Administrator James Beggs, and dozens of elementary school children. All the Teacher in Space finalists also attended. Reagan commended the program's achievements as "this generation moves forward to harness the immense potential of space." He also greeted a "living" Young Astronaut Cabbage Patch doll (an

actor costumed in a life-sized spacesuit), a representation of the branded doll that flew aboard STS-61A later that month.

To do the work that would prepare students to "operate the computers, robots, and lasers that will be standard equipment in just a few years," council executive director Wendell Butler sought corporate sponsors using the model offered by Peter Uberoff's 1984 Summer Games in Los Angeles, the first profitable Olympic Games since 1932. The Young Astronaut Program created a partnership among educators, parents, and the business community. Although several of the participating organizations were either government or affiliated organizations (including NASA, the Department of Education, and the Smithsonian Institution's National Air and Space Museum), private companies such as Commodore computers also took a leading role. The Young Astronaut Council allowed participating sponsors to use Young Astronaut Program logos on their product. Such partnerships allowed the group's organizers to tout the program's independence from government support. The emphasis on private enterprise dovetailed with the Reagan administration's hopes for the American space program itself.

Companies joined the program even if the connection between their products and spaceflight enthusiasm was tenuous. The Safeway chain of grocery stores printed Young Astronaut registration forms on its brown paper grocery bags. Monogram, a company that produced boxed model kits, rebranded its existing Snap-Tite Space Shuttle model kit to carry the Young Astronaut's logo. Marvel Comics planned a series of branded comic books. CBS proposed an animated Saturday morning television show. Each episode of *The Young Astronauts* would conclude with an "Astro-minute" in which real astronauts would explain scientific concepts.

As a Young Astronaut Program partner, NASA flew memorabilia for the group on both STS-51F and STS-61A to build excitement about the project. On the first of the two missions, however, NASA also negotiated a delicate truce. In 1984, Coca-Cola, the major rival of program sponsor Pepsi-Cola, modified a soda can so that astronauts could drink a Coke while in orbit. Caught between the two rivals in the 1980s cola wars, NASA also allowed Pepsi to provide its own modified can. The space agency called the comparison the "Carbonated Beverage Dispenser Evaluation." Although the demonstration largely failed (neither unrefrigerated soda had much appeal), Pepsi nonetheless celebrated. Commemorative cans with the Young Astronaut Program logo appeared in stores. More than just a

Duplicates of the modified Coca-Cola and Pepsi-Cola cans that flew on STS-51F became artifacts in the collection of the Smithsonian National Air and Space Museum. Note the Pepsi can's prominent Young Astronaut Program logo. Photo courtesy of the National Air and Space Museum / Eric Long, WEB1058822—006.

promotional gimmick, the co-branded soda symbolized a complex intersection of business, politics, and spaceflight aimed at a youth market.

In 1985, two Young Astronaut members even went on location with ABC Motion Pictures for the filming of *Space Camp* (1986). The movie's plot featured a group of space campers who accidentally fly a real space shuttle mission—and in true 1980s teen flick fashion, come together as a team without losing their quirky individuality. Monologues extolled the inspirational and educational value of human spaceflight. The plot's resolution rested in each character's ability, when tested, to rise to a challenge. The movie's overall message reflected the contradiction at the heart of the era's belief in the redemptive power of spaceflight: the assertion that exposure to spaceflight was inherently educational without any particular lessons learned other than excitement and familiarity with the vehicle itself.

Although the Young Astronaut Council's literature did advertise, "Eventually, we hope to send a Young Astronaut on a Space Shuttle mission," including a child on a future launch was not the group's express purpose. In contrast, flying a teacher was the centerpiece of NASA's Teacher in Space Program. Both it and the privately funded Young Astronaut Council were announced in close succession during the summer of 1984. In addition, both arose from similar impulses to excite young people about spaceflight.

WHY NOT SEND A KID?

In the early 1980s, NASA officials suggested that ordinary people might soon be able to participate in space shuttle flights. Based on the capacity that the reusable orbiters offered, NASA's Space Flight Participant program actively sought civilians who might eventually fly on a mission. Initially considering journalists or possibly artists, the project generated a widespread response. Indeed, the records in the NASA Historical Reference Collection maintained by the NASA headquarters history office contain appeals to President Reagan or NASA Administrator James M. Beggs from all types of people. The letters record not only expressions of excitement about spaceflight but also genuine requests to participate.

The appeals that were saved include letters from a salesman, a farmer, a priest, a minister, a "disabled American veteran," a steel worker, an "enlisted man," an insurance salesman, a "newspaperman," and a maid. The records include multiple nominations for CBS news anchor Walter Cronkite, who was considered a likely choice. Such flights seemed to be a first step toward fulfilling the dream of regular spaceflights for ordinary citizens. On August 27, 1984, Reagan signed off on NASA's plans for the Teacher in Space Project to select and fly a representative American educator. Once initial missions demonstrated that the concept would work, NASA officials expected to offer as many as two or three private citizens a year a seat on a space mission.

Many of those who volunteered themselves for spaceflight were responding both to NASA's official Space Flight Participant program as well as Reagan's appeals to voluntarism. The American civil religion that the president preached came naturally to a man who believed in dismantling big government and drawing forth the power of individual initiatives. Voluntarism, according to Reagan, demonstrated the American spirit and the nation's moral strength. In many of

his speeches, Reagan's folksy humor and simple direct language framed NASA's space truck as accessible to ordinary people.

Especially in the weeks and months after the Teacher in Space Project announcement, young people responded enthusiastically. The connection seemed obvious: a teacher would need a student. Even my own brother, Ray—inspired perhaps by a family trip to the Kennedy Space Center as well as the inclusive rhetoric of the shuttle program—wrote to NASA volunteering to be the first child in space. In response, he received a large envelope stuffed with fact sheets and brochures as well as posters and stickers that soon decorated his bedroom and filled a scrapbook.

Children understood that not just anyone could hope to go into space. Young aspirants vying for shuttle flights often mentioned their good school records or demonstrated their excitement about the Space Shuttle Program. Children also noticed that NASA had included some high-profile passengers on recent shuttle flights. In April 1985, Senator E. J. "Jake" Garn (R-UT), the chairman of the Senate subcommittee that authorized NASA's budget, flew on STS-51D as a payload specialist with the task of conducting space sickness experiments. Likewise, in June 1985, Prince Sultan Salman Al-Saud flew on STS-51G as the representative of the Arab Satellite Communications Organization during the deployment of ARABSAT-1B. In January 1986, a second sitting politician, Rep. Bill Nelson (D-Florida), who later became NASA Administrator in 2021, flew aboard STS-61C. As twelve-year-old Karen Rall of Kent, Washington, reasoned in her letter to President Reagan in 1985, "We have sent senators, scientists, foreigners, and soon a teacher into space; why not send a kid?" Rall was not alone. Sending a child into space—or just getting children excited about space—seemed like a potential strategy for helping the younger generation to succeed.

Other individuals felt moved to create educational outreach initiatives. Between 1980 and 1986, three different space-themed organizations aimed at youth were created or revived: the National Aerospace Cadets (NAC), Astro Cosmo and the Youngstars in Space, and the INTERSECT Space Training Center. Inspired by the events of the time, all three founders expended considerable money and effort to create space-themed programs aimed to excite children about the future. None of them came anywhere close to the success of something like Space Camp. Collectively, though, all three illustrated the grassroots enthusiasm generated by the early space shuttle era.

GENERATION X, THE SPACE SHUTTLE, AND PROMOTING EDUCATION

GRASSROOTS SPACEFLIGHT EDUCATION PROGRAMS

The idea for Kenneth E. Beatty's National Aerospace Cadets began when he and some friends learned that 2.5 million people had paid five dollars to join *Star Wars* fan clubs. Rather than invest in fantasies, they reasoned, why not focus on teaching something realistic? Beatty had a background in scouting, education, and aerospace. His career as a schoolteacher and technical illustrator for various aerospace firms also included working with the Boy Scouts of America as an Eagle Scout, troop leader, and executive. Spurred by his epiphany, Beatty concluded that the Boy Scouts, a group that he still admired greatly, emphasized nineteenth-century "Daniel Boone" skills—using a penknife, tying knots, and building campfires—in the midst of a budding Space Age. He founded the National Aerospace Cadets in 1980 to educate boys and girls about astronomy, computers, electronics, model rocketry, and celestial navigation. The NAC's military-styled

Kenneth E. Beatty had a formal flag made with his original logo for the National Aerospace Cadets, an organization that he hoped would become a nationwide space-themed scouting group for students. He led the organization from his Maryland home for decades. Photo courtesy of the National Air and Space Museum.

structure organized participants into starship crews, with each member earning ranks from plebe through lieutenant as they acquired new skills. Cadets saluted while entering the learning space and learned to march in close order drill. Beatty encouraged structure and discipline. The backs of the NAC's membership cards warned, "This card may be revoked at any time if the bearer fails to maintain a high standard of conduct or attend training exercises regularly."

Beatty based the NAC out of what he called the Delmarva Space Training Center, a space-themed schoolroom that filled the basement of his Maryland home. It contained an extensive print and video library and many models, as well as hands-on electronics, robotics, and rocketry kits. Using a spaceflight simulator of his own creation, Beatty put cadets through simulated missions. During the school year as well as special week-long summer camps, Beatty presented his cadets with space-themed problems and encouraged them to find answers independently. He proudly asserted that the NAC could transform a teen from a lackluster student into someone with college aspirations.

As many as 250 young people participated in the organization in its lifetime, although Beatty sometimes claimed thousands. Ultimately, he hoped that the NAC would eventually rival the Boy and Girl Scouts, with a national headquarters to house the academy and training grounds. Although the dream never materialized, he ran a successful local organization for more than twenty years that educated and inspired young people using an entirely space-themed approach.

In 1984, a lawyer named H. J. M. Melaro of Arlington, Virginia, revived plans for a television show called *Astro Cosmo and the Youngstars in Outer Space*. Melaro had initially developed the idea after the Apollo 11 lunar landing in 1969. Working with the Kaiser Network (UHF), Melaro outlined a plan for an ambitious television program that could be the basis for a larger business and education project. In the show, "Astro Cosmo," a character from Uranus, joins forces with the Youngstars, a group made up of teenaged representatives from each country on Earth. Together they keep the peace in the solar system. Melaro's initial goal in 1969 had been "to combat the '1968 Yippie Revolution' and bring youth into a more moral feeling and a better recognition of space and high tech." In the early 1980s, those sentiments once again resonated; Melaro saw Jack Anderson's Young Astronauts Program as an opportunity. In July 1984, he sent a thick packet of information and supporting letters to President Reagan suggesting that the Young Astronauts adopt the television program and its associated marketing. As Melaro

GENERATION X, THE SPACE SHUTTLE, AND PROMOTING EDUCATION

explained, "While there is an element of the future in our program ... everything we do follows the NASA program—real, genuine space technology is involved, not the fantasy of some brain in a globe who rules the world." The show would only be the beginning, however. Melaro envisioned a comprehensive Youngstar organization that would provide the show's fans with educational programming, branded merchandise, and a Youngstar business.

Melaro's organizational chart for the business described five different "planets" in the Astro Cosmo and the Youngstars universe: administration, productions, publications, products, and promotions. By employing an estimated 25,000 teenagers across those areas, the Youngstars organization would offer educational employment. If expanded internationally, he proposed, the program could multiply that by a factor of ten, engaging 250,000 teens. Melaro imagined a branded credit union and even an affiliated university. The information packet included color sketches depicting not only the show's main characters, uniforms, and spaceships but also the associated comic books, space games, books, and toys. The jewelry line would include rings, watches, pins, and pendants. Endorsements would appear on cereal boxes or in motion pictures. Melaro saw all of the pieces of the Youngstar Astronaut enterprise tied together neatly to "turn the morals of our youth into more acceptable norms and guide them into the future of computers and high tech advances." Commercial consumption would motivate both space-themed education and moral improvement. But it was not to be. Anderson's Young Astronauts Program already served some of the same needs; the White House directed Melaro to contact them.

Beatty's organization was home-based and Melaro's plans only existed on paper. But by 1986, a third man invested in a full-fledged space training center for youth in Cape Canaveral, Florida. His timing could not have been worse. On January 6, 1986, after three years of work, David Adair used the occasion of his thirty-second birthday to found the INTERSECT (International Space Education Concept and Techniques) Space Training Center, or ISTC. Its new permanent location was the former Cape Canaveral Hilton. The site included two hundred guest rooms and enough land to build a planned 20,000-square-foot training building.

By February, Adair assembled a large packet of ISTC information, which he sent to the White House through the office of Rep. Bill Nelson, the STS-61C spaceflight veteran. The Space Training Center, he explained, would welcome "people of all ages, races, and backgrounds" to prepare them for aerospace related careers.

Adair hoped that someone at the federal level—or perhaps an association with the Young Astronauts Program—could help him to acquire the $800,000 that he still needed to supply, staff, and open the space training center. Adair's ISTC plans echoed two prevalent themes of the early 1980s space craze: engaging America's youth through space education and using private businesses to support the effort.

Although the ISTC's professed goal was to prepare young people for work in the high technology world of the aerospace industry, the curriculum focused on one elite job description: astronaut. The trainees' rooms were "cabins," and the core curriculum followed a "five phase mission profile" occurring over five days on campus. Beginning with a briefing on rocket propulsion and a tour of the Kennedy Space Center, trainees would next spend a day learning how to don a spacesuit and another day learning to navigate microgravity using a one-sixth gravity chair and a special training pool. Only on day four would trainees learn about other parts of the space industry by focusing on space manufacturing through a tour of launchpads and an exercise in building and launching model rockets. The camp's final day asked trainees "to carry out a Shuttle flight simulation from beginning to end." At graduation on the afternoon of day five, each trainee would receive his or her "Space Readiness Wings . . . and then depart for home taking with them an unlimited source of knowledge and unforgettable, exciting memories."

These ambitious plans arrived in Washington at the wrong political moment. On May 2, 1986, the Rogers Commission conducted its last day of public hearings about the tragic loss of the Space Shuttle *Challenger*. The United States was entering its fourth month without an operating human spaceflight program. Although the reply complimented INTERSECT as "a very innovative concept for giving young people a unique 'hands-on' educational experience in science, mathematics, and technology," the Space Training Center would not receive help from the federal government or from the Young Astronauts program.

None of the three space education initiatives achieved what they planned, but they were nonetheless ideas deeply rooted in their time. They illustrated how spaceflight enthusiasm could reflect changing times. Promoting the Space Shuttle to young people fit with other social and political goals of the time: injecting evangelical morality into politics, encouraging private enterprise over government projects, and ensuring future strength in a Cold War–defined world. In the same historical moment when NASA officials pursued top-down efforts to

GENERATION X, THE SPACE SHUTTLE, AND PROMOTING EDUCATION

connect spaceflight excitement with education (such as in the Teacher in Space project), these three initiatives represented grassroots local efforts to make similar connections.

CHALLENGER CENTERS

The destruction of the Space Shuttle *Challenger* on January 28, 1986, had profound effects. The disaster killed all seven crew members (including Teacher in Space Christa McAuliffe). The resulting investigation sparked a major reevaluation of the entire Space Shuttle Program, including NASA's decision-making processes. American human spaceflights halted for more than two years. In addition, the *Challenger* disaster was a particularly traumatic event for Generation X. Many schoolchildren watched the launch live on television, an unusual event in 1986, when live television programming was not regularly available in most American classrooms. In fact, many schools had arranged to view the launch in order to allow students to see the culmination of the Teacher in Space Project. Instead, the event became one of those searing moments when people remember exactly where they were when they saw it or heard the news.

The *Challenger* disaster also affected immediate efforts being made to prepare children for full participation in the new everyday Space Age. The animated *Young Astronauts* Saturday morning television show being prepared by CBS never aired. Likewise, the Young Astronauts Program–affiliated Marvel comic books never appeared. The *Challenger* disaster ended NASA's Space Flight Participant Program, any hopes for including a child in a shuttle mission, and the broad societal effort to prepare young people for life in an everyday Space Age. The optimism of that moment was gone. Historian Philip Jenkins has argued that 1986 marked a political transition as well. As Cold War antagonisms began to shift, the Democratic recapture of Congress that year stymied further passage of the Reagan administration's agenda. At the same time, the revelation of the Iran-Contra affair embroiled the administration in messy hearings. Within the next two years, scandals for some evangelical leaders and the eventual savings and loan collapse raised questions about moral leadership and fiscal deregulation. The year 1986 became a watershed in many ways.

Broad public support for human spaceflight became more tempered after the *Challenger* disaster, but it never faded completely. In the wake of President

Reagan's powerful address to the nation and his eulogy of the STS-51L crew, the American public renewed its commitment to supporting the Space Shuttle Program. Even children responded to the call. Within a month of the explosion, Jack Anderson was writing in his newspaper column about the letters and pictures he received from young people. They were stunned and saddened by the disaster but nonetheless wanted the space shuttle to continue flying.

As time passed, the emphasis on getting children interested in space changed, but less than one might think. After 1986, the optimistic visions of shuttle-as-educational-inspiration lost their innocence but not their power. In tribute to the lost astronauts—and their highly visible companion, Christa McAuliffe—educational efforts centering on the Space Shuttle Program found a permanent home. To create a lasting tribute to their family members, the families of the fallen astronauts founded the Challenger Learning Centers for Science Education. As the organization's website explains, "In the aftermath of the *Challenger* accident, the crew's families came together, firmly committed to the belief that they must carry on the spirit of their loved ones by continuing the *Challenger* crew's educational mission." Galvanized by the drive to create a fitting memorial, the astronauts' families succeeded where some others had floundered. They created centers nationwide, one in each state, offering space-themed lessons to school groups, as afterschool programs, and through summer camps. Challenger Centers have provided educational and inspirational experiences for generations of schoolchildren excited to learn about spaceflight. By 2007, fifty such centers were operating in the United States and internationally. By 2016, after thirty years of work, the Challenger Centers had reached more than 4.4 million students around the globe.

For the Space Shuttle Program itself, the reevaluation took more than two and a half years. Finally, 975 days after the loss of the *Challenger* and crew, the Space Shuttle *Discovery* launched on September 29, 1988. With the new mission, NASA also returned to a simpler numbering scheme that did not evoke the pattern of missions up to and including STS-51L. Instead, the shuttle's return to flight mission was simply called STS-26.

GENERATION X, THE SPACE SHUTTLE, AND PROMOTING EDUCATION

A CULT PHENOMENON IN ITS OWN RIGHT

Discovery's return to flight came almost a year to the day after the launch of a new fictional vessel, the *Enterprise-D*. The reimagined starship was the flagship of *Star Trek: The Next Generation* (abbreviated as *ST:TNG*). The new iteration of the *Star Trek* television universe illustrated not only how the Western-styled archetypes of American space science fiction could be reshaped but also the complexity of *Trek*'s multifaceted fandom.

Creating *ST:TNG* had a long history. As the *Star Trek* series from the 1960s continued to entertain television audiences in syndication and four films with the original cast drew viewers to movie theaters, Paramount executives began discussions of bringing the franchise back to the airwaves. After years of fractured relations between Paramount and series creator Gene Roddenberry, he accepted the studio's overtures, bolstered by the good feelings shared during the twentieth-anniversary celebrations of the original series in 1986. Paramount executives initially sought a television network to purchase the new program. After extensive negotiations with Fox Broadcasting fell through, however, Paramount chose not to sell the series to any particular television network. Instead, they produced the show for first-run syndication. Any station could pick it up. In the end, the highly successful series ran for seven seasons, beginning in fall 1987.

The program reconfigured the Western-styled spaceflight crew to reflect new times. The new starship crew consisted not only of Federation explorers but also their families. Women had a real place in space. One reviewer noted in particular that "the role played by women on the new Enterprise has been updated. Gone are the mini-skirted helpmates of the original, replaced by bright officers in clear positions of authority." The shift in characters could be crystalized in Counselor Deanna Troi (Marina Sirtis), an empath stationed on the bridge as an officer and advisor. Her ability to sense deception or honesty supports the crew's negotiations with a wide variety of aliens. Led by Captain Jean-Luc Picard (Patrick Stewart), the crew encounters new worlds with the goal of peacekeeping. As one reviewer noted, in *ST:TNG* "problems are solved by diplomacy and compassion rather than weaponry," distinguishing the new series from the original. And yet the impulse to inject contemporary issues into the spaceflight setting endured. In

its new configuration, the reviewer argued, "the show shares with the best literary science fiction the power to make us see ourselves in a new way."

The program quickly found its audience. In its first season, the show ranked third in syndication, behind only the well-established game shows *Wheel of Fortune* and *Jeopardy*. Moreover, the show captured a new generation of fans. In the television ratings, *ST:TNG* ranked first among the sought-after eighteen-to-forty-nine age group. The show earned critical acclaim as well. In its first season, an imaginative episode set on the holodeck won a Peabody Award, the only *Star Trek* episode ever to earn that honor. Based on ratings, Paramount boasted honestly that the program was "one of the most successful TV shows in history."

As might be expected, the reimagined *Star Trek* attracted some new adherents to the fan community. Some devotees of the original series greatly enjoyed the new show. Others diehard loyalists thought that the new captain could not compare to their beloved Captain James T. Kirk. Passionate fans could also be the most demanding critics, calling on writers and producers to develop stories, add characters, or change messages. A significant point of division between producers and admirers emerged around the question of whether there could be an openly gay character depicted in *ST:TNG*. After all, years before it was commonplace on other series, the original *Star Trek* television program depicted racial integration and gender equality. (Although largely in supporting roles, not leading ones, those representations still sent a message.) Even before the new show began broadcasting, some fans hoped that the next iteration of the franchise might include an openly gay or lesbian character or a positive, or even neutral, depiction of a same-sex relationship.

Beginning in 1987, lesbian and gay *Star Trek* followers began forming their own fan groups, calling themselves the Gaylactic Network. Seeking fellow enthusiasts with similar interests, they organized under the slogan, "out of the closet and into the universe." According to scholar Bruce Drushel, the special interest fan group eventually included eight different chapters with five hundred members. Some of them confronted Roddenberry and *Star Trek* writer David Gerrold with their concerns at a convention. In response, Gerrold and Herbert Wright cowrote a script in 1987 during the first season of *ST:TNG*. The proposed episode was called "Blood and Fire." Its plot, about the *Enterprise* crew encountering an infected vessel, served as an allegory for the AIDS crisis. The episode also

included a committed gay couple. For a variety of reasons, mostly driven by reticence and fear among the executives, the episode was never produced.

Instead, the *ST:TNG* episodes that included same-sex themes did not satisfy fans who wanted a supportive depiction of their representation. In the fourth season, "The Host" depicted the ship's doctor, Beverly Crusher, falling in love with Odan, a handsome Trill mediator from a symbiotic joined species. After he was fatally wounded, Odan's symbiont—his true nature—was eventually, after several plot twists, transferred to a new female Trill host. Faced with the reality that Odan, now in a woman's body, would continue to change hosts in the future, Crusher ended the relationship, confessing, "I can't live with that kind of uncertainty. Perhaps, someday, our [human] ability to love won't be so limited." Likewise, "The Outcast" attempted to address intolerance without explicitly portraying homosexuality. The episode used a planet of androgynous, genderless aliens as an allegorical setting. When First Officer William Riker (Jonathan Frakes) falls in love with Soren (Melinda Culea), an alien who is secretly female, the alien society requires Soren to undergo "psychotectic therapy" to become genderless again. The episode evoked the real-life issue of anti–gay conversion treatments without depicting an actual same-sex relationship.

In both instances, the science fiction technique of defamiliarization—setting a social, cultural, or political issue in an (in this case literally) alien context so that viewers could see it with new eyes—backfired. By relegating any depictions of a gay or lesbian community to aliens only, rather than showing Federation officers in everyday same-sex relationships, the producers continued to treat homosexuality as a deviation, an Other, not a normalized subject. As media studies scholar Henry Jenkins has written, "What the Galaxians wanted was to be visible without being an 'issue' or a 'problem' that the scriptwriters needed to confront and resolve." Fans grew frustrated when the writers and producers did not respond. By 1991, the Gaylactic Network turned to a tactic often used by previous generations of *Trek* fans, a letter-writing campaign.

The Gaylactic Network illustrated how fans envisioned themselves as more than just passive consumers of culture. Earlier *Star Trek* enthusiasts had exercised their collective clout in the 1970s to save the original series' third season or rename a space shuttle orbiter. By the 1980s, fans used conventions not only as an opportunity to hear from show creators and stars, but also to respond to them. As a trio of scholars explained in an overview of the academic study of fandom,

"Fans, for better for worse, tend to engage with these texts not in a rationally detached but in an emotionally involved and invested way." In some fashion, the direct demands made of *ST:TNG* producers were mild echoes of the activism of contemporary groups like ACT UP (AIDS Coalition to Unleash Power). The grassroots political organization founded in March 1987 led direct action campaigns demanding a proactive response to the growing AIDS crisis. Those who are most deeply affected and who love something the most can be the most incisive and insightful critics. From Students for the Exploration and Development of Space (SEDS) to various campaigns to create spaceflight education initiatives and the Gaylactic Network, spaceflight enthusiasm in the 1980s encompassed advocacy as well as admiration.

If the 1980s began in a lull of excitement about spaceflight, the decade also ended with a dip in public enthusiasm, especially in comparison to the outright exuberance displayed during the first five years of space shuttle flights. Even after 1986, thousands of people still flocked to attend launches, wanting to experience their power in person. But human spaceflight missions became less frequent. The nine missions flown in 1985 would not be duplicated again in the history of the shuttle program. By the time NASA built back up to flying seven or eight space shuttle missions per year in the mid-1990s, the program had found a new purpose: cooperation with the new Russian Federation.

CHAPTER 6

Space Stations, Spaceflight Enthusiasm, and Online Fandom

The front plate of the brass brooch in my gloved hand was missing the pinback. That made it particularly intriguing. The handcrafted piece of jewelry came to the National Air and Space Museum as a part of a larger donation of memorabilia from the television program *Babylon 5*. Created by J. Michael Straczynski and aired on cable from 1993 to 1998, *Babylon 5* attracted passionate fans with computer-generated spacecraft, complex evolving characters, and innovative long-form storytelling. Some viewers even interacted with the series creator online. A user of computer-enabled communication since 1984, Straczynski regularly had messages posted on online forums signed with the lowercase initials "jms." When I accepted the donation of *Babylon 5* memorabilia in 2005, I was particularly excited that along with the T-shirts, pencil toppers, and action figures, the donation included long printouts of some of those interactions between Straczynski and fans on electronic bulletin boards.

The pin's design celebrated the ways that fans used computer keyboards to communicate. The horizontal diamond-shaped ornament featured a symbol created from three keystrokes. Typing <*> resembled a "jumpgate," the program's fictional technology for interstellar travel. At a time when newgroup posts included text but not images, users often combined letter and non-letter keys to create designs in their messages or email signature blocks. In this case, the pattern served as a subtle signal. For those who did not recognize the typed jumpgate, the keystroke combination just looked like a decorative flourish. For readers who followed the show, however, the shape identified a fellow enthusiast. It was a typewritten version of a secret handshake.

SPACE CRAZE

The brass brooch created by a fan known as Elena turned a keystroke representation of the jumpgate, the fictional means of interstellar travel in the *Babylon 5* television show, into a wearable ornament that signaled the wearer's fandom. Photo courtesy of the National Air and Space Museum.

One dedicated fan created a wearable version. In the first season of *Babylon 5*, before other show merchandise existed, an online follower and talented artist who identified herself only as Elena began making keystroke jumpgate brooches. She did not need official licensing for the design, but out of respect for Straczynski, she sent him the first example. He approved. But Elena still had a minor problem. In the first generation of pins, the black electroplated lacquer set off the brass symbol beautifully, but the pinbacks occasionally fell off. The absence of an actual pin on the Museum's artifact potentially identified it as part of the earliest generation of such memorabilia.

The show's setting also reflected a particular historical moment. In the 1990s, space stations took center stage in both fiction and reality. The International Space Station (ISS) resulted from an agreement between the United States and the Russian Federation that was first announced in 1993 and formally signed in 1998. After the fall of the Soviet Union, nine Space Shuttle–*Mir* missions were flown between 1994 and 1998, establishing the basis for future international cooperation in low Earth orbit. Even as the many details of the diplomatic, scientific, engineering, and cultural collaboration were being worked out, American audiences could already see space stations every week on television. In addition to *Babylon 5*, *Star Trek: Deep Space Nine*, a new iteration of the *Star Trek* franchise also based on a

space station, was produced by CBS Television Distribution for syndication from 1993 to 1999. Indeed, the mid-1990s saw a resurgence of television science fiction designed to entertain audiences via a range of new cable channels.

Space stations offered a practical and literary way of working through significant issues. The 1990s saw the end of the Cold War and the beginning of the modern Internet, both events that fundamentally reshaped how nations, cultures, and individuals related to each other. Simultaneously, culture wars sparked and flamed. Intense public debates raged about science, history, art, and education, especially when those initiatives were supported by public funds. Together, these controversies reengaged opposing opinions about the social and cultural changes forged in the previous decades. In this fraught political moment, space stations functioned as both setting and metaphor. As literal locations, they were where former Cold War adversaries struggled to cooperate. As a narrative setting, an extraterrestrial version of the Western fort, they provided a meeting place for diverse characters. In reality and in fiction, space stations served as sites of compromise, negotiation, and tension. In turn, popular interest in spaceflight embraced a new generation of Western-inflected stories in which diverse populations grappled with the complex realities of integration.

RETHINKING SPACEFLIGHT ADVENTURE STORIES

Beginning in the early 1990s, opinion polls showed a distinct weakening in the public's commitment to spaceflight as an endeavor important to the nation. There had always been some disconnect between a generalized cultural enthusiasm for spaceflight and Americans' willingness to spend tax dollars on space exploration. Despite historic moments of widespread excitement about space, when asked on polls taken between 1963 and 2008 whether the nation was spending too much on space exploration, historian Roger Launius reported that a "persistent average of about 40 percent...said yes." Liking something did not always mean being willing to pay for it. But even noncommittal excitement about spaceflight declined in the early 1990s. Charts of public opinion show a marked drop, even when uncoupled from questions about spending. In 1993, as the end of the Cold War seemed to remove the impetus for space spending, the number of people responding negatively to these questions rose as high as 80 percent.

Working against this declining interest, writers and producers in the early 1990s rethought the usual spaceflight adventure stories in order to appeal to new audiences. When asked in 1991 about her starring role in *Plymouth*, a series planned for ABC, actor Cindy Pickett told a reporter that she thought of it as "a Western in space." *Plymouth* would not be a tale of rocketing adventurers with guns at the ready, however, but rather a story of settlers titled after the New England community founded by the pilgrims aboard the *Mayflower*. Pickett explained that she was comparing the movie's depiction of a self-reliant lunar mining colony to stories of her Oklahoma pioneer ancestors. Having a female lead was another deviation from the usual formula. Pickett played the town doctor, Addy Mathewson, a widow with four children. "It's so rare for a woman to be the heart and soul of an ensemble," Pickett noted while promoting the show.

The prospective show's premise was that after a radiation accident contaminated a mining town in the Pacific Northwest, the company responsible relocated the entire community to populate its lunar mining colony. Creator Lee David Zlotoff wanted *Plymouth*'s space settlements to seem realistic, with technology that might be possible in the near future. To that end, when he was creating the show's concept in 1989, Zlotoff solicited NASA's input. In a binder sent to the agency's headquarters, he included storyboards and various artists' concepts for sets and technology, as well as the script for a two-hour pilot episode. Summarizing the show's potential appeal, Zlotoff argued, "As we enter this final decade of the millennium, *Plymouth*, more than anything, represents an idea and a show whose time has come." The combination of scientific and technical accuracy in a family-friendly program would, he hoped, "capture the cultural imagination not only of America but of the entire world."

In 1989, Zlotoff was in a strong position to propose an expensive new television series. Just four years earlier, he had created *MacGyver* (ABC, 1985–92), which he also coproduced. On the strength of that success, the fledgling space show had tremendous resources even before the network committed to it. Three immense sound stages at Culver Studios housed the sets. Seven hundred tons of specially dyed sand mimicked the lunar surface. Technical consultants included NASA's Marc Craig, who was leading the agency's planning for humans on the Moon and Mars. From NASA's Johnson Space Center, both space scientist Mark Cintala and planetary scientist Wendell Mendell lent their expertise. Lockheed Corporation also advised the project. The budget for the pilot episode was

considerable: $8 million. In addition to financial backing from ABC and Disney, an Italian company, RAI-Uno, supported the program's development in exchange for the foreign distribution rights.

Plymouth never fulfilled its promise. Despite the significant investment in the pilot movie, when ABC announced the network's fall television schedule in 1990, *Plymouth* was not on it. The pilot did not even air. In the end, the decision not to include it stemmed from dramatic problems, not technical ones. As one anonymous executive put it, when quoted by the *Los Angeles Times* in 1991, "You can make a high-tech, scientifically accurate movie with beautiful sets and lots of special effects, but if you have problems with the story, forget it." After a year in limbo, the prospective television show's two-hour pilot episode became a standalone ABC Sunday Night Movie shown in May 1991.

The structure of *Plymouth*'s storytelling may have varied from previous space adventures, but like its predecessors, the focus remained on its majority-white cast. Other characters appeared mostly as background community members. An African American pilot (Eric Chambers) floated past in the prologue; Hiro Kanamoto (Sab Shimono) managed the settlement's farm; and Jimenez "Jimmy" Sandoval (Carlos Gómez) worked on the Tech Crew. Dr. Mathewson's second daughter, April, described in the script as adopted, was played by a mixed-race actress of Korean descent (Lindsay Price). Perhaps if the show had continued on episodic television, those characters or a few others who had only brief appearances might have been developed more fully. In the pilot/television movie version, however, the focus remained on the dangers inherent in being on the Moon—and the pending crisis caused by a secret pregnancy. Mathewson's short-lived relationship with a dashing pilot on the Tech Crew served as the movie's throughline. Despite a cameo by NASA astronaut and real-life Apollo moonwalker Pete Conrad, *Plymouth* felt more like a "will they/won't they" soap opera than a classic space adventure.

Just over six months after *Plymouth* finally appeared, Paramount also shifted the paradigm. The studio released *Star Trek VI: The Undiscovered Country* (1991), the final movie with the original cast. The plot imagined the Federation adjusting to a sudden peace with its longtime enemies, the Klingon Empire, just as the Cold War was ending in real life. It was directed by Nicholas Meyer, who also directed *Star Trek II: The Wrath of Khan* (1982) and helped write the screenplay for *Star Trek IV: The Voyage Home* (1986). (If, as some fans would say,

the even-numbered *Star Trek* films are stronger than the odd-numbered ones, Meyer's influence helped that.) Along with the rest of the world, Meyer watched the Berlin Wall fall in November 1989 and began thinking about the practical complications of resolving long-standing political conflicts.

The movie imagines Federation and Klingon officers called upon to execute a truce, ending the oppositional duality that defined so many space Westerns. But Meyer wondered whether entrenched combatants might resist such change. The plot turns on the assassination of the conciliatory Klingon Chancellor Gorkon carried out by hardline Klingons in order to disrupt the peace process. Although fans enjoyed the film—*Star Trek VI* had the highest grossing opening weekend of any of the franchise's films—critics' reviews were mixed.

But the film's plot seemed prescient. Specifically, the action loosely paralleled the August coup in the Soviet Union. Over several days in August 1991, Soviet hard-liners attempted to wrest the state apparatus back from Premier Mikhail Gorbachev because they feared the implications of his reforms. As Meyer recalled in his memoir, "The Klingons were stand-ins for the Russians. We called Gorbachev 'Gorkon' and so on and basically staged the coup before the one that actually happened in the USSR." The movie was released on December 6, 1991. On December 8, the signatories of the Belovezha Accords recognized the end of the Soviet Union, establishing the Commonwealth of Independent States, and by December 25 the Soviet flag was lowered for the last time. Meyer's perceptive foreshadowing of the crumbling Soviet bloc enlivened the analogous events imagined in the *Star Trek* universe.

INTEGRATING TWO SEPARATE SYSTEMS

The end of the Cold War fundamentally shifted the framework for human spaceflight and thus, the context for popular interest in it. As the Soviet Union ceased to exist, the public watched not only changes happening on the ground, but the status of former Soviet assets in space. By 1991, the Soviet space station *Mir* consisted of four pressurized modules, which would eventually number seven upon full build-out. These were serviced by remotely piloted Progress resupply modules and maintained by rotating two-person crews. Each long-term crew had a flight engineer and a commander, flown to the station aboard a three-seat Soyuz capsule. In May 1991, engineer Sergei Krikalev launched from the Soviet Union to

the *Mir* space station along with commander Anatoly Artsebarsky as the ninth long-term crewmember. But the volatile situation on the ground soon affected those in space. The circumstances behind Krikalev's unexpectedly long mission briefly captured the public imagination while highlighting the complexity of the systems required to maintain an orbiting space station.

As Moscow's control fragmented, a political deal traded away Krikalev's seat on a return flight to Earth, forcing him to remain in space much longer than planned. Because the Soviet Baikonur Cosmodrome launch facilities were outside Russia in the Kazakh Soviet Socialist Republic, the Soviet space agency agreed to fly a Kazakh cosmonaut to *Mir* in order to keep using the launch site. The second seat on that mission held a paying customer whose cash infusion helped keep the program going even as the nation collapsed. The third and final seat went to the new commander, Alexander Volkov, leaving Krikalev without a ride home. When Gorbachev officially resigned and Russian President Boris Yeltsin assumed power on December 25, both Volkov and Krikalev were living aboard *Mir*. By the time the two cosmonauts finally returned to Earth in March 1992, after 311 days in space for Krikalev, their uniforms bore the flag of a nation that had not existed for months. Fascinated by the extraordinary length of his stay, Western media portrayed Krikalev as having been stranded in space, calling him "the last Soviet citizen."

Just as important, however, Krikalev's impromptu double shift as *Mir*'s flight engineer illustrated how much coordination was required to sustain a space station. That technical challenge became a political opportunity. Born out of the crisis of the Cold War's end, a series of agreements between the United States and the emerging Russian Federation led to the initial plans for a joint space station. The Shuttle–*Mir* Program, a spaceflight project defined as much by political goals as any technical or scientific ones, was developed to smooth the path to cooperation. To enact the bilateral initiative, NASA planners needed to change direction. After all, the US was already well on the way to designing an American space station. As NASA astronaut and inaugural ISS commander William Shepherd recalled, "In early 1993, there was a complete review of the Space Station program. We were in the middle of trying to decide whether Space Station Freedom [the planned US station] would continue as a program or be canceled or be transformed into something else." In the end, the diplomatic, economic, and political negotiations being carried out by the United States and Russia in public were echoed by a series of

scientific, engineering, and cultural accommodations that needed to be made for the former rivals to begin to cooperate.

After decades of separate and parallel engineering, the incompatibilities between the two nations' spaceflight system were extensive. Each nation's equipment ran on electrical power with different voltages. The vehicles used incompatible systems to process breathable air. Dissimilar purification standards governed water use. At a basic level, the United States used the imperial system of measurement when the Russians—and the rest of the world—relied on the metric system. Communication was also complicated. Not only did the prospective crew members not speak the same language, but those languages also did not share an alphabet. In addition to affecting the compatibility of keyboards or software, the language differences also posed critical safety questions. If an emergency occurred, clear signs, labels, and other communication would be critically important. The preliminary requirements dictated, "English on the Shuttle side of the docking interface and Russian on the *Mir* side." NASA would be responsible for docking and undocking the shuttle orbiter with *Mir*, but "once the two vehicles have been mated the responsibility for joint operations/activities will be determined by which side of the docking interface the specific joint activity occurs." The disparities between the respective nations' spacecraft served both as practical concerns and as metaphorical symbols of just how different the two systems were.

Nonetheless, crewmembers needed to be able to work together. According to early planning documents, individual participants could choose which language to speak to each other. The sleep cycles of the Russian cosmonauts aboard *Mir* needed to shift to match the astronauts approaching via the space shuttle, since coordinating on the orbiter's side would constrain the number of available launch days. Standards for spacesuits and conducting spacewalks differed so greatly that the NASA representative implored, "I suggest that we cannot effectively operate a single Space Station with two different sets of rules, one for cosmonauts and one for astronauts. One set of rules is required and should be agreed to." Each side wanted to maintain its own technological spaceflight culture even as both sought to take advantage of the geopolitical collaboration.

Planning for the Shuttle–*Mir* Program occurred during historical circumstances when many Americans thought that spending on spaceflight would become less necessary. Analysts speculated that "lows [registered on public

opinion polls] in the early 1990s are tied somewhat, if not absolutely, to the end of the Cold War, the perception of NASA as a Cold War agency, and the belief that a 'peace dividend' would be forthcoming." After years of rising civil and military defense budgets, Americans hoped that spending could be redirected. Before the new joint project, congressional support also lagged. When voting in June 1993 to fund a space station to be created by the United States alone, the bill only passed by one vote. But the need for new cooperation in spaceflight reinvigorated legislative support. When Congress revisited the issue under the changed circumstances that included Russian cooperation, the result was remarkably different, with a margin of more than one hundred votes in favor of the redesigned space station. In the end, public opinion also shifted. After the summer of 1995, polls recorded improved enthusiasm about public commitment to spaceflight. Analysts attributed the shift to two different events, the symbolism of the first docked Shuttle–Mir missions and a popular movie that highlighted Americans' can-do spirit and engineering creativity, *Apollo 13*.

The Shuttle–Mir missions came first chronologically. During two initial flights, the same cosmonaut who endured a particularly long stay aboard *Mir*, Krikalev, also became the first cosmonaut aboard a space shuttle orbiter (STS-60). STS-63, known as the near-*Mir* mission, approached but did not dock with the Russian station. The first docking mission, STS-71, launched in June 1995. For the first time since the Apollo–Soyuz Test Project in 1975, spacecraft from the two superpowers successfully docked.

NASA and the Russian Space Agency marked the political significance of the docked missions by creating space-flown memorabilia. In addition to the mission patches commonly used as commemorative souvenirs, each of the nine docking missions flown between 1995 and 1998 also included symbolic pairs of small American and Russian flags. A complete set representing each of the nine flights was transferred to the Smithsonian's National Air and Space Museum in 1999. Creating mementoes marked the program's significance in the historic record but likely did little to arouse widespread public excitement.

What did have a marked effect on public opinion was director Ron Howard's film *Apollo 13* (1995), which told the story of the ill-fated lunar mission that launched in 1970. The screenplay, based on *Lost Moon*, astronaut Jim Lovell's coauthored account of the mission, recounted the experience of Apollo 13, which was to have been the third human landing on the Moon. During the journey to

STS-71 was the third US / Russian Shuttle-Mir Program mission, and the first to include actual docking. The mission patch depicts the Space Shuttle *Atlantis* about to dock with the Russian space station *Mir*. The rising Sun in the center symbolized a new era of cooperation. Photo courtesy of the National Air and Space Museum.

the Moon, however, an explosion in an oxygen tank in the service module crippled the spacecraft. The story personalized the Apollo 13 crew, with Commander Jim Lovell played by veteran actor (and spaceflight enthusiast) Tom Hanks. Just as much as it featured the flight crew, however, the film also highlights the engineers in Mission Control. Led by flight director Gene Kranz (played by Ed Harris), they work relentlessly to solve a series of cascading problems, one after another, to bring the crew home. The film debuted as the number one movie at the box office during the week of July 4. In fact, it performed so well that it helped to break a record set three years earlier. As the *New York Times* reported, "A strong debut for 'Apollo 13' over the holiday weekend helped lift Hollywood to its best five-day box-office performance ever."

In the end, the movie's laudatory depiction of NASA's "successful failure" measurably strengthened general favorability numbers. As space historian Roger Launius reported, "Polling depicts the beginning in 1995 of consistently high marks for spaceflight after several years of steady decline." The movie also

(*Left*): The white suit vest worn by flight director Gene Kranz during the Apollo 13 mission in 1970 became iconic through both its role in history and its depiction in the major motion picture *Apollo 13* (1995). Photo courtesy of the National Air and Space Museum / Eric Long, NASM 2009-30597. (*Right*): Kranz, with a cigar between his teeth, celebrates the successful recovery of the Apollo 13 crew while wearing his characteristic white vest. Photo courtesy of NASA.

cemented the mission in the public imagination. The National Air and Space Museum later collected one of Kranz's signature vests in 2008. The white vest made famous by the Apollo 13 mission joined the Smithsonian's collection, both for its significance during the actual mission and because the fictionalized film version made that garment iconic.

DEEP SPACE NINE

The same historical moment in which two former rivals planned for a joint space station saw two television programs imagining fictional space stations. Created independently of any influence from real-life spaceflight plans, *Star Trek: Deep Space Nine* and *Babylon 5*, two series with similar premises, each debuted during a moment of fresh competition for television production and dissemination. Beginning in May 1991, the Federal Communications Commission relaxed a series of antimonopoly rules barring television networks from owning the content that they broadcast. The changes opened the marketplace for production companies

to launch new cable networks showcasing their own creations. To draw new viewers to their channels, executives looked to a genre of programming that had proved successful in the past. After all, science fiction fans had a reputation for being active and loyal. If they liked a program, they would seek it out week after week—and that was exactly what the new cable stations needed to build their audiences in this highly competitive marketplace.

The circumstances that led *Deep Space Nine* to beat *Babylon 5* to the airwaves began with a pitch. Straczynski shopped *Babylon 5* to Paramount before it was picked up by Warner Bros. television. The story focused on a space station in the aftermath of a destructive Earth war. Paramount rejected the pitch, and then launched its own program about a distant space station in the aftermath of a destructive *alien* war. For years, Straczynski said that he did not think that the *Deep Space Nine* creative team was aware of his pitch. He now argues that Paramount's executives knew, and that the show's premise became a pawn as the major studios sought a strategic advantage in the rapidly shifting media landscape. After all, there was no love lost between Paramount and Warner Bros. The companies had conducted unsuccessful talks aimed at creating a joint television network before going their separate ways, acrimoniously. In the aftermath, as *Deep Space Nine* moved toward broadcast, *Babylon 5*'s start was significantly delayed. In his memoir, Straczynski stated that "only the top studio brass on either side of the contretemps really know the truth of what happened."

In the end, *Deep Space Nine* debuted in syndication in January 1993, a month before the movie *Babylon 5: The Gathering* aired. *Deep Space Nine* and *Babylon 5* gradually earned their own loyal fan bases. Based on their success, each merits separate consideration of how they tapped into Americans' spaceflight enthusiasm.

Deep Space Nine both benefited from and had to contend with its place in the *Star Trek* canon. In some fundamental ways, the program hewed to the *Buck Rogers* traditions of space adventures rooted in frontier tales. NBC president Brandon Tartikoff specifically directed that the new show begin from a classic Western premise of a man and his son arriving at a frontier town on the edge of known civilization. One of the show's own writers also described it that way. "We had the country doctor, and we had the barkeeper, and we had the sheriff and we had the mayor ... the common man ... [and] the Native American." The show's creators used that formula to build on the franchise's traditions. As scholar Daniel Bernardi noted, "Fans' passion for *Trek*'s multicultural future prompted

Paramount... to continue casting an increasingly diverse group of actors in Deep Space Nine and Voyager." Significantly, *Deep Space Nine* was the first *Star Trek* program created without the direct input of Gene Roddenberry, who died in 1991. Without Roddenberry cautioning against too much conflict in the storytelling, the new series' two creators, Rick Berman and Michael Piller, used their years of experience working on *Star Trek: The Next Generation* (as executive producer and showrunner respectively) to take the show in new directions.

For example, *Deep Space Nine*'s pilot, a two-part, feature-length episode titled "Emissary," invoked new scholarly interpretations of the Western frontier. In the late 1980s and 1990s, rather than imagining a line of white settlers and civilization sweeping inexorably from East to West, a new generation of scholars described the American West as a zone of multicultural exchange that included Native people. In 1991, these academic debates gained broader public notice when controversy erupted over a museum exhibit. *The West as America* at the Smithsonian's National Museum of American Art examined how frontier myths had been valorized in classic Western landscape paintings.

A year or so after the controversy, *Deep Space Nine* specifically invoked that debate through the first interactions of two main characters. While picking through the medical lab ransacked by the Cardassians as they left the station, which they had occupied, Major Kira Nerys (Nana Visitor) and Dr. Julian Bashir (Siddig El Fadil) have a pointed exchange. After Bashir enthuses about his own ambitions, "Oh, this will be perfect! Real frontier medicine!" Kira retorts, "This wilderness is my home." As Bashir stutters, searching for a reply, Kira answers quickly, "The Cardassians left behind a lot of injured people, Doctor. You can make yourself useful by bringing your Federation medicine to the natives. Oh, you'll find them a friendly, simple folk." Her direct confrontation of the frontier mythos leaves the doctor speechless.

In addition to introducing characters, the pilot episodes established complex themes of conflict and loss. The show opens with a space battle in which the Federation, including first officer Benjamin Sisko (Avery Brooks), endures punishing attacks that result in the death of his wife. The rest of the pilot follows Commander Sisko, yet to be promoted to captain, three years later, taking charge of a distant space station alongside staff from the local planet, Bajor. Until a Bajoran rebellion overthrew them, a reptilian race called the Cardassians occupied the planet and the station. Previous *Star Trek* shows had the central characters

dip in and out of external worlds, returning to the ship at the end so that the next installment started fresh. The conventions of episodic television cut against allowing complexity to play out. Yet, as actor René Auberjonois (Constable Odo) recalled, *Deep Space Nine* engaged contemporary issues in a sustained way. "It was being developed at the time of the riots in Los Angeles and the burning of South Central [Los Angeles in April and May 1992]. And also politically [the war in] Bosnia and [the breakup of] Yugoslavia. . . . I think that deeply influenced the style of the show." Berman and Piller have said that they deliberately evoked the aftermath of the LA riots in the scenes in which Sisko surveys the formerly occupied space station.

The show's setting supported longer story arcs and gradual character development. In the course of the pilot, the Deep Space Nine station, previously understood to be light-years away from anything interesting, is discovered to be near the mouth of a stable wormhole, a subspace shortcut to the distant Gamma quadrant. As the Federation repositions the station to protect the strategic asset, the deep-space station becomes a major cultural crossroads. The setting allows new characters to disembark on the station each episode, even as the close quarters force the core crew to work through longer-term issues, including coping with intractable conflicts and real cultural differences. Rather than present an idyllic vision of smooth integration, the show explores the struggles inherent in complex encounters.

That the main character, Sisko, is an African American widower and a single father deepens that dynamic. The *Star Trek* universe has been criticized for including characters of color but never challenging the overriding uniformity of Roddenberry's liberal humanist vision or addressing the real history of race relations. In contrast, De Witt Douglas Kilgore argues, "The work of actor-director Avery Brooks represents a significant resistance to the whiteness of *Star Trek*." For the first time, the lead character's role included cultural touchstones rooted in the African American experience and the African diaspora. For instance, in the double episode that opened the third season, Sisko brings his African art collection to the station, a sign that he feels at home there.

Several excellent scholarly analyses have unpacked the cultural significance of Brooks's role. Instead of repeating earlier depictions of diversity that deemphasized real difference, scholar Lisa Alexander argues that "the writers and the actor used elements of African and African American history and culture to make

Sisko a more well-rounded character and to set him apart from previous Starfleet captains." One episode in particular, "Far Beyond the Stars," which Brooks himself directed, saw Sisko's character transformed in a series of visions into a Black science fiction writer in the 1950s. Exploring the discrimination experienced by that character engages the real history of exclusion in the genre more broadly.

Other *Deep Space Nine* episodes deal with racism, genocide, prison camps, mass destruction, and torture. Such plotlines echo contemporary debates about understanding a complicated past. In the 1990s, controversies about public funding of art, national history education standards, and historical museum exhibits served as battlefields in a culture war. Fifty years after the end of World War II, for instance, the controversy over the exhibit planned for the *Enola Gay* at the National Air and Space Museum made national news in 1994–95. In *Deep Space Nine*, episodes about the aftermath of the Cardassian occupation of Bajor also showed characters wrestling with a complicated fictional past. Moreover, as the series unfolded over the course of seven seasons, the program's authors also ventured into longer-form storytelling, a break from a strict episodic formula. Notably, *Deep Space Nine* used long story arcs to explore the moral ambiguities involved in carrying out a war with the Dominion, an enemy from the other side of the wormhole. Roddenberry had created *Star Trek* as a universe that had transcended wars. With deep experience in the writers' room and behind the camera, however, the *Deep Space Nine* writers and producers felt comfortable pushing the boundaries of the franchise parameters.

Fans came to enjoy the long-arc storytelling of this less optimistic version of *Trek*. After the program's initial midseason debut, *Deep Space Nine* did so well during the February sweeps that it finished fourth out of 137 syndicated programs on the air. One of the few shows ahead of it was *Star Trek: The Next Generation*. That meant that two of the top four programs in syndication were series about imagined spaceflight. *Babylon 5* soon joined the category.

BABYLON 5

More than a year before *Babylon 5*'s pilot movie aired in February 1993 on Warner Bros. Prime Time Entertainment Network (PTEN), fans had already been recruited by the series' creator. In November 1991, Straczynski offered online readers of a GEnie newsgroup some insights into the show's previous three years in

development. He explained that he wanted an adult approach to science fiction. As he wrote, his goal was to "attempt to do for television SF [science fiction] what *Hill Street Blues* did for cop shows." He appealed directly to potential viewers, counting on their understanding of television as a business: "By choosing to go the route of a movie first as a pilot, we basically have one shot at the ratings. It's better than a single pilot, but still chancy, so we will need support and every ratings point we can get our hands on to guarantee the number of episodes ordered subsequent to the movie." The show's intricate storytelling and award-winning visual style ultimately attracted loyal followers.

Babylon 5's fans loved the narrative depth and long-form storytelling. Even before production started, Straczynski imagined a story arc that had a beginning, middle, and end that would require five seasons to develop. As a result, although individual episodes could be watched as chapters, plot points were not always resolved by the end of the hour. Subplots stretched between shows and over seasons. Individual lines, situations, or character dilemmas foreshadowed things to come. To carry this off, the episodes were meticulously written. Little to no improvisation was allowed in delivering the scripted lines. Straczynski personally executed his vision from beginning to end; of the 110 total episodes, he wrote 92 in their entirety. As Straczynski wrote, he reflected on his choices, both in person and online. When asked early on about possible women's roles on the show in an online forum, for instance, he cited his experience at conventions or "cons": "There is going to be a VERY strong female character. . . . By talking to the fans, and appearing at cons, and using this and other systems, I've been able to find out what the fans want, and to combine that with my own personal vision." Straczynski relished interacting with fans—within limits. In his online interactions, Straczynski remained strict about not wanting to hear any story ideas. He feared that an enthusiastic suggestion of a plot turn or story device could create an appearance of conflict of interest if the same idea occurred organically in his own writing process.

For their part, viewers valued their active role. In fact, when PTEN canceled the show after the fourth season, a determined fan campaign found it a new home at the Ted Turner's TNT cable network. *Babylon 5* earned a reputation for appealing to discerning, thoughtful audiences. As one article pointed out, "Babylon 5 has friends in high places: NASA, the White House, [and] the ivory towers of

England." As the final season headed to air, *TV Guide* heralded *Babylon 5* as "TV's most complex and compelling sci-fi series."

Part of that compliment was due to *Babylon 5*'s fresh visual style. The series was shot in widescreen to take advantage of the imminent adoption of high-definition television, although cropped to 4:3 for broadcast on standard cathode ray tube televisions. In addition, all exterior shots—of the central space station as well as ships departing or arriving, or other space-based action—were rendered using computers, not practical miniatures. The decision to use computer-generated imaging for visual effects saved money. But some elements, such as the visual effect of the jumpgate, could not have been easily depicted otherwise. The interstellar gateway appeared as an immense four-part structure hanging in space, surrounding a swirling vortex. Using the new technology distinguished the show, aided the storytelling, and minimized costs. *Babylon 5* also held the production budget in check by confining much of the action to one setting: the space station.

The titular Babylon 5 was an Earth Alliance station, the fifth of its kind, located in neutral space. In the aftermath of a war that Earth barely survived, the show explained, the Babylon stations were created to be places much like the United Nations. As such, the station served both as a diplomatic neutral ground and as a kind of hierarchical municipality. Babylon 5 was a place where people came and went, though some occupants were also stuck there. Throughout the show, viewers saw multiple decks that constituted neighborhoods and even slums. In online postings to fans, Straczynski explained that in the *Babylon 5* universe, space travel was so expensive that some inhabitants found themselves unable to afford to leave. Such circumstances rendered them effectively homeless, living in a section called the Downbelow.

Babylon 5 also depicted a complex array of aliens, written as well-rounded supporting characters. Previous space science fiction television shows often featured an episodic "alien of the week" format. Each new race of extraterrestrials was strange to encounter—literally alien to the core human crew—and was left behind at the end of the episode as the spaceship departed. In contrast, *Babylon 5* envisioned regular interactions between humans and aliens. Moreover, Straczynski imagined that aliens might not take anthropomorphic bipedal form, live in the same gravity load, or even breathe the same atmosphere that humans do. For instance, one of the major characters introduced in the very first episode

was Kosh Naranek (acted by Jeffrey Willerth, voiced by Ardwright Chamberlain). As the Vorlon ambassador to *Babylon 5*, Kosh uses an "encounter suit" for environmental protection. This large protective apparatus allowed the character to remain within his required atmosphere. In addition, viewers eventually learned that the large and encompassing suit also disguised Kosh's true nature as a First One, a being of light that takes a different appearance for different species. Human characters stayed at the center of the storylines, but over time, some of the supporting alien characters developed significant backstories, emotional depth, and strong fan support.

Most important, the characters learned and grew as the show progressed. As Straczynski reflected later, "I wanted the characters to evolve in ways that could change the world around them." The character of G'Kar (Andreas Katsulas) offers a striking example. G'Kar (pronounced jeh-car) evolved significantly during the run of the show. The series' first episode introduced the character as the combative representative of the Narn, a race that launched a sneak attack on a Centauri agricultural outpost. Yet, by the fifth season, G'Kar had become a sympathetic and complex character, a spiritual leader of his people—and a fan favorite. The shift in the representation of aliens can be seen in the show's merchandise. When five different limited-edition large-scale action figures were released in 1997, three of the five represented aliens, including G'Kar. In this case, the inclusion of alien figures was intended very differently than when aliens were added to Mattel's Major Matt Mason line in the 1960s or Mego's *Star Trek* figures in the 1970s. In those cases, aliens were produced to provide adversaries for imagined battles with the core human crew (or half-human, as in the case of *Star Trek*'s Mr. Spock).

The large-scale *Babylon 5* action figures, however, were marketed as collectibles. Such figurines were aimed at an adult audience whose members were unlikely to play with them. That is evident in their form and presentation. The clear semicylindrical packaging showed the figures already posed with an arm raised, ready to go on display as is. These are not toys that were intended to be opened, with the packaging discarded as extraneous by eager children. If toys carry suggestions about how they might be used in their shapes and features, then these were clearly designed to be kept "new in box." As such, the alien figures needed to be endearing characters that charmed audiences enough for fans to want to collect them.

This Babylon 5 poster, which is in the Museum's collection, shows the main human and alien characters on the fictional space station. The series's long-form storytelling stretched between episodes and over five seasons. Well-developed alien characters even became fan favorites. Photo courtesy of the National Air and Space Museum.

Another piece of licensed memorabilia, a branded set of CD-ROMs, appealed to *Babylon 5*'s computer-savvy fans. The silvery, round data disks contained screen savers, computer wallpaper, and other themed graphics that fans could add to their own personal computer setups. These may have appealed to the same people who built and maintained the many fan sites available online. A short piece published about the show's heavy Internet presence included information about four notable sites dedicated to the show, only the last of which was the official Warner Bros.' one. One long-lived encyclopedic site, "The Lurker's Guide to Babylon 5," played off the double meaning of lurker as a name for newsgroup subscribers who read but did not contribute to the conversations and *Babylon 5*'s term for the homeless residents of the Downbelow. *Babylon 5* may have taken the lead in online fan interactions, but the space craze of the late 1990s had a strong online presence generally. By 1997, for instance, *Star Trek: Voyager* boasted more than ninety different websites. These held thousands of fan fiction stories and encyclopedias of show-based information. The fan-created resources represented one part of a late 1990s space craze.

THE LATE 1990S BOOM

Undeniably, the late 1990s saw a new space craze, expressed in space-themed television shows and films, both fictional and realistic. During the week of July 5–11, 1997, *TV Guide* highlighted the surge of new programming in its "Summer Sci-Fi Special" issue, which featured *Babylon 5* on its cover. That kind of coverage had tremendous reach. In an era before digital television included an onscreen guide to the day's programming, *TV Guide* was a fixture on the coffee tables in millions of American homes. Published regularly nationwide since 1953, the iconic magazine had two parts by 1997. A glossy, full-color introductory section featured articles on current series, television specials, or retrospective topics. Behind that, dense tables printed on uncoated paper listed local television schedules.

Along with the weekly issue, *TV Guide* produced a documentary-style series called "*TV Guide* Looks at ..." The "TV Guide Looks at Science Fiction" special aired on July 5 on the USA Network. William Shatner, who portrayed Captain Kirk in the original *Star Trek* television program, hosted the special, which featured him in conversation with the robot from the 1960s series *Lost in Space*. The retrospective went back as far as *Captain Video and His Video Rangers*, connecting

the early offerings to the more recent *Quantum Leap* (NBC, 1989–93) and *Babylon 5*. In addition to promoting its own special, the "Summer Sci-Fi Special" issue previewed what fans could expect from the fall television season. There was a lot. *Babylon 5* and *Deep Space Nine* were both entering their fifth seasons. *Star Trek: Voyager* (1995–2001), around which Paramount launched its own new television network, UPN, was starting its third. In addition, the long-running *Stargate SG-1* (Showtime and Syfy, 1997–2007) premiered that fall.

Even as *TV Guide* grouped *Stargate SG-1* in with other popular science fiction television programs, however, the show's creators attempted to distinguish it. As executive producer Jonathan Glassner told *TV Guide*'s Mark Nollinger, "It's not one of those weird science-fiction things with a big spaceship. It's us, today, finding a piece of technology we don't understand and [getting] into situations we don't know how to handle." Nonetheless, the show benefited from the recent bankable success of science fiction; the program had two seasons guaranteed from the beginning. It proved to be a sound investment. *Stargate SG-1* remained on the air for eight more seasons after the initial two, ending its run on a new cable channel dedicated to the genre, the Sci-Fi channel (later Syfy).

The Sci-Fi channel made a less successful investment with *Mission Genesis*, its first original series, which lasted just a single season. Inspired by Ken Catran's *Deepwater* trilogy of youth novels, the show was known as *Deepwater Black* in Britain and Canada. The series centered on six clones sent into space aboard a ship serving as a gene bank/ark to be used to repopulate Earth after a twentieth-century plague. Aimed at Generation X viewers, the show's production featured a small cast working in sets that looked dark and crowded (not big and bright like *Star Trek*'s original shipboard settings), supplemented with lots of computer-generated graphics.

That same fall, a new Gene Roddenberry program launched in first-run syndication. *Earth: Final Conflict* (1997–2002) depicts a resistance movement battling a seemingly benevolent but suspicious alien domination on Earth. Based on an unsold manuscript by Roddenberry brought to network attention by his widow, Majel Barrett Roddenberry, *Earth: Final Conflict* posed significant questions. Originally green-lit by CBS in 1977 under the title *Battleground Earth*, the show had fallen to the side when Roddenberry started working on the *Star Trek* feature films in the late 1970s. Taking advantage of new visual effects and developing the 1970s premise in ways that addressed issues reflecting a 1990s context,

Earth: Final Conflict explicitly plays with the question of whether the aliens had a fixed gender presentation and how biotechnology might evolve. As Barrett Roddenberry explained, the *Earth: Final Conflict* aliens were different things to different people:

> In each other's presence, they are pure, translucent energy. When face-to-face with earthlings, they take on a sensuous, seductive outer shell—a blend of Queen Nefertiti, the Buddha, and other historical and religious icons. Seemingly genderless, they become more male when interacting with human females, more female with males. Their graceful, almost poetic architecture is grown, rather than built, using a bioengineered concrete that comes to life when a special enzyme is added.

The complex world building that had come to characterize science fiction and fantasy also found expression in the invented alien culture. The show found a steady audience and ran for five seasons.

Spaceflight themes in movies also saw banner years in 1997 and 1998. Several of the most successful space-themed movies in the United States in those two years were notably helmed by directors from outside the United States. The core elements of American space science fiction films had been so thoroughly exported over the years that directors from all over the world had their own individual takes on the formula. American audiences, attuned to watching variations on the cultural form, responded. Indeed, the only major space film of 1997 directed by an American was *Contact*, helmed by Robert Zemeckis. The film adapted Carl Sagan's novel from 1985 about a radio astronomer who detects an alien signal and wrestles with the conflicts between science and religion.

French director Luc Besson's *The Fifth Element* (1997) presents a story that he had started writing as a teenager. Released with a tremendous splash as the first film shown at the 1997 Cannes Film Festival, the hoopla included fireworks and a fashion show by film costume designer Jean-Paul Gaultier. In theaters, audiences enjoyed the comic-book-inspired world building. Scholars have dug into film's depictions of gender, pointing out the hypersexualized flight attendants, the giddy schoolgirls, and Milla Jovovich's portrayal as the scantily clad Leeloo. Although Leeloo is actually the titular "fifth element" capable of saving the world, she ultimately needs rescuing—and convincing that a man's love makes

humanity worth saving at all. The gender-bending performance of Chris Tucker as Ruby Rhod also serves as a foil to action hero Bruce Willis's portrayal of Korben Dallas as the ultimate male protector of the universe.

Fans of space movies had many choices throughout the year. *Gattaca* (1997), directed by New Zealander Andrew Niccol, depicts a future society rife with genetic discrimination. Although the film never shows a space launch up close, the allure of making one—a privilege only available to the most successful of the genetically engineered—drives all the action. Although only moderately successful at the box office, the film became an often-cited touchpoint for discussion of the perils of unregulated genetic engineering and rigid social hierarchies.

In 1997 as well, Dutch director Paul Verhoeven adapted Robert Heinlein's 1959 novel *Starship Troopers*. Provocatively blending fascist imagery with patriotic overtones and a reassertion of the American frontier myth, the movie was a blend of horror and space science fiction. Several other films used spaceflight settings as the basis for horror pictures. After a five-year gap in the franchise, *Alien: Resurrection* (1997) offered the last installment of the original series of films before the franchise was later rebooted with prequels. Featuring a screenplay by Joss Whedon, the follow-on to *Alien 3* (1992) was led by French director Jean-Pierre Jeunet. Englishman Paul W. S. Anderson directed the thriller *Event Horizon* (1997), which imagines a deep-space rescue mission that uncovers horrific circumstances, with the devil himself aboard an unfortunate ship. Even the low-budget *Leprechaun* horror-comedy film series, directed by English-Australian filmmaker Brian Trenchard-Smith, set its third sequel in space.

The trend for space films spilled over into the next year. Drawing on an established property, Jamaican-born British-Australian director Stephen Hopkins directed an updated reimagining of *Lost in Space* (1998), based on the iconic 1960s television series. It was tepidly received. As one of the few women on this list, American Mariam "Mimi" Leder directed *Deep Impact* (1998), one of two comet-heading-for-Earth films to grace the silver screen in 1998. The other was *Armageddon* (1998), released just two months later. The second movie, which was less realistic but more commercially successful, benefited from the official participation of NASA. Recognizing the power of popular culture to influence audiences, NASA began actively participating in shaping their image by supporting not just news outlets covering their achievements, but also fictional depictions including major motion pictures. The agency established an office dedicated

to working with film companies. As a result, director Michael Bay included frequent uses of the circular NASA "meatball" logo in *Armageddon*. Training scenes were filmed at recognizable locations on site at NASA's Johnson Space Center.

In the resulting film, the framework of the Buck Rogers archetype continued to shape fictional depictions of spaceflight even seventy years after the comic strip first debuted. The rag-tag team of irascible oil drillers sent to save the world in *Armageddon* deliberately plays against the cultural archetypes established in heroic science fiction. Lead actor Bruce Willis plays a variation of a role that he did so well, the acerbic antihero/action hero. Rather than somber space adventurers, however, an irreverent, rough-hewn space crew flies into space carrying bombs, not sidearms. Indeed, the humor in the crew's introductions relies upon the audience's understanding of the genre's history of depicting spacefarers as earnest do-gooders. In the end, the fast-paced, action-packed depiction of blue-collar guys succeeding where white-collar professionals were failing was highly successful. *Armageddon* was the second highest grossing movie of the year in the United States and the first overall worldwide. The success of the adventure picture echoed the revenues and responses elicited by a similar movie two years earlier, German director Roland Emmerich's alien-invasion blockbuster *Independence Day* (1996).

Just as the canonical composition of a space adventure crew underscored *Armageddon*'s satirical depictions, so too the assumptions of whiteness as the baseline expectation for the genre continued. Even as late as 1998 when *Star Trek: Insurrection* was released, depictions of racial diversity continued to be contrasted with homogeneous ideals. The third film featuring the *Star Trek: The Next Generation* cast opened on an idealistic, agrarian society under covert observation by the Federation. The unwittingly observed Baku citizens till the land, hammer iron at a forge, and bake bread in a collective kitchen. They are all white. Their lack of conflict and collective sense of purpose grows from their uniformity. When the scene switches to the inside of the cloaked Federation blind, however, the diverse group includes both humans and aliens—and the first person to speak is Black. At the same time, in intercut scenes, Captain Jean-Luc Picard (Patrick Stewart) betrays his discomfort as he negotiates a delicate diplomatic greeting. After his carefully practiced alien salutation, he reluctantly submits to his bald head's being adorned with an alien beaded headdress. Although the Baku turn out to be less primitive than first assumed and the Federation's ideals

eventually result in a beneficial outcome, the visual depiction of a utopian society still relies upon racial exclusivity.

Even as multiple fictional films and television programs competed for audience attention, the excitement about spaceflight in the late 1990s also included an historic miniseries recapturing the stories behind the golden age of human spaceflight. In 1998, HBO presented the twelve-part *From the Earth to the Moon*, organized and introduced by Tom Hanks. The docudrama series about the Apollo Program borrowed its title from Jules Verne's famous novel about a lunar flight. Although the series told a coherent and historically accurate story, each individual episode had a different director, each of whom lent his or her own approach and visual style to the specific episodes. The series was a demonstration of the distinctive kind of project that could be produced by a network like HBO, which operated in the middle ground created by the absence of network television's restrictions and the more affordable budgets of television (rather than movies). The result was a critical and audience success. Shown in two-episode segments over six sequential Sundays, *From the Earth to the Moon* became what was known as "appointment television." The collective social experience of watching the same program at the same time nationwide was soon challenged, however. The adoption of digital video recorders, which became available to US consumers in 1999 via DishTV or TiVO, once again altered the social experience of popular culture.

NEW AND CHANGING INFRASTRUCTURE

The advent of time-shifted viewing was just one of the transformations that reshaped how fans and collectors participated in spaceflight enthusiasm. In the 1990s, key elements of the business community that bought and sold collectible souvenirs changed in big ways. Drawn by profits, commercial concerns created special pieces aimed at the fan market and designed to appeal to collectors. At the same time, eBay upended the collectors' marketplace.

First, the abundance of available merchandise reached new heights in the 1990s. Branded memorabilia so saturated the marketplace that its very overabundance became the subject of commentary. As an editorial in *Sci-Fi Flix* magazine noted, the depth and breadth of available products related to *Star Trek*, for instance, knew few bounds:

SPACE CRAZE

You can watch Trek tapes, read Trek books and magazines, play Trek games, dress Trek, eat from Trek plates (OK, they're meant for display, but you could eat from them), Trek-orize your computer, decorate your room with all manner of Trek arts, crafts, and collectibles, speak Trek (Klingon, at least), join Trek clubs, convene at Trek conventions, go online with Trek, and even decorate your Christmas tree with Trek ornaments.

In the summer of 1997, just months after this piece was published, Mattel released *Star Trek* Barbie and Ken dolls. By January 1998, *Star Trek: The Experience* opened at the Las Vegas Hilton. The theme park–style attraction, which remained open for the next ten years, took groups of tourists through an adventure on full-sized sets with actors playing out the action. The attraction also offered ways to acquire merchandise. At the end of the paid experience, a *Star Trek* museum, theme restaurant, and a well-stocked gift shop satisfied enthusiasts' desires.

Second, fan conventions also became larger and more commercial. For instance, Creation Entertainment, known especially for hosting officially branded *Star Trek* gatherings, built its business by holding fan conventions for all kinds of television and movie properties. The company had its roots in a simple comic book convention convened in New York City in 1971 by Gary Berman and Adam Malin when they were just fourteen years old. The company grew in the 1980s, hosting dozens of annual commercial gatherings in communities across the country. But it really came into its own in the 1990s. According to popular culture scholar Elizabeth Thomas, "At the height of *Star Trek*'s popularity in the early to mid-1990s, Creation was organizing 110 conventions a year, sometimes three in a single weekend." Beginning in 2001, Creation began hosting the official *Star Trek* convention, known as *Star Trek* Las Vegas.

The San Diego Comic-Con, one of the largest and best known multiplatform fandom gatherings, followed a similar path. That convention originated as the Golden State Comic-Con with just three hundred people in 1970. Although one of its main founders had created some of the first commercial comic book conventions in Detroit in the 1960s, Comic-Con is run by a nonprofit board, not a commercial company. Nonetheless, its economic impact in San Diego has been extensive. In addition to the hotel rooms rented, meals eaten, and transportation used, there is the sale of souvenirs and other merchandise. Rows of booths fill the immense San Diego Convention Center. Comic-Con has also become a go-to

location for television networks, movie production houses, and other brands to launch new series, films, or products.

Related to these developments, the way that fans engaged with collectible things also shifted. Commercial brands responded to the popularity of big conventions by producing exclusive souvenirs, only available for purchase during the gathering's run. Such rare or limited-edition pieces fit a trend of manufacturers creating popular culture memorabilia aimed at adult collectors with disposable income. This phenomenon certainly had roots in the 1970s and 1980s, as with *Star Wars* toys. But especially in the 1990s, collector's markets went wild. Baseball cards and Beanie Babies became leading examples of the inflationary craze that magnified the values of toys, dolls, porcelain figures, and other ephemera.

The speculative marketplace not only raised the prices of individual products, but it also affected the kinds of things that were sold. By the early 1990s, for instance, using a technique that paralleled the strategy behind exclusive convention pieces, baseball card manufacturers developed more expensive, gilt, or even holographic baseball cards aimed especially at collectors. Such products encouraged the practice of purchasing collectibles with the intention that they be saved and speculated on, not opened or played with. In 1991, Americans spent $7.7 billion on new, limited edition, or collectible pieces. In retrospect, however, the early 1990s were the peak of the collectibles market boom. By 2001, that figure was down to $6.5 billion. The artificiality of the marketplace was partially to blame. Collectors who stockpiled their collections waiting for them to appreciate ended up disappointed. The explanation was straightforward. Other collectors who might pay top dollar for a piece likely had their own collections, also carefully stored in hope of increased values.

Finally, a new company, eBay, radically disrupted that marketplace. Initially called AuctionWeb, the company that became eBay was founded in 1995 by Pierre Omidyar. The online auction site allowed users to sell objects to buyers nationwide (and later, internationally). In many ways, an online marketplace was a collector's dream. Rather than have to search flea markets, scour auction catalogs, or cultivate relationships with dealers, hoping for the happenstance of locating a desired thing, collectors could seek out particular items anywhere in the country or around the world. The ability to execute person-to-person sales built eBay's business quickly; Beanie Babies actually comprised a significant portion of the site's early traffic. But eBay fundamentally undercut the very market scarcity

that made limited-edition items attractive. Within just a few years, the effect on prices was significant. In 2002, Mary Sieber, editor of *Collectors Mart Magazine*, summed up the change, "Just about everything has fallen in value." As eBay built its own value, it burst the bubble of inflationary collectors' markets.

A NEW SPACE AGE

These changes in business structures would seem to have very little in common with the international agreements that underlay the construction of a massive new International Space Station. Yet, to draw a loose comparison, the ISS served as the infrastructure that defined the objectives of human spaceflight for decades to come. At the same time, advocates who wanted spaceflight to become commercially viable created new incentives for private companies to take on the challenge. The dawn of the twenty-first century saw several significant efforts to turn spaceflight into a venture pursued by individual businesses. Most notably, several billionaire entrepreneurs used their riches to create private rocketry companies inspired by their own youthful passions for spaceflight. The public's excitement about new developments in spaceflight rose and fell with these developments.

Together, the United States, Russia, Canada, Japan, and the European Space Agency created the International Space Station (ISS) as a long-term research platform. The first component, a Russian-built module named *Zarya* (dawn/sunrise), had originally been intended for *Mir*, and the third, *Zvezda* (star), had been intended for its successor, *Mir-2*. For its part, rather than pursue the ongoing development of Space Station *Freedom*, the United States provided financial support for the Russian contributions while also developing its own components. The United States paid for the development of *Zarya*, which launched on November 20, 1998. Over the next twenty-two months, four shuttle missions constructed the core of the physical infrastructure. The three-person crew of Expedition 1 launched on a Russian Soyuz rocket on Halloween 2000. Even after spending 136 days in space, however, NASA astronaut and Expedition 1 commander Bill Shepherd noted how much work remained, stating: "We do not even have a standard vocabulary, let alone a standard understanding of even how we do the mathematics, the computer algorithms, the intricate computations that are necessary to guide vehicles through space." Nonetheless, Expedition 1 began the human occupation of the station that has continued uninterrupted for more than twenty years.

SPACE STATIONS, SPACEFLIGHT ENTHUSIASM, AND ONLINE FANDOM

The same year that an American infusion of financial support allowed the first ISS segments be launched, Eric C. Anderson created a new business designed to turn the Russian space program's need for financial investment into a tourism opportunity. Space Adventures Ltd. allowed an exclusive group of enthusiasts to experience their dreams of spaceflight firsthand. Initially, the company arranged a deal between financier Dennis Tito and MirCorp, a private company founded to make money from the aging *Mir* space station. But when Russia deorbited *Mir* in 2001, Space Adventures renegotiated. Tito became the first space tourist, buying a seat on a Soyuz flight to the ISS later that year. Since then, Space Adventures, based in Tysons Corner, Virginia, with an office in Moscow, arranged for more clients to make trips to the ISS. All told, between 2001 and 2009, seven people flew into space as tourists (one twice). The experiences, which included the necessary testing and training, reportedly cost approximately $20 million each. (As the saying goes, if you have to ask, you can't afford it.) In addition, seven clients underwent spaceflight training brokered by Space Adventures but did not complete a space flight. Even as they experienced the ultimate realization of spaceflight enthusiasm, each of the space tourists also used the opportunity to promote more excitement. During the flights, they spoke to students, conducted experiments, and generally promoted the benefits of spaceflight.

Another long-time enthusiast, Peter Diamandis—the same man who founded Students for the Exploration and Development of Space (SEDS) as a college student in 1981—created a different way to promote privately funded spaceflight. Diamandis started the XPrize Foundation after reading Charles Lindbergh's *The Spirit of St. Louis* (1953). He was inspired by the example of the Orteig Prize, the money put up by hotelier Raymond Orteig in 1919 for the first nonstop transatlantic flight from New York to Paris, which Lindbergh claimed in 1927. In that vein, Diamandis established the XPrize Foundation in 1994. When he began, the "X," (10 in Roman numerals), was a placeholder. Diamandis planned to rename the organization after the big donor who funded the $10 million prize.

Even before the money for the initial prize had been raised, the Foundation outlined the challenge. To win, companies needed to create "a spacecraft that can carry three adults sixty-two miles into space, make two flights in two weeks and land intact." By 1997, ten teams had registered to compete. By 2003, that number had increased to two dozen teams from five countries. The payout for what became the Ansari X Prize came from Anousheh Ansari and her

brother-in-law Amir Ansari, a pair of Iranian American spaceflight enthusiasts who made their money in telecommunications. (Anousheh later flew into space in 2006 on a trip brokered by Space Adventures.) On September 29 and October 4, 2004, *SpaceShipOne*—created by Scaled Composites and Mojave Aerospace Ventures—completed the two flights required to win the Ansari X Prize.

The incentive did just what Diamandis had hoped: jumpstart a new private spaceflight industry. In the week before the second Ansari X Prize flight, Sir Richard Branson announced the creation of Virgin Galactic. The new company sold suborbital recreational spaceflights to be carried out aboard new versions of the prize-winning vehicle. The *New York Times* reported that even with each flight priced at $190,000 and later climbing to $250,000, "5,000 people . . . made serious inquiries about tickets." By early 2006, as the company worked to develop a spaceport in New Mexico, 157 people had put down deposits for Virgin Galactic flights.

Already, however, the company had competition. In 2006, the Ansaris joined forces with Space Adventures to create a company offering its own suborbital spaceflights using Russian-designed vehicles. New companies, such as PlanetSpace and Rocketplane-Kistler, joined the growing list of such businesses founded between 1998 and 2000. Other competitors included XCOR Aerospace, Aera Corp, Armadillo Aerospace, and Bigelow Aerospace. Each had its own approach to making a mark—and hopefully, a profit. Among the small startups looking to revolutionize the spaceflight industry were two companies that eventually led the pack: Jeff Bezos's Blue Origin and Elon Musk's SpaceX.

A science fiction fan and a spaceflight enthusiast—and an early member of SEDS—Bezos had always been excited by the idea of space travel. As a teen, he spoke during his high school valedictorian speech of his interest in seeing humans colonize other worlds. Bezos made his fortune as the founder of Amazon .com, the online bookstore turned behemoth e-commerce site. Although he counts himself as a diehard *Star Trek* fan, in the end, he was inspired to pursue his own dream of getting involved in spaceflight by *October Sky* (1999), the movie based on NASA engineer Homer Hickam's memoir, *Rocket Boys*. The next year, Bezos started his own rocketry company. Its name, Blue Origin, refers to Earth, the blue planet and humanity's origin. Its early activities—purchasing land in Texas for a testing site and developing a reusable rocket—took several years to became public knowledge. The company's motto, *Gradatim Ferociter*, means "step by step, ferociously," reflecting the company's commitment to quiet

but steady progress. Bezos envisions the company's creating the infrastructure that will allow the next great leaps in spaceflight, much as Amazon.com built its business on the frameworks provided by the interstate highway system, delivery companies, and Internet service. Blue Origin's first rocket is called New Shepard, a tribute to NASA astronaut Alan Shepard, the first American in space.

For his part, South Africa–born Elon Musk put $100 million from his PayPal fortune into Space Explorations Technologies Corporation, or SpaceX, which he founded in 2002. The immediate goal was to create a low-cost rocket that could compete for satellite launch business. His long-term goal, however, was inspired by his dream of colonizing Mars. Musk's idea for a "Mars Oasis" imagined landing a small greenhouse on the red planet's surface. Once there, it would serve as a laboratory and an inspiration for further exploration. Musk himself drew on his own youthful science fiction passions for inspiration. SpaceX's Falcon rocket series was named after the *Millennium Falcon* from *Star Wars*. In the end, SpaceX emerged as a force in the space launch business. The successful flight of Falcon 1 in 2008 achieved the first privately developed liquid-fuel orbital flight. And with the successful deployment of a Malaysian satellite during the vehicle's next use, SpaceX executed on its promise as a satellite launch company.

Both Blue Origin and SpaceX began competing to support NASA's human spaceflight efforts. Beginning in 2006, even before the end of the Space Shuttle Program, NASA initiated the Commercial Orbital Transportation Services (COTS) Program to develop new vehicles for bringing cargo and crew to the ISS. Shortly thereafter, NASA awarded missions to commercial concerns to deliver cargo and supplies to the station. This policy shift changed NASA's relationships with private companies from the model that had existed during the Apollo Program. The new requirements asked companies to share both risk and costs. NASA continued to shift ISS servicing to private companies through competitive contracts even as their short-lived Constellation Program to develop new human spaceflight launch vehicles was canceled by the Obama administration in 2009 and the Space Shuttle Program wound to a close in 2011. Aside from the passionate following that Musk and SpaceX inspired independently, however, NASA's restructuring did not inspire public enthusiasm.

What did bring new attention to the agency was NASA's adeptness in adopting social media. Twitter, a microblogging site on which users could post short public declarations, began in 2006. That same year, Facebook, which famously

started as a way for Harvard students to connect with each other, opened its platform to "everyone at least 13 years old with a valid email address." NASA eventually became a savvy user of such platforms. Astronaut Mike Massimino, who sent the first Tweet from space, signed up for Twitter about a month before his STS-125 launch in May 2009. By October, his account had a million followers. His tweets not only gave spaceflight enthusiasts a glimpse of his firsthand experiences, but many followers also responded actively to his messages and engaged each other in conversation. Social media became a regular part of all astronauts' mission duties. To expand that reach, NASA invited influential social media users to special behind-the-scenes gatherings, called NASA Socials, as a regular feature of the agency's public affairs strategy. By 2009, NASA won in the government category the first of several different Shorty Awards for best use of social media. And spaceflight enthusiasts learned to use social media to find like-minded friends, following fellow spaceflight boosters and amplifying each other's accounts.

Remarkable achievements in robotic spaceflight and science education also captured public attention. When the Mars Science Laboratory *Curiosity* touched down on the Martian planet's surface, the landing—and the celebration at NASA's Jet Propulsion Laboratory (JPL) control room—was broadcast live in New York City's Time Square in the wee hours of the morning, on August 6, 2012. Participants reveled in watching planetary science happen in real time. Enthusiasts also made "Mohawk Guy," JPL's coolly coifed systems engineer Bobak Ferdowsi, into a social media sensation.

POST-9 / 11 VISIONS OF SPACEFLIGHT

Even as spaceflight businesses pursued space tourism and NASA shifted some cost and risk to private industry, the first years of the new millennium offered a dark turn in the fictional depictions of spaceflight. The destruction wrought during the terrorist attacks on the World Trade Center, Pentagon, and the airplane downed in Shanksville, Pennsylvania, on September 11, 2001, reverberated for years. The prolonged war on terror transformed American foreign policy. The use of "enhanced interrogation" techniques put the national principles being defended into direct conflict with the strategic means being used to secure them. Science fiction responded to 9/11 and its aftermath with shows and films that worked through difficult themes.

SPACE STATIONS, SPACEFLIGHT ENTHUSIASM, AND ONLINE FANDOM

The newest television series in the *Star Trek* franchise aired its pilot episode just weeks after that fateful date. Initially named just *Enterprise*, without the usual "Star Trek" prefix, the series focused on the prehistory of the Federation and the adventures of the crew piloting the first warp-five-capable starship, the *Enterprise NX-01*. The opening credits established the show's place in the fictional timeline by connecting the program's events to the real-life history of actual spaceflight development, although one focused almost entirely on American achievements. The show's theme song, "Where My Heart Will Take Me," played over a roughly chronological montage that included Amelia Earhart's flights, Chuck Yeager's Bell X-1 flight, the Apollo lunar launches, and the Mars rover *Sojourner*. For the first two seasons, the show hewed to the popular *Star Trek* formula of exploring the lives of the crew, led by Captain Jonathan Archer (Scott Bakula), and its mission of exploration. Several episodes suggested the larger context of a temporal cold war, a battle carried out across time by various characters seeking to change or preserve timelines.

None of these plots particularly reacted to 9/11. As people grappled with the immensity of the events and the societal changes made as the United States entered a perpetual war on terrorism, it is not surprising that it took a couple of years for writers and producers to create art that responded to those themes. For *Enterprise*, the shift in tone accompanied a change in format.

As the second season transitioned to the third, the show began a long story arc that spanned the entire third season with themes that became prevalent after 9/11, including increasing acceptance of militarization and the moral complexity of prolonged confrontations. In the second season finale, "The Expanse," Earth suffers a devastating and seemingly unprovoked attack from a new enemy, the Xindi. A laser-like superweapon burns the planet from Florida to Venezuela, killing millions of innocent civilians. The victims include the sister of *Enterprise*'s chief engineer, Charles "Trip" Tucker III (Connor Trineer). As the episodes unfold, the *Enterprise* crew grapple with the realization that the Xindi think that their preemptive strike is justified by what they know about Earth's attack on the Xindi home world four hundred years later.

In the end, the change in the program's tone and content could not save the series. Despite adding the prefix "Star Trek:" to the show's title partway through the third season, the program did not draw the same level of viewership that previous shows in the franchise had. In the fourth season, the per-episode budget

was slashed by more than half. Despite a fan campaign to save the show, *Star Trek: Enterprise* went off the air in 2005.

The clear influence of 9/11 could also be seen in Steven Spielberg's directorial adaptation of H. G. Wells's classic story of alien invasion, *War of the Worlds*. The film, released in 2005, stars Tom Cruise as Ray Ferrier, a divorced dockworker whose two children happen to be visiting when otherworldly electrical storms signal an attack by hostile aliens. As in the original story, giant three-legged assault platforms rise from the ground and wreak destruction. As the tripods vaporize people, ash and debris rain down. This aesthetic choice incorporates the visual history of 9/11, offering a stark contrast with another film about aliens attacking Earth. In *Independence Day*, when hostile aliens destroy major recognizable landmarks, the buildings blow apart in fiery but sterile explosions. In contrast, Ferrier staggers back home covered in dust, looking every bit as dazed and dirty as those near the World Trade Center. Other visual elements also evoked the terrorist attacks. On their pell-mell journey, Ferrier and his children pick their way through the wreckage of an airliner that crashed on the house where they were hiding and pass walls covered with homemade posters of missing people sought by their families. Throughout the movie, viewers follow Ferrier and his children as they flee. The audience sees the global event only through its effect on these individual lives. The result is disconcerting, robbing viewers of the insight or comfort of a wider context. In the end, the film employs the same denouement that Wells originally wrote, bringing the invasion to a sudden close.

A third, and perhaps most clearly realized, example of space-themed science fiction shaped by 9/11 and its aftermath is *Battlestar Galactica*. Just months after *Enterprise* began its significant third season arc, Ronald D. Moore, who had worked as a writer on three different *Star Trek* series, launched his own version of a well-known space science fiction television show. The reboot of *Battlestar Galactica* reimagined Glen A. Lawson's program, which aired for one season on ABC in 1978–79. Moore understood that reviving the show in this political moment carried new connotations: "I realized if you redo [*Battlestar Galactica*] today, people are going to bring with them memories and feelings about 9/11." A three-hour miniseries on the Sci-Fi cable channel in December 2003 established the basic plot. After a long and bloody war between the human Twelve Colonies and the robotic Cylons, forty years of silence is broken by a coordinated nuclear attack on human sites led by evolved Cylons that look human. About fifty thousand people

survive aboard a flotilla of spaceships, led by the *Galactica*. Together, the fleet set out for a fabled planet where a reputed thirteenth tribe had made its home: Earth. The plotlines that unfolded during the next four years (an abbreviated season in the fall of 2004, followed by three full ones, ending in 2007) explore the survivors' desperation and the moral compromises made by all sides during the bitter conflict. As reviewer Robert Bianco summed up the second season, "Driven by violence and rage, *Galactica* is perhaps the darkest space opera American TV has ever produced."

The show's casting deliberately played against the expectations of the genre. Edward James Olmos, an acclaimed actor of Mexican descent, portrays military commander William Adama, who led the human fleet. In addition, four of the seven actors listed as the main cast are women, playing leading roles as both Cylons and humans. The first appearance of an evolved Cylon comes in the form of Number Six (Tricia Helfer), a statuesque blonde customarily dressed in red. Grace Park, an actress of Korean descent, plays multiple roles, appearing initially as Colonial Raptor pilot Lieutenant Junior Grade Sharon "Boomer" Valerii. The political leadership of the human survivors falls to Secretary of Education Laura Roslin (Mary McDonnell), thrust into the role of president—despite being forty-third in the line of succession—after the existing president, cabinet heads, and other officials are all annihilated in the attacks. Finally, in the reboot, the brash fighter pilot with the callsign "Starbuck" still chomps on cigars and gets into fights, but now in the person of Kara Thrace (Katee Sackhoff). *Battlestar Galactica*'s depictions of women soldiers had particular relevance at a time when some real-life combat exclusion rules in the US military services were still being debated.

Battlestar Galactica deliberately engaged culturally relevant subjects. As the episodes unfold, continual attacks on the dwindling group of human survivors deepen the mood of desperation. The Cylons are relentless, clever, and well-disguised. In the opening credits, the count of human survivors regularly diminishes. In response, the Colonists condone unethical and brutal tactics, including rape and torture, all issues of ongoing concern as the post-9/11 era raised the specter of war crimes and genocide, as well as religious and political fanaticism.

The series also broke new ground in its proliferation across what are called "ancillary content models." Simply put, producers responded to the prevalence of online fan communities by creating their own official media supplements, such

as podcasts, webisodes, or blogs. For example, *Battlestar Galactica: The Resistance* was a series of ten very short (two- to five-minute) webisodes created by the Sci-Fi Channel to promote the show on its website. Together, the short pieces bridged the events of seasons two and three. Fans who viewed the additional pieces on the official website could understand references in the subsequent television episodes in ways that those who only watched the actual program could not. Likewise, series creator Moore recorded a weekly podcast that offered listeners his commentary on past episodes.

Such ancillary material raised significant questions about what it meant to watch a show or be a fan. Should fans debate popular interpretations or defer to the creator's authority? Could one enjoy the program without the extra information offered in the supplementary pieces? And if not, what did that mean for viewers without timely access to that content because such material was not always released globally or distributed simultaneously? Ancillary content also became a major impetus for the 2007–8 Writers Guild of America strike. During that action, professional television and film writers walked a picket line over issues that included negotiating fees for their work when it was distributed using new methods, including websites, streaming, iTunes, and so on. In some significant ways, the issues that sparked the work stoppage presaged the radical reordering of television still to come. Streaming services and digital content eventually became more easily available without cable subscriptions or traditional network affiliations.

#WHERESREY AND OTHER ONLINE RESPONSES

The availability of such avenues for creative work, whether officially sanctioned by studios or created by fans as tributes, led to the expanded use of online resources to distribute fan fiction, original art, episode reviews, or series commentaries. Fan groups, often comprising or led by women, created their own responses to established science fiction franchises through blogs, vlogs, writing, and sketches. In many ways, Internet-enabled fandom removed geographic and other barriers to creating communities. But over time, the proliferation of online avenues of communication, including social media, has also permitted some ill-intentioned people to carry out vicious campaigns against those who would

encourage more diversity in the casting or subjects of science fiction. In notable cases, passionate fandom has been used to attack rather than unify.

In the first years of the twenty-first century, online resources allowed information to flourish. The organizers of bulletin boards and newsgroups that linked fans in the 1990s transitioned to webpages and other online resources. For example, Harry Doddema and Dan Carlson started Memory Alpha to be "a collaborative project to create the most definitive, accurate, and accessible encyclopedia and reference for everything related to *Star Trek*." Like the identically named project to record fan newsletters on microfilm in the 1970s, the Memory Alpha project took its moniker from the name of the Federation's largest archives. Using wiki software, which allows all users to contribute or adjust entries, the online encyclopedia was created, edited, and maintained by fans. Although they conceived of the project in 2003, a change of platform locked in the site's birthdate as 2004. Likewise, Steven Greenwood and Chad Barbry created an online *Star Wars* encyclopedia cleverly called "Wookieepedia" in 2005. The creation of the social news aggregation website Reddit that same year allowed fans of various topics to post and "upvote" interesting content on subreddits, which are topically specific boards. Years before most online information about many subjects could be considered reliable, science fiction fan sites tended to have accurate accounts of popular culture subjects. Websites about vintage shows or films became particularly relevant in an era characterized by reboots.

For producers, reboots or new versions of older properties allowed studios to do three things at once. They could simultaneously appeal to diehard fans, attempt to attract a new generation of viewers, and take advantage of new distribution formats. For instance, Lucasfilm created a *Star Wars* prequel trilogy: *Episode I—The Phantom Menace* (1999), *Episode II—Attack of the Clones* (2002), and *Episode III—Revenge of the Sith* (2005). In between the final two of those three films, however, an animated series called *Star Wars: Clone Wars* aired over two seasons on the Cartoon Network between 2003 and 2005. *Star Wars: The Clone Wars* (notice the "the") offered an animated "3-D" continuation on Cartoon Network for five seasons from 2008 to 2013. Two shorter seasons, numbers six and seven, then streamed on Netflix in 2014 and Disney+ in 2020. Finally, another 3-D animated series, *Star Wars: Rebels*, spawned a comic book series and several different novels. Throughout, toys that reflected the prequel movies and multiple animated series allowed children (or collectors) to purchase new versions of old

favorites, such as Chewbacca or R2-D2 action figures, along with new characters, such as Ahsoka Tano, Anakin Skywalker's female and alien Togruta apprentice.

In the first decades of the new millennium, fans enjoyed many reboots, sequels, or prequels. In 2008, Scott Derrickson directed Keanu Reeves and Jennifer Connelly in a reinterpretation of *The Day the Earth Stood Still*. The classic black-and-white movie warning about nuclear weapons became a CGI-heavy movie about environmental damage. Working with Paramount, director J. J. Abrams rebooted *Star Trek* with three films that took versions of the characters from the original 1960s television series into new adventures. The movies—*Star Trek* (2009), *Star Trek: Into Darkness* (2013), and *Star Trek: Beyond* (2016)—established an alternate version of events that came to be called the Kelvin timeline. Finally, Lucasfilm, which was purchased by Disney in 2012, released a sequel trilogy comprising *Star Wars: The Force Awakens* (2015), *Star Wars: The Last Jedi* (2017), and *Star Wars: The Rise of Skywalker* (2019). Lucasfilm also released two standalone movies, *Rogue One: A Star Wars Story* (2016) and *Solo: A Star Wars Story* (2018). They offered new opportunities for writers, directors, and actors to tweak the expected formula for space-themed science fiction. Most significantly, these films included an increasing number of characters played by actors with diverse backgrounds and more women in significant action roles, including Rey (Daisy Ridley), who first appeared as the lead in *The Force Awakens*.

Although a wealth of merchandise accompanied the films, the fans quickly identified a gap: the representation of women, especially Rey. Although the film's marketing campaign had been constructed to avoid giving away major plot points, once fans had seen how much *The Force Awakens* was driven by Rey's journey, they began to question how infrequently the character appeared in the toys, games, and other branded souvenirs. When the Target retail chain carried an exclusive boxed set of six *Force Awakens* action figures, Twitter users quickly called out the product for including only male characters, omitting either Rey or Captain Phasma (Gwendoline Christie), the female Stormtrooper officer. The hashtag #wheresrey linked frustrated posts on multiple social media platforms. The complaint jumped from fan sites to major news, however, when eight-year-old Annie Rose Goldman appealed to toymaker Hasbro, writing "How could you leave out Rey!?" to convey her disappointment at not finding a Rey figure in the *Star Wars* Monopoly board game. For many fans, more screen time for women needed

to translate into better representation for female characters on toy shelves as well.

In contrast, a very different segment of fans balked at the increased diversity, calling for a return to the casting they remembered from their youth. In particular, online bullies directed months of racist harassment at Kelly Marie Tran, who played Rose Tico, a rebel mechanic who led a major secondary plot in *The Last Jedi*. As the first lead actress of color in the *Star Wars* film franchise, Tran found herself facing persistent online attacks focusing on her appearance, talent, and worth. In response, she deleted her Instagram account in June 2018. After several months of public silence, however, she answered her critics directly in an editorial published in the *New York Times* in August. Tran pushed back on the body-shaming insults and asserted her right to take the leading role she had earned.

Tran's abuse echoed the harassment that had already occurred in the literary science fiction and online gaming communities. For a few years beginning in 2013, a group calling itself the Sad Puppies, a reference to the ASPCA's ubiquitous televised appeals for support, sought to influence the outcome of the World Science Fiction Convention's Hugo Awards. The prestigious awards for the best science fiction or fantasy work are decided by popular vote by members. The Sad Puppies voted for traditional subjects and white, male authors, attempting to counter a trend that they perceived as favoring people of color, members of the LGBTQIA+ community, women, or literary content related to such groups. Another group, calling themselves the Rabid Puppies, launched a parallel campaign in 2015. In reaction, the convention ratified new rules and procedures for nominations after 2016.

The conflict was also frequently compared to the far more disturbing misogynist backlash in the world of videogames. That conflict, dubbed Gamergate, began with the online harassment of Zoë Quinn. Attacks made in reaction to an unconventional game that Quinn created were exacerbated by a tell-all blog written by their ex (Quinn uses they/them pronouns). The intimidation escalated to include rape and murder threats as well as doxing (publishing personally identifiable information online). Threats aimed at Quinn broadened into a general offensive aimed at "social justice warriors" seen as threatening the white male dominance of traditional gaming. Quinn and two other videogame professionals were driven from their homes by threats. Gamergate came to additional public attention when the public appearance of feminist media critic Anita Sarkeesian

at Utah State University was canceled after anonymous calls threatened a mass shooting on campus. In addition to the women who were targeted, their defenders, both men and women, also found themselves subject to abuse and threats.

The reactions to increased diversity in the final *Star Wars* trilogy came in the form of relentless insults, not overt threats of violence. Regardless, the fervent passion of those responses illustrated how deeply embedded assumptions about identity had become for some fans. For decades, the particularly American form of space science fiction storytelling on which *Star Wars* and other stories in the genre relied assumed the whiteness and maleness of its heroes. Likewise, femininity or racial Otherness denoted aliens, which were always held at a distance as curiosities and quite often also figured as enemies. When those lessons about national character fused with formative childhood memories, fans internalized the genre's narrative conventions. Among a certain audience, the new changes in casting came to be perceived as attacks on the kinds of fans who identified closely with the genre in its earlier forms to the point of believing that they owned it.

Just as online fan communities logged on to their computers to exchange messages with J. Michael Straczynski about *Babylon 5* or work together to build the *Star Wars* Wookieepedia, so too those same tools could be directed in more aggressive forms. Certain fans lashed out as they defended their particular idea of what space-themed science fiction should be—and who had a right to participate. The homogeneity at the core of the Buck Rogers archetype seemed to have promised such buffs a persistent central role, one that they resented losing. Their frustration revealed a fundamental misunderstanding of the adaptability that has made spaceflight enthusiasm such an enduring theme in American culture.

CHAPTER 7

Streaming Services, Battling Billionaires, and Accelerated Change

As colleagues opened the shipping box for a collectible model of the *Rocinante* from the television series *The Expanse* (Syfy and Amazon Prime, 2015–22), my fellow curator Matt Shindell watched online from his home computer. In ordinary times, he would have been in the same room inspecting this new piece acquired for the social and cultural collection. To minimize unnecessary contact during the COVID-19 pandemic, however, curators worked from home while collections specialists, masked and gloved, handled objects on site.

In some ways, an inspection through a computer monitor suited the artifact well, revealing its nature as a product of the current moment. A quick Internet search found multiple videos or descriptions of unpacking this *Rocinante* model in podcasts and on Reddit, Twitter, and YouTube. Funded by an online Kickstarter campaign, the model of the program's primary spacecraft was packaged to produce a satisfying unboxing experience, whether the recipient unwrapped the new acquisition privately or uploaded a recording to social media.

Inside the plain brown shipping box, foam inserts held two layers of decorated boxes that offered moments of discovery. Opening the main model's container, packed on top, required sliding off an elegant, thin black cardboard sleeve decorated with a starfield and the program's name in the clean, futuristic font used in the show's title sequence. Inside was a black box with an angled lid edged in sky blue. Lifting the top exposed a Styrofoam block with "Rocinate, A Legitimate Salvage" imprinted on the top. The clever subtitle outshined the inadvertent misspelling of the ship's name. A blue satin ribbon helped lift the Styrofoam block from its case. Inside, the model and its accessories rested in custom

Supporters of a Kickstarter campaign for memorabilia from the television program *The Expanse* received this *Rocinante* model and different levels of associated accessories depending on their contributions. Photo courtesy of the National Air and Space Museum.

contributionss. At the bottom of the shipping box, two smaller boxes decorated to match the sleeve of the main box nestled in black packing foam. One contained metal plaques depicting three of the show's spaceships, the other held themed challenge coins, pins, and trading cards. A thin cardboard sheet protected a page of stickers. The detailed model in the main box included attachable guns, a display stand, and a nameplate. The collections specialists photographed and catalogued each piece—including some of the packaging—to preserve the materials of the unboxing experience as another aspect of the artifact.

The Expanse illustrates the continued power of fandoms as well as the active interplay between visions of imagined and real spaceflight in recent years. When the Syfy cable channel canceled the show in May 2018 after three seasons, loyal followers implored streaming services to pick it up. A petition on the website change.org, "Amazon or Netflix, please buy the rights to The Expanse—#SaveTheExpanse," received signatures from 138,616 supporters. Fans also paid to have an aerial advertisement company fly a "#SAVE THE EXPANSE" banner over Amazon Studios headquarters in Santa Monica, California, for four hours on

May 15, 2018. On social media, supporters posted photos or videos of the airborne campaign, linked with the hashtag, to boost awareness of their efforts. Even its writers joined via their Twitter account.

Amazon and Blue Origin founder Jeff Bezos personally announced that the Amazon Prime Video streaming service had acquired *The Expanse*. More so, he did it at the awards banquet for the National Space Society (NSS), a nonprofit spaceflight advocacy organization. Saving the show fit Bezos's broader interests. Personally, Bezos is a science fiction fan. Additionally, as a spaceflight entrepreneur, he sees himself both creating reusable rockets and a new infrastructure for spaceflight. Bankrolling a television drama that envisioned complex and sophisticated human settlements throughout Earth's solar system fit well with Bezos's own stated interest in reinvigorating excitement in spaceflight.

With Bezos's announcement, *The Expanse* went from being a cable television show to original programming for a streaming service, a shift that was emblematic of how many consumers' own television viewing preferences changed since 2015. For three additional seasons, the show gained even more loyal adherents. At the same time, amid an accelerating pace of change, public attention to actual space activities also grew—including criticism, especially about the high cost. Looking at examples from recent years reveals that the interplay between fictional visions and real spaceflight has gotten stronger. Both sides have recognized the power of drawing upon each other. The emphasis on employing the full range of diverse human talents and experiences, whether in storytelling or in technological programs, is also woven inextricably into spaceflight, both imagined and real.

LADIES ROCK OUTER SPACE

In recent years, real spaceflight and space science have shaped compelling visions of imagined space adventures—and vice versa. To create the rapidly spinning black hole for Christopher Nolan's *Interstellar* (2014), theoretical astrophysicist Kip Thorne supplied calculations to scientist Oliver James and effects specialist Eugénie von Tunzelmann for their computerized visual effects. For the first time, they created in ultrahigh definition an accurate rendering of the astronomical phenomenon. The fast-spinning black hole appears as a three-dimensional spherical rip in spacetime, drawing in all of the light around it, with a flattened, ringlike

accretion disk around it. As Thorne described it, the image was a revelation. His work only used math, not images. In 2019, when an international group of scientists from the Event Horizon Project announced that they had combined signals from eight telescopes around the globe to construct the first image of a real black hole, reporters immediately compared the scientific image with the fictional imagination depicted in Nolan's film.

Working in the other direction, director Ridley Scott's fictional film, *The Martian* (2015) had measurable effects on real spaceflight. The film brought Andrew Weir's novel about a stranded astronaut on Mars to movie screens around the world. Weir's story drew heavily on real spaceflight practices to drive the story's plot. In fact, Mars advocate Robert Zubrin reviewed the movie favorably because the threats presented were "actually about human beings grappling with the problems of exploring Mars." Viewers followed the drama as astronaut Mark Watney (Matt Damon) and the NASA community on Earth worked systematically, eventually with Chinese help, to solve scientific and engineering problems in order to save his life. The story attracted impressive audiences. Worldwide, *The Martian* was one of the top-grossing films in a year crowded with popular releases from established blockbuster franchises. Damon's appealing depiction of a can-do astronaut also boosted the public image of the inherently aspirational job. Just two months later, the largest group of people ever—more than 18,300—applied to be real NASA astronaut candidates when the agency opened a new call for applications.

The critically acclaimed film *Hidden Figures* (2016) brought public attention to significant aspects of NASA's history. Based on Margo Lee Shetterly's book of the same name, the movie dramatized the real-life story of three African American female mathematicians—Katherine Johnson (Taraji P. Henson), Mary Jackson (Janelle Monáe), and Dorothy Vaughn (Octavia Spencer)—who worked at the aeronautical research facility that became NASA's Langley Research Center. They began their careers as human computers, a mathematical equivalent of the secretarial pool used in many research centers at the time. Unlike fledgling male engineers, however, women computers did their work without the hope of professional advancement beyond their existing employment. At Langley in Hampton, Virginia, those jobs were also racially segregated. The award-winning movie took some liberties with historical accuracy, but it brought widespread recognition to the women's remarkable careers. Johnson, Jackson, and Vaughn all

made significant real-life contributions to the space program: Johnson calculated rocket trajectories and orbital paths, publishing her technical findings; Jackson became NASA's first Black female engineer; and Vaughn, the first Black woman to be a supervisor at Langley, also helped program the first mechanical computers at the center.

This history was not unknown. After all, President Barack Obama awarded Katherine Johnson the Presidential Medal of Freedom in November 2015, before both the movie and the book came out. And NASA announced some months before the movie was released that a new building at Langley would be called the Katherine G. Johnson Computational Research Facility. But the popular reception of the movie greatly increased awareness of their story. Perhaps most significantly, the term "hidden figures" became shorthand for histories that had been forgotten (or previously ignored or dismissed), giving people a way to name those whose work had largely been overlooked.

The time seemed right for celebrating NASA's women. In April 2016, Nathalia Holt published *Rise of the Rocket Girls*, recounting the histories of the women working at the Jet Propulsion Laboratory from its earliest days. Also in early 2016, months before *Hidden Figures* came out, Maia Weinstock, a science writer at MIT and Lego enthusiast, began designing a set of minifigures or "minifigs" depicting notable women of NASA.

Weinstock was particularly attuned to stories of women she thought were underappreciated, such as astronomers or engineers. Weinstock created the figures and their miniature stages using a technique called "kit bashing": combining or altering existing pieces from many different Lego sets. She also used Minifigs.me, a company that creates custom minifigures. In the end, her prototype set depicted five women, including fellow MIT engineer Margaret Hamilton, who developed the software for the Apollo lunar guidance system, and Nancy Grace Roman, NASA's first chief of astronomy and an early proponent of the Hubble Space Telescope. When posed on their small stages, each minifig evoked famous photographs of the actual women. Mathematician Katherine Johnson was shown working at her desk. Sally K. Ride, the first American woman in space, and Mae Jemison, the first African American woman in space, stood on either side of a space shuttle orbiter.

Weinstock created the set to compete in an ongoing contest on the Lego Ideas website, where it met with popular acclaim. Her entry, titled "Ladies Rock Outer

SPACE CRAZE

Maia Weinstock's "Women of NASA" prototypes for the LEGO Ideas website photographed when the Museum acquired them. The figures illustrated five pathbreaking women: Shuttle astronauts Sally K. Ride and Mae Jemison, astronomer Dr. Nancy Grace Roman, Apollo guidance computer programmer Margaret Hamilton, and mathematician Katherine Johnson. Because Johnson's family declined to participate, her likeness did not appear in the final set. Photo courtesy of the National Air and Space Museum.

Space," included photographs and descriptions of her creations. According to the website's rules, suggestions that receive ten thousand online votes are considered by Lego for production, although adoption is not guaranteed. As she promoted her entry on social media, online articles quickly picked up the story and well-known stars boosted its visibility. It also got some unexpected celebrity endorsements. Musician Pharrell Williams, a producer of *Hidden Figures*, tweeted about it, as did Jemison herself. Janelle Monáe put it on her Instagram. Some respondents expressed their wishes that they had had a toy like this, highlighting prominent women, when they were growing up. The Girl Scouts' Twitter account tweeted about the prospective set. In less than two weeks, Weinstock's entry reached the required ten thousand votes. Over the next year, Lego's design team crafted the final 231-piece commercial set, which launched in November 2017. The three

builds included in the final set captured the spirit of Weinstock's creation with slightly different execution of the final concepts. The final set did not include the Katherine Johnson minifig because she declined to participate.

The popular response to the hotly anticipated original Lego set revealed that customers were eager to embrace historical figures who had been long overshadowed. At the Lego store in Manhattan, customers lined up out the door for the kit's first day of sale. According to CNN.com, within its first twenty-four hours on sale, the Women of NASA Lego playset became the best-selling toy on Amazon. The kit tapped into a contemporary interest in recovering the history of women in science, technology, engineering, and mathematics (STEM) and promoting those fields to young women and girls. Women's significance to spaceflight was seen as important to celebrating past achievements and inspiring the next generation.

THE SISTER OF APOLLO

NASA's leadership had its own interest in reclaiming women's contributions to the agency in order to redefine its future. In 2019, NASA renamed the street outside its headquarters building in the nation's capital "Hidden Figures Way." In 2020, NASA held a separate ceremony to name the headquarters building for Mary W. Jackson. These public recognitions of the Black women who supported NASA's early achievements dovetailed with the stated goals of NASA's Artemis Program.

Artemis, which was announced in late 2017, reoriented NASA's human spaceflight exploration targets. Rather than pursuing, in sequence, the ambitious triple destinations of Earth (ISS), Moon, and then Mars, as previously planned, Artemis focused on returning humans to the Moon. Initially, the goal was to return a man and send the first woman to the lunar surface. As reformulated, however, the program aims became more directed: "to land the first woman and first person of color on the Moon." The program's name, Artemis, after the sister of Apollo, both recalled the heyday of lunar landings and looked forward to women's planned inclusion. The Orion spacecraft will carry those astronauts to and from the Moon by way of a space station in its orbit, Lunar Gateway. Meanwhile, the work of providing services and supplies for the ISS will continue shifting to private contractors. NASA has also sought to secure international partnerships for the effort, promising that Artemis will be "the broadest and most diverse international

human space exploration program in history." In order to achieve the goal of landing a diverse astronaut corps on the Moon, NASA recruited the previously mentioned class of astronaut candidates in 2017 and an additional group in 2021.

The agency's institutional commitment to gender inclusion came under sharp scrutiny, however, when NASA canceled the first all-women spacewalk in 2019. The scheduled extravehicular activity (EVA) in 2019 would have seen two women, NASA astronauts Anne McClain and Christina Koch, achieving an historic first in the final days of March, which is Women's History Month. Significantly, it had not been planned for publicity. Rather, the NASA astronaut corps included enough women that McClain and Koch were simply the next two on the spacewalk rotation, an even more impactful message. Aware of the upcoming event, news shows began compiling interviews that would support their coverage of the historic first. But then NASA called off the well-publicized event for a lack of EVA-ready spacesuit components in appropriate sizes. Media coverage quickly ranged beyond the specific issue of the available spacesuits to broader questions about how truly welcoming to women the astronaut corps—and NASA—really were.

In preparation for the series of scheduled spacewalks, of which the proposed all-women's EVA was just one, the astronauts on the ISS had readied for use only two complete suits, one size medium and the other large. The plan was for McClain to wear the large spacesuit while Koch donned the medium. On Earth, in the deep pool that NASA used for training, McClain had used both sizes. Moreover, while in space, she had grown slightly taller, as all astronauts do; without gravity compressing her spine, she had gained two full inches in height. After completing her first in-orbit spacewalk, however, McClain reconsidered the plan to wear a large the next time. Instead, she requested the medium for her own comfort and safety. That meant that both women needed a medium-size spacesuit, but only one had been prepared for use.

A little bit of background explanation helps here. Unlike the individually measured spacesuits created for early spaceflight missions including the Apollo lunar landings, NASA's modern spacesuits come in standardized sizes. Think off-the-shelf separates, not custom-fit couture. The specialized spacesuits created for spacewalks consist of a top (called a hard upper torso or HUT) and a bottom (basically spacesuit pants). The top or HUT has at its core a rigid structure with openings for the head, arms, and waist. Wearing one that is too large would be more like trying to maneuver in an oversized knight's armor than just donning a

voluminous overcoat. If the occupant's shoulders and joints do not match up with the suit's, it is hard to move and react reliably. When McClain and NASA's leadership decided to change the roster of assignments rather than spend an extra twelve hours to make another medium HUT operationally ready, the agency endured a public relations backlash.

Ironically, McClain's ability to assert her need for appropriately sized equipment actually demonstrated her security as a professional in the astronaut corps. NASA's flight controllers—and management—supported McClain's assessment of what she needed in order to carry out the dangerous task safely. Nonetheless, critics questioned why the agency had not readied more than one medium-sized torso, charging that if women's full participation had been a priority, then NASA would have ensured that more than one medium HUT was space-ready. As former Secretary of State and presidential candidate Hillary Clinton advised in a terse tweet: "Make another suit." Significantly, years before, NASA had authorized the extra expense of creating extra-large sized suits to accommodate tall men who wanted to spacewalk but declined to fund small and extra small suits. In 2017, NASA's inspector general warned that spacesuit sizing was an issue that limited spacewalking readiness, potentially compromising the agency's ability to utilize the talents of the full range of the astronaut corps, including smaller-statured astronauts, both men and women.

In the end, the first all-woman spacewalk occurred in October 2019, when Christina Koch and Jessica Meir conducted scheduled work outside the ISS. For the autumn series of spacewalks, only medium spacesuits were prepared for both the male and female astronauts. Nonetheless, NASA cited the occurrence as evidence of greater representation of women in all aspects of space and an investment in future exploration. As a feature story on NASA's website explained, "The first all-woman spacewalk is a milestone worth noting and celebrating as the agency looks forward to putting the first woman and next man on the Moon by 2024 with NASA's Artemis lunar exploration program." The piece concluded by reminding readers that Koch and Meir continue "a tradition that goes back to our earliest days," citing, by name, Katherine Johnson, Dorothy Vaughn, and Mary Jackson as well as astronomy chief Nancy Grace Roman and Apollo guidance computer software engineer Margaret Hamilton. NASA's public commitment to including the first woman and the first person of color in the next human Moon landing will require supporting a diverse astronaut corps in ways big and small.

The scrutiny of NASA's actions comes even as the agency's brand is as popular as it has ever been. NASA centers have long had gift shops where employees and visitors can purchase merchandise with the agency's logos, but NASA has also become a kind of lifestyle brand promulgated across different makers and markets. In recent years, NASA's emblems—both the round insignia affectionately called the "meatball" and the modernist logo typeface called "the worm"—have shown up on clothes, bags, caps, and even couture. For instance, high-end handbag maker Coach offered a limited-edition NASA-themed Space Collection in 2017. In 2018, streetwear designer Heron Preston released a capsule collection designed in collaboration with NASA for its sixtieth anniversary. Swiss watchmaker Swatch has a line of NASA-themed watches. Space historian Dwayne Day has speculated that the appeal of NASA as a brand comes from the ways it can be "simultaneously nostalgic and futuristic, patriotic and apolitical."

This explosion of branded products comes with the agency's cooperation and encouragement. As a federal agency, NASA does not sell licenses for its logos. Rather, manufacturers must request authorization and follow specific usage guidelines. In 2021 alone, NASA received eleven thousand requests from companies seeking permission to use NASA's two logos. If popular culture depictions of NASA have boosted the agency's appeal—and even its astronaut application numbers—that is also because NASA worked directly to support many collaborations with film and television companies. For instance, NASA was involved with *The Martian* and *Hidden Figures*, as well as the dramatic Neil Armstrong biopic *First Man* (2018). According to Bert Ulrich, NASA's multimedia liaison for film and TV collaboration, in 2021, NASA worked with "18 feature films, 44 TV programs and nearly 200 documentary projects." Those relationships have benefits for both sides. For its part, NASA connects with stories that excite audiences, while the programs and films benefit by aligning themselves with NASA's authenticity, history, and ambition.

MULTIRACIAL FUTURES

In 2016, the Syfy channel partnered with NASA to produce a short online video released as a teaser in anticipation of the second season of its new program, *The Expanse*. The television program featuring the *Rocinante* vessel portrayed in the Kickstarter-funded model was a popular and pathbreaking series, offering

compelling visions of spaceflight that speak to the current moment with diverse casting and plotlines that explore social and cultural inequalities.

The television series *The Expanse* was based on a series of novels written under the pen name James S. A. Corey, a collaboration between Daniel Abraham and Ty Franck. Franck initially conceived of the premise as the setting for a videogame that would be organized as a massively multiplayer online role-playing game (MMORPG). But Abraham suggested that the sophisticated world building merited book-length treatment. Together they have written nine novels, five novellas, and three short stories conveying a continuous and branching narrative. When Syfy committed to adapting the series for television, both authors joined the writers' room.

The Expanse played out its plotlines against a backdrop of scientifically realistic depictions of what interplanetary life could look like in a distant future, including the real dangers of spaceflight. According to actor Cas Anvar, who played Martian *Rocinante* pilot Alex Kamal, space itself functions like another ever-present character in the show: "Space is trying to kill you twenty-four hours a day." Cracked visors, punctured spacecraft, and vented atmospheres all pose threats. When ships maneuver sharply, characters who are not tightly strapped in are thrown across the room—and get hurt. Even some of the solutions have a practical basis. For instance, characters wearing spacesuits work around non-functioning communications transmitters by leaning their helmet faceshields together, enabling them to hear each other as the sound conducts directly. The one fictionalized technological leap is propulsion. The ability to traverse the solar system in *The Expanse* relies upon the fictional invention of the Epstein drive, a fusion drive (named after its fictive inventor) that provides continuous acceleration with extraordinarily efficient fuel use. To help travelers withstand the high gravity loads during accelerations, the spaceships' chairs inject the occupants with a fluid that helps stave off strokes.

The Expanse imagines human settlements on the Moon, Mars, in the Asteroid Belt, and on the moons of some outer planets. These communities have existed for so long that most people are racially mixed. Instead, the real cultural differences stem from the oppression and exploitation that has persisted throughout generations of human habitation in space. Belters, those born in the Asteroid Belt or the outer planets' moons, eke out an existence in space, suffering from the physical effects of growing up malnourished, in low gravity, with poor air

and water because of political corruption that forced people to live in poor conditions. Belter culture exists in factions with some commonalities, including an original Belter Creole language and corresponding accent in English as well as a hard-earned resentment of Inyalowda, or inner planets dwellers. Earthers, those still on Earth or living on the Moon (Luna), assume their own superiority. Because Mars requires continual efforts at terraforming, Martians take pride in their loyalty to the vision of the planet as independent and sustainable. The multifaceted world building and well-developed characters in *The Expanse*, both the books and the television series, explore the complex legacies of colonialism, oppression, and exclusion.

The Expanse echoes certain elements of the Buck Rogers archetype. The plot follows a core crew rocketing off for adventures in space on a named spaceship with many guns—both on the ships and wielded by the crews. James Holden (Steven Strait), Naomi Nagata (Dominque Tipper), Amos Burton (Wes Chatham), and Alex Kamal (Anvar) form the *Rocinante*'s prime crew, a found family in the tradition of decades of television programming. Holden does not begin the show as the dashing and earnest hero. Throughout the first season, however, Holden's sense of right and wrong drives him to take on roles that move him from being a disaffected crewman to becoming the ship's captain. The adopted name of the commandeered ship, *Rocinante*, offers a wry nod to the steed of unflappable optimist Don Quixote, never shying away from a quest. Yet the rest of the core cast defies the classic *Buck Rogers* mold. Belter Naomi Nagata, an expert engineer with a complicated past, is no one's damsel in distress. Even when in mortal peril, she finds ways to communicate and persevere. Earther Amos Burton appears to be a simple enforcer but shows surprising depth. And Martian Alex Kamal is a smooth blend of his Texan and Pakistani ancestors who colonized Mars.

As a television program, *The Expanse* did not translate the books directly into scripts. Timelines were realigned and stories told in a different order. But Abraham and Franck insisted, and the producers agreed, that the actors chosen for the main and supporting casts be as diverse as the characters portrayed in the books. As Franck has explained in interviews, that was fundamental to what they wrote. He and Abraham made a deliberate choice before they started the books that their visions would not replicate the persistent homogeneity of early science fiction: "We didn't want it to be 'white men in space.'" Notably, the character of Chrisjen Avasarala, portrayed by Iranian American actress Shogren

Aghdashloo, is a mature and politically savvy woman who wields power deftly. In a show full of gun battles and spaceship chases, Avasarala maneuvers from within (and sometimes outside) the United Nations, the governing body of Earth and its settlements. The Martian marine Roberta "Bobbie" Draper is written in the novels as a tall, physically powerful Samoan woman, which is why statuesque Samoan actress Frankie Adams felt so strongly about the role. Draper's character also grows and develops in her worldview, even as she remains an imposing ally in a fight.

One thrilling sequence in the season three opener, "Fight or Flight," illustrates the strength of these two characters. Draper helps Avasarala, then secretary general of the United Nations, to escape an assassination attempt aboard the pleasure craft *Guanshiyin* by stealing the *Razorback*, the spaceship equivalent of a sleek sportscar. Climbing aboard the racing spacecraft, two women of color become the main protagonists in a classic adventure chase scene. It departs significantly from the genre's conventions and yet remains in character for both Draper and Avasarala. As she accelerates the racer, Draper's sharp directions to the anxious official—"Hitch your tits and pucker up, it's time to peel the paint"— reminds viewers of their shared femininity even as each character embodies a very different kind of woman. Notably, that paint about to peel connects the fictional *Razorback* to a lineage of real-world airplanes and spacecraft. As Draper pilots the ship to escape the *Guanshiyin*'s massive explosion, the camera skims a series of silhouettes painted down the side of the sleek red and white vehicle.

The graphic builds on Virgin Galactic's "DNA of Flight," the original artwork used on SpaceShipTwo and the VMS Eve launch plane. The sequence of images illustrates the evolution of aviation and spaceflight technologies with silhouettes depicting Icarus, the Wright flyer, *Spirit of St. Louis*, Bell X-1, Boeing 747 commercial jetliner, lunar lander, and SpaceShipOne, ending with SpaceShipTwo. The fictionalized version simplified the sequence, added a space shuttle orbiter and an Epstein Drive ship, and topped the reimagined sequence with the *Razorback* itself. In an era of streaming video, producers know that viewers could easily pause the show to study the graphic more carefully. For those fans who caught it or learned about it in online discussions, the reference connected *The Expanse*'s fictional vision to current spaceflight activities. In another nod to real world contexts, in season 5, the *Razorback* is renamed the *Screaming Firehawk*, after the

moniker adopted by the show's dedicated fans, a tribute to their success in keeping the program on the air.

As *The Expanse* entered its third season depicting a multiracial solar system, an art piece making a simple statement about a similarly multiracial future sparked controversy in Pittsburgh, Pennsylvania. In March 2018, award-winning artist Alisha Wormsley installed the short sentence "THERE ARE BLACK PEOPLE IN THE FUTURE" in an ongoing project called "The Last Billboard." Carnegie Mellon University's Frank-Ratchye Studio for Creative Inquiry invited a different artist each month to contribute text to a thirty-six-foot-long sign perched atop a building at a busy intersection. Composed in large uppercase wooden letters changed by hand on an old-fashioned frame system, the messages represented a throwback form of communication in a digital age. Wormsley was one in a series of artists to contribute her thoughts as the subject of the art piece.

Wormsley's contribution drew on her interest in Afrofuturism, visions of the future that are rooted in the African diaspora. According to her artist's statement released April 6, 2018, her idea "started out as a black nerd sci-fi joke," responding to "the absence of non-white faces in science fiction films and TV." Wormsley's straightforward assertion hit a nerve, especially in the context of the rapidly gentrifying neighborhood of East Liberty, which has a rich history as a historically African American community. The building's owner, a small company called We Do Property Management, reported that it received messages from people offended by the "divisive" sign. In response, the building owners invoked a clause in the lease about approving the text on the site and had it removed. News of the art's censorship led to a far greater outcry, however. By mid-April, after a public panel discussion about the piece, Wormsley's text was reinstated. In January 2019, the Heinz Endowments and the Pittsburgh Office of Public Art announced a new artwork-in-residency program directed by Wormsley. The program offered microgrants to support artists who addressed questions of race in their work. Wormsley's simple assertion that Black people would exist in the future challenged not only the way that many fictional visions erase people of color but also the systemic marginalization and denial of Black experiences in American history. The censorship and pro-art response made national news.

Wormsley's work came to attention in a time when scholars, artists, and activists had spent the previous decades studying and producing Afrofuturism, the global, diasporic cultural aesthetic featuring Black visions of the future

and technology. The term was first coined in 1993 by cultural commentator Mark Dery, who is white, but award-winning researcher Alondra Nelson's scholarship and investigations of race and technology get credit for developing in the late 1990s the academic framework for considering Afrofuturism. Ytasha Womack brought the artistry and history of the movement to a popular audience in her book titled *Afrofuturism* (2013). In it, she argues that the subject is "as much about soul retrieval" as about the future. Since then, Afrofuturism has become a vibrant area of academic study—as well as a proliferating means of artistic expression.

Afrofuturism includes music, art, poetry, science fiction, comics, and many other forms. Beginning in 2007, musician (and *Hidden Figures* actress) Janelle Monáe created a seven-part musical series beginning with *Metropolis: The Chase Suite*, inspired by Fritz Lang's classic science fiction film, *Metropolis* (1927). In it, Monáe assumes the alter ego Cindi Mayweather, an android. Like George Clinton's spacey Dr. Funkenstein alter ego, alien or nonhuman characters in Afrofuturist visions often function to comment on embodying otherness. Monáe continued these themes in her albums *The ArchAndroid* (2010) and *The Electric Lady* (2013). Working in a similar vein, the experimental hip-hop group clipping., which includes rapper Daveed Diggs (of *Hamilton* fame) and producers William Hutson and Jonathan Snipes, released their second studio album *Splendor & Misery* in 2016. The songs tell the story of the lone human survivor of an uprising on a spaceship carrying enslaved people. The refrain in its longest track, "all black everything," collectively evokes the depth of outer space, the darkness of the defunct ship's controls, and the power of the Black man struggling to survive after commandeering the ship.

Award-winning Nigerian American writer Nnedi Okorafor, author of the *Binti* trilogy of novellas, *Binti* (2015), *Binti: Home* (2017), and *Binti: The Night Masquerade* (2018), has argued that the movement should be Africanfuturism. She would like the movement to shift from emphasizing the US-centric experience back to its African roots—and the African present and future with technology. The blockbuster hit *Black Panther* (2018) brought the African king/superhero first envisioned in a *Fantastic Four* comic in 1966 to the silver screen, a part of the Marvel Cinematic Universe. The story of T'Challa, ruler and protector of the fictional African nation Wakanda, does not involve spaceflight. As directed by Ryan Coogler and starring Chadwick Boseman as T'Challa/Black Panther, however, the film emphasizes the superhero's use of advanced tech. T'Challa's sister,

Shuri (Letitia Wright) engineers the superhero's arsenal of protections and weapons from Wakanda's vibranium, a fictional metal that absorbs and transmits kinetic energy.

A UNIVERSE OF VIEWING OPTIONS

These examples only scratch the surface for Afrofuturist works, as does any list of recent spaceflight-themed popular culture. Recent years have seen a renewed space craze with abundant space-themed entertainment. Some of these pieces are continuations of well-known franchises, simultaneously evoking nostalgia, attracting new viewers, and producing revenue for established companies. Others are new visions, approved by studios that appraise space shows or movies as good investments in the current entertainment marketplace. In some ways, this new craze owes its success to the proliferation of platforms on which high-quality television and films are being produced.

Since Netflix started producing original shows in 2013 with *House of Cards*, streaming services have shifted their business models to include creating original content to attract and retain viewers. The shortened seasons that suit viewers' binge-watching habits have allowed programs to work with cinematic effects and postproduction budgets that rival moviemaking. One great way to show off that capacity has been to create special effects–heavy space-themed shows as a draw. New streaming services continue to use science fiction to attract loyal viewers in an increasingly fragmented marketplace.

Much as UPN used *Star Trek: Voyager* as an incentive for fans to call their cable providers in 1995, requesting that regional carriers include the new channel in their local packages, so too in the fall of 2017, CBS All Access sought to draw subscribers to its streaming video service by making *Star Trek: Discovery* available exclusively on the new platform. That streaming service marked a distinct turn in the television business. CBS All Access was the first over-the-top (OTT) or direct Internet media service created by an existing broadcast television network.

In significant ways, then, the presentation of new space science fiction programming has been embedded in the shifting marketing strategies of the television streaming landscape. When CBS All Access first launched in 2014, it offered viewers access to a catalog of CBS's current and historic fare as well as

STREAMING, BILLIONAIRES, AND ACCELERATED CHANGE

live streaming from local CBS affiliates, including some sports coverage. *Star Trek: Discovery* was its first scripted series—and the first new series to be created in the franchise since *Star Trek: Enterprise* ended its fourth season in 2005. Limiting *Discovery*'s availability to the streaming service forced fans to choose: either subscribe or miss out. Cable subscribers complained that they were already paying for CBS's content; adding the streaming service seemed like being forced to purchase the same thing twice.

Over time, the addition of streaming subscriptions to personal and household budgets led many television consumers to "cut the cord," canceling traditional cable in favor of streaming-only options. External digital media players such as Roku, introduced in 2008, or television sets with streaming video capabilities built into them, such as Amazon Fire TVs, introduced in 2014, facilitated the shift. For consumers, streaming services included more options but also became more complicated. The first step in enjoying a desired film or program is now often an Internet search to determine whether it is available within the viewer's existing subscriptions or if it requires a new investment, buying into a different purveyor of capitalist entertainment.

Star Trek's branded content has become a staple offering for ViacomCBS's (now Paramount Global's) streaming service, which was renamed Paramount+ in 2021. The announcement in 2018 that Patrick Stewart would return to his role as Captain Jean Luc Picard in a new web television series, *Picard*, which first aired in early 2020, boosted attention to the channel. *Star Trek: Lower Decks* offers animated stories of crewmembers who never sit on the command deck. *Star Trek: Strange New Worlds* imagines the adventures of the USS *Enterprise* crew in the decade before the original 1960s show's timeline. Many fans not only watch the episodes as they drop, but also seek out online discussions on Reddit or other Internet fora. Commentary shows, such as *After Trek* (2017–18), turned dissecting a recent episode into an official branded program presented on the same platform as the original episodes. The successor to *After Trek*, a new aftershow called *The Ready Room* that debuted in 2019, illustrates in its distribution methods how permeable the divisions have become between social media, online activities, and streaming services. *The Ready Room* is distributed on IGTV (Instagram TV), YouTube, and Facebook Live as well as Paramount+. The show has also commented on *Star Trek: Prodigy*. The computer-animated series, which airs on Nickelodeon and is carried on Paramount+, launched in 2021 and is aimed at youth audiences.

SPACE CRAZE

In ways that were less visible when television broadcasts and fan gatherings depended on being local, the inequality in how worldwide audiences can access content has become very noticeable. For the first three seasons, outside North America, *Star Trek: Discovery* streamed on Netflix. That rights deal included 190 countries and territories. Just two days before the release of the fourth season, however, ViacomCBS announced that that next set of *Discovery* episodes would be released exclusively via Paramount+, which had much narrower international reach, projected to be available in just forty-five countries by the end of 2022. Entertainment executives hoped once again that the lure of exclusive *Star Trek* content would convince fans around the world to add yet another streaming service to their regular viewing—and monthly budgets. Changes in access raise questions of content piracy, when viewers decide to access entertainment illegally rather than pay for the licensed content (or because the licensed content is not available where they live).

However they are viewed, the new iterations of *Star Trek* have taken the adventures in fresh directions even as they have doubled-down on the Vulcan/Trek maxim of IDIC, infinite diversity in infinite combinations. *Star Trek: Discovery* stars a Black woman as the lead, Michael Burnham (Sonequa Martin-Green), and features a same-sex relationship between two of the main core cast, medical doctor Hugh Culber (Wilson Cruz) and scientist/engineer Paul Stamets (Anthony Rapp), the first such depiction between regular cast members in *Star Trek* television. A regular, if unnamed, member of the *Discovery* crew in the first two seasons uses a wheelchair, a role played by George Alevizos, an actor who also uses a wheelchair in real life. And actor Kenneth Mitchell appeared in multiple roles both before and after he developed a progressive neurological disorder. In season three, Mitchell, who had previously played three different Klingon roles in the show, appeared as Aurellio, a scientist with a genetic condition that requires him to use a hover chair. It was a role written for Mitchell that incorporated his real-life wheelchair use as a result of ALS. The show's production team built a futuristic prop chair with its base wrapped in green-screen material; in postproduction, editing out the base made the hoverchair look like it floated under the character's control.

Season three included the introduction of Adira Tal (Blu del Barrio) as a nonbinary character as well as their transgender Trill partner, Grey (Ian Alexander). As reported in the news release announcing the additions, Alexander was

STREAMING, BILLIONAIRES, AND ACCELERATED CHANGE

identified as the "first out transgender Asian American person to act on television." A well-established *Star Trek* alien, Trill can bond with an implanted symbiont that shares its generations of memories—including experiences lived as both men and women—integrally with its host. Significantly, in past *Star Trek* series, Trill provided a way for writers to explore gender identity or same-sex relationships without having openly gay characters. On *Discovery*, the show's writers worked with both del Barrio and Alexander to make sure their characters (and the actors) felt respected and honestly portrayed. In a telling sequence in the eighth episode of season three ("The Sanctuary"), Adira states as a part of a scene that they do not use feminine pronouns. Later in the episode, as Culber and Stamets find the exhausted Adira asleep at a console, the couple's conversation serves as a master class in the smooth and respectful use of a person's chosen pronouns. Notably, pronoun preference is not the point of the scene; their growing sense of wanting to protect the young Adira is. By later episodes, the characters of Culber, Stamets, Adira, and Grey have become a queer family of choice.

As a fan of *Star Trek*, science fiction, and science popularizing, Seth MacFarlane, the originator of the Fox animated comedy *Family Guy*, turned the influence and fortune that he built in comedy to supporting educational outreach when he coproduced in 2011 a new version of the documentary science series *Cosmos*, starring Neil deGrasse Tyson. The next year, he supported the creation of The Seth MacFarlane Collection of the Carl Sagan and Ann Druyan Archive at the Library of Congress. MacFarlane then used his clout to launch *The Orville* in 2017. The program functions in equal parts as an homage to various iterations of *Star Trek*, an affectionate parody of the genre, and its own original comedic drama. *The Orville*, in which MacFarlane stars as Captain Ed Mercer, follows the crew complement of the titular starship on a series of adventures. The structure of the show's core cast deliberately tweaks the Buck Rogers archetype, part of its self-conscious sendup of the genre. For example, the ship's first officer, Commander Kelly Grayson (Adrianne Palicki) is not the classic plucky love interest but rather Mercer's ex-wife, creating both tension and affection in the relationship. After the creative season two finale aired in April 2019, filming for a third season began that October, only to be paused for months by COVID-19 in April 2020. As a result, the third season debuted well into 2022, more than two full years after the end of season two.

SPACE CRAZE

Space-themed films or television series featuring prominent stars have become a staple of new and emerging video streaming services. In some cases, this was as intended, using streaming as a platform for new content. For instance, Netflix reimagined Irwin Allen's *Lost in Space* series from the 1960s, updating the special effects and production values to meet current viewer expectations and recasting Dr. Smith with Parker Posey. As has become the practice with some streaming shows, all of the episodes for each season were released as a group on the same day rather than spreading them out as weekly offerings throughout a televised season. The three-season run of *Lost in Space* ended with the release of the final eight-episode season in December 2021. *Away*, starring Hilary Swank, was a less successful space drama also created by Netflix. Debuting in September 2020 to lackluster reviews, the ten-episode drama about a crew of astronauts on their way to Mars and the families that they left behind was canceled shortly thereafter. When Apple+ launched as an on-demand television platform in November 2019, one of the first offerings was *For All Mankind*, an alternate history that imagined how spaceflight efforts might have changed if the Soviet Union landed on the Moon first. Created and written by Ronald D. Moore, well known for his work on various *Star Trek* iterations as well as the reimagined *Battlestar Galactica*, the show takes well-calculated creative liberties with history. At the same time, the program includes enough accurate period detail—whether in NASA work rooms, with the actual spaceflight hardware, or just the vintage set dressing in homes and bars—to keep it plausible.

In the midst of the global COVID-19 pandemic, streaming also became a way to save a film timed for theatrical release in a moment when theaters were closed or practically empty. *The Midnight Sky*, directed by George Clooney, was scheduled to debut in theaters in December 2020, at the height of COVID shutdowns and before the availability of vaccines. The film tells a multiperspectival story about a scientist trying to warn a space crew returning from Jupiter about a planetary disaster back on Earth. After a limited public release, it began streaming on Netflix.

Disney+ began in 2019 when The Walt Disney Company pulled back the streaming rights to its deep catalog of material and turned that into the core attraction of its own service. Since Disney purchased Pixar in 2006, Marvel in 2009, Lucasfilm in 2012, and Twentieth Century Fox (which included National Geographic Partners) in 2019, the new streaming service offers well-known

content from established franchises. An eight-episode television series loosely based on Tom Wolfe's *The Right Stuff*, a creation of National Geographic, debuted on Disney+ in October 2020, although it was not renewed. Most significantly, the streaming service is the home for all of the *Star Wars* films produced since the original debuted in 1977.

In addition, Disney+ has become the base for a plethora of original content set in the *Star Wars* universe. Debuting in 2019, *The Mandalorian*, created by Jon Favreau, envisioned the tale of a singular bounty hunter as a space Western blended with Samurai influences. The story focuses on a laconic yet paternal warrior (played by Chilean American actor Pedro Pascal) on the run while caring for The Child, revealed to be named Grogu. Their adventures take them to planets and settings vividly rendered using Lucasfilms's new high-resolution stage called "the volume." Instead of being the vision of one director, the continuing story was directed by a diverse group of men and women. The first season's episode directors included Dave Filoni, Rick Famuyiwa, Deborah Chow, Bryce Dallas Howard, and Taika Waititi. Season two added Favreau himself, Payton Reed, Carl Weathers, and Robert Rodriguez to the impressive roster.

The Book of Boba Fett envisions the extended story of a different iconic bounty hunter in Mandalorian armor. The opening of the first episode in 2021 reveals that the character of Boba Fett, first introduced in live action in *Star Wars: The Empire Strikes Back* (1980), did not die in the Sarlacc pit on Tatooine (nor, it seems, did he find a new definition of pain and suffering by being slowly digested over a thousand years). Rather, his story continued. Portrayed by Temuera Morrison, an actor from New Zealand with Māori heritage, Boba Fett is accompanied in his work by mercenary and assassin Fennec Shand (played by Chinese American actor Ming-Na Wen). Boba Fett is just one of many stories to be picked up and continued on this new platform. More than a half-dozen other prominent *Star Wars* characters have already been designated to have their own treatment in a dedicated film or series. A proposed spinoff series centered on Rebel shock trooper turned marshal Cara Dune (Gina Carano) was canceled in 2021, however, after the actor's social media posts caused controversy.

Innovative animated series have also proliferated. *Star Wars: The Bad Batch*, created by Dave Filoni in 2021, follows an elite group of clone troopers. In September of that year, *Star Wars: Visions* premiered with nine distinctive short films created by seven different Japanese animation studios. The cross-cultural

collaboration tapped into the artistic styles of the anime creators to offer new takes on canonical *Star Wars* stories.

The streaming channel also uses the platform to present content that might, in an earlier time, have been the extras included on DVD or video releases. Accompanying the new live-action series are several specials that offer insights into how the various series were planned, filmed, and executed. Roundtables with the various directors of *The Mandalorian* share stories from behind the scenes of production, revealing the decisions underlying artistic choices throughout the episodes. Other *Star Wars* specials focus on vehicle flythroughs, or biomes, or the soundscapes that enliven the movies and programs. The rich and varied content in the *Star Wars* universe continues to grow.

TRANSMEDIA STORYTELLING

As much as streaming services have driven new creativity in television, videogames have also offered compelling visions of space settings. In 2019, for instance, Obsidian Entertainment released *Outer Worlds* for Microsoft Windows, PlayStation 4, and Xbox One. A Nintendo Switch version came out in 2020. As a role playing game (RPG), *Outer Worlds* immerses players in an alternate future. The premise begins with a divergence from the real-world historical timeline, President William McKinley's *not* being assassinated in 1901, that has unexpected consequences. Without President Theodore Roosevelt to break up business conglomerates, the descendants of those trusts eventually spawn megacorporations funding space colonization and terraforming. Through characters that the real-life players build, they take on challenges in Halcyon, a six-planet system in which the hopes of human colonists have taken some dark turns. *Outer Worlds* immerses players in creative storytelling about spaceflight that builds on old narratives about expansion, exploration, and conflict. Its creativity won a 2020 Nebula Award from the Science Fiction and Fantasy Writers of America for Game Writing. *Outer Worlds* follows in a long line of videogames that use space-based places and imagination about spaceflight to drive adventure narratives.

One of the most notable videogame space settings is the *Halo* universe. *Halo* is also an outstanding example of what cultural historian Henry Jenkins has called transmedia storytelling, narratives that play out across multiple related media platforms, each contributing to and building the overall experience of a

complex world or universe. The *Halo* universe encompasses not only gaming but also popular novels, graphic novels, comic books, short movies, animated movies, short films, and licensed products.

The first piece of this narrative was the original videogame, *Halo: Combat Evolved*, a first-person shooter developed by Bungie and released on November 15, 2001, for the popular Microsoft Xbox console gaming system. Over time, *Halo* grew into a trilogy and more. Released in 2004, *Halo 2* used Xbox Live to allow online multiplayer competition with far-flung combatants playing in the same virtual world. In *Halo 3*, released in 2007, players continue the narrative arc developed in the first two installments. In addition to compelling gameplay, high-quality graphics and faster rendering led to a smoother, more cinematic look.

The *Halo* series of games imagines an army of twenty-sixth-century super-soldiers, called Spartans, wearing armored spacesuits. With the aid of an artificial intelligence, Cortana, they fight aliens known as the Covenant. The Halo Array, a network of seven ring-shaped artificial worlds that give the games their primary name, are contested sites. For the aliens, they are religious relics that need to be activated to fulfill a prophecy. The protagonists understand, however, that activating the Halo Array will exterminate all life in the universe. Throughout the first three games, then, preventing the activation of the Halo Array motivates the gameplay. The well-developed storytelling relies on complex world/universe building and draws persuasively on existing science fiction. According to Kevin Grazier, a planetary physicist and the science advisor to *Battlestar Galactica*, the strength of *Halo*'s world building built from how the game tapped into many other popular science fiction books and movies—even classical mythology and biblical references—to build a compelling story: "*Halo* is an amalgam of all of these."

As a type of videogame, first-person shooters allow players to immerse themselves into the playable characters, seeing what they see, walking (or running or leaping) through the rendered landscape. In the first *Halo* game, gamers entered the *Halo* franchise initially through the character of Master Chief Petty Officer John-117, known simply as Master Chief. The clearly male but racially undefined character was designed to allow players to see the universe through his eyes rather than focus on who Master Chief is. As novelist Matthew Stover pointed out, the character's helmet transforms his face into a convex mirror: "a reflection of the world around him." This perspective allows players to embody the heroic figure as they eliminate opponents and solve the puzzles that allow participants

SPACE CRAZE

The *Halo* franchise includes not only videogames but also many other pieces of the same space-based adventure canon. The franchise's main hero is Master Chief Petty Officer John-117, a supersoldier. Phil Shinner of EVAkura Armor produced this helmet for 343 Industries in 2021 as part of a costume for Master Chief, for use at Xbox and Make-a-Wish events. Photo courtesy of the National Air and Space Museum.

to move to different levels of game play. In multiplayer mode, each participant became an unidentified Spartan.

A *Halo* television series was in development for years, following a path that illustrates how much the landscape for entertainment media has been shifting. In 2014, Xbox Entertainment Studios announced that the *Halo* television series would appear on Showtime, the premium television network. That statement surprised fans, mostly because previously announced plans included having the Halo television series as original programming for the Microsoft Xbox itself. In that vision, Xbox would produce and host original content that included

built-in enhanced interactivity, providing an experience for the gaming platform's 48 million subscribers that would keep their attention from straying to emerging streaming services. Actually *Halo: Nightfall*, a five-episode live-action web series that did have connections to *Halo* gameplay, appeared in late 2014, produced by Ridley Scott's Scott Free Productions. But that was not the intended television series. After 2015, even though Hollywood heavyweight Steven Spielberg was the executive producer, the project just got stuck. Although principal photography for the main *Halo* television series eventually commenced in 2019, its postproduction was then delayed by the pandemic. The nine-episode television series finally appeared on Paramount+ in 2022.

The transmedia storytelling of *Halo* presents some challenges and some opportunities. For example, having *Halo* in a new format momentarily confused one of the people who was supposed to be promoting the new television program. When the trailer for *Halo* was released for the first time during the 2022 AFC Championship football game on sister company CBS Sports, former Dallas Cowboys quarterback and sportscaster Tony Romo audibly voiced his confusion, wondering live on air, "That's a videogame, right? Why are we plugging it as a show or a movie or a series?" The writers and producers of the series also seem to have wrestled with whether the new program would require viewers to be familiar with *Halo*'s full canon. In the end, the new *Halo* television series advances a noncanonical timeline, meaning that it does not follow the history established in its complex predecessors. Such a choice presumably opens the door for viewers who are not steeped in the franchise's lore to enjoy the new production without feeling lost or overwhelmed by the need to catch up. Much as J. J. Abrams sought to make the *Star Trek* franchise interesting to non–*Star Trek* fans by creating the Kelvin timeline in his rebooted trilogy films in 2009, 2013, and 2016, the television series *Halo* has the Silver Timeline. The new storytelling direction also allows for new casting. For instance, Captain Jacob Keyes, seen in the games as a mature white man, is being played in the new program by Rafael Fernandez.

Another example of transmedia storytelling can be found in the continued production of new content around Joss Whedon's *Firefly*, which originally aired on television for just one abbreviated season in 2002. A deliberate mashup of space science fiction with elements of Westerns, *Firefly* self-consciously straddled the line between the genres. The opening shot of the main spaceship flying above a herd of stampeding horses summed up the thrust and flavor of the program.

The main cast of nine characters centered on Captain Malcolm "Mal" Reynolds (Nathan Fillon) and Zoe Washburne (Gina Torres), former comrades in arms from the losing side of a war against the Alliance. The motley crew aboard the Firefly-class spaceship *Serenity* operates on the fringes of settled space, beyond the Alliance's control. In each episode, the jobs that Mal and the crew take on, whether smuggling and robbing, usually involved rich folks as the targets. Originally aired out of order on television by Fox, the show did poorly enough to be canceled before all fourteen original episodes aired but gained unexpected life afterward. Although loyal fans pushed to save the show, no network picked it up. But fan support led to the complete series being released on DVD in 2003, in turn generating an even larger cult following. That popularity enabled the feature film *Serenity* (2005), also directed by Whedon, which took the story to a resolution that had not been possible in the short-lived series.

Firefly fans, who call themselves "Browncoats," have been strong and visible presences at science fiction gatherings for years and consistent audiences for the franchise's transmedia storytelling. For instance, a *Serenity* role playing game (RPG) was released in 2005, as well as a *Firefly* RPG in 2014. Not every piece has worked out. There was a planned videogame, *Firefly Online*, which was announced to be in production at the 2013 San Diego Comic-Con. It was never canceled but also never released, with the last update on its progress issued in 2016. Since then, the storytelling of *Firefly* has continued in print. Dark Horse Comics published a series of *Serenity* comic books between 2005 and 2017 that tell stories considered to be a part of *Firefly*'s canon. There's a *Firefly* encyclopedia and more than one themed cookbook. After 2018, Boom! Studios picked up the *Firefly* license, producing comic books, graphic novels, and compiled collections. Fans who want to continue to enjoy tales from across the 'verse still have new stories to read.

THE DAWN OF A NEW SPACE AGE?

The renewed space craze also includes a flurry of activity in human spaceflight. The second decade of the twenty-first century began with a lull in popular spaceflight enthusiasm, despite steady work being done to operate the International Space Station, the US orbital segment of which had been declared complete in 2011. Avid industry-watchers knew that after the end of the space shuttle program in 2011, the Russian Soyuz continued to carry astronauts and cosmonauts

STREAMING, BILLIONAIRES, AND ACCELERATED CHANGE

to the International Space Station (ISS), with NASA and the US government paying a premium for those seats. And the Chinese space program slowly developed its human spaceflight capacity following its first such flight in 2003. In the United States, however, progress on developing other human-rated spacecraft seemed frustratingly slow. Finally, in 2020, the long-awaited era of commercial human spaceflight seemed to have begun. At the same time, the contexts for these flights—and the critiques of the money spent on them—continue to call on observers to view these efforts as a part of broader social, cultural, and political frameworks.

NASA's ongoing efforts to promote privately funded solutions for transporting cargo and crew to and from the ISS remain in progress. After determining which companies could reliably compete for NASA contracts, the space agency purchased cargo services from SpaceX and Orbital Sciences. SpaceX developed and began flying the reusable Cargo Dragon spacecraft, while Orbital Sciences served the need using expendable Cygnus spacecraft. To develop proposals for ISS crew transport vehicles, the Commercial Crew Program selected four successful bids from Boeing, Blue Origin, Sierra Nevada, and SpaceX. In 2014, NASA officials selected Boeing and SpaceX as the final two to develop crew systems. The first orbital test of the Boeing CST-100 failed in 2019, however, when the vehicle was not able to dock with the ISS. NASA determined that a second test flight, flown at Boeing's expense, was needed before human flights. When SpaceX started flying the Crew Dragon, it reestablished a native US capability to bring human beings back and forth from orbit.

On May 30, 2020, the same day that the first human beings launched from American soil since 2011 aboard SpaceX's Crew Dragon, widespread protests erupted in cities across the United States, sparked by the murder of George Floyd, an African American man, at the hands of a white police officer, and heightened by the profound racial disparities exposed by COVID-19. The protests connected with the Black Lives Matter movement that began in 2013 after George Zimmerman was acquitted of killing teenager Trayvon Martin as he walked home from a convenience store. Having racial and economic injustice as front-page news at the same moment as the SpaceX/NASA launch offered a striking historical parallel. The media coverage seemed to toggle between the elegant, high-tech cockpit of the Crew Dragon capsule *Endeavour* carrying NASA astronauts Doug Hurley and Bob Behnken and the chaotic footage emerging from cities across the nation.

The confluence of events drew comparisons to 1968 and 1969, when successful flights to the Moon occurred during a similarly fraught political moment. The disjunction between the dream of spaceflight and the harsh realities of American racism and poverty drew commentary and calls for action.

One such appeal came from a well-known retired Black astronaut, who is also a former football player, published author, and previous NASA associate administrator for education. In the break between the first attempted Dragon launch on Wednesday and Saturday's ultimate success, Leland Melvin posted an impassioned video on Facebook. He reflected that when he saw George Floyd being pinned by the knee of a white Minneapolis police officer, he thought that it could have been him. In his call for action, he reminded his audience, "It's going to be the good people that do nothing now that start doing something to stamp this hatred, evil, and racism out." Even as spaceflight efforts continued, they also remain connected to and embedded in the social issues on the ground.

In the midst of the global pandemic, 2021 became a record-setting year in human spaceflight. Thirteen crewed missions flew during that calendar year, the most ever, exceeding the previous high of eleven from 1985. The flights of 2021 included two by the Chinese space program to its new Tiangong space station and three Russian launches aboard Soyuz spacecraft to the ISS. The other eight orbital or suborbital human spaceflight missions were either flown by, or in NASA's partnership with, three US-based private companies: Virgin Galactic, Blue Origin, and SpaceX. Elon Musk's SpaceX also hit a remarkable milestone in 2021, achieving its one hundredth successful landing of a reusable first stage booster.

For Virgin Galactic, the first successful suborbital passenger flight of the SpaceShipTwo *Unity* came after a long period of halting progress. Having achieved the flights of SpaceShipOne, which won the Ansari X Prize in 2004, the era in which a (rich) citizen could purchase a ticket for a spaceflight seemed to be at hand. However, scaling up SpaceShipOne into a larger vehicle that could accommodate paying passengers proved more difficult—and dangerous—than expected. A disastrous accident during a test flight in 2014 killed one pilot and badly injured another when the VSS *Enterprise* came apart at high altitude due to a combination of vehicle design flaw and pilot error. After that incident, spaceflight journalist and author Jeffrey Kluger took Virgin Galactic's charismatic leader Richard Branson to task in a scathing editorial in *Time* magazine. He accused Branson of being "a man driven by too much hubris, too much

hucksterism and too little knowledge of the head-crackingly complex business of engineering." Kluger also aimed his criticism at the whole field of privately funded human spaceflight, arguing, "For the twenty-first century billionaire, space travel is what buying a professional sports team was for the rich boys of an earlier era: the biggest, coolest, most impressive toy imaginable." Kluger suggested quite strongly that dilletantes did not belong in such a perilous business.

For his part, three years later, SpaceShipOne builder and Scaled Composites founder Burt Rutan shared his frustration that those in the private spaceflight arena were not pushing hard enough. In a webcast meeting organized in 2017 to promote a book about SpaceShipOne, Rutan lit into the participants for their overly rosy assessments. Pointing out that thirteen years had passed since the successful X Prize flights, Rutan exclaimed, "What the hell happened? We got nothing done! Why aren't you horribly disappointed?" In the end, it took Virgin Galactic another four years to achieve the first crewed flight of the next generation vehicle, SpaceShipTwo, piloted by David Mackay and Frederick Sturckow.

Virgin Galactic's first flight with passengers on board came less than two months later. On July 11, 2021, the VSS *Unity* flew above fifty miles altitude, the US definition of space, with six occupants on board, including two pilots and Branson himself. When they began floating out of their seats, Branson declared, "To all you kids out there—I was once a child with a dream, looking up to the stars. Now I'm an adult in a spaceship. . . . If we can do this, just imagine what you can do." The audience for the flight was not only on the ground in New Mexico at Virgin Galactic's Spaceport America, where the party atmosphere included musical performances, but also online. During the flight, Virgin Galactic posted on social media Branson's quote along with a short video of the flight's participants tumbling in microgravity. Speaking on the tarmac afterward, Branson boldly declared the feat to be "the dawn of a new space age."

Yet the dream of selling passengers a ticket into space remains challenging. Virgin Galactic's flight system requires the talents of highly trained pilots to make the passenger flights successful. Virgin Galactic was also briefly grounded by the Federal Aviation Administration (FAA) for straying beyond its approved airspace during the mission. But those who are excited about this new venture remain enthusiastic. Upon the news that the mishap investigation had been

cleared, shares in Virgin Galactic jumped almost 10 percent. Human spaceflight continues to be expensive, risky—and highly competitive.

Branson's flight in early July upstaged competitor Jeff Bezos's announced launch of the first flight of his suborbital passenger vehicle, New Shepard. As announced in advance, on the highly symbolic date of July 20, 2021 (exactly fifty-two years after the Apollo 11 astronauts landed on the Moon in 1969), Jeff Bezos boarded the aptly named RSS *First Step*. In addition to his brother, Mark, Bezos was accompanied by teenager Oliver Daemen, whose father purchased his seat for him. As such, Daemen became Blue Origin's first official paying customer. In an inspired gesture, Bezos invited Wally Funk, an accomplished pilot, long-time flight instructor, and the first female air safety investigator and inspector. Notably, Funk was also one of the women pilots who took astronaut fitness tests in 1960 as a part of the privately funded experiment run at the Lovelace Foundation, where NASA's own Project Mercury physicals were also conducted. Together, the crew of four flew on an automated flight that took them above the Kármán line, which is at sixty-two miles (100km) altitude, the Fédération Aéronautique International definition of space.

In her commentary on the flight, the *Washington Post*'s Pulitzer Prize–winning senior critic-at-large Robin Givhan opened by describing Funk and Daemon before noting, "They were accompanied [into space] by a cowboy hat, a billionaire and his brother." Bezos's hat was a nod to his youth in Texas, she noted. But it was also, "an outsized reminder—as if one was needed—that Bezos is the big hat . . . with the overflowing bank account financing this experiment." Givhan's willingness to analyze Bezos's sartorial choice, which she also called "a caricature of overzealous machismo," is all the bolder because Bezos bought the *Washington Post* in 2013. But the cowboy hat was a significant symbolic choice. It stood out in the many photos taken that day. All four Blue Origin commercial astronauts wore identical blue jumpsuits without any other unique adornments, other than sunglasses and Bezos's cowboy hat. He wore it out in the sun but also kept it on indoors throughout the press conference. In that way, the deliberate choice seemed to signal a knowing link between the spaceflight achievement of the day and the framework of the American Western genre that helped to define its meaning.

With two more flights in October and December, Blue Origin launched fourteen passengers into space in 2021, including *Star Trek* television star William

STREAMING, BILLIONAIRES, AND ACCELERATED CHANGE

Amazon and Blue Origin founder Jeff Bezos raises his hands in triumph after the first crewed suborbital flight of New Shepard carried him and, from left to right, Oliver Daemen, Mark Bezos, and Wally Funk into space on July 20, 2021. Bezos wore his cowboy hat to the West Texas launch and throughout the postflight ceremony. Photo by Joe Raedle / Getty Images.

Shatner, NFL Hall of Famer turned broadcaster Michael Strahan, and Alan Shepard's daughter, Laura Shepard Churchley. The December flight included six passengers, the full capacity of the vehicle. After his landing on October 12, Shatner's eloquent and emotional reaction went viral. Struck by the thin layer of atmosphere that sustains life on Earth and the stark disparity with the blackness of space, Shatner was overwhelmed with appreciation for life and the experience's profound revelation. As he said upon landing, "I hope I never recover from this. I hope that I can maintain what I feel now. I don't want to lose it." Shatner joined an exclusive coterie of private citizens who had experienced the transformative experience of spaceflight.

The story of the space barons who created these experiences, who built such substantial personal fortunes that they could found their own spaceflight companies, is not a global one. Nor is the disparity of wealth exhibited by these American and British businessmen something that has been received uncritically. In

addition to more substantive critiques expressed in opinion pieces, *Saturday Night Live* parodied all three billionaires in a skit called "Star Trek: Ego Quest." The pointed sketch, starring guest host Owen Wilson as Jeff Bezos, depicted Bezos, Branson, and Musk meeting in space like excited teenagers, goofing off and literally racing each other in orbit. An Amazon delivery guy played by Kenan Thompson drew attention to the social, economic, and even racial disparity between his circumstances and that of his spacefaring boss. That parody took a very different tone than the flattering 2021 documentary designed to record Shatner's experience. *Shatner in Space* was produced for Bezos's own Amazon Prime Video streaming service.

In September 2021, viewers of a different docuseries, this one on Netflix, got behind-the-scenes insight into the crew of four non-professional spacefarers—including billionaire Jared Isaacman, who paid for the trip—as they made a three-day orbital flight on the SpaceX Crew Dragon *Resilience*. The tug-the-heartstrings documentary *Countdown: Inspiration4 Mission to Space* walked viewers through the choices of the crew members. As commander, Isaacman (and his company) chose artist, pilot, and scientist Sian Proctor for the mission's pilot. Haley Arcineaux, a childhood cancer survivor who grew up to be a physician assistant at St. Jude Children's Research Hospital, represented St. Jude, the charity for which the mission raised money and awareness. Christopher Sembroski took the seat reserved for the winner of a lottery made up of charitable contributors. When the original winner could not participate, he gave his seat to Sembroski.

The Netflix series emphasized the idea that Isaacman, Proctor, Arcineaux, and Sembroski represented the first crew of all ordinary "civilians" participating in a spaceflight. (The choice of the term "civilian" to describe the crew was not quite accurate. Any astronauts who are not active military are civilians in the original sense of the word. But pointing that out would nitpick at what is really a lovely story of inspired people who exuded enthusiasm for spaceflight.) Remarkably, as the pilot on this flight, Proctor became only the fourth Black woman in space ever. That low count speaks volumes about the continued lack of racial diversity in most spaceflight crews. Although the mission encountered some complications—a broken space toilet had to be repaired—the flight allowed all four to experience an extended orbital flight from September 16 to 18, 2021. To facilitate Earth-gazing, the usual docking port on the Dragon spacecraft was replaced with a special viewing port. After the flight, a special issue of *Time*

magazine on "The New Space Age" served as a companion volume to the Netflix documentary. The glossy well-illustrated issue, sold on newsstands and designed as a keepsake, set the flight in the context of space history as well as Virgin Galactic's and Blue Origin's recent achievements.

In addition to the notable flights aboard these new human spaceflight vehicles, some of the established avenues for space tourism continue to be traveled. As recently as 2021, seats on Russian Soyuz launches have been purchased for privately funded trips to the ISS. In October 2021, film director Klim Shipenko and actor Yulia Peresild rode in a Soyuz craft to visit the space station, filming scenes to be incorporated in an upcoming movie. Then, in December 2021, Japanese businessman Yusaku Maezawa spent twelve days on the ISS in a flight brokered by Space Adventures, the same company that organized the flights of other space tourists beginning with Dennis Tito in 2001. Like Shipenko and Peresild, Maezawa flew aboard a Russian Soyuz. Notably, Maezawa purchased not just one but two of the seats on the three-person-capacity vehicle. He brought with him video producer Yozo Hirano, who documented the trip for the billionaire's YouTube channel. In 2019, Maezawa announced hopes to pursue an additional space flight. On that mission, called dearMoon, he would fly around the Moon as a private passenger, purchasing all of the seats on a SpaceX-organized flight for himself and eight members of the public.

The future of new contributors in human spaceflight is still emerging. At this writing, Sierra Nevada Corporation, owned by two married Turkish American entrepreneurs, Fatih and Eren Ozmen, is developing the Dreamchaser to provide yet another mode of transportation for cargo—and eventually crew—to the ISS. The astronauts set to fly as commercial crews for the flights of the Boeing CST-100 Starliner, also designed to provide crew transportation for the ISS, have been announced. And Jared Isaacman has commissioned three more spaceflights from SpaceX, including plans for the first spacewalk by a private citizen. As these flights have become reality, the names of the spacecraft and launch vehicles—*Endeavour*, *Enterprise*, Falcon, New Shepard, and New Glenn—illustrate their important ties to the history of spaceflight.

SPACEFLIGHT AND AMERICAN IDENTITY

Spaceflight—and Americans' public excitement about it—remains inextricably embedded in, and reflective of, the stories that we tell ourselves about American national identity. It says powerful things about who Americans can be at their best: inventive, creative, passionate explorers. The power to harness American ingenuity to solve big problems put human beings on the Moon and launched spacecraft to explore the planets. This persistent and recurring theme in American culture has always carried in its very form other assumptions equally rooted in foundational ideals. Just as American Westerns built upon assumptions about heroic men with a yearning for exploration, so too space science fiction tapped into those standards and projected definite ideas about the presumed gender and racial identifications of the explorers. Beginning in the late 1920s, American space science fiction solidified into a basic cultural format that has become so ubiquitous that even the most ardent fans of the genre have not always recognized the formula as inherently culturally grounded.

The persistence of American's investment in the kinds of stories told about spaceflight hints at deep-seated issues that we still struggle with as a nation. The multipart Buck Rogers archetype, with its spacefaring crew aboard a named ship rocketing off to space-based places for new adventures, often at gunpoint, contained in its DNA some very specific ideas about who should be doing that exploring. The formula included narrowly cast gender roles and assumed the explorers' whiteness. Indeed, many early versions of space adventures in comics or on television not only imagined the whole central cast as white, but also as golden-haired. Physical difference as slight as having brown hair could signify alien origins. Consequently, spaceflight adventures conveyed not only ideas about possible exploration or adventures but also who deserved to participate in that future. The erasure of people of color in science fiction, other than as alien enemies, echoed broader cultural practices.

Likewise, the accomplishments of actual spaceflights were defined by the realities of the time. Social, cultural, and political circumstances shaped who could fly, where they went, and how the missions were understood. The Space Age, which began in 1957 with the launch of the Soviet satellite *Sputnik*, quickly became a proxy battlefield in the Cold War. Launching satellites or humans used the technologies of warfare to demonstrate capacities without deploying them to

fatal effect. But the framing of those missions drew upon deeper cultural ideals about pioneering exploration, new frontiers, and technological progress. Science fiction also played a crucial role in shaping the expectations about what actual space exploration would look like. As other scholars have already established, science fiction and reality have fed into each other, creating an active interplay between what has been imagined and how it was executed.

And yet, the formula has never been static. Popular excitement about spaceflight, both real and imagined, persisted in American culture precisely because the cultural forms adjusted in reaction to changing circumstances. Whether escapist, optimistic, dystopian, or allegorical, the stories and the characters shifted because the people creating and consuming them lived in those same everchanging times. But the backbone remained. The power of the stereotypes embedded in the core formula can be seen in the strength of the reaction when those assumptions are challenged. Representations of both gender and race in science fiction and actual space exploration still give rise to controversy.

The ubiquitous presence of ray guns—a key component of the Buck Rogers archetype—represents another largely unexamined part of American space science fiction. As part of a national mythos grounded in exploration and pioneer expansion, imagined ray guns, phasers, and blasters carry unexpected cultural weight. For many years, the influence of America's gun culture in comic strips, television programs, and popular films also spilled over into childhood play. Toy ray guns do not directly influence real firearms policy, of course. Yet, the idea that a good guy with a gun will save the day runs strongly through both. The persistence of ray guns in American space science emanates from core ideas about national identity that continue to shape national policy. That has real consequences. Policies that protect large ammunition magazines and semi-automatic weapons cannot be uncoupled from the lost lives of schoolchildren, concertgoers, and churchgoers, as well as the families and communities who mourn them. Even in a time when fewer families promote imaginary gunplay, the persistence of handheld guns in space-themed popular culture speaks to how enduring those ideas are.

Present-day spaceflight advocates often misremember how popular spaceflight was in the past, lamenting the lack of current widespread enthusiasm. Even in the heyday of the 1960s, however, human spaceflight competed for public attention with all the other events of the day. Public opinion polls, which often

linked approval for space efforts to support for funding them, illustrate the disconnect between general cultural interest and widespread willingness to dedicate tax money. As former NASA historian Roger Launius has argued, "A general public lack of support for expending many dollars on spaceflight has been a fundamental reality of NASA since its beginning. It is not changing, and probably not changeable, in the predictive future." The newest human spaceflights carried out by private companies have sparked new versions of persistent arguments about whether capital resources should be concentrated and spent on rocket dreams.

Yet, examining the popularity of spaceflight as a cultural phenomenon reveals how consistently the theme has recurred and sustained, rooted in big ideas woven deeply into the fabric of national identity. Over time, those big ideas have been reflected in small things owned by ordinary people. Americans' spaceflight enthusiasm has been carried out via mass media, memorialized in souvenirs, and literally played with via space-themed toys in bedrooms, dens, family rooms, and backyards. These seemingly ephemeral artifacts represent the physical talismans of memories, whether of a real space achievement or a beloved science fiction show or film. This history has real consequences. Tracing how space was popular at particular times deepens the insight into how and why space exploration found fertile soil in American culture. Together, this material accumulation tells a story about the history of how Americans have participated in an evolving conversation, one that remains vital to current debates and concerns, and one for which change has been a constant, the source of its persistence and power.

Acknowledgments

Just as this book begins with *Buck Rogers* memorabilia, where Americans' fascination with spaceflight took form, these acknowledgments must start by thanking the two gentlemen who built the core of the Museum's social and cultural history collection. In the early 1990s, curator Frank Winter acquired more than two thousand pieces of space science fiction memorabilia from Michael O'Harro, a businessman and collector. O'Harro's interest in Buster Crabbe, who played both Buck Rogers and Flash Gordon in movie serials in the 1930s, inspired him to build a rich and deep collection. He generously donated it and later sat for an oral history interview. Over the years, the collection developed through generous gifts from donors who entrusted their family's objects and memories to the Smithsonian. This book builds from those amazing resources.

It has been my immense privilege to work daily with some of the best historians in the field and be their colleague. I am grateful for the example set by Martin Collins, Jim David, David DeVorkin, Cathleen Lewis, Jennifer Levasseur, Teasel Muir-Harmony, Allan Needell, Matthew Shindell, Samantha Thompson, Emily Margolis, Bob van der Linden, Alex Spencer, Mike Hankins, John Anderson, and Russell Lee. Thank you to Roger Launius for giving me my start in this work. Special appreciation to Valerie Neal and Paul Ceruzzi for their gentle prodding and steady encouragement. I am particularly indebted to Mike Neufeld for his stalwart support and thoughtful edits. Together, Peter Jakab, Jeremy Kinney, and the Museum's leadership, including General Jack Dailey, Ellen Stofan, and Christopher Browne, have created a strong environment for scholarship. Likewise, the

ACKNOWLEDGMENTS

Writers' Group provided structure and support; thank you to the colleagues and fellows who participated over the years.

Museum work in inherently collaborative. This book was possible because of the hard work and consummate professionalism of my colleagues in Collections Processing, Preservation and Restoration, Conservation, Archives, Education, Photography, Exhibits, Communications, the Front Office, Business Operations, and the Museum's Solutions Center. Special shoutout to Jeannie Whited, Hana Kim, and Ashley Hornish for their insights, and to Polly McKenna-Cress and Phyllis Wright for their support. Many of the artifact photos in this book came from Mark Avino, Eric Long, and Jim Preston as well as Collections staff who capture the essence of the Museum's objects. Thank you to Jill Corcoran and Taylor Paige at Smithsonian Enterprises.

A special thanks to Marilyn Graskowiak for giving me Benjamin W. Lawless Jr.'s copy of the collected *Buck Rogers* comic strips. Thanks to Mark Taylor for helping me research the mutoscope reel as well as to Chris Cottrill and the Smithsonian Institution Libraries. I cannot possibly list all of the librarians, curators, and archivists who aided my work over the years, but I am grateful for your help.

The research and energy of some very talented interns informed this book as well as the Museum's exhibits and public programs. Thanks to Rebecca Mueller, Owen Volzke, Tracee Haupt, Emily Gibson, and Peter Kleeman. Special thanks to Ingrid Ockert, Bert Ulrich, and Larry Burke for connecting me to wonderful resources, whether in archives or in person. Thanks also to the wider community of scholars who engaged with my work and pushed me in new directions. With a subject this broad, I drew from the insights and research of many. Their works are listed the notes with appreciation.

On a personal level, I am grateful to my pipestem family: the Greens, the Ouarts, the Tramels, the Steins, the Lindners, and the Thorntons. Thanks to Gloria Steiner for always listening and never judging. Thanks also to the friends who are family: Emily Longnecker, Gwendolyn Llewellyn, Kimberly and Rick Weinberg, Pamela Weinberg, Steven Nevid, Kit Sturgeon, and Amiko and Robin Rorick. And my extended family: Ray and Colleen Weitekamp, Patsy Myers and Edward Hayes, Megan Orhan and her family, Gabriel Hayes, Cheryl Adams and Shawn Grey, Tracy Days, Terrance Days, and my mother-in-law, Antoinette Adams, as well as my nieces and nephews.

ACKNOWLEDGMENTS

At Smithsonian Books, thanks to Carolyn Gleason, Julie Huggins, and Gregory McNamee, whose guidance greatly improved this book.

Space Craze is dedicated to my parents, John and Ann Gannon. After their many years of support and encouragement, I was grateful to show them both the completed manuscript.

Finally, all my love to my children, Xavier, Katharine, and Quincy Days. To my husband, Kevin Days, thank you for your love and support as I worked on this book and in everything else. I could not have done it without you.

Notes

In researching and writing this book, I consulted scores of scholarly articles, websites, newspaper articles and advertisements, US patent records, oral history interviews, and other documentary materials that are not specifically cited in the notes that follow but that helped inform my narrative. Important sources of information also included archival files and publications issued and held by these institutions: Columbia University Oral History Collection; Jay Kay Klein Photographs and Papers on Science Fiction Fandom, University of California Riverside Library; Harry S. Truman Library, Independence, Missouri; Library of Congress, Washington, DC; John F. Kennedy Presidential Library and Museum; National Aeronautics and Space Administration (NASA), especially oral histories and the Historical Reference Collection at NASA Headquarters; Ronald Reagan Presidential Library, Simi Valley, California; Smithsonian National Air and Space Museum, including the archival collections of Gerard O'Neill, Arthur C. Clarke, the National Aerospace Cadets, and *Babylon 5* fan materials; Smithsonian National Museum of American History; the Smithsonian Institution Archives, especially the Frederick C. Durant III papers; Wisconsin Center for Film and Theater Research, Wisconsin Historical Society Archives, Madison; and the Paley Center for Media, New York City. I am deeply grateful for the help of these institutions and the librarians, curators, and archivists who work in them.

NOTES

INTRODUCTION

2: "So, too, with spaceflight": Joseph Corn, *The Winged Gospel: America's Romance with Aviation, 1900–1980* (New York: Oxford University Press, 1983); Howard McCurdy, *Space and the American Imagination* (Washington, DC: Smithsonian Institution Press, 1997); Walter McDougall, . . . *The Heavens and the Earth: A Political History of the Space Age* (New York: Basic Books, 1985).

2: "just as historically grounded and culturally based": Asif Siddiqi, *The Red Rockets' Glare: Spaceflight and the Soviet Imagination, 1857–1957* (Cambridge: Cambridge University Press, 2010); Slava Gerovitch, *Soviet Space Mythologies: Public Images, Private Memories, and the Making of a Cultural Identity* (Pittsburgh, PA: University of Pittsburgh Press, 2015); Alexander C. T. Geppert, ed., *Imagining Outer Space: European Astroculture in the Twentieth Century* (New York: Palgrave Macmillan, 2012); Alexander C. T. Geppert, ed., *Limiting Outer Space: Astroculture After Apollo* (New York: Palgrave Macmillan, 2018); Alexander C. T. Geppert, Daniel Brandau, and Tilmann Siebeneichner, eds., *Militarizing Outer Space: Astroculture, Dystopia and the Cold War* (New York: Palgrave Macmillan, 2020); Dong-Won Kim, "Science Fiction in South and North Korea," *East Asian Science, Technology, and Society* 12 (September 2018): 309–326.

2: "the dream of spaceflight that coalesced in the United States": Brian W. Aldiss, *Trillion Year Spree: The History of Science Fiction* (New York: Avon Books, 1986), 13.

3: "As space policy expert Linda Billings has chronicled": Linda Billings, "Overview: Ideology, Advocacy, and Spaceflight—Evolution of a Cultural Narrative," in *Societal Impact of Spaceflight*, ed. Steven J. Dick and Roger D. Launius (Washington, DC: National Aeronautics and Space Administration, 2007), 483.

5: "I reexamined how playthings should be understood": Brian Sutton-Smith, *Toys as Culture* (New York: Gardner Press, 1986); Howard P. Chudacoff, *Children at Play: An American History* (New York: New York University Press, 2007); Robin Bernstein, "Dances with Things: Material Culture and the Performance of Race," *Social Text* 27, no. 4 (2009): 70. The *American Journal of Play*, published by the Strong National Museum of

NOTES

Play, is a peer-reviewed interdisciplinary journal examining "the history, science, and culture of play."

1. *BUCK ROGERS*, RAY GUNS, AND THE SPACE FRONTIER

10: "Metropolitan Newspaper Service began publishing *Tarzan*": Popular culture historian William H. Young Jr. credits *Tarzan*, drawn by Harold Foster, for setting standards as the first adventure strip. In particular, he argues, adventure strips usually featured "1) the physically strong and attractive male hero, 2) the helpless and acquiescent female heroine (the famous 'Jane' in Tarzan), [and] 3) the concept of justice administered by one man, answerable to no one." Young, however, misdates the debut of *Buck Rogers* as 1930, robbing Nowlan and Calkins of due credit for the archetypes they developed simultaneously alongside Foster's *Tarzan*. William H. Young Jr., "The Serious Funnies: Adventure Comics during the Depression, 1929–1938," *Journal of Popular Culture* 3, no. 3 (December 1969), 407. For *Flash Gordon*, see Roy Kinnard, Tony Crankovich, and R. J. Vitone, *The Flash Gordon Serials, 1936–1940* (Jefferson, NC: McFarland & Company, 2008).

12: "French science fiction author Jules Verne": Jules Verne, *From the Earth to the Moon Direct in Ninety-Seven Hours and Twenty Minutes, and a Trip Around It*, trans. Louis Mercier and Eleanor King (New York: Scribner, Armstrong & Company, 1874).

13: "George Méliès's innovative spaceflight tale": *A Trip to the Moon*, dir. George Méliès (Star Film, 1902).

13: "paraded the alien through the streets": Film scholar Matthew Solomon interprets both lost scenes as reminiscent of Méliès's comic parodies of British colonialism. Matthew Solomon, ed., *Fantastic Voyages of the Cinematic Imagination: Georges Méliès's Trip to the Moon* (Albany: State University of New York Press, 2011), 14.

14: "became better known in the United States": See Richard Abel, "*A Trip to the Moon* as an American Phenomenon," in Solomon, *Fantastic Voyages of the Cinematic Imagination: Georges Méliès's Trip to the Moon*, 138.

NOTES

15: "formative element of American spaceflight stories": See Miriam Hansen, "Early Cinema, Late Cinema: Permutations of the Public Sphere," *Screen* 34, no. 3 (Autumn 1993): 197–210, at 198.

15: "Thompson's imagined trip to the Moon": Frank H. Winter, "The 'Trip to the Moon' and Other Early Spaceflight Simulation Shows, ca. 1901–1915: Part I," in *History of Rocketry and Astronautics*, ed. Donald C. Elder and Christophe Rothmund (San Diego, CA: AAS Publications Office, 2001), 145; Richard Abel, "*A Trip to the Moon* as an American Phenomenon," in Solomon, *Fantastic Voyages of the Cinematic Imagination: Georges Méliès's Trip to the Moon*, 131–134.

16: "The racial homogeneity of Buffalo's crowds": Andrew R. Valint, "Fighting for Recognition: The Role African Americans Played in World Fairs," MA thesis, State University of New York College at Buffalo—Buffalo State College, 2011.

16: "Coney Island had grown since 1895": See Robin Jaffee Frank, ed., *Coney Island: Visions of An American Dreamland, 1861–2008* (New Haven, CT: Wadsworth Atheneum Museum of Art and Yale University Press, 2015); John F. Kasson, *Amusing the Million: Coney Island at the Turn of the Century* (New York: Hill & Wang, 1978).

17: "the idea that space-based places such as the Moon or Mars": Frank H. Winter, "The 'Trip to the Moon,' and Other Early Spaceflight Simulation Shows ca. 1901–1915: Part 2," in *History of Rocketry and Astronautics*, ed. Hervé Moulin and Donald C. Elder (San Diego, CA: AAS Publications Office, 2003), 5, 9, 15–18.

18: "the idea of an inhabited Mars": See Robert Crossley, *Imagining Mars: A Literary History* (Middletown, CT: Wesleyan University Press, 2011).

19: "Propulsion became his passion": See David A. Clary, *Rocket Man: Robert H. Goddard and the Birth of the Space Age* (New York: Hyperion, 2003).

19: "New ways of disseminating popular culture": For more on early science fiction and popular culture, see John Cheng, *Astounding Wonder: Imagining Science and Science Fiction in Interwar America* (Philadelphia: University of Pennsylvania Press, 2012).

21: "Lt. Dick Calkins, U.S. Air Corps": Robert C. Dille, ed., *The Collected Works of Buck Rogers in the 25th Century* (New York: Bonanza Books, 1969), 1.

21: "simplistic Asian-inspired villains": Young, "The Serious Funnies," 417–418.

NOTES

22: "the growing importance of sportswear": Rebecca Arnold, *The American Look: Fashion, Sportswear and the Image of Women in 1930s and 1940s New York* (New York: I. B. Tauris, 2009). The quotations are at 24, 1, and 7.

22: "might start following the strip because of a hometown cameo": Robert Lesser, *A Celebration of Comic Art and Memorabilia* (New York: Hawthorn, 1975), 171.

23: "the old doctor will take care of that": Clary, *Rocket Man*, 123.

23: "marvelous new techniques": "New Program Creates Striking Sound Effects; Marvelous New Technique Used for 'Buck Rogers in the Twenty-fifth Century,'" *Daily Boston Globe*, November 11, 1932.

25: "For the two *Flash Gordon* movie serials": *Flash Gordon*, dir. Frederick Stephani, 13 parts (Universal Pictures, 1936); *Flash Gordon's Trip to Mars*, dir. Ford Beebe and Robert F. Hill, 15 parts (Universal Pictures, 1938). See Kinnard, Crankovich, and Vitone, *The Flash Gordon Movie Serials*.

26: "furnish the forces dominating American character": Frederick Jackson Turner, *The Frontier in American History* (New York: Henry Holt, 1920), 2.

27: "the company added futuristic space guns to its product line": Frederick J. Augustyn Jr., *Dictionary of Toys and Games in American Popular Culture* (New York: Haworth Reference Press, 2004), s.v. "BB Guns," 16; Sharon M. Scott, *Toys and American Culture: An Encyclopedia* (Santa Barbara, CA: Greenwood, 2010), s.v. "Daisy Outdoor Products," 67.

28: "even to its distinctive sound—ZAP!": Charles F. Lefever, Toy Gun, U.S. Patent 2,006,741, filed April 25, 1934, and issued July 2, 1935; Lesser, *A Celebration of Comic Art and Memorabilia*, 173.

29: "[it] produces an exceptionally loud report": Charles F. Lefever, Toy Gun, U.S. Patent 2,055,900, filed March 11, 1935, and issued September 29, 1936.

29: "well below the manufacturing cost": Lesser, *A Celebration of Comic Art and Memorabilia*, 173–174.

29: "or the costume as some other character": Advertisement pictured in S. Mark Young, Steve Duin, and Mike Richardson, *Blast Off!: Rockets, Robots, Ray Guns, and Rarities from the Golden Age of Space Toys* (Milwaukie, OR: Dark Horse Comics, 2001), 32.

31: "paintable models of their favorite comic characters": Lesser, *A Celebration of Comic Art and Memorabilia*, 200–201; Young, Duin, and Richardson, *Blast Off!*, 72–73.

31: "encourage boys to be independent, handy, and industrious": See Aaron L. Alcorn, "Modeling Behavior: Boyhood, Engineering, and the Model," PhD dissertation, Case Western Reserve University, 2009, esp. chap. 2.

32: "will want this exciting but harmless toy": Young, "The Serious Funnies," 422.

33: "The White House granted permission": See "FDR: Space Ranger" in the blog of the Franklin D. Roosevelt Presidential Library and Museum, May 31, 2011, https://bit.ly/35hrFIf.

34: "the most amazing toy of the atomic age!": Lesser, *A Celebration of Comic Art and Memorabilia*, 172.

34: "coined by science fiction writer William Gibson": see Gibson's story "The Gernsback Continuum" in his collection *Burning Chrome* (Gettysburg, PA: Arbor House, 1986).

2. SPACE FORTS, TELEVISION, AND THE COLD WAR MINDSET

38: "Fort playsets such as O'Harro's reflected that tension": Melvin E. Matthews Jr., *Hostile Aliens, Hollywood and Today's News: Science Fiction Films and 9/11* (Sanford, NC: Algora Publishing, 2007), 4.

40: "In each of the variations on the show's introduction": A similar introduction also opened the *Captain Video* movie serials. See "Journey Into Space," *Captain Video, Master of the Stratosphere*, n.d. See also Patrick Lucanio and Gary Colville, *American Space Science Fiction Television Series of the 1950s: Episode Guides and Casts and Credits for Twenty Shows* (Jefferson, NC: McFarland & Company, 1998), 96–101.

40: "the exaggerated villainous look of Ming the Merciless": Roy Kinnard, Tony Crankovich, and R. J. Vitone, *The Flash Gordon Serials, 1936–1940* (Jefferson, NC: McFarland & Company, 2008).

41: "preserved using a kinescope recorder": For early science fiction television series, see *1950s "Rocketman" TV Series and Their Fans*, ed. Cynthia J. Miller and A. Bowdoin Van Riper (New York: Palgrave Macmillan, 2012), xiv–xv; Lucanio and Colville, *American Space Science Fiction Television Series of the 1950s*, 96–97.

NOTES

42: "Frederick J. Augustyn Jr. argues": Frederick J. Augustyn Jr., *Dictionary of Toys and Games in American Popular Culture* (New York: Haworth Reference Press, 2004), s.v. "Captain Video," 24.

43: "*Space Patrol* was a great example": See *Space Patrol*, series premiere, ABC, September 11, 1950; Lucanio and Coville, *American Space Science Fiction Television*, 195; Jean-Noel Bassior, *Space Patrol: Missions of Daring in the Name of Early Television* (Jefferson, NC: McFarland & Company, 2005), 218.

44: "Tonga's brunette hair set her apart as exotic": Jean-Noel Bassior, "*Space Patrol*: Missions of Daring in the Name of Early Television," in Miller and Van Riper, *1950s "Rocketman" TV Series and Their Fans*, 166.

44: "counted adults as the majority of its audience": Mark Young, Steve Duin, and Mike Richardson, *Blast Off!: Rockets, Robots, Ray Guns, and Rarities from the Golden Age of Space Toys* (Milwaukie, OR: Dark Horse Books, 2001), 136; Christopher H. Sterling and John Michael Kittross, *Stay Tuned: A History of American Broadcasting*, 3rd ed. (Mahwah, NJ: Lawrence Erlbaum Associates, 2002), 370; Lucanio and Coville, *American Science Fiction Television*, 195–199; Bassior, *Space Patrol*, 1.

45: "the envy of Space Patrollers across the nation": Young, Duin, and Richardson, *Blast Off!*, 187–197; Bassior, *Space Patrol*, esp. chap. 16, 252–278.

45: "the ongoing popularity of space-themed programs": Luciano and Coville, *American Space Science Fiction Television*, 81–82, 113–118.

46: "drew upon stereotypes rooted in postwar suburban identity": Elaine Tyler May, *Homeward Bound: American Families in the Cold War Era* (New York: Basic Books, 1988); Emily Badger, "'White Flight' Began a Lot Earlier Than We Think," *Washington Post*, March 17, 2016.

46: "drawn by Dan Barry": For the entire run of the comic series, see Dan Barry and Harvey Kurtzman, *Flash Gordon: The Complete Daily Strips, November 1951–April 1953* (Princeton, WI: Kitchen Sink Press, 1988).

47: "Another striking example of postwar racial homogeneity": See *When Worlds Collide*, dir. Rudolph Maté (Paramount Pictures, 1951).

49: "the designers for *Star Trek II*": *Star Trek II: The Wrath of Khan*, dir. Nicholas Meyer (Paramount, 1982).

50: "were nonetheless rooted in real science and engineering": Willy Ley, *The Conquest of Space* (New York: Viking Press, 1949); Howard E. McCurdy, *Space and the American Imagination* (Washington, DC: Smithsonian

NOTES

Institution Press, 1997). McCurdy's excellent scholarship on the Disney television show and the *Collier's* magazine series inform the summary here.

50: "*Destination Moon*": *Destination Moon*, dir. Irving Pichel (George Pal Productions, 1950).

51: "The show struggled to find a permanent home": *Tom Corbett, Space Cadet*, series debut, ABC, 1950; Lucanio and Colville, *American Space Science Fiction Television*, 212. See also Jared Buss, *Willy Ley: Prophet of the Space Age* (Gainesville: University Press of Florida, 2017).

52: "A *Space Patrol* episode from 1954": "Baccarratti and Black Magic," *Space Patrol*, ABC, original airdate December 11, 1954.

53: "rotating space station inspired by von Braun's ideas": McCurdy, *Space and the American Imagination*, 33–47.

53: "layout evoked a filmmaker's perspective on simpler times": Michael J. Neufeld, *Von Braun: Dreamer of Space, Engineer of War* (New York: Knopf, 2007), 287; Raymond M. Weinstein, "Disneyland and Coney Island: Reflections on the Evolution of the Modern Amusement Park," *Journal of Popular Culture* 26 (Summer 1992): 131–164; McCurdy, *Space and the American Imagination*, esp. 29–51.

54: "it became famous for playsets": Sharon M. Scott, *Toys and American Culture: An Encyclopedia* (Santa Barbara, CA: Greenwood, 2010), 195, 197; Russell S. Kern, *Marx Toy Kings*, vol. 1, *The Marx Men, 1919–1954* (San Francisco: Atomic Enterprises LLC, 2014), 152. After the business collapsed in the early 1970s, Marx sold it to Quaker Oats in 1972.

55: "Marx sold many versions of the same toy": Young, Duin, and Richardson, *Blast Off!*, 164–165, 147, 152, and 148–149.

55: "toys with appeal and playability": Young, Duin, and Richardson, *Blast Off!*, 140–141.

55: "children could acquire more than one set": Young, Duin, and Richardson, *Blast Off!*, 164–165.

56: "such depictions had lasting effects": For a powerful condemnation of plastic "cowboys and Indians" as tools of colonialism, see Michael Yellow Bird, "Cowboys and Indians: Toys of Genocide, Icons of American Colonialism," *Wicazo Sa Review* 19, no. 2 (Autumn 2004): 33–48; David Levinthal and David Corey, *Small Wonder: Worlds in a Box* (New York: DAP, 1996), 19, 8.

NOTES

56: "nostalgia remains powerful": Francis Turner ran the Official Marx Toy Museum in Glen Dale, West Virginia, displaying parts of his personal toy collection. Additional information about *Playset* magazine can be found at www.playsetmagazine.com. Levinthal and Corey, *Small Wonder*; Jeffrey Hammond, *Little Big World: Collecting Louis Marx and the American Fifties* (Iowa City: University of Iowa Press, 2010); Kern, *Marx Toy Kings*; Russell S. Kern, *Marx Toy Kings*, rev. ed., vol. 2, *The Playset Era, 1955–1982* (San Francisco: Atomic Enterprises LLC, 2014).

56: "Another type of space toy with a lasting impact was the space robot": *Forbidden Planet*, dir. Fred M. Wilcox (Metro-Goldwyn-Mayer, 1956); Scott, *Toys and American Culture*, s.v. "Ideal Novelty & Toy Company," 157; For an analysis of *Forbidden Planet* as emblematic of postwar consumerism, see Rick Worland and David Slayden, "From Apocalypse to Appliances: Postwar Anxiety and Modern Convenience in Forbidden Planet," in *Hollywood Goes Shopping*, ed. David Desser and Garth S. Jowett (Minneapolis: University of Minnesota Press, 2000), 139–158.

59: "Tin toy production began in Japan around 1947": Young, Duin, and Richardson, *Blast Off!* 229; Dale Kelley, *Collecting the Tin Toy Car, 1950–1970* (Exton, PA: Schiffer, 1984), 8.

60: "As tin toys expert Michael Buhler summarizes": Michael Buhler, *Tin Toys, 1945–1975* (New York: Quick Fox, 1978).

64: "Harvard astronomer Fred Whipple": Patrick McCray, *Keep Watching the Skies! Project Moonwatch and the Dawn of the Space Age* (Princeton, NJ: Princeton University Press, 2008); David H. DeVorkin, *Fred Whipple's Empire: The Smithsonian Astrophysical Observatory, 1955–1973* (Washington, DC: Smithsonian Books, 2018).

64: "Space historian Roger Launius has called this": Roger D. Launius, "NASA's Quest for Human Spaceflight Popular Appeal," *Social Science Quarterly* 98, no. 4 (December 2017): 1217.

65: "midcentury modern design became all the rage": For a well-illustrated account of this design history, see Sean Topham, *Where's My Space Age? The Rise and Fall of Futuristic Design* (Munich: Prestel, 2003).

67: "two new dramas appeared on American television": Complete runs of both *The Man and the Challenge* and *Men Into Space* are in the United Artists Corporation Records, which are held by the Wisconsin Center for

Film and Theatre Research at the Wisconsin Historical Society in Madison. The episodes of the former cited herein were first aired from September 1959 to April 1960; of the latter, "Moon Probe" was originally aired on September 30, 1959, and "Moon Landing" on October 7, 1959.

67: "*Science Fiction Theater* was always first or second in the ratings": Morleen G. Rouse, "A History of the F.W. Ziv Radio and Television Syndication Companies, 1930–1960," PhD dissertation, University of Michigan, 1976, 197, 200; Lucanio and Coville, *American Space Science Fiction Television*, 179.

68: "against the predicted rigors of spaceflight": Lucanio and Coville, *American Space Science Fiction Television*, 142; Sterling and Kittross, *Stay Tuned*, 377.

70: "underscored cultural concerns about a loss of toughness": May, *Homeward Bound*; Ruth Rosen, *The World Split Open: How the Women's Movement Changed America* (New York: Penguin Books, 2000); Robert D. Dean, *Imperial Brotherhood: Gender and the Making of Cold War Foreign Policy* (Amherst: University of Massachusetts Press, 2001).

70: "Nader's identity as a gay man": Claude J. Summers, ed., *The Queer Encyclopedia of Film and Television* (Jersey City, NJ: Cleis Press, 2005).

71: "*Men Into Space* imagined a functioning military human spaceflight program": Lucanio and Coville, *American Space Science Fiction Television*, 147–150.

3. JOHN GLENN, THE APOLLO PROGRAM, AND FLUCTUATING SPACEFLIGHT ENTHUSIASM

77: "how deeply Kennedy felt the imperative to exhibit strength": For more, see John Logsdon, *John F. Kennedy and the Race to the Moon* (New York: Palgrave Macmillan, 2010).

78: "Policymakers never really considered a women's program": See Margaret A. Weitekamp, *Right Stuff, Wrong Sex: America's First Women in Space Program* (Baltimore, MD: Johns Hopkins University Press, 2004), 77, 82.

78: "The racial integration of NASA had barely begun": See Joseph D. Atkinson Jr. and Jay M. Shafritz, *The Real Stuff: A History of NASA's Astronaut Recruitment Program* (New York: Praeger, 1985), 99, 98; Richard Paul and

NOTES

Steven Moss, *We Could Not Fail: The First African Americans in the Space Program* (Austin: University of Texas Press, 2015) 3, 29, 39–41.

80: "a national catharsis unparalleled": Walter McDougall, . . . *The Heavens and the Earth: A Political History of the Space Age* (New York: Basic Books, 1985), 347.

80: "As the *Los Angeles Times* noted": Dick West, "Missile Revamped for Orbital Flight: Glenn's Atlas Was Originally Designed as Weapons System," *Los Angeles Times*, January 21, 1962. See also Matt Weinstock, "A Grim Moment in Life of Spaceman," *Los Angeles Times*, January 25, 1962.

84: "one of the very first videogames": Ryan P. Smith, "How the First Popular Video Game Kicked Off Generations of Virtual Adventure," Smithsonian.com, December 13, 2018, https://www.smithsonianmag.com/smithsonian-institution/how-first-popular-video-game-kicked-off-generations-virtual-adventure-180971020/; Jeff Spry, "Firsts: Spacewar! Was the World's First Video Game," SYFY Wire, January 29, 2018,

87: "This roadside Space Age became part of daily life": Sean Topham, *Where's My Space Age? The Rise and Fall of Futuristic Design* (Munich: Prestel, 2003).

88: "rehashing standard television sitcom fare": Christopher A. Lehman, *American Animated Cartoons of the Vietnam Era: A Study of Social Commentary in Films and Television Programs, 1961–1973* (Jefferson, NC: McFarland & Company, 2007), 26.

90: "Dwight initially took being passed over quietly": Paul and Moss, *We Could Not Fail*, chap. 5, 89–104.

91: "their makers reinvented the very idea of dolls": Sharon M. Scott, *Toys and American Culture: An Encyclopedia* (Santa Barbara, CA: Greenwood, 2010), xxvi; Frederick J. Augustyn Jr., *Dictionary of Toys and Games in American Popular Culture* (New York: Haworth Reference Press, 2004), 1.

93: "Originally the ship was to have been named *Gemini 12*": *Lost in Space* (Irwin Allen Productions, 1965–68); see Lynn Spigel, *Welcome to the Dreamhouse: Popular Media and Postwar Suburbs* (Durham, NC: Duke University Press, 2001), 117.

94: "NASA's budget reached an all-time high": See *The Apollo Spacecraft: A Chronology*, vols. 1–4, NASA SP-4009 (Washington, DC, 1969–78), appendix 2. See also Jane Van Nimmer and Leonard C. Bruno with Robert L.

NOTES

Rosholt, *NASA Historical Data Book, 1958–1968, Volume 1, NASA Resources*, NASA Historical Series, NASA SP-4012 (Washington, DC: National Aeronautics and Space Administration, 1976), 115.

98: "while men built spacecraft, women built communities": See "The Spaceport's Impact on the Local Communities," in Charles D. Benson and William Barnaby Faherty, *Moonport: A History of Apollo Launch Facilities and Operations*, NASA Special Publication 4204 (Washington, DC: NASA, 1978).

99: "heavily skewed the populations who visited": Emily Margolis, "Space Travel at 1G: Space Tourism in Cold War America," PhD dissertation, Johns Hopkins University, 2019; Joy Wallace Dickinson, "During Days of 'Green Book,' Dr. Wells' Hotel Offered Haven," *Orlando Sentinel*, February 3, 2019.

101: "Roddenberry's vision offered a stark contrast": See Herbert F. Solow and Robert H. Justman, *Inside Star Trek: The Real Story* (New York: Pocket Books, 1996), xviii, 16; Daniel Leonard Bernardi, *Star Trek and History: Race-ing Toward a White Future* (New Brunswick, NJ: Rutgers University Press, 1998); DeWitt Douglas Kilgore, *Astrofuturism: Science, Race, and Visions of Utopia in Space* (Philadelphia: University of Pennsylvania Press, 2003); and andré m. carrington, *Speculative Blackness: The Future of Race in Science Fiction* (Minneapolis: University of Minnesota Press, 2016).

102: "just how influential her character was": Nichelle Nichols, interview with the author, National Air and Space Museum, Washington, DC, May 24, 2011. See also Nichelle Nichols, *Beyond Uhura: Star Trek and Other Memories* (New York: Putnam, 1994), 164–165, and J. Alfred Phelps, *They Had a Dream: The Story of African-American Astronauts* (Novato, CA: Presidio Press, 1994), 62.

104: "hundreds and then thousands of fans wrote to support the show": Bjo Trimble, *On the Good Ship Enterprise: My 15 Years with Star Trek* (Norfolk, VA: Donning Company, 1983), 26–36.

104: "the show's influence would reverberate far longer": Edward Gross and Mark A. Altman, "An Oral History of 'Star Trek,'" *Smithsonian Magazine*, May 2016, https://bit.ly/3HXTbcb; Trimble, *On the Good Ship Enterprise*, 26–36.

104: "Another pathbreaking vision of spaceflight": *2001: A Space Odyssey*, dir. Stanley Kubrick (Metro-Goldwyn-Mayer, 1968).

NOTES

107: "he donated his card to the Museum": Jeff Gates, "I Was a Card-Carrying Member of the 'First Moon Flights' Club," smithsonian.com, October 20, 2016, https://bit.ly/3GWF05Q.

108: "the Robbins Company of Attleboro, Massachusetts": See Howard C. Weinberger, *The Robbins Medallions: Flown Treasure from the Apollo Space Program* (Birmingham, MI: Toy Ring Journal, 2000).

110: "a color photograph of Earth in the distance": Jennifer Levasseur, *Through Astronaut Eyes: Photographing Early Human Spaceflight* (West Lafayette, IN: Purdue University Press, 2020).

112: "they read the plaque's message aloud": Tahir Rahman, *We Came in Peace for All Mankind: The Untold Story of the Apollo 11 Silicon Disc* (Overland Park, KS: Leathers Publishing, 2008); Michael Collins, *Carrying the Fire: An Astronaut's Journeys* (New York: Farrar, Straus and Giroux, 1989), 335.

113: "The demanding tour encompassed a worldwide exchange of honors": See Teasel Muir-Harmony, *Operation Moonglow: A Political History of Project Apollo* (New York: Basic Books, 2020).

114: "Scott-Heron was not alone": Gil Scott-Heron, "Whitey on the Moon," on *Small Talk at 125th and Lenox* (Ace Records, 1970). See Neil M. Maher, *Apollo in the Age of Aquarius* (Cambridge, MA: Harvard University Press, 2017), 29–30.

4. *STAR TREK*, *STAR WARS*, AND BURGEONING FANDOMS

117: "disillusionment set in": Alexander C. T. Geppert, "The Post-Apollo Paradox: Envisioning Limits During the Planetized 1970s," in *Limiting Outer Space: Astroculture After Apollo*, ed. Alexander C. T. Geppert (London: Palgrave Macmillan, 2018), 3, 10.

118: "the program's fans went to great lengths to connect with others": Bjo Trimble, *On the Good Ship Enterprise: My 15 Years with Star Trek* (Norfolk, VA: Donning Company, 1983), 19. Other details about fan activity throughout this chapter are taken from Trimble's memoir.

118: "far-flung pockets of enthusiasts became a national force": The burgeoning academic study of fandom as well as fan fiction has roots in pathbreaking analyses that include Henry Jenkins, *Textual Poachers:*

Television Fans and Participatory Culture (New York: Routledge, 1992); Camille Bacon Smith, *Enterprising Women: Television Fandom and the Creation of Popular Myth* (Philadelphia: University of Pennsylvania Press, 1992); and Constance Penley, *NASA/TREK: Popular Science and Sex in America* (New York: Verso, 1997).

119: "the first *Star Trek* fan convention assembled": Elizabeth Thomas, "Live Long and Prosper: How Fans Made *Star Trek* a Cultural Phenomenon," in *Fan Phenomena: Star Trek*, ed. Bruce E. Drushel (Chicago: University of Chicago Press, 2013), 13–14.

122: "The *Planet of the Apes* movie series began in 1968": *Planet of the Apes*, dir. Franklin J. Schaffner (20th Century Fox, 1968); *Beneath the Planet of the Apes*, dir. Ted Post (20th Century Fox, 1970); *Escape from the Planet of the Apes*, dir. Don Taylor (20th Century Fox, 1971); *Conquest of the Planet of the Apes*, dir. J. Lee Thompson (20th Century Fox, 1972); *Battle for the Planet of the Apes*, dir. J. Lee Thompson (20th Century Fox, 1973); live-action television series, *Planet of the Apes* (CBS, September 13–December 20, 1974); animated television series, *Return to the Planet of the Apes* (NBC, September 6–November 29, 1975).

123: "a movie influenced by the burgeoning environmental movement": *Silent Running*, dir. Douglas Trumbull (Universal Pictures, 1972).

123: "the grisly compromises required for humanity to survive": *Soylent Green*, dir. Richard Fleischer (Metro-Goldwyn-Mayer, 1973); *Westworld*, dir. Michael Crichton (Metro-Goldwyn-Mayer, 1973). For the relationship between environmentalism and the Space Age, see Neil Maher, *Apollo in the Age of Aquarius* (Cambridge, MA: Harvard University Press, 2017), esp. chap. 3.

124: "a satirical student film titled *Dark Star*": *Dark Star*, dir. John Carpenter (Bryanston Distributing Company, 1975); J. W. Rinzler, *The Making of Alien* (London: Titan Books, 2019), 15.

125: "when news reports covered problem after problem": W. David Compton and Charles D. Benson, *Living and Working in Space: A History of Skylab* (Washington, DC: National Aeronautics and Space Administration, 1983), 251.

126: "the first officially licensed *Star Trek* playthings": Steve Kelley, *Star Trek: The Collectibles* (Iola, WI: Krause Publications, 2008), 225.

NOTES

128: "the model illustrated imaginative visions of future travel": For a fuller analysis of the studio model, see Margaret A. Weitekamp, "Two Enterprises: *Star Trek*'s Iconic Starship as Studio Model and Celebrity," *Journal of Popular Film and Television* 44, no. 1 (2016): 2–13.

130: "fans found them": Edward Gross and Mark A. Altman, *The Fifty-Year Mission: The Complete, Uncensored, Unauthorized Oral History of Star Trek—The First 25 Years* (New York: St. Martin's Press, 2016), 254.

131: "the time seemed right for next steps in space": For a detailed history, see Edward Clinton Ezell and Linda Neuman Ezell, *The Partnership: A History of the Apollo-Soyuz Test Project* (Washington, DC: US Government Printing Office, 1978).

132: "Where else would you not find Black people?": Hua Hsu, "How George Clinton Made Funk a World View," *The New Yorker*, July 2, 2018.

133: "O'Neill was impressed by the results": Gerard K. O'Neill, *The High Frontier: Human Colonies in Space* (Princeton, NJ: Space Studies Institute Press, 1989), 277–279.

134: "L5 was the point that O'Neill named as a good location for space colonies": W. Patrick McCray, *The Visioneers: How a Group of Elite Scientists Pursued Space Colonies, Nanotechnologies, and a Limitless Future* (Princeton, NJ: Princeton University Press, 2013), 90.

137: "The size of the crowds both thrilled and surprised the Museum's staff": Michael J. Neufeld and Alex M. Spencer, eds., *Smithsonian National Air and Space Museum: An Autobiography* (Washington, DC: National Geographic, 2010).

141: "Sagan called the plaques": Carl Sagan, F. D. Drake, Ann Druyan, Timothy Ferris, Jon Lomberg, and Linda Salzman Sagan, *Murmurs of Earth: The Voyager Interstellar Record* (New York: Random House, 1978), 23. See also Daniel K. L. Chua and Alexander Rehding, *Alien Listening: Voyager's Golden Record and Music from Earth* (Princeton, NJ: Princeton University Press, 2021).

143: "George Lucas was heavily influenced": *Star Wars*, dir. George Lucas (Lucasfilm/Twentieth Century Fox, 1977). See Diane Masters Watson, ed., *The Star Wars Album* (New York: Ballantine Books, 1977). This influence holds true as well for the first sequels, *Star Wars: Episode V—The Empire*

Strikes Back, dir. Irvin Kerschner (Lucasfilm, 1980), and *Star Wars: Episode VI—Return of the Jedi*, dir. Richard Marquand (Lucasfilm, 1983).

145: "the company's designers reinvented the action figure": Sharon M. Scott, *Toys and American Culture: An Encyclopedia* (Santa Barbara, CA: Greenwood, 2010), s.v. "Action Figures," 3; J. Richard Stevens, "Plastic Military Mythology: Hypercommercialism and Hasbro's G.I. Joe: A Real American Hero," in *Articulating the Action Figure: Essays on Toys and Their Messages*, ed. Jonathan Alexandratos (Jefferson, NC: McFarland & Company, 2017), 48.

146: "The toys' wide appeal accounted for some of their success": Stephen J. Sawsweet with Anne Neumann, *Star Wars: 1,000 Collectibles, Memorabilia and Stories From a Galaxy Far, Far Away* (New York: Abrams, 2009).

153: "One of those women, Kathryn Sullivan, recalled": Kathryn D. Sullivan, *Handprints on Hubble: An Astronaut's Story of Invention* (Cambridge, MA: MIT Press, 2019), 27.

153: "The era's cynicism permeates *Capricorn One*": *Capricorn One*, dir. Peter Hyams (Warner Brothers, 1978).

154: "*Alien* (1979) offers a dystopian vision of spaceflight": *Alien*, dir. Ridley Scott (20th Century-Fox, 1979).

5. GENERATION X, THE SPACE SHUTTLE, AND PROMOTING EDUCATION

159: "The original Kids had been handcrafted soft sculptures": Sharon M. Scott, *Toys and American Culture: An Encyclopedia* (Santa Barbara, CA: Greenwood, 2010), s.v. "Roberts, Xavier (b. 1955)," 260–261.

160: "The space shuttle was a reusable launch vehicle": See Roger Launius, "NASA and the Decision to Build the Space Shuttle, 1969–72," *The Historian* 57 (Autumn 1994): 17–34. See also Dennis Jenkins, *Space Shuttle: Developing an Icon, 1972–2013* (Forest Lake, MN: Specialty Press, 2017), and Valerie Neal, *Spaceflight in the Shuttle Era and Beyond: Redefining Humanity's Purpose in Space* (New Haven, CT: Yale University Press, 2017).

162: "*Moonraker* (1979) also capitalized on the hype": *Moonraker*, dir. Lewis Gilbert (United Artists, 1979).

NOTES

165: "offered readers a chance to immerse themselves": Kerry Mark Joels and Gregory P. Kennedy with David Larkin, *The Space Shuttle Operator's Manual* (New York: Ballantine Books, 1982).

166: "A space shuttle toy even appeared in Steven Spielberg's blockbuster film *E.T.*": *E.T. the Extraterrestrial*, dir. Steven Spielberg (Universal Pictures, 1982).

168: "Sally K. Ride would be the first American woman in space": For the history of how women became a part of NASA's astronaut corps, see Amy E. Foster, *Integrating Women into the Astronaut Corps: Politics and Logistics at NASA, 1972–2004* (Baltimore, MD: Johns Hopkins University Press, 2011), and Lynn Sherr, *Sally Ride: America's First Woman in Space* (New York: Simon & Schuster, 2014).

170: "The presence of payload specialists": See Melvin Croft and John Youskauskas, *Come Fly with Us: NASA's Payload Specialist Program* (Lincoln: University of Nebraska Press, 2019).

174: "went on location with ABC Motion Pictures for the filming of *Space Camp*": *Space Camp*, dir. Harry Winer (ABC Motion Pictures, 1986).

181: "the *Challenger* disaster was a particularly traumatic event for Generation X": See Nick Otten and Marjorie Stelmach, "Creative Reading/Creative Writing: What Do They Write About?" *The English Journal* 77 (February 1988): 80–81.

184: "out of the closet and into the universe": Henry Jenkins with John Campbell, "'Out of the Closet and into the Universe': Queers and *Star Trek*," in *Fandom: Identities and Communities in a Mediated World*, ed. Jonathan Gray, C. Lee Harrington, and Cornel Sandvoss (New York: New York University Press, 2007), 91; Bruce E. Drushel, *Fan Phenomena: Star Trek* (Chicago: University of Chicago Press, 2013), 31–33.

185: "the *ST:TNG* episodes that included same-sex themes": See the discussion of these episodes in Robin Roberts, *Sexual Generations: "Star Trek: The Next Generation" and Gender* (Urbana: University of Illinois Press, 1999).

NOTES

6. SPACE STATIONS, SPACEFLIGHT ENTHUSIASM, AND ONLINE FANDOM

187: "*Babylon 5* attracted passionate fans": *Babylon 5* (Warner Bros. Television, 1993–1998).

189: "the number of people responding negatively to these questions": Roger D. Launius, "Public Opinion Polls and Perceptions of US Human Spaceflight," *Space Policy* 19 (2003): 164; Roger D. Launius, "NASA's Quest for Human Spaceflight Popular Appeal," *Social Science Quarterly* 98, no. 4 (December 2017): 1228–1229.

192: "as Meyer recalled in his memoir": Nicholas Meyer, *The View from the Bridge: Memories of Star Trek and a Life in Hollywood* (New York: Penguin, 2009), 229.

193: "the last Soviet citizen": Eric Betz, "The Last Soviet Citizen," *Discover*, December 19, 2016.

193: "the diplomatic, economic, and political negotiations being carried out": William M. Shepherd, "Preparing for New Challenges," in *Looking Backward, Looking Forward: Forty Years of U.S. Human Spaceflight Symposium*, ed. Stephen J. Garber (Washington, DC: National Aeronautics and Space Administration, 2002), 205.

195: "a popular movie that highlighted Americans' can-do spirit": *Apollo 13*, dir. Ron Howard (Universal Pictures, 1995).

197: "the fictionalized film version made that garment iconic": Launius, "NASA's Quest for Human Spaceflight Popular Appeal," 1228.

197: "Created independently of any influence from real-life spaceflight plans": *Star Trek: Deep Space Nine* (Paramount Television, 1993–1999).

197: "antimonopoly rules barring television networks from owning the content": Patrick R. Parsons, *Blue Skies: A History of Cable Television* (Philadelphia: Temple University Press, 2008), 622; Jennifer Holt, *Empires of Entertainment: Media Industries and the Politics of Deregulation, 1980–1996* (New Brunswick, NJ: Rutgers University Press, 2011), 153–155.

198: "only the top studio brass on either side": See J. Michael Straczynski, *Becoming Superman: My Journey from Poverty to Hollywood* (New York: Harper Voyager, 2019), 321–322.

NOTES

199: "increasingly diverse group of actors": Daniel Bernardi, *Star Trek and History: Race-ing Toward a White Future* (New Brunswick, NJ: Rutgers University Press, 1998), 6.

200: "Several excellent scholarly analyses have unpacked": See Lisa Doris Alexander, "Far Beyond the Stars: The Framing of Blackness in *Star Trek: Deep Space Nine*," *Journal of Popular Film and Television* 44, no. 3 (2016): 150–158, at 152. See also De Witt Douglas Kilgore, "'The Best Is Yet to Come'; Or, Saving the Future: *Star Trek: Deep Space Nine* as Reform Astrofuturism," in *Black and Brown Planets: The Politics of Race in Science Fiction*, ed. Isiah Washington III (Jackson: University Press of Mississippi, 2016), 32; Michael Charles Pounds, "'Explorers'—Star Trek: Deep Space Nine," in *The Black Imagination, Science Fiction, Futurism, and the Speculative* (Bern: Peter Lang, 2011), 51; andré m. carrington, *Speculative Blackness: The Future of Race in Science Fiction* (Minneapolis: University of Minnesota Press, 2016), 159–175.

204: "significant backstories, emotional depth, and strong fan support": Straczynski, *Becoming Superman*, 325; David Bassom, *The A-Z Guide to Babylon 5* (New York: Dell, 1997), 157.

206: "The fan-created resources represented one part of a late 1990s space craze": Bruce E. Drushel, "Introduction: The Exemplar of Fan Culture?" in *Fan Phenomena: Star Trek*, ed. Bruce E. Drushel (Chicago: University of Chicago Press, 2013), 5.

208: "Spaceflight themes in movies also saw banner years in 1997 and 1998": *Contact*, dir. Robert Zemeckis (Warner Bros., 1997); *The Fifth Element*, dir. Luc Besson (Gaumont, 1997); *Gattaca*, dir. Andrew Niccol (Columbia Pictures, 1997); *Starship Troopers*, dir. Paul Verhoeven (TriStar Pictures, 1997); *Alien: Resurrection*, dir. Jean-Pierre Jeunet (Twentieth Century Fox, 1997); *Lost in Space*, dir. Stephen Hopkins (New Line Cinema, 1998); *Deep Impact*, dir. Mimi Leder (Paramount Pictures, 1998); *Armageddon*, dir. Michael Bay (Touchstone Pictures, 1998); *Star Trek: Insurrection*, dir. Jonathan Frakes (Paramount Pictures, 1998); *From the Earth to the Moon* (HBO, 1998).

212: "known as *Star Trek* Las Vegas": Elizabeth Thomas, "Live Long and Prosper: How Fans Made *Star Trek* a Cultural Phenomenon," in Drushel, *Fan Phenomena*, 15.

NOTES

217: "Both Blue Origin and SpaceX began competing": A fuller history of these developments can be found in Christian Davenport, *The Space Barons: Elon Musk, Jeff Bezos, and the Quest to Colonize the Cosmos* (New York: Public Affairs, 2018).

220: "The clear influence of 9/11 could also be seen": *Star Trek: Enterprise* (Paramount Network Television, 2001–5); *War of the Worlds*, dir. Steven Spielberg (Paramount Pictures, 2005); *Battlestar Galactica* (NBC Universal Television, 2004–9).

222: "led to the expanded use of online resources": See especially Henry Jenkins, *Convergence Culture: Where Old and New Media Collide* (New York: New York University Press, 2005).

223: "reboots or new versions of older properties allowed studios": *Star Wars: Episode I—The Phantom Menace*, dir. George Lucas (Lucasfilm, 1999); *Star Wars: Episode II—Attack of the Clones*, dir. George Lucas (Lucasfilm, 2002); *Star Wars: Episode III—Revenge of the Sith*, dir. George Lucas (Lucasfilm, 2005); *Star Wars: Clone Wars* (Cartoon Network, 2003–5); *Star Wars: The Clone Wars* (Lucasfilm Animation, 2008–20); *Star Wars: Rebels* (Lucasfilm Animation, 2014–18); *The Day the Earth Stood Still*, dir. Scott Derrickson (Twentieth Century Fox, 2008); *Star Trek*, dir. J. J. Abrams (Paramount Pictures, 2009), *Star Trek: Into Darkness*, dir. J. J. Abrams (Paramount Pictures, 2013); *Star Trek: Beyond*, dir. Justin Lin (Paramount Pictures, 2016); *Star Wars: Episode VII—The Force Awakens*, dir. J. J. Abrams (Lucasfilm, 2015), *Star Wars: Episode VIII—The Last Jedi*, dir. Rian Johnson (Walt Disney Pictures, 2017); *Star Wars: Episode IX—The Rise of Skywalker*, dir. J. J. Abrams (Walt Disney Pictures, 2019); *Rogue One: A Star Wars Story*, dir. Gareth Edwards (Lucasfilm, 2016); *Solo: A Star Wars Story*, dir. Ron Howard (Lucasfilm, 2018).

7. STREAMING SERVICES, BATTLING BILLIONAIRES, AND ACCELERATED CHANGE

228: "to preserve the materials of the unboxing experience": See David Craig and Stuart Cunningham, "Toy Unboxing: Living in a(n Unregulated) Material World," *Media International Australia* 163 (no. 1): 77–86.

NOTES

228: "*The Expanse* illustrates the continued power of fandoms": *The Expanse* (Syfy, 2015–18; Amazon Prime Video, 2018–22).

229: "Jeff Bezos personally announced": See "How *Star Trek* and Sci-Fi Influenced Jeff Bezos," *Wired*, January 26, 2019, https://bit.ly/3I5ELqB. The National Space Society was founded in 1987 when the National Space Institute merged with the L5 Society.

229: "To create the rapidly spinning black hole": Kip Thorne, *The Science of Interstellar* (New York: W.W. Norton & Company, 2014).

230: "Robert Zubrin reviewed the movie favorably": *The Martian*, dir. Ridley Scott (Twentieth Century Fox, 2015); Andy Weir, *The Martian* (New York: Crown, 2014). See Robert Zubrin, "How Scientifically Accurate Is *The Martian*?" *The Guardian*, October 6, 2015.

230: "*Hidden Figures* (2016) brought public attention": *Hidden Figures*, dir. Theodore Melfi (Fox 2000 Pictures, 2016).

230–31: "Johnson, Jackson, and Vaughn all made significant real-life contributions": Margo Lee Shetterly, *Hidden Figures: The American Dream and the Untold Story of the Black Women Mathematicians Who Helped Win the Space Race* (New York: William Morrow, 2016).

231: "histories of the women working at the Jet Propulsion Laboratory": Nathalia Holt, *Rise of the Rocket Girls: The Women Who Propelled Us, From Missiles to the Moon to Mars* (New York: Little, Brown, 2016).

236: "Space historian Dwayne Day has speculated": See Dwayne A. Day, "NASA as a Brand," *The Space Review*, August 6, 2018, https://bit.ly/3Ju3B3t.

240: "Wormsley's straightforward assertion hit a nerve": "There Are Black People in the Future," *Pittsburgh Post-Gazette*, October 3, 2019.

241: "Afrofuturism has become a vibrant area of academic study": See the special issue on Afrofuturism in *Social Text* 20, no. 2 (2002), particularly guest editor Alondra Nelson's "Future Texts," 1–15. See also Ytasha L. Womack, *Afrofuturism: The World of Black Sci-Fi and Fantasy Culture* (Chicago: Lawrence Hill Books, 2013), 2.

241: "Janelle Monáe created": Janelle Monáe, *Metropolis: The Chase Suite* (Bad Boy Records, 2007); *The ArchAndroid* (Bad Boy Records, 2010); *The Electric Lady* (Bad Boy Records, 2013); clipping., *Splendor & Misery* (Sub Pop, 2016).

241: "The blockbuster hit *Black Panther*": *Black Panther*, dir. Ryan Coogler (Marvel Studios, 2018).

NOTES

244: "*Star Trek: Discovery* streamed on Netflix": Chris Stokel-Walker, "*Star Trek: Discovery* Is Tearing the Streaming World Apart: Season Four of *Discovery* Is Boldly Going Where No Multibillion-Dollar Franchise Has Gone Before—and Fans Are Outraged," *Wired*, November 19, 2021, https://bit.ly/3BpnlCL.

246: "Space-themed films or television series": *Lost in Space* (Netflix, 2018–21); *Away* (Netflix, 2020); *For All Mankind* (Apple TV+, 2019–); *The Midnight Sky*, dir. George Clooney (Netflix, 2019); *The Mandalorian* (Disney+, 2019–); *The Book of Boba Fett* (Disney+, 2021–); *Star Wars: The Bad Batch* (Disney+, 2021–); *Star Wars: Visions* (Disney+, 2021–).

248: "what cultural historian Henry Jenkins has called transmedia storytelling": Henry Jenkins, *Convergence Culture: Where Old and New Media Collide* (New York: New York University Press, 2006), 293.

249: "*Halo* is an amalgam of all of these": Kevin R. Grazier, "Halo Science 101," in *Halo Effect: An Unauthorized Look at the Most Successful Video Game of All Time*, ed. Glenn Yeffeth (Dallas, TX: BenBella Books, 2007), 38.

254: "The confluence of events drew comparisons to 1968 and 1969": See Diane McWhorter, "As Astronauts Rocket into Space, Protesters are Beaten in the Street—Just Like Before," *Washington Post*, June 5, 2020; Margaret A. Weitekamp, "The Challenge Before Us: A Historical Reflection on 1969 and 2020," June 2, 2020, National Air and Space Museum website, https://s.si.edu/3sHy731; reprinted on *Smithsonian Magazine*'s blog, June 15, 2020, https://bit.ly/351WIY4.

256: "In her commentary on the flight": Robin Givhan, "Astronaut Wally and the Cowboy Hat That Rocketed into Space," *Washington Post*, July 20, 2021.

261: "science fiction and reality have fed into each other": See Howard McCurdy, *Space and the American Imagination* (Baltimore, MD: Johns Hopkins University Press, 1998).

262: "As former NASA historian Roger Launius has argued": Roger D. Launius, "NASA's Quest for Human Spaceflight Popular Appeal," *Social Science Quarterly* 98, no. 4 (December 2017): 1216.

Index

Page numbers in italics indicate photos.

9/11, influence of, 218–22
2001: A Space Odyssey (film), 104–6

A

Abernathy, Ralph, 111
Abraham, Daniel, 237, 238–39
Adair, David, 179–80
African American experience, the
 Afrofuturism, 79, 132–33, 240–42
 astronauts, 77–78, 90
 civil rights movement of the 1960s, 100, 109–10, 111, 113–14
 representation in toys, TV, and movies, 91, 92, 144, 155
 on *Star Trek*, 101, 102–3, 200–201
 violence against Blacks, 79, 253–54
 "Whitey on the Moon" (spoken-word poem), 114
Aldrin, Buzz, 3, 111, 172

Alien (film), 154–56
Alta (*Forbidden Planet* character), as racialized, 57–58
Amazing Stories (magazine), 10, 19
American identity and flight, 3–4, 260–62
amusement parks celebrating space, 15–18, 33, 53, 86
Anderson, Jack, 171–72, 182
Ansari, Amir, 215–16
Ansari, Anousheh, 215–16
Ansari X Prize, 215–16
Apollo 1 fire, 100
Apollo 11, 3, 106, 108, *109*, 111–13, 122, 136, 172, 178, 256
Apollo 13 (film), 195–97, *197*
Apollo Program, 108–14
Apollo-Soyuz Test Project (ASTP), 131–32
Arden, Dale (*Flash Gordon* character), 24, 47
Armageddon (film), 209–10
Armstrong, Neil, 109, *109*, 113
Arnold, Rebecca, 22
Artemis Program, 233–34

Astroland, 86, *87*
astronauts
 African American, 77–78, 90
 female, 77–78, 89–91, 151, 168–69
 NASA's first group of, *65*, 66
 physical challenges for, 68–69
 recruitment of more diverse candidates, 150–53, 168
Autour de la Lune (*Around the Moon*) (Verne), 13

B

Babylon 5 (TV show), 187–88, *188*, 197–98, 201–6, *205*
Ball, Lucille, 88–89
Barbie dolls, 91
Barlow, Ron, 130–31, 137
Barrett Roddenberry, Majel, 207–8
Barton, Glenn (*The Man and the Challenge* character), 68–70

INDEX

Battlestar Galactica (TV show), 150, 220–22
Beatty, Kenneth E., *177*, 177–78
Bernstein, Robin, 5
Bezos, Jeff, 216–17, 229
Black Panther (film), 241–42
Blue Origin, 216–17, 256–57
Bonestell, Chesley, 47, 50, 71
Book of Boba Fett, The (TV series), 247
Branson, Richard, 216, 254–56
Bremond, Walter, 144
Brooks, Avery, 200–201
Buck Rogers
 archetype, 2, 26–27, 38, 260
 first appearance, 10–11
 legacy of, 34–35, 50
 popularity of, 11
 as a reflection of its time, 20–22, 33
 toys, *28*, 28–34
Buck Rogers in the 25th Century
 comic strip (formerly *Buck Rogers, 2429 A.D.*), 10–11, 20–23, 32–33
 radio program, 23–24
 TV show, 150

C

Cabbage Patch Kids, 157–59, *158*, 172–73
Calkins, Dick, 10–11, 20–21
Capricorn One (film), 153–54
Captain Video and His Video Rangers (TV show), 39–42
Carpenter, John, 124
Carpenter, M. Scott, *65*, 66, 90

Challenger Learning Centers for Science Education, 182
Challenger space shuttle orbiter, 168, *169*, 181–82
children's participation in spaceflight, 176, 181
China, space program of, 253, 254
Churchley, Laura Shepard, 257
civil rights movement of the 1960s, 100, 109–10, 111, 113–14
Clarke, Arthur C., 104, 112–13
Clinton, George, 132–33
clipping, 241
clothing
 American sportswear in the 1930s, 22
 Close Encounters of the Third Kind (film), 139, 149
 Cobb, Geraldyn "Jerrie," 78, 89–90
 Cochran, Jacqueline, 78, 90
 spacesuits, 234–35
 worn by Wilma Deering in *Buck Rogers*, 21–22
Cold War, 4, 37–38, 56, 75, 131–32, 189
collectibles, 112, *148*, 148–49, 204, 211–12, 213
Collier's magazine, 52
Collins, Michael, 3, 136
"Colonies in Space" (article), 133–34
comic books, 6, 11, 150, 173, 179, 181, 223, 241, 249, 252
comic strips, 5, 6, 10–11, 20–22, 24, 25–28, 31–32, 33, 46–47, 145

communication, interstellar, 140–43, *142*
Coney Island, 16–18, 53, 86–87, *87*
Conquest of Space, The (Ley), 50
conventions ("cons"), 6, 101–2, 119–22, 130, 152, 184–85, 212–13, 225
Cooper, Leroy Gordon, Jr., *65*, 66, 94–95, *95*
cosmism, 2
"cosplay," 6, 117, 122
Countdown: Inspiration4 Mission to Space (film), 258
COVID-19 pandemic, 227, 246
Crippen, Robert "Bob," 163–64

D

Daisy Manufacturing Company, 27–30, 32, 33–34, 53–54
Dark Star (film), 124
Deering, Wilma (*Flash Gordon* character), 10, 21–22, 24, 29–30
De la Terre à la Lune (*From the Earth to the Moon*) (Verne), 12–13, 18
Destination Moon (film), 50–51
Diamandis, Peter, 163, 215–16
Disney, Walt, 52–53
Disneyland, 52–53
Dixon, Mark E., *83*, 83–84
Drexler, Doug, 115, 130–31
Dr. Huer (*Buck Rogers* character), 23, 24
DuMont Network, 39, 41

INDEX

Dundy, Elmer "Skip," 15, 16
Durant, Frederick Clark "Fred," III, 103, 128–30
Dwight, Ed, 90

E

Earth: Final Conflict (TV show), 207–8
eBay, 213–14
economic growth of the 1950s, 55
Edison, Thomas, 14, 17
education programs for young people
 INTERSECT Space Training Center (ISTC), 179–81
 National Aerospace Cadets (NAC), 177, 177–78, 180–81
 Young Astronaut Program, 157–59, *158*, 170–75, 178–79
 Youngstars, 178–79, 180–81
Edward McCauley (*Men Into Space* character), 71–73
Enterprise (*Star Trek* ship), 49, 101, 127–28, *129*, 130, 137–8
Enterprise-D, 183
Enterprise NX-01, 219
Enterprise space shuttle flight test vehicle, 137–39, *139*, 151, 160–61, *161*, 163
E.T. the Extraterrestrial (film), 166–67
Expanse, The
 novel series, 237, 238–39
 TV show, 227–29, *228*, 236–39

F

fans and fandom
 ancillary content models, 221–22
 fan-created resources, 206
 the Gaylactic Network, 184–86
 letter-writing campaigns, 104, 137, 185
 online communities, 222–23, 227–29, *228*
 radio program fan clubs, 23–34
 role of fans in *Babylon 5*'s development, 201–2
 Star Trek fandom, 118–22, 128–31, 184
 tribute memorabilia, 115–17, *116*, 130–31
female characters, depictions of, 20–22, 25, 47, 51–52, 57–58, 69, 73, 88–89, 155, 183, 221
Fifth Element, The (film), 208–9
firearms, personal, 25–26, 261
Firefly (TV show), 251–52
Flash Gordon
 comic strip, 24, 46–47
 film, 150
 movie serials, 24–25
Flash Gordon toys, 32, 33, 34
Fletcher, James, 151–52
For All Mankind (TV show), 246
Forbidden Planet (film), 56–59
Ford, Gerald, 136, 138
Foster, Robert L. "Bob," 96–98, *97*
Foster, Toni, 96–98, *97*
Franck, Ty, 237, 238–39

Friendship 7 memorabilia, 74–75, 76, 81–84, *83*
From the Earth to the Moon (TV show), 211
Funk, Wally, 256
Gagarin, Yuri, 77, 79
Gates, Jeffrey, 106–7, *107*
Gattaca (film), 209
gender issues
 aggression against female stars, 225–26
 depictions of female characters, 20–22, 25, 47, 51–52, 57–58, 69, 73, 88–89, 155, 183, 221
 female astronauts, 77–78, 89–91, 151
 masculinity, 70, 73
 questions about women's physical capabilities, 69, 89–90
 sexual identity, 70, 184–85, 244–45
 spacesuits, appropriately-sized, 234–35
 women's rights, 100

G

Generation X, 160, 162–63, 170–71, 181
G.I. Joe action figures, 91
Glenn, John H., Jr., 74–77, *76*, 79–84, *83*
Goddard, Esther, 23
Goddard, Robert H., 18–19, 23
Grissom, Virgil I. "Gus," 94

H

Halo universe, 248–51, *250*
Heat-Ray, 18
Hidden Figures (film), 230–31
Hough, Cass, 27, 29

INDEX

IDIC (infinite diversity in infinite combinations), 244–45

I
Ingersoll, Fred, 17
Inspiration4 mission. *See* SpaceX
International Space Station (ISS), 188–89, 214–15, 252–53
Interstellar (film), 229–30
interstellar communication, 140–43, *142*
Isaacman, Jared, 258–59

J
Jackson, Mary, 230–31, 233
Japanese tin toys, 59–60, *61*
Jemison, Mae, 153, 231
Jetsons, The (TV show), 88
Johnson, Katherine, 230–31
Johnson, Lyndon B., 77, 94
jumpgate brooches, 187–88, *188*

K
Kennedy, John F., 77, 93–94
Kennedy Space Center (KSC), 99–100
Kenner Toys, 145–47, 149
Kluger, Jeffrey, 254–55
Koch, Christina, 234–35
Kraft rocket promotion, 64–65
Kranz, Gene, 196–97, *197*
Krikalev, Sergei, 192–93, 195
Kubrick, Stanley, 104–5

L
L5 Society, 134–35
Labelle (musical group), 133
"Last Billboard, The" (art installation), 240–41
Leonov, Alexei, 131–32
Ley, Willy, 50, 51
Life in the Universe? exhibit, 128–30, *129*
liquid-fuel rocket engines, 18–19
Lost in Space
film, 209
TV show, 93, 246
Lowell, Percival, 18
Lucas, George, 143
Lucy Show, The (TV show), 88–89
Luna (amusement park airship), 15–18
Luna Park, 16–18, 33, 86
lunchbox depicting *Enterprise*, 160–61, *161*
Lundy, Lamar J., Jr., 93

M
MacFarlane, Seth, 245
Major Matt Mason toy line, 92
Man and the Challenge, The (TV show), 67–70, 73
Mandalorian, The (TV show), 247
Mars, 18, 218, 230
Mars and Its Canals (Lowell), 18
Martian, The (film), 230
Marx toys (Louis Marx and Company), 54–56
McAuliffe, Christa, 181–82
McClain, Anne, 234–35
McMahon, David, 74–75, 76
Mead, Margaret, 62
Meir, Jessica, 235
Melaro, H. J. M., 178–79
Méliès, George, 13–15
Melvin, Leland, 254
memorabilia
from Apollo missions, 111–13
Coca-Cola and Pepsi can replicas from STS-51F, 173–74, *174*
collectibles, 112, 148, *148*, 204, 211–12, 213
commemorative medallions, 108
Toni Foster's charm bracelet, 96–98, *97*
Friendship 7, 74–75, *76*, 81–84, *83*
mission patches, 94–96, *95*, 108, 125–26, *127*, 196
movie merchandising, 145–50, *148*
"Neil Armstrong for President" button, *109*
personal connections to, 6, 75
Rocinante model from *The Expanse*, 227–28, *228*
space-related, 81–82, 96, 112
from the STS-1 shuttle launch, 164
STS-7 pendant, *169*, 169–70
as tributes from fans, 115–17, *116*
Memory Alpha, *Star Trek*, 223
Men Into Space (TV show), 67, 71–73
"Method of Reaching Extreme Altitudes" (report), 19
Métraux, Rhoda, 62

INDEX

Midnight Sky, The (film), 246
Millennium Falcon (*Star Wars* ship), 143, 217
Mir. See Space Shuttle: Shuttle-*Mir* missions
mission patches, 94–96, 95, 108, 125–26, 127, 196
Monáe, Janelle, 230, 232, 241
Moon, the
 American flag planted on, 111–12
 lunar travel, 106–7, 107
 Moon-themed amusement parks, 15–18
 Jules Verne's novels about, 12–13
Moonraker (film), 162
Moon Voyage, The (Verne), 13
Moore, Don W., 24
movie serials, 24–25
multiracialism
 art depicting a multiracial future, 240–42
 in casting, 200–201, 225–26, 238–39
 in *Star Trek*, 49, 101, 102–3, 139
Murrow, Edward R., 78
music
 Afrofuturism, 79, 132–33, 240–41
 Parliament, 132–33
 Sounds of Earth record, 140–43, 142
 Sun Ra, 79
Musk, Elon, 217
mutoscope reels, 14, 14–15

N

NASA
 families of aerospace employees, 96–98
 female employees, 230–31, 233
 first group of astronauts, 65, 66
 growth in the 1960s, 93–94
 logos and merchandise, 236
 mission patches and commemorative medallions, 94–96, 95, 108, 125–26, 127, 196
 payload specialists, 170
 racial integration of, 78–79
 recruitment of more diverse astronaut candidates, 150–53, 168
 relationship with private companies, 217, 253
 Space Flight Participant Program, 175–76
 Teacher in Space Project, 175–76, 181
New Glenn, Blue Origin, 259
New Shepard, Blue Origin, 256, 257, 259
Nichols, Nichelle, 101, 102–3, 151–53
Nowlan, Philip Francis, 10–11, 33

O

O'Bannon, Dan, 124, 154
O'Harro, Michael, 36–37
O'Neill, Gerard K., 133–35
Orville, The (TV show), 245

P

Parade magazine, 78
parades, 82, 164
phasers, 25
Planet of the Apes film franchise, 122–23
playsets, 36–38, 37, 54–56, 127
Plymouth (TV show), 190–91
political protest, 123, 126, 181, 200, 253–54
popular culture, 5–6, 19–20, 147–49
Proctor, Sian, 258
Project Gemini, 94–96
pulp magazines, 19–20

Q

Quinn, Zoë, 225

R

race relations
 anti-Asian behavior, 10, 11, 21, 25, 40–41, 150, 225
 civil rights movement of the 1960s, 100, 109–10, 111, 113–14
 in depiction of aliens and villains, 40–41, 46–47, 93, 128, 155
 within playsets, 56, 127–28
 racial inequality, 38, 48–49, 123, 144, 191, 253–54
 racial integration of NASA, 78–79, 150–53
 reactions to increased diversity, 153, 200–201, 225–26
 segregation, 16
 white flight, 46
radio programs, 23–24
Ralston Rocket promotion, 44–45, 64–65
ray guns, 8–9, 9, 18, 25, 34–35, 53–54, 261

INDEX

Reagan, Ronald, 157, 168, 175–76
reboots of TV shows and movies, 223–24
Ride, Sally, 168–69, *169*
Robby the Robot, 56, 58
robots and robot toys, 56, 60, *61*
Rocinante (vessel from *The Expanse*), 227–28, *228*
Roddenberry, Gene, 101–4, 138, 199, 207
role playing games (RPGs), 248, 252
Roosevelt, Franklin Delano, 32–33
Rush (rock band), 164
Russell, Steve, 84–85
Russia. *See* Soviet Union
Rutan, Burt, 255

S

Sagan, Carl, 140–41
Sarris, Sandy, 130
satellite launches, 62–64, *63*
Schirra, Walter M., Jr. "Wally," 35
science fiction
 as a child-oriented genre, 49–50
 defamiliarization, 185
 depiction of human space adventures, 2, 11–12
 development of more sophisticated films, 153–55
 dystopian predictions, 122–23
 jumpgate design, 187, *188*
 major elements of, 20
 similarity to Westerns, 8, 12, 24–26, 34–35, 198

Science Fiction Theater (TV show), 67
Sci-Fi channel, 207, 228
Scott, Sharon, 146, 147–48
Scott-Heron, Gil, 114
scriptive things, 5
Seaton, Dick (*The Skylark of Space* character), 10
Selenites, 13, 15–16
Shatner, William, 257
Shepherd, William, 193, 214
Silent Running (film), 123
Skylab, 124–26, 156
Slayton, Donald K. "Deke," 65, 66, 131
Smithsonian National Air and Space Museum, 1–2, 3, 6–7, 128–30, *129*, 135–37
social media, 217–18, 222–23, 227–29
Sounds of Earth record, 140–43, *142*
Soviet Union (now Russia), 62, 75, 77, 131–32, 188, 192–95, *196*, 214–15, 259
Space Adventures Ltd., 215
Space Age, the, *65*, 65–66, 86–87, 93–94
Space and the American Imagination (McCurdy), 50
Space Camp (film), 174
space colonies, 133–35
spaceflight
 in the 1970s, 117–18, 124–26
 all-women spacewalks, 234–35
 children's participation in, 176, 181
 criticism of, 110, 114, 261–62
 fictional depictions of, 38–39, 49–50
 popular opinion about, 62, 64, 125, 139–40, 163–65, 186, 189–90
 privately financed, 214–18, 253–59, *257*
 rationales for pursuing, 72
 sale of cargo space on shuttles, 167–68
 space boosters, 50–51
 suborbital flight, 255–58, *257*
 in various cultures and time periods, 2–3
 vehicle capabilities, 160–61, *161*
 visualizations of future space exploration, 50–53
Space Patrol (TV show), 43–45
Space Patrol Rocket Port Set, 36–38, *37*
SpaceShipOne, 216, 239, 254–55
Space Shuttle
 books and activities about the Space Shuttle, 165–67
 shuttle launches, 163–64, 167–70, 174
 Shuttle-*Mir* missions, 188, 192–95, *196*
 The Space Shuttle: A Complete Kit in a Book (McLoughlin), 165
 The Space Shuttle Operator's Manual (Larkin, Kennedy, and Joels), 165–66
space tourism, 215–18, 253–59, *257*
Space Transportation System (STS), definition, 160

INDEX

Spacewar! (videogame), 84–85
SpaceX, 217, 253, 254
Sputnik satellite, 62
Stafford, Thomas P., 131–32
Stargate SG-1 (TV show), 207
Starship Troopers (film), 209
Star Trek: Deep Space Nine (TV show), 197–201
Star Trek: Discovery (TV show), 242–43, 244–45
Star Trek: Enterprise (TV show), 219–20
Star Trek: Insurrection (film), 210–11
Star Trek VI: The Undiscovered Country (film), 191–92
Star Trek: The Animated Series (TV show), 126
Star Trek: The Motion Picture (film), 149
Star Trek: The Next Generation (ST:TNG) (TV show), 183–86
Star Trek: The Original Series (TV show)
 cast diversity, 101, 102–3, *139*
 fan support, 104, 118–22, 128–31, *129*
 franchise offerings via streaming services, 242–45
 and NASA's campaign for more diverse astronaut candidates, 151–53
 phasers, 25
 racially integrated crew, 49
 range of show-related products, 211–12

Vulcan ear tip replica prop, 115–17, *116*
Star Trek: Voyager (TV show), 199, 206, 207, 242
Star Wars Album, The (Ballantine Books), 143–44
Star Wars: Episode IV—A New Hope (film), 25, 118, 139, 143–45
Star Wars film franchise
 female representation, 224–26
 movie merchandising, 145–50, *148*, 224–25
 prequels and sequels, 223–24, 247–48
 related television programs, 247–48
 Western-inspired narrative, 143–44
stereotypes, 10, 11, 21, 25
Straczynski, J. Michael, 187, 198, 201–4
streaming services, 228–29, 242–48
Students for the Exploration and Development of Space (SEDS), 162–63, 164–65
Sun Ra, 79
Syfy channel, 207, 228

T
technology
 digital video recorders, 211
 early television programming, 41–42
 early videogames, 84–85
 introduced in *Buck Rogers*, 22–23
 likely innovations seen in films, 105
 online fan communities, 222–23, 227–29, *228*

social media, 217–18, 222–23, 227–29
streaming services, 228–29, 242–48
television
 addressing the challenges of space travel, 67–70
 appointment television, 211
 early programming, 41–42
Terry and the Pirates (comic strip), 21
Thompson, Frederic, 15–17, 18
Tito, Dennis, 215
Tom Corbett, Space Cadet (TV show), 51–52
Topsy (elephant), 16–17
tourism around space centers, 99
toys
 absence of female figurines, 224–25
 African American representation in, 91, 92
 Babylon 5, 204, 206
 Barbie dolls, 91
 books and activities about the space shuttle, 165–67
 Buck Rogers, 28, 28–34
 Cabbage Patch Kids, 157–59, *158*
 Captain Video and His Video Rangers game, 42, *42*
 as cultural artifacts, 4–5, 146–49
 Flash Gordon toys, 32, *33*, 34
 G.I. Joe action figures, 91
 guns modeled after real weapons, 25–26

295

INDEX

Japanese tin toys, 59–60, *61*
Lego sets celebrating women in science, 231–33, *232*
Major Matt Mason line, 92
paper guns, 27
playsets, 36–38, *37*, 54–56
ray guns, 8–9, *9*, 18, 25, 34–35, 53–54, 261
rocket pistols, 27, *28*, 28–30
Shuttle Challenge board game, 166
space forts, 37–38
Space Patrol Rocket Port Set, 36–38, *37*
Star Trek, 126–28
Star Wars, 145–50
Tran, Kelly Marie, 225
transmedia storytelling, 248–52
Trill (*Star Trek* alien), 185, 244–45
Trimble, Bjo, 104, 121, 137
Trimble, John, 104, 121, 137
"Trip to the Moon, A" (amusement park ride), 15–18
Trip to the Moon, A (film), 13–15, *14*
Turner, Frederick Jackson, 26
TV Guide (magazine), 206–7

U

USS *Enterprise*. See *Enterprise* (*Star Trek* ship)
US Space Camp, 167

V

Vanguard TV-3 satellite, 62, *63*
Vaughn, Dorothy, 230–31
Verne, Jules, 12–13, 18
videogames
 first-person shooter games, 249–50
 Gamergate, 225–26
 Halo universe, 248–51, *250*
 Spacewar!, 84–85
 transmedia storytelling, 248–52
Vietnam War, 100, 108, 123
Virgin Galactic, 216, 254–55, 259
Virginian, The (Owen Wister novel), 26
Voyager I & II spacecraft, 140–43, *142*
VSS *Enterprise*, Virgin Galactic, 254

W

War of the Worlds (film), 220
War of the Worlds (Wells), 18, *19*
Weinstock, Maia, 231–33, *232*
Weiss, Chuck, 130
Wells, H. G., 18
Westerns
 common characters in, 24–25
 concept of the American frontier, 26–27, 77
 science fiction's similarity to, 8, 12, 34–35, 198
 as trend in 1950s TV shows, 67
When Worlds Collide (film), 47–49
"Whitey on the Moon" (spoken-word poem), 114
Wookieepedia, *Star Wars*, 223, 226
World War I, 22
World War II, 32, 59
Wormsley, Alisha, 240–41

X

XPrize Foundation, 215–16

Y

Young, John, 163–64
Young Astronaut Program, 157–59, *158*, 170–75, 178–79

Z

Zlotoff, Lee David, 190